WOMEN ARTISTS AT THE MILLENNIUM

OCTOBER BOOKS

George Baker, Yve-Alain Bois, Benjamin H. D. Buchloh, Catherine de Zegher, Leah Dickerman, Hal Foster, Denis Hollier, Rosalind Krauss, Annette Michelson, Mignon Nixon, and Malcolm Turvey, editors

Broodthaers, edited by Benjamin H. D. Buchloh

AIDS: Cultural Analysis/Cultural Activism, edited by Douglas Crimp

Against Architecture: The Writings of Georges Bataille, by Denis Hollier

Painting as Model, by Yve-Alain Bois

The Destruction of Tilted Arc: Documents, edited by Clara Weyergraf-Serra and Martha Buskirk

Techniques of the Observer: On Vision and Modernity in the Nineteenth Century, by Jonathan Crary

Looking Awry: An Introduction to Jacques Lacan through Popular Culture, by Slavoj Žižek

Cinema, Censorship, and the State: The Writings of Nagisa Oshima, by Nagisa Oshima

The Optical Unconscious, by Rosalind E. Krauss

Gesture and Speech, by André Leroi-Gourhan

Compulsive Beauty, by Hal Foster

Continuous Project Altered Daily: The Writings of Robert Morris, by Robert Morris

Read My Desire: Lacan against the Historicists, by Joan Copjec

Fast Cars, Clean Bodies: Decolonization and the Reordering of French Culture, by Kristin Ross

Kant after Duchamp, by Thierry de Duve

The Duchamp Effect, edited by Martha Buskirk and Mignon Nixon

The Return of the Real: The Avant-Garde at the End of the Century, by Hal Foster

October: The Second Decade, 1986–1996, edited by Rosalind Krauss, Annette Michelson, Yve-Alain Bois, Benjamin H. D. Buchloh, Hal Foster, Denis Hollier, and Silvia Kolbowski

Infinite Regress: Marcel Duchamp 1910–1941, by David Joselit

Caravaggio's Secrets, by Leo Bersani and Ulysse Dutoit

Scenes in a Library: Reading the Photograph in the Book, 1843–1875, by Carol Armstrong

Neo-Avantgarde and Culture Industry: Essays on European and American Art from 1955 to 1975, by Benjamin H. D. Buchloh

Suspensions of Perception: Attention, Spectacle, and Modern Culture, by Jonathan Crary

Leave Any Information at the Signal: Writings, Interviews, Bits, Pages, by Ed Ruscha

Guy Debord and the Situationist International: Texts and Documents, edited by Tom McDonough

Random Order: Robert Rauschenberg and the Neo-Avant-Garde, by Branden W. Joseph

Decoys and Disruptions: Selected Writings, 1975–2001, by Martha Rosler

Prosthetic Gods, by Hal Foster

Fantastic Reality: Louise Bourgeois and a Story of Modern Art, by Mignon Nixon

Women Artists at the Millennium, edited by Carol Armstrong and Catherine de Zegher

WOMEN ARTISTS AT THE MILLENNIUM

EDITED BY CAROL ARMSTRONG AND CATHERINE DE ZEGHER

OCTOBER Books

THE MIT PRESS

CAMBRIDGE, MASSACHUSETTS

LONDON, ENGLAND

© 2006 Massachusetts Institute of Technology

Support for this publication has been provided by The Publications Commitee, Department of Art and Archaeology, Princeton University.

MIT Press books may be purchased at special quantity discounts for business or sales promotional use. For information, please email special_sales@mitpress.mit.edu or write to Special Sales Department, The MIT Press, 55 Hayward Street, Cambridge, MA 02142.

This book was set in Bembo by Graphic Composition, Inc., and was printed and bound in the United States of America.

Library of Congress Cataloging-in-Publication Data

Women artists at the millennium / edited by Carol Armstrong and Catherine de Zegher.
 p. cm.
 "October books."
 Includes index.
 ISBN 0-262-01226-X (alk. paper) — ISBN 978-0-262-01226-3
 1. Feminism and the arts—Congresses. 2. Women artists—Congresses. 3. Arts, Modern—20th century—Congresses. I. Armstrong, Carol M. II. Zegher, M. Catherine de.

NX180.F4W655 2006
704'.042—dc22
 2005058051

CONTENTS

PREFACE

CAROL ARMSTRONG

In November 2001, I organized a conference called "Women Artists at the Millennium," which brought together papers and discussion by and about women artists and art historians at Princeton University, with the cosponsorship of the Program in the Study of Women and Gender and the Department of Art and Archaeology. Four years later, I return to the motivation for the conference, and to the links among the three nouns in its title: "women," "artists," and "millennium." I want to reconsider them from the more sober vantage point of a time to which no millennial freight need be attached, in spite of—or perhaps precisely because of—our living through September 11, 2001, and its aftermath. Those of us at the conference in November 20001 had already begun to live through that tragic event, but its shadow hung over us so immediately that the triumphalism that initially seemed to hover around the notion of "women artists at the millennium" was converted into its epically anxious opposite. I myself am not epically minded, but I believe there is a special need now to retreat from our desire for epic adventures and conclusions. So I will reconsider the category of the "woman artist" here in a more modest light, taking some critical distance from the conference which this book records, modifies, and supplements and from which it departs.

There are, in fact, reasons from within the category of the "woman artist" for withdrawing from the epic perspective and the baggage of greatness that goes

with it. Back in 1971, at the outset of the modern women's movement and the onset of feminist art-making, Linda Nochlin had asked the question, "Why have there been no great women artists?" The thirty-year anniversary of that famous, double-sided query was the first of the motivations for the conference held in 2001. The question had been asked and answered—the answers, of course, were historical, institutional, cultural, psychological, not biological—primarily with regard to nineteenth-century painting and what came before it. In 2001, the idea was to ask and answer the question with regard to what came after, particularly during the thirty years after 1971. Thus the focus was on the contemporary situation, with regard to which Nochlin herself had to reframe the original question, so that it now read, "Why have there been great women artists?" In my view, something unexpected happened with that simple, one-word change. Suddenly the reformulated question seemed a little less double-sided, less equivocal than it had in its original negative incarnation: now that there have been and continue to be increasing numbers of "women artists" producing some of the most compelling work in the contemporary scene, and being recognized for doing so, the conundrum of greatness with regard to women artists had lost some of its edge. At least, so I felt, and still feel now.

Crucial to its cleverness was what I had taken to be the ambivalence of the original question—if the "great artist" is a mythic figure borne aloft by patriarchal values, should the "woman artist" aspire and be assimilated to the very same greatness that the question implicitly criticizes? One of the missions of feminist art (by men and by women) has been canon critique—what does that say about the millennial mission of adding women to the pantheon of great artists? Of course it is a good thing that we can now argue the reasons for there being plenty of prominent female contributors to the contemporary canon, paradoxical as this may be. Of course it is a good thing that some of us can even assume that proposition as a fact and proceed from there, either taking the class of the "woman artist" for granted or ignoring it as a special category altogether, as most of the art historian participants in the conference did. Yet the contemporary inversion of the question not only turns it inside out, it also—quite inadvertently—goes a long way toward blunting its critical pointedness and undoing its destabilizing

potential. And assuming or ignoring the "woman artist" as such vitiates the question itself, thus eliminating one of the prime motivations for the conference in the first place, and for the somewhat different book that follows upon it.

Four years later, then, what are we to do with our terms? Well, first we should reconsider some of the things we may have come to take for granted since 1971. So what about the category that the original question put in place? Is a "woman artist" a woman who happens to be an artist, or the other way around, an artist who happens to be a woman? Well, the other way around, surely, if we take her artistry seriously. But then, of what importance is the fact that the artist happens to be a woman—relative to other facts about her, such as her race, her class, her geographical and historical situation, her personal history, and her artistic formation? I am a woman professor—but I consider myself such only at certain moments; at other moments I consider myself a professor *tout court;* at yet other moments I don't consider myself a professor, but I do consider myself a woman, or a mother, or a lover, or a daughter, or a sister, or a friend, or some combination thereof. Sometimes I don't consider myself either a professor or a woman, but simply a person with a particular history, a fifty-year-old, white Anglo-Saxon, middle-class, left-leaning, culturally Protestant, agnostic person who converted to Judaism but only in certain circumstances considers herself Jewish. Sometimes I consider myself an artist, a writer, and/or an intellectual with a particular point of view and particular curiosities who is sometimes "feminine" and sometimes "masculine" of mind and behavior (and sometimes neither and/or both). Sometimes I consider myself a feminist, but I have to admit, sometimes I don't: especially when feminism entails orthodoxy, the espousal of permanent victimhood, or gender self-hatred—feminist misogyny is just as prevalent as Jewish anti-Semitism, for example; and I for one am a girl who has always liked being a girl. Sometimes, thankfully, I don't consider myself at all: it is instructive that that happens most frequently when I simply get down to work. Often I am a nomad among different places and personas, calling nowhere and no one home. I assume that some different version of what I just said about myself as a "woman professor" applies to most "women artists," or artists-who-happen-to-be-women. And yet . . .

———

If I take one of the personal descriptors listed above—my whiteness, for instance—perhaps the "and yet" may come into better focus. (As it turned out—this had not been the intention—all of the participants in the original conference were white women.) When one of the terms that describes me happens to fall within a group defined as mainstream, normative, or universal, I tend to think of it as a neutral, invisible aspect of my personhood—as lacking color—until someone else outside of that mainstream turns around, looks my whiteness in the eye and forces me to do so too. So I think it must be for the "man artist." But so it can never be, quite, for the "woman artist," just as it can never be for the person "of color." For like it or not, the woman in the artist colors her experience as an artist with the fact that she is not the normative case, that she does not occupy the position of universality, that she will always be looked at by others, and therefore by herself at least sometimes, as other and outsider, as exceptional, as different by definition.

What I want to claim here, however, is that that coloring by otherness, by outsiderness, by difference, is a positive, not a negative—an expansion, not a reduction, of what it means to be a person and an artist. Neither lesser nor greater, if we remove the hierarchical scale of evaluation from the equation, the difference of the "woman artist" alters the balance and opens the closed system of values that structures the canon of human "genius." It does so, I would argue, not only for women but for men as well, for we all gain by the changed face and expanded definition of humanness that ensues: as we always gain by recognizing each other in and through the differences that we share as human beings. For this reason it would be a shame to repeat the historically necessary single-sex constitution of a conference like Women Artists at the Millennium.

This is to take the figure of the "woman artist," then, as a construction just as much as that of the "great artist." It is to see the "woman artist" as a figure whose womanness is historically constructed, and to whom a set of historically disparaged (and often contradictory) values has been attached, such as smallness, domesticity, interiority, superficiality, artificiality, animality, mobility, incoherence, irrationality, particularity, plurality, supplementarity, and so on. Defined in opposition to a set of historically privileged "masculine" values, the descriptors of

"femininity" have been defined as lacks—the lack of essence, coherence, singularity, depth, transcendence, etc. (Couldn't we finally forget about that little-boy absurdity, the famous lack of a phallus? Spell it with a little *p*, say penis-phallus, same difference, and girls, stop joining the ranks of priapic high priests and false-idol worshippers?) The feminist trick, then, is to call them not lacks but differences and additions, to upend the opposition that they involve, to take its vertical arrangement and turn it horizontal, to set the "lower" values inside the "higher" ones in order to rework them from within: to intertwine Mother Earth with Father Sky, so to speak, rather than setting her beneath (or for that matter above) him, and see what happens to the Old Man then. No millennium, no revolution, no utopia, no heroic advance, no final destiny, no messiah (and no Great Goddess, either), just this: an alteration, a different world of art, not the same-old-same-old.

So, although I think there are philosophical essentialisms to be learned from—I also think that the question of what role biology plays in the binary structure of "femininity" and "masculinity" must remain forever open (both in the sense that it can never finally be answered satisfactorily, and in the sense that it remains an interesting question)—it is not the X chromosome that determines and defines the "woman artist." But of course, all of this has to do with mythologies of the artist, not the fact and function of the art itself. What of that? Does it matter? And does the "different world of art" mentioned above simply refer to a more inclusive terrain, a standardless anticanon with no exclusions (except that of "man artist")? In response to the last question, I think not; I think for the figure of the "woman artist" to matter at all now, her art must make some kind of difference, a difference that has to do with the ethics of and in aesthetics. I offer no prescriptions or proscriptions, only the proposition that the purpose of the artist, whether man or woman, is not celebrity, either now, for posterity or in the millennial roll call—not greatness, that is—but art. And the ethical purpose of art is to make you see, think, and feel anew—not "new" in the sense of modernist novelty, but "anew," in the generative sense, which is to say again but as if for the first time; to move you to those redeeming features of human life, care and curiosity of the noninstrumental kinds; to induce you to respond to the domicile you inhabit—to be receptive to it, to allow it to affect you and be affec-

tionate toward it; to make live what is so often deadened by the doing-time of day-to-day getting-by; even to make you love what is simultaneously the horror, the farce, and the beauty of the flawed world we live in, which would not even be if it were not flawed. This ethics is an aesthetics that is an erotics. In this ethical-aesthetical-erotic enterprise, this ethos-eros, the art-producing task of the "woman artist" as I have defined her is not, in my opinion, radical critique (which, like that which it critiques, just goes on reproducing itself) or a separatist aesthetic—neither the ultimate denaturing nor the essentializing of gender—but the judicious, amorous, and constant testing of the boundaries between Nature (X) and Culture (Y), between the matter of the one and the thought of the other. Without end, millennial or otherwise.

I wish to thank Catherine de Zegher, Director of the Drawing Center and one of the participants in Women Artists at the Millennium, for coediting this volume with me. Where I organized the conference, it is her commitment to this book that has made it possible, her genius for producing beautifully and intensively considered books, and her dedication to contemporary art and its feminist projects, that make it what it is. She has done the real work of addressing and bringing together the contributions of the separate essays in this book, so I have chosen to leave that to her introduction. There is no one better suited to the task: as the conceiver, curator, and editor of the justly famous *Inside the Visible,* she is uniquely qualified to comment on the book version of *Women Artists at the Millennium,* and to consider some of the ways in which it might be understood as a sequel to the earlier set of essays, with their nuanced and differentiated views on the intertwined matters of contemporary art and feminism. I owe much to her as a friend and co-conspirator on this and other projects: I am grateful for having this space to credit her with the labor of love that she has performed here. That labor is truly exemplary of the ethics, aesthetics, and erotics alluded to above.

Today, a generation of younger artists is producing work that can be considered as soundly inspired by, among other factors, the legacies of feminist practice and critical theory. The conference Women Artists at the Millennium addressed these legacies and its key issues, such as the intersection of gender, class, race, and ethnicity, in four separate sections: Legacies, Spaces, Subjectivities, and Identities. Collected in an October Book, the conference papers evolve around the work of women artists, who either were speaking about their own practice—Yvonne Rainer, Martha Rosler, Ann Hamilton, and Mary Kelly—or were presented by the participating art historians—Louise Bourgeois, Lygia Clark, Ellen Gallagher, Mona Hatoum, Carrie Mae Weems, Anna Maria Maiolino, and Rosemarie Trockel, to mention a few. The book follows the structure of the conference with four sections, each of which is introduced by an artist and concluded by a respondent. Although occasionally taking up the mother/daughter relationship, the participants are not interested in linear art history (Lisa Tickner, Tamar Garb, Carol Armstrong) but in a multiplicity of practices, which at times attends to the periphery (Catherine de Zegher), so-called "minoritarian" art (Abigail Solomon-Godeau), and also "scandalous" art (Anne Higonnet, Maria DiBattista). Most of the papers suggest that women artists' innovative work results in newly developing parameters and perspectives, often defined by notions such as reciprocity,

co-affectivity, transference, the relational, and the transsubjective. In the end, as Solomon-Godeau so concisely summarizes it, "a transformative recognition may lay the groundwork for a transformative politics."

The work of women artists, which often transgresses the racial, ethnic, and gender dictates of society, asks us to consider the ambiguous boundary between self and other not with horror and fear—a convention of exclusion on which much of society is founded—but as offering an opening onto a new form of identity construction. These artists had to reconceive themselves through a set of fragile dependencies as "subject matter out of place," and have inventively mapped reality at the fringes of vision reframing feminine imagery. Interleaving language, alterity, and space, their work forms a configuration of a ground for resistance against the rules that govern the intelligible invocation of identity as they operate through a stylized repetition of bodily gestures and movements (Anne Wagner). Invoking Sylvia Plath, Ewa Lajer-Burcharth writes: "The new woman artist, then, as 'duchess of nothing.' . . . These borrowed words capture well . . . the sense of the creative woman's new position in relation to the visible world. . . . Materialized in these works is an elusive, contingent, and entitled, though emphatically *un*possessing, femininity—a woman who lays claim to space without having it." Or speaking about an artist from a former generation, Briony Fer quotes Agnes Martin, "Look between the rain, the drops are insular," insisting on the significance of the infinitesimal difference between things: "Everything is in the interval."

Throughout the conference it became clear that in the second half of the twentieth century, many artists challenged the phallic paradigm of binary thinking—rejection or assimilation, aggression or identification—that shapes everything from how art is viewed to how societies treat immigrants. Against this restrictive, modernist axis, they posed questions of distribution and audience, of participation and the "feminine"—art-making imbued with reciprocity, an enactment of exchange, of participatory thought in the relationship between artist and viewer. New possibilities for connections in the shared space among work, maker, and beholder emerged. In this context, feminism, often employing semiotics and psychoanalysis, enabled us to see what formerly was (or still is) eclipsed:

what does not align with that which is considered important at the moment, or which has different conditions of perceptibility. The artists have included many women, but also men as diverse in their work as Hélio Oiticica, Paul Thek, Cildo Meireles, Richard Tuttle, Giuseppe Penone, and Craigie Horsfield. All these figures recognized the great potential for notions of relation and connectivity to provide a more profound understanding of what art can be. However, because their work could hardly be apprehended through the prevalent modernist and postmodernist criteria, it took a long time for them to be valued and acknowledged. Remarkably, at that time in the 1960s to 1970s, some of the only available theoretical structures for that understanding were provided by psychoanalysis and feminism (Emily Apter, Molly Nesbit).

From Lygia Clark's "relational objects" in the sixties to Bracha Ettinger's "matrixial gaze" in the nineties, what became most essential was the wording of this relational and fluid space of co-emergence involving not only an altered perception of art but a redefinition of the "feminine." Both artists used terms, such as "matrix" and "pregnancy," that were metaphorically loaded images of mother and unborn child to conceptualize an archaic experience of several unknown partial subjects co-emerging and co-affecting, and to generate a symbol for an intersubjective encounter radically different from the historically predominant (phallic) model. In this naming, Bracha Ettinger's writings play an important role, as they allow the feminine to become legible in works of art—radically extending and reshaping our understanding of some artistic practices and their temporary eclipse. Because by introducing into culture another symbolic signifier to stand beside the phallus (signifier of difference and division in terms of absence and loss orchestrating these either/or models), Griselda Pollock argues, we could be on the way to allowing the invisible feminine bodily specificity to enter and realign aspects of our consciousness and unconsciousness: "This feminist theorization is not an alternative in opposition to the phallus; rather, the opening up of the symbolic field to extended possibilities which, in a nonphallic logic, do not need to displace the other to be." In her response to the session about Spaces, Brigid Doherty also takes up Ettinger's theory, relating space to a process of creation that is always several, connected, and co-productive. In other words,

quoting Pollock again: "It is a logic of 'subjectivity as encounter' that works not through cuts and fusions, through presence and absence, but through constant retunings and shiftings that can emerge into a certain visibility at the level of certain kinds of artistic . . . practices at certain historical moments and only unpredictably."

Significantly, these art practices and critical writings allow us to formulate a different vision of art as an experience that is premised upon subjective transitivity. Challenging the existing canon, this vision brings forward an idea based not on essence or negation but on the idea of an artist working through traces coming from others to whom she or he is "borderlinked." Tickner formulates this process as the following: "[The woman artist] seeks attachment, not separation. A sense of kinship with her 'strong precursors' reveals and preserves the heritage that forms and enriches her." And further on: "No doubt both positions are overidealized and overdetermined: the son's struggle to the death on the one hand, the daughter's filial reciprocity on the other. It might help to consider the question of attachment or rupture not as a *gendered* distinction, but in terms of a *historical* contrast in modes of production." As Pollock clarifies, it is "the working of the artwork [that] then produces the artist in the feminine, rather than the pre-existing status of the maker who confers 'her' femininity on the work: a problem for any advanced theoretical notion of art as text, as productivity."

Following Shoshana Felman, who writes that "knowledge is not a substance but a structural dynamic, [which] is essentially, irreducibly dialogic," Mignon Nixon reminds us of the necessity of sustained interlocution in human relationships. She addresses transference as an intersubjective encounter with a communicational dimension in psychoanalytic practice that might be projected onto a cultural matrix, specifically in the dynamics of viewing. I want to conclude this introduction by referring to Nixon's position, which evolves from the specific to a more general approach of relation and transference: "Is there, then, anything in this transference of transference that is specific to the figure of the 'woman artist'? . . . The 'woman artist' might be seen as a creative effect of transference in culture. The emergence of new figures of transference might be seen to instigate new transferences: rather than the death of the author, it might be possible

to imagine the transformation of authorship. . . . Taking the dynamics of transference in the analytic situation as a logic through which to reflect on this question, I would like to suggest that transference offers an alternative to the theoretical discourse of identification that has recently prevailed when subjectivity has been at stake." However, if the potential of transference to transform culture has been recognized, it still seems to be very hard in cultural discourse to keep it from being restabilized as a system of interpretation, split off from its transferential and intersubjective dimension.

Importantly, the dialogic of transference and its intergenerational and intersubjective dynamics were the subject of artists and theorists who from the 1970s to the 1990s exposed its potential radicalism. In this context, it is revealing to consider the work of artists such as Oiticica, Horsfield (in Documenta 10 and 11), and Rosler (in the Venice Biennale 2003), who have often presented large-scale collaborative and social projects, another significant relational model. Their extensive writings have also clarified this sociopolitical attitude. For these artists, the artwork is realized only in togetherness, conversation, and communality—questioning, in effect, the validity of modernist notions of alienation, separation, and de(con)struction in the formation of art. Other current examples are the Royal Art Lodge and Red76, whose young artists similarly overturn modernist formulations of artistic solitude and negativity, but only while appearing to pursue no particular aim other than to spend time together and share domestic jokes and sociopolitical concerns. Recently, many other collectives and collaborations have come on the scene, as in Documenta 11 of Okwui Enwezor, whose curatorial project I consider very important and, in many ways, feminist, but without any necessary self-definition as such. Considering all these artistic, theoretical, and curatorial practices, I am hopeful that it will be possible to "degender" and "deracialize" difference, and to think it in positive, nonreifying terms.

An introduction has the tendency to generalize, and an anthology derived from a conference has the tendency to fall short of the goal of representing as many different voices as possible. *Women Artists at the Millennium* is necessarily incomplete and inconclusive. Major feminist artists and critics in other parts of the world are not represented in it. Nevertheless, together with them, we feel that

feminist practice in so many countries still has an important role to fulfill, and as Carol Armstrong suggested in her conference introduction: "This is nobody's final word, only a timely intervention, at a moment when it might be felt that feminist art and art history had either entrenched themselves in worn-out positions or simply lost their political momentum." The conference brought the debate to life again, so many felt, and so we hope this book will do: "It is, finally, questioning that matters, that does the political work, more than any hard-and-fast answer."

As a way of ending, I would like to take this rare opportunity, in which two coeditors can thank each other, to say what a tremendous delight and privilege it has been to coedit this volume with Carol Armstrong, Professor of Art and Archaeology and the Director and Doris Stevens Professor of the Study of Women and Gender at Princeton University. She had the nerve to organize this extraordinary conference, with great success. As a woman, in the many guises she so eloquently describes in the preface, she possesses a truly rare combination of gifts and talents as a scholar, a critic, a story-writer, and an artist, making any collaboration with her an exceptionally joyful, fascinating, and intellectually exhilarating adventure. Once again, I have had the great pleasure to share her extraordinary knowledge and always provocatively original insights. Let's hope our collaboration has resulted in a book that puts forward what we and the other authors, whom we all wish to warmly acknowledge here, believe to be a persuasive, innovative, and timely thesis. Books are not the result of one person's efforts alone, and in this case we profoundly thank the editorial board of October, in particular Yve-Alain Bois, Benjamin H. D. Buchloh, Hal Foster, Rosalind Krauss, and Annette Michelson who enthusiastically decided to endorse the book project; the Publications Committee, Department of Art and Archaeology, Princeton University for their generous grant toward the publication of the conference papers; Roger Conover at the MIT Press, who with great loyalty supported our proposal; and Ann Tarantino, who tirelessly and literally pulled this book together with us.

YVONNE RAINER

I'm going to start by reading portions of an essay that was published several years ago and which seems more appropriate to this feminist occasion than simply recounting a list of my accomplishments.

It must have been sometime in 1985 that I bragged to a friend, "I'm no longer afraid of men." I hadn't trucked sexually with "them" for at least four years—I was fifty years old—and it would be another five years before I would venture into intimacy with a woman, although I had already begun to call myself a "political lesbian." The question continues to vex me as to why I spent so many years fooling around with what now seem to have been preordained doomed heterosexual partnerships. Though the answers are as numerous as the day is long, a pertinent one for this occasion is that until the late eighties, I was more attuned to heterosexual feminism than to the gay rights movement and therefore was not given, or could not give myself, permission to tune in to another level of desire.

But it hadn't always been that way. My first "liberation" came at age eighteen when I moved out of my parents' house across the bay to Berkeley. While I was browsing in a bookstore, the most beautiful woman I had ever seen struck up a conversation with me. Tim was twenty-five, a graduate student in psychology at UC Berkeley, and "bisexual." She took me to her house, told me her life story, talked about her conquests. I fell in love. Tim was worldly-wise, wore Navajo jewelry, had studied modern dance, could discuss anything and everything, had an IQ of 165 (so she said) and long flowing black hair. (I had chopped off my hair bowl-fashion shortly after falling in with some socialist Zionists from Hashomer Hatzair in my third year in high school.) Although we slept in the same bed, she refused to make love to me, her reason being that she didn't want the responsibility. I confided to her that the woman in my sexual fantasies looked like Marilyn Monroe or Jayne Mansfield. She said that a woman like that would probably want someone more butch than me. It was 1953.

The foregoing anecdote can be further situated in its proper historical context when I confess that shortly thereafter I got myself picked up by an ex-GI in a North Beach bar, thereby unwittingly launching a life of compulsive (as well as compulsory) heterosexuality. It cannot be said often enough that, for a young woman in 1953, everything in the culture militated toward pleasing men.

By 1970 I was reading *Sisterhood Is Powerful,* Valerie Solanas's *SCUM Manifesto,* and Shulamith Firestone's *The Dialectic of Sex.* Excerpts from Firestone's analysis of romantic love still read with a burning clarity:

> Thus "falling in love" is no more than the process of alteration of male vision—idealization, mystification glorification—that renders void the woman's class inferiority.
>
> However, the woman knows that this idealization, which she works so hard to produce, is a lie, and that it is only a matter of time before he "sees through her." Her life is a hell, vacillating between an all-consuming need for male love and approval to raise her class subjection, to persistent feelings of inauthenticity when she does achieve his love. Thus her whole identity hangs in the balance of her love life. She is allowed to love herself only if a man finds her worthy of love.[1]

Yes, it was the light from *his* eyes as I described the making of *Trio A*—the dance that was to become my signature piece—that first illuminated my achievement. This may have taken place in Monte's, or maybe the San Remo, in the Village, over double vodka martinis in the winter of 1965. I watched his expression change from polite attention to intense appreciation, even wonderment, as I described the details of creation. I was saved.

Firestone's recasting of Freud and Marx and Solanas's apocalyptic vision did more than fuel my outrage at private and patriarchal, imagined and real oppression. Their writings—and those of a welter of other feminists—gave me permission to begin examining my experience as a woman, as an intelligent and intelligible participant in culture and society rather than the overdetermined outcome of a lousy childhood that had previously dominated my self-perception. (I should add that at this point, in the early seventies, the debates around the competing definitions of "woman"—as biological entity, mythical archetype, or social construction—were barely on the horizon.) I began to come of age reading this stuff. Change, of course, comes with greater difficulty than the reading of a couple of books. The struggle to throw off the status of unknowing collaborator in victimization—at both ends of the domination scale—is uneven and ongoing. But after 1971 my work began to reflect with ever more confidence the details of daily life and social implications of "being a woman" in a white middle-class culture.[2]

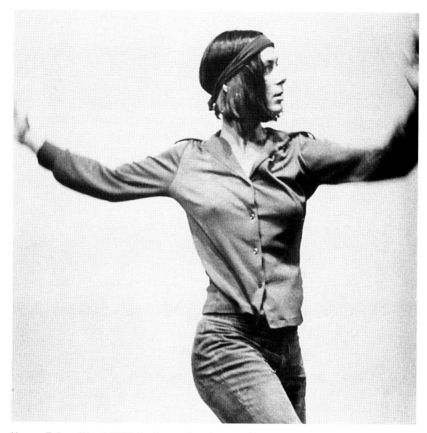

Yvonne Rainer, *Trio A,* 1966. 5 minutes, 3 performers. (Performer: Yvonne Rainer, 1973.)

I made a transition from choreography to filmmaking between 1972 and 1975. In a general sense my burgeoning feminist consciousness was an important factor. An equally urgent stimulus was the encroaching physical changes in my aging body. But I can also attribute the change in medium, from moving body to moving image, to the emotional power of Hollywood and European art films seen from a very early age, plus the films of Maya Deren, Hollis Frampton, and Andy Warhol viewed in the

early and late sixties. Against a dual background of (1) cinematic melodrama and TV soap opera as vehicles for telling women's stories, and (2) the formal strategies of the avant-garde, I intuited that I was venturing into a mother lode of possibility.

```
He presses his face and chest
against the wall. He gives way,
without shame, to a fit of un-
controllable sobbing.
```

Projected text from Yvonne Rainer, *This is the story of a woman who . . .* , 1973. 120 minutes, 3 performers.

Emotions are the repressed detritus of life in the public sphere. There they regularly erupt, with varying degrees of credibility, in news stories, theatrical dramatizations, and television's "real time." From wrestling matches, reports of murder, and terrorist attacks to Shakespeare and *One Life to Live,* we have become accustomed to the vicarious experience of phatic extremity.

In the 1960s the nuts and bolts of emotional life comprised the unseen (or should I say "unseemly"?) underbelly of high U.S. minimalism. While some of us aspired to the lofty and cerebral plane of a quotidian materiality, our unconscious lives unraveled with an intensity and melodrama that inversely matched their absence in the boxes, portals, and jogging of our austere creations.

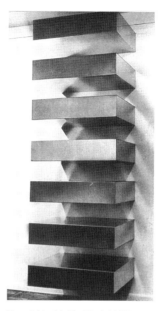

Donald Judd, *Untitled,* 1965.

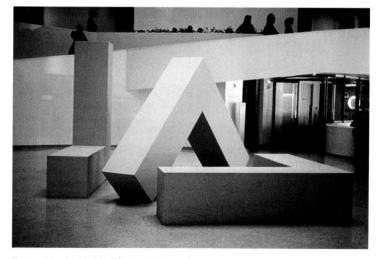

Robert Morris, *Untitled (Three L-Beams),* 1965.

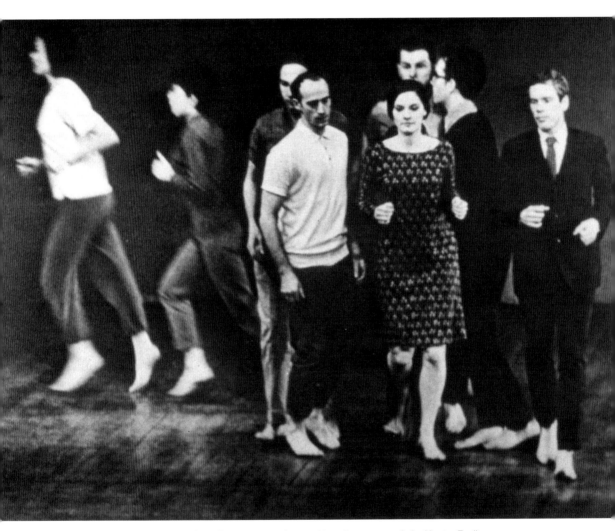

Yvonne Rainer, *We Shall Run,* 1963. 7 minutes, 12 performers, music by Hector Berlioz.
(Small version for 8 performers, 1965.) Photograph by Peter Moore, © Estate of Peter Moore /
VAGA, NY, NY.

By 1973 my own private Sturm und Drang had catapulted me into a new terrain of representation. As a survivor of various physical and psychic traumas, and emboldened by the women's movement, I felt entitled to struggle with an entirely new lexicon. The language of specific emotional experience, already familiar outside the avant-garde art world in drama, novels, cinema, and soap opera, promised all the ambivalent pleasures of the experiences themselves: seduction, passion, rage, betrayal, terror, grief, and joy.

However, the *terms,* or formal conditions, of this new world would remain tied to the disjunctive and aleatory procedures that had laid claim to my earliest development as an artist. In a nutshell, this mindset can be characterized as a refusal of narrative, a refusal to pretend that the world speaks itself, or speaks of or with the desire that is hidden in the "telling" and shaping strategies of history and fiction. But more about this later.

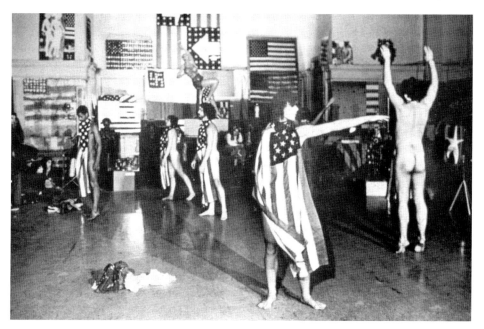

Yvonne Rainer, *Trio A with Flags,* 1970. 10 minutes, 6 performers. People's Flag Show, Judson Church.

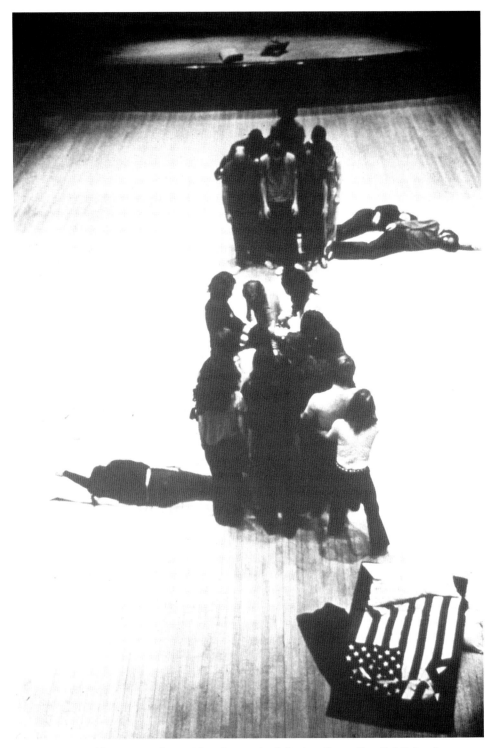

Yvonne Rainer, *WAR,* 1970. 60 minutes, 30 performers. Loeb Student Center, New York University.

Some of my dances had contained specific political references—during the Vietnam War, for instance—when they also incorporated language. But to deal more directly with the specifics of emotional life, which was what I set out to do as I began to inch toward film, was such a novel enterprise that I had to find justification in literary criticism for what felt like clichéd and stereotyped expression. It was Leo Bersani's observations about cliché that offered me the support I needed:

```
Cliche is, in a sense, the purest
art of intelligibility; it tempts
us with the possibility of enclos-
ing life within beautifully inal-
terable formulas, of obscuring the
arbitrary nature of imagination
with an appearance of necessity.
```

Projected text from *This is the story of a woman who*

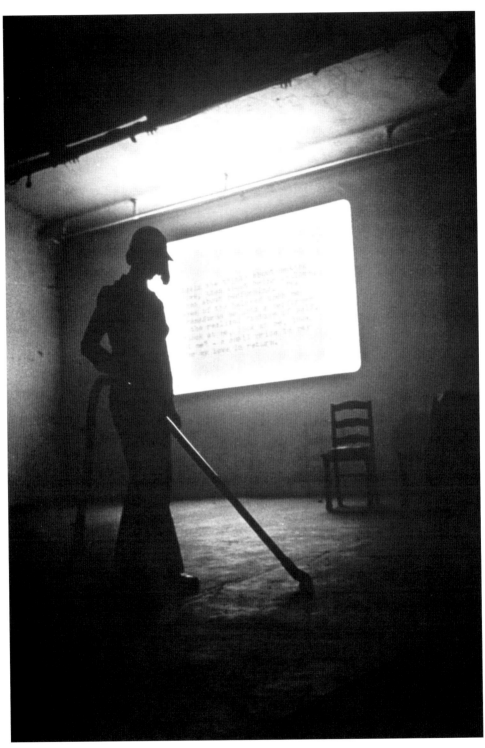

Yvonne Rainer, *Inner Appearances,* 1972. 12 minutes. Photograph by Peter Moore, © Estate of Peter Moore / VAGA, NY, NY.

Inner Appearances of 1973 was the first section of a multimedia theater piece titled This is the story of a woman who . . . , which was originally performed by John Erdman, Shirley Soffer, and me at the Theater for the New City in New York in the spring of 1973. Chronologically it lies between the dances and theater pieces I made from 1960 to 1975 and the films I made from 1972 to 1996, but it also bridges the abstractions and "radical juxtapositions" of dance and the emotional specificities, linkages, and obligations of narrative.

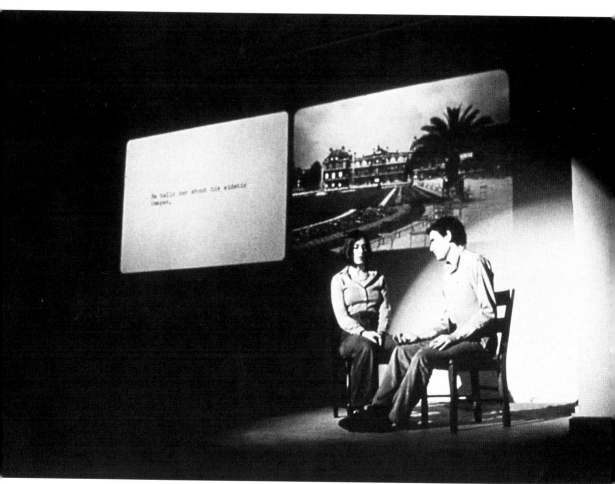

This is the story of a woman who (Performers: Yvonne Rainer and John Erdman.)

In *Inner Appearances* a solitary performer, initially myself, dressed in casual pants and shirt and an old-fashioned green printer's eyeshade, alternated everyday actions—from slowly and meditatively vacuuming the floor to turning off the vacuum cleaner, lying down on a mattress, or standing, apparently lost in thought. Behind the performer a sequence of texts appeared on a white wall dealing with the inner thoughts of a female protagonist who was designated only by third-person pronouns. In later performances the projected texts were adapted for a male protagonist simply by substituting male pronouns for the female.

This work can be seen as an exercise in psychological attribution, a first step in a twenty-five-year trajectory from performer to persona, from everyday movement to illusionist narrative, a journey that was never without ambivalence and misgiving and would necessarily force me constantly to reassess conventions of fictional authenticity.

The first projection in the piece was this text:

```
The face of this character is a fixed
mask. We shall have her wear an eye
shade to reveal her inner and outer
appearance. The eye shade hides the
movement of the upper half of her
face, but the lower half, where the
tongue works, stays visible. She
must function with a face of stone
and at the same time reveal her
characteristic dissembling.
```

Projected text from *Inner Appearances*. (Also used as voice-over in *Lives of Performers.*)

The above is a paraphrase, extracted from a description of a film workshop conducted by Sergei Eisenstein in which he discussed Balzac's characterization of Mademoiselle Michonneau in *Le père Goriot*.[3] The paragraph seemed to encapsulate perfectly both dilemma and solution of the narrative conundrum. If the unmoving human facial exterior gave up neither interpretation nor meaning, and visual representation belied human interiority, the "inner and outer appearance" of a performer could be nudged toward a *semblance* of coherence and "sense" by very minimal means indeed. In an epiphany, I appropriated Eisenstein's eyeshade and text and proceeded to deploy the standard form of anecdotal third-person narrative writing to create a disjunctive sequence of memories, events, and feelings. The spatial and temporal contiguity of performer and texts would, hopefully, produce not an illusion of character and authentic history but something in that vicinity, something provisional and surprising, even unsettling, perhaps something that might call into question what narrative traditionally accomplishes. In the words of Hayden White, "narrativity . . . arises out of a desire to have real events display the coherence, integrity, fullness, and closure of an image of life that is and can only be imaginary."[4] In the embarrassing wars around prospecting for proxies of experience, I was ever on the lookout for strategies that would evade the siren calls of that desire and its unacknowledged, or unconscious, acting out.

At the same time, paradoxically and a little naively, I rejoiced in the potential of "visualized text"—read simultaneously and communally, in the dark, by the theater audience—to induce a frisson similar to the effect of a monologue delivered by a great actor. Print, because it was eschewed by traditional theatrical practice, would "defamiliarize" the clichés of enacted emotional excess and make them fresh. The words, isolated from a social or characterological context, and coexisting with a task-involved figure, would in and of themselves cause a quickening in those who read them in the darkened theater. Or so I hoped.

```
Events of the past rose like
waves and battering against
her mind threw it into a wild
commotion of shame, grief, and
joy.
```

Projected text from *This is the story of a woman who*

Brechtian notions of alienation and distantiation had already infused the work of the Living Theater and Richard Foreman which I had followed throughout the sixties. I would now embark on bringing a version of these techniques to the representation of episodes in my own checkered past, events that would be fictionalized through narrative fragmentation, text/image combinations, and uninflected delivery of lines designed to invoke but not replicate the familiar rhetoric and role-playing of disaffected love. These were my guidelines when I assayed a first 16mm feature film in 1972.

Yvonne Rainer, *Lives of Performers,* 1972. 16mm, b/w, 90 minutes. (Performer: Valda Setterfield.)

Some people have called those early films of mine "prepolitical" or "prefeminist." In fact, *Film about a Woman Who . . .* of 1974 became a focal point for more than one brouhaha in the feminist film theory wars of the late seventies and early eighties. The battles raged over issues of positive versus negative imaging of women, avant-garde versus Hollywood, strategies of distantiation versus traditional tactics of identification, elitism versus populism, documentary versus fiction, accessibility versus obscurity, etc., etc. I sometimes found myself fending off partisans from both sides of the barricades. It was a vexing, glorious era.

NOTES

1. Shulamith Firestone, *The Dialectic of Sex* (New York: William Morrow, 1970), p. 132.

2. Yvonne Rainer, "Skirting," in Rachel Blau DuPlessis and Ann Snitow, eds., *The Feminist Memoir Project* (New York: Crown Press, 1998), pp. 443–449.

3. Vladimir Nizhny, *Lessons with Eisenstein* (New York: Hill & Wang, 1962), p. 9.

4. Hayden White, "The Value of Narrativity in the Representation of Reality," *Critical Inquiry* 7, no. 1 (Autumn 1980), p. 24.

I LEGACIES

"Why Have There Been No Great Women Artists?" Thirty Years After

Linda Nochlin

———

I'd like to roll the clock back to November 1970, a time when there were no women's studies, no feminist theory, no African American studies, no queer theory, no postcolonial studies. What there was was Art I or Art 105—a seamless web of great art, often called "The Pyramids to Picasso"—that unrolled fluidly in darkened rooms throughout the country, extolling great (male, of course) artistic achievement since the very dawn of history. In art journals of record, like *Art News,*[1] out of a total of eighty-one major articles on artists, just two were devoted to women painters. In the following year, ten out of eighty-four articles were devoted to women,[2] but that includes the nine articles in the special Woman Issue in January, in which "Why Have There Been No Great Women Artists?" appeared; without that issue, the total would have been one out of eighty-four. *Artforum* of 1970–1971 did a little better: five articles on women out of seventy-four.

Things have certainly changed in academia and the art world, and I would like to direct my attention to those changes, a revolution that no one article or event could possibly have achieved, but that was a totally communal affair and, of course, overdetermined. "Why Have There Been No Great Women Artists?" was conceived during the heady days of the birth of the women's liberation movement in 1970 and shares the political energy and the optimism of the period. It was at least partially based on research carried out the previous year, when I had conducted the first seminar at Vassar College on women and art. It was intended

for publication in one of the earliest scholarly texts of the feminist movement, *Women in Sexist Society,*[3] edited by Vivian Gornick and Barbara Moran, but appeared first as a richly illustrated article in the pioneering, and controversial, issue of *Art News* edited by Elizabeth Baker and dedicated to women's issues.[4]

What were some of the goals and aims of the women's movement in art in these early days? A primary goal was to change or displace the traditional, almost entirely male-oriented notion of "greatness" itself. There had been a particular and recent historical reconsecration of the cultural ideal of greatness in the United States in the 1950s and 1960s, a reconsecration that, I must admit, I was not consciously aware of when I wrote the article, but which surely must have colored my thinking about the issue. As Louis Menand pointed out in a recent *New Yorker* article dedicated to the Readers' Subscription Book Club, initiated in 1951, "What dates the essays [used to preface the book club selections and written by such certified experts as Lionel Trilling, W. H. Auden, and Jacques Barzun] is not that they are better written or less given to 'the Theoretical' than contemporary criticism. It is their incessant invocation of 'greatness.' It is almost a crutch, as though 'How great is it?' were the only way to begin a conversation about a work of art."[5] Tied to the idea of greatness was the idea that it was immutable and that it was the particular possession of the white male and his works, although the latter was unstated. In the post–World War II years, greatness was constructed as a sex-linked characteristic in the cultural struggle in which the promotion of "intellectuals" was a cold war priority, "at a time when a dominant strategic concern was the fear of losing Western Europe to Communism."[6]

Today, I believe it is safe to say that most members of the art world are far less ready to worry about what is great and what is not, nor do they assert as often the necessary connection of important art with virility or the phallus. No longer is it the case that the boys are the important artists, the girls positioned as appreciative muses or groupies. There has been a change in what counts—from phallic "greatness" to being innovative, making interesting, provocative work, making an impact, and making one's voice heard. There is less and less emphasis on the masterpiece, more on the piece. While "great" may be a shorthand way of talking about high importance in art, it seems to me always to run the risk of

obscurantism and mystification. How can the same term "great"—or "genius," for that matter—account for the particular qualities or virtues of an artist like Michelangelo and one like Duchamp, or, for that matter, within a narrower perimeter, Manet and Cézanne? There has been a change in the discourse about contemporary art. Greatness, like beauty, hardly seems an issue for postmodernism, with whose coming of age "Why Have There Been No Great Women Artists?" coincided.

The impact of theory on art discourse and especially feminist and/or gender-based discourse is another change. When I wrote "Why Have There Been No Great Women Artists?," theory in its now accepted form did not exist for art historians, or if it did, I was not aware of it: the Frankfurt school—yes; Freud—up to a point; but Lacan and French feminism were little dots on the horizon, as far as I could tell. Within academia, and in the art world to a certain extent, that impact has since been enormous. It, of course, has changed our way of thinking about art—and gender and sexuality themselves. What effect it has had on a feminist politics of art is, perhaps, more ambiguous, and needs consideration. It has certainly acted to cut the wider public off from a great deal of the hot issues discussed by in-the-know art historians and critics.

If the ideal of the great artist is no longer as prominent as it once was, there have nevertheless been some extraordinary, large-scale, and long-lasting careers in art to be dealt with, some old-style grandeur that has flourished in the work of women artists in recent years. First of all, there is the career of Joan Mitchell. Her work has sometimes been dismissed as "second-generation" abstract expressionism, with the implication that she was not an inventor or that she lacked originality, the cardinal insignia of modernist greatness. Yet why should it not be possible to consider this belatedness as a culmination, the culmination of the project of painterly abstraction that had come before? Think of Johann Sebastian Bach in relation to the baroque counterpoint tradition; the *Art of the Fugue* might have been created at the end of a stylistic period, but surely it was the grandest of grand finales, at a time when originality was not so highly prized. Or, one might think of Mitchell's position as parallel to Berthe Morisot's in relation to classical impressionism: a carrying farther of all that was implicit in the movement.

———

In the case of Louise Bourgeois, another major figure of our era, we have quite a different situation: nothing less than the transformation of the canon itself in terms of certain feminist or, at least, gender-related priorities. It is no accident that Bourgeois's work has given rise to such a rich crop of critical discourse by mostly theory-based women writers: Rosalind Krauss, Mignon Nixon, Anne Wagner, Griselda Pollock, Mieke Bal, Briony Fer, and others. For Bourgeois has transformed the whole notion of sculpture, including the issue of gendered representation of the body as central to the work. In addition, the discourse on Bourgeois must confront two of the major "post-greatness" points of debate of our time: the role of biography in the interpretation of the artwork; and the new importance of the abject, the viscous, the formless, or the polyform.

Bourgeois's work is characterized by a brilliant quirkiness of conception and imagination in relation to the materiality and structure of sculpture itself. This, of course, problematizes the viewing of her pieces. Indeed, as Alex Potts (whom I will take as an honorary woman in this situation) has stated, "One of the more characteristic and intriguing features of Louise Bourgeois's work is the way it stages such a vivid psychodynamics of viewing." And he continues, "There seems to be an unusual attentiveness on her part to the structure of a viewer's encounter with three-dimensional art works in a modern gallery setting as well as to the forms of psychic phantasy activated in such interactions between viewer and work."[7]

It is important to realize that although Bourgeois had been working since the 1940s, she did not really come into prominence and recognition until the seventies, in the wake of the women's movement. I remember walking to my seat with her at one of the early, large-scale women's meetings and telling her about my plan to match a nineteenth-century photograph, *Buy My Apples,* with a male equivalent—well, maybe, *Buy My Sausages.* Louise said, "Why not bananas?" and an icon was born—at least I think it happened that way.

A younger generation of women artists often engages with ways of undermining the representational doxa that may be subtle or violent. Not the least achievement of Mary Kelly, for example, in her innovative *Birth Project,* was the way it desublimated Clement Greenberg's famous dictum, that the final step in

the teleology of modernist art is simply the stain on the surface of the canvas, by reducing that stain to a smear of baby's shit on the surface of a diaper. Cindy Sherman, to take another example, sent up the movie still, making strange this most conventional of genres, and later shattered the idea of the body as a whole, natural, coherent entity with an imagery characterized by grotesquery, redundancy, and abjection. Yet, I would venture that Sherman's photographs also create a fierce new antibeauty, making Bellmer look positively pastoral, but in particular pulling the carpet out from under such admired painterly subverters of canonical femininity as de Kooning or Dubuffet.

Another profound change that has taken place is that of the relation of women to public space and its public monuments. This relationship has been problematic since the beginning of modern times. The very asymmetry of our idiomatic speech tells us as much; a public man (as in Richard Sennett's *The Fall of Public Man)* is an admirable person, politically active, socially engaged, known, and respected. A public woman, on the contrary, is the lowest form of prostitute. And women, historically, have been confined to and associated with the domestic sphere in social theory and in pictorial representation.

Things certainly began to change, if at a slow pace, in the twentieth century, with the advent of the "New Woman": the working woman and the suffrage movement, as well as the entry of women—in limited numbers to be sure—into the public world of business and the professions. Yet this change is reflected more in literature than in the visual arts. As Deborah Parsons has demonstrated in her important study of the phenomenon, *Streetwalking the Metropolis: Women, the City and Modernity,* novels like Dorothy Richardson's *Pilgrimage* or Virginia Woolf's *Night and Day* or *The Years* represented women engaging with the city in newer, freer ways—as watchers, walkers, workers, denizens of cafés and clubs, apartment dwellers, observers and negotiators of the public space of the city—breaking new ground without the help of tradition, literary or otherwise.

But, it was not until the late 1960s and early 1970s that women as a group, as activists rather than mere *flâneuses,* really took over public space for themselves, marching for a woman's right to control her own body as their grandmothers had marched for the vote. And, not coincidentally, as Luc Nadal points out in his

2000 Columbia dissertation, "Discourses of Public Space: USA 1960–1995: A Historical Critique," the term "public space" itself began to be used by architects, urban designers, historians, and theoreticians at just this time. Says Nadal, "The rise of 'public space' in the 1960s corresponded to a shift at the center of the discourse of planning and design." Nadal connects this project with the "vast movement of liberatory culture and politics of the 1960's and early 70's." It is within this context of liberatory culture and politics that we must consider woman not merely as a visible presence in public space, but in her practice as a highly visible and original shaper and constructor of it. For women today play a major role in the construction of public sculpture and urban monuments. And, these monuments are of a new and different sort, inassimilable to those of the past, often centers of controversy. Some have called them antimonuments. Rachel Whiteread, for example, recreated a condemned house on a bleak plot in London, turning the architecture inside out and creating a storm of reaction and public opinion. A temporary antimonument, it was later destroyed amid equal controversy (see figure 1.19). Whiteread's recent *Holocaust Memorial* in Vienna at the Judenplatz also turns both subject and form inside out, forcing the viewer not only to contemplate the fate of the Jews, but to rethink the meaning of the monumental itself by setting the memorial in the heart of Vienna, one of the major sites of their extermination.

Jenny Holzer, using both words and traditional and untraditional materials, also created scandals in Munich and Leipzig with her provocative public works. Her 1997 *Memorial to Oskar Maria Graf,* a German poet, exists as a functional café at the Literaturhaus in Munich. This is, to borrow the words of doctoral student Leah Sweet, a "conceptual memorial [that] refuses to present its subject . . . through a likeness or a biographic account of his life and work." Rather, Graf is represented through excerpts of his writing selected by Holzer and scattered throughout the café. Shorter excerpts appear on dishes, place mats, and coasters—an ironic use of what one might call the domestic-abject mode of memorialization!

Maya Lin is probably the foremost and best known of these women inventors of new monuments with new meanings and, above all, with new, untried

ways of conveying meaning and feeling in public places. Lin's own words best convey her unconventional intentions and her antimonumental achievement in this most public of memorials: "I imagined taking a knife and cutting into the earth, opening it up, an initial violence and pain that in time would heal. The grass would grow back, but the initial cut would remain a pure flat surface in the earth with a polished mirrored surface . . . the need for the names to be on the memorial would become the memorial; there was no need to embellish the design further. The people and their names would allow everyone to respond and remember."[8] Still another unconventional public memorial is Lin's *The Women's Table,* a water table created in the heart of Yale's urban campus in 1993, commemorating with words, stone, and water the admission of women to Yale in 1969. It is a strong but gentle monument, asserting women's increasing presence at Yale itself, but also commemorating in more general terms women's emergent place in modern society. Yet, despite its assertive message inscribed in facts and figures on its surface, the *Women's Table* is at one with its surroundings. Although it constitutes a critical intervention into public space, its effect vis-à-vis that space is very different from that of a work like Richard Serra's controversial *Tilted Arc* of 1981. Lin's Yale project, like her Vietnam memorial, establishes a very different relationship to the environment and to the meaning and function of the public monument than Serra's aggressive confrontation with public space. I am not coming out for a "feminine" versus a "masculine" style of public monument with this comparison. I am merely returning to the theme of this session and suggesting that now, as in the nineteenth century, although in very different circumstances, women may have—and wish to construct—a very different experience of public space and the monuments that engage with it than their male counterparts.

I would next like to consider very briefly the dominance of women's production in a wide variety of media that are not painting or sculpture in the traditional sense, and above all, the role of women artists in breaking down the barriers between media and genres in exploring new modes of investigation and expression. These are all women artists who might be said to be inventing new media or, to borrow a useful phrase from critic George Baker, "occupying a space

between mediums."[9] The list would include installation artists like Ann Hamilton, who has made the wall weep and the floor sprout hair, and the photographer Sam Taylor-Wood, working with the enlarged and/or altered photo, who produces "cinematic photographs or video-like films."[10] This list of innovators would include innovative users of photography like Carrie Mae Weems, video and film inventors such as Pipilotti Rist and Shirin Neshat, performance artists like Janine Antoni, or such original and provocative recyclers of old practices as Kara Walker, who has created the postmodern silhouette with a difference.

Finally, although I can only hint at it, I would like to indicate the impact, conscious or unconscious, of the new women's production on the work of male artists. The recent emphasis on the body, the rejection of phallic control, the exploration of psychosexuality, and the refusal of the perfect, the self-expressive, the fixed, and the domineering are certainly to some degree implicated, however indirectly, with what women have been doing. Yes, in the beginning was Duchamp, but it seems to me that many of the most radical and interesting male artists working today have, in one way or another, felt the impact of that gender-bending, body-conscious wave of thought generated by women artists, overtly feminist or not. William Kentridge's films, with their insistent metamorphoses of form, fluidity of identity, and melding of the personal and the political, seem to me unthinkable without the anterior presence of feminist, or women's, art. Would the work of male performance and video artists, abjectifiers, or decorative artists have been the same without the enormous impact and alteration of the stakes and the meanings of art production in the seventies, eighties, and nineties that were produced by women's innovations?

Women artists, women art historians, and women critics have made a difference, then, over the past thirty years. We have—as a community, working together—changed the discourse and the production of our field. Things are not the same as they were in 1971 for women artists and the people who write about them. There is a whole flourishing area of gender studies in the academy, a whole production of critical representation that engages with issues of gender in the museums and art galleries. Women artists, of all kinds, are talked about, looked at, have made their mark—and this includes women artists of color.

Yet, there is still, again, a long way to go. Critical practice must, I think, remain at the heart of our enterprise. In 1988, in the introduction to *Women, Art and Power,* I wrote,

> Critique has always been at the heart of my project and remains there today. I do not conceive of a feminist art history as a "positive" approach to the field, a way of simply adding a token list of women painters and sculptors to the canon, although such recuperation of lost production and lost modes of productivity has its own historical validity and . . . can function as part of the questioning of the conventional formulation of the parameters of the discipline. Even when discussing individual artists, like Florine Stettheimer or Berthe Morisot or Rosa Bonheur, it is not merely to validate their work . . . but rather, in reading them, and often reading them against the grain, to question the whole art-historical apparatus which contrived to "put them in their place"; in other words, to reveal the structures and operations that tend to marginalize certain kinds of artistic production while centralizing others.

The role of ideology constantly appears as a motivating force in all such canon formation and has, as such, been a constant object of my critical attention, in the sense that such analysis "makes visible the invisible." Althusser's work on ideology was basic to this undertaking, but I have never been a consistent Althusserian. On the contrary, I have paid considerable attention to other ways of formulating the role of the ideological in the visual arts.

Or to put it another way: when I embarked on "Why Have There Been No Great Women Artists?" in 1970, there was no such thing as a feminist art history. Like all other forms of historical discourse, it had to be constructed. New materials had to be sought out, theoretical bases put in place, methodologies gradually developed. Since that time, feminist art history and criticism, and, more recently, gender studies, have become an important branch of the discipline. Perhaps more importantly, the feminist critique (and of course allied

critiques including colonialist studies, queer theory, African-American studies, etc.) has entered into the mainstream discourse itself: often, it is true, perfunctorily, but in the work of the best scholars, as an integral part of a new, more theoretically grounded and socially and psychoanalytically contextualized historical practice.

Perhaps this makes it sound as though feminism is safely ensconced in the bosom of one of the most conservative of the intellectual disciplines. This is far from the case. There is still resistance to the more radical varieties of the feminist critique in the visual arts, and its practitioners are accused of such sins as neglecting the issue of quality, destroying the canon, scanting the innately visual dimension of the artwork, and reducing art to the circumstances of its production—in other words, of undermining the ideological and, above all, aesthetic biases of the discipline. All of this is to the good; feminist art history is there to make trouble, to call into question, to ruffle feathers in the patriarchal dovecotes. It should not be mistaken for just another variant of or supplement to mainstream art history. At its strongest, a feminist art history is a transgressive and antiestablishment practice meant to call many of the major precepts of the discipline into question.

I would like to end on this somewhat contentious note: at a time when certain patriarchal values are making a comeback, as they invariably do during periods of conflict and stress, women must be staunch in refusing their time-honored role as victims, or mere supporters, of men. It is time to rethink the bases of our position and strengthen them for the fight ahead. As a feminist, I fear this moment's overt reversion to the most blatant forms of patriarchy, a great moment for so-called real men to assert their sinister dominance over "others"—women, gays, the artistic or sensitive—the return of the barely repressed. Forgetting that "terrorists" operate under the very same sign of patriarchy (more blatantly of course), we find in the *New York Times,* under the rubric "Heavy Lifting Required: The Return of Manly Men," "The operative word is men. Brawny, heroic, manly men." On it goes: we need father figures—forget heroic women, of course. What of the murdered airline hostesses—were they feisty heroines or just "victims," patriarchy's favorite position for women? Although

the female writer of the article admits that "part of understanding terrorism . . . often involves getting to the root of what is masculine," and that "the dark side of manliness has been on abundant display as information about the lives of the hijackers, as well as Osama bin Laden himself comes to light, revealing a society in which manhood is equated with violent conquest and women have been ruthlessly prevented from participating in almost every aspect of life," and, in quoting Gloria Steinem, contends that "the common thread in violent societies is the polarization of sex roles," and even though the *Times* felt uncomfortable enough about "The Return of Manly Men" to append at its base an article, "Not to Worry: Real Men Can Cry," the implications of the piece ring out loud and clear.[11] Real men are the good guys; the rest of us are wimps and whiners—read "womanish."

In a similar but more specifically art-oriented vein, a recent *New Yorker* profile of departing MoMA curator Kirk Varnedoe brings the call for the return of manly men directly into the art world—Varnedoe is described as "handsome, dynamic, fiercely intelligent and dauntingly articulate."[12] He made himself into a football player. At Williams College, whose art history department would shortly become famous as an incubator of American museum directors, he found that what his remarkable teachers, S. Lane Faison, Whitney Stoddard, and William Pierson, did "in the first place, was to take the curse of effeminacy off art history."[13] Stoddard went to all the hockey games and came to class on skis in the winter—a sure antifeminine qualification in an art historian. At the Institute of Fine Arts, "legions of female students fell in love with him. One of them wrote him a love letter in lieu of an exam paper."[14]

Of course, this description is over the top in its advocacy of masculine dominance in the art world. It is not, alas, totally exceptional. Every time I see an all-male art panel talking "at" a mostly female audience, I realize there is still a way to go before true equality is achieved. But I think this is a critical moment for feminism and women's place in the art world. Now, more than ever, we need to be aware not only of our achievements but of the dangers and difficulties lying in the future. We will need all our wit and courage to make sure that women's voices are heard, their work seen and written about. That is our task for the future.

———

NOTES

1. *Art News* 68 (March 1969–February 1970).

2. *Art News* 69 (March 1970–February 1971).

3. Vivian Gornick and Barbara Moran, ed., *Women in Sexist Society* (New York: Basic Books, 1971).

4. *Art News* 69 (January 1971).

5. Louis Menand, *New Yorker,* 15 October 2001, p. 203.

6. Ibid., p. 210.

7. Alex Potts, "Louise Bourgeois—Sculptural Confrontations," *Oxford Art Journal,* 22, no.2 (1999), p. 37.

8. *New York Review of Books,* 20 November 2000, p. 33.

9. *Artforum,* November 2001, p. 143.

10. Ibid.

11. *New York Times,* 28 October 2001, section 4, p. 5.

12. *New Yorker,* 5 November 2001, p. 72.

13. Ibid., p. 76.

14. Ibid., p. 78.

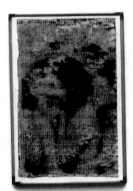

1.1 Installation shot: Bracha Ettinger, *Eurydice* and *Woman-Other-Thing,* at the exhibition *Kabinet,* Stedelijk Museum, Amsterdam, 1997.

Rethinking the Artist in the Woman, the Woman in the Artist, and That Old Chestnut, the Gaze

Griselda Pollock

Encountering the Event: Painting and the Face

Two images will start my journey through this complex topic. Both belong in a long series of paintings titled *Eurydice,* undertaken over more than a decade by the Israeli–French artist Bracha Ettinger (figure 1.1; images at top left and bottom right).[1] The classical myth of Orpheus and Eurydice concerns not only a legend about the origins of masculine creativity in the loss of the poet's beloved, but the figuration in the feminine, via Eurydice, of a borderline or threshold between two antithetical worlds: life and death (figure 1.2).

Comparable to the figure of Antigone in Lacan's reading of the Sophoclean tragedy, Eurydice stands between two deaths.[2] Uncanny and consoling, Eurydice has looked on the inhuman by her descent into Hades, yet she is cast back into its annihilation by Orpheus's second, backward glance as he fails to heed the condition of his wife's return to life: that he must not turn to look back at her as she follows him up from the darkness. The Orphic look, looking back into the space of death rather than following the light to a future, is, therefore, deadly; it kills a second time. But this scenario of Orpheus and Eurydice opens up a space *between* two deaths. What, asks artist Bracha Ettinger, does Eurydice *say,* she who has seen the inhuman and suffers a second, mortal blow from a human gaze in whose

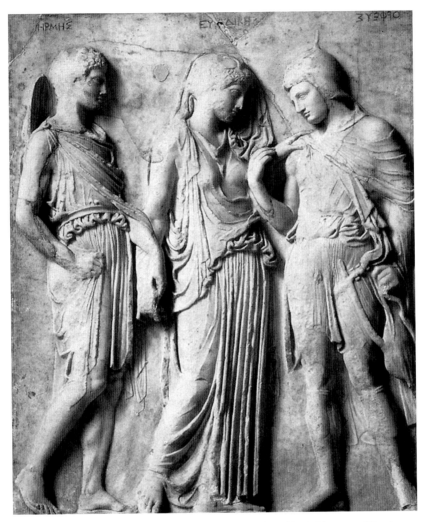

1.2 *Hermes Psychopompos Leading Eurydice Back into the Underworld.* Marble copy of Greek original, c. 420 BCE. Museo Nazionale Archeologica, Naples.

homicidal return she is condemned to become a lost image, an image of the lost, loss itself as a feminine image? Thus this space between two deaths comes to be linked with the image, loss, death, and the feminine in ways that history has overdetermined as singularly pertinent to a present moment. Bracha Ettinger writes, "The figure of Eurydice seems to me to be emblematic of my generation, seems to offer a possibility for thinking about art. Eurydice awakens a space of re–diffusion for the traumas that are not reabsorbed. The gaze of Eurydice start-ing from the trauma and within the traumas, opens up, differently from the gaze of Orpheus, a place for art and it incarnates the figure of the artist in the femi-nine."[3] Thus these faces, the figure of Eurydice, and the artist Bracha Ettinger propose a novel way to think the question of the artist in the feminine (psycho-linguistic position/sexual difference), as opposed to and as related to the woman artist (gender).

The two paintings I have chosen belong in a series of painterly transformations of fragments of archival photographs from the genocidal Europe of the 1930s and 1940s. Initially the photographs were passed through a photocopier. Before the machine could complete its replication of the image, the machine was inter-rupted at the point at which a light dusting of photocopic granules had been deposited in the shadowy spaces where light and dark began to reconstitute the photographically captured world in its stark massing of black and white, of neg-ative and positive space and form. Appearing but equally disappearing, traced but equally erased in the bleached monochrome by black ash, spectral apparitions be-come a screen and support for the artist's paint-laden encounter with an affec-tively charged and traumatizing archive of loss and lost in the spirit of Eurydice: poised between appearance and disappearance. The image is caught between two deaths. The first is that of its initial photographic seizure. The second is its in-complete repetition by the photo-machinic replication.

Much of the artist's painting returns to, lives in the presence of, stays with one tiny document from the chaotic and uncatalogued photographic archive of twentieth-century death: the Shoah, the genocidal destruction of European Jewry and the Romany and Sinti peoples at a time when other totalitarian states

1.3 Bracha Ettinger, *Autistwork No. 1,* 1993. Oil and photocopic dust on paper mounted on canvas, 32.5 × 28 cm.

also assumed the right of life and death over millions in the name of political power. To reproduce it here would be to deny the whole purpose of this artist's work on the relations held before us in the work of her painting in relation to the very fact of the existence of a representation of a moment before a death that the photograph's "shooting" disturbingly doubled in that inexplicable act of documenting wholesale murder. Yet for those unfamiliar with the source, the work Bracha Ettinger is doing to move toward its fading human moment may not be legible.[4] So I show only one of its clearest existences in an earlier series, *Autistwork No. 1* (figure 1.3). A central woman with her head averted is also visible in a painting in figure 1.1 (*Woman-Other-Thing No. 11,* 1990–93), and another element of this procession, a woman weeping, is visible in the lower left (*Eurydice No. 1,* 1990–93). Later the artist would work with a frieze, taking on the pro-

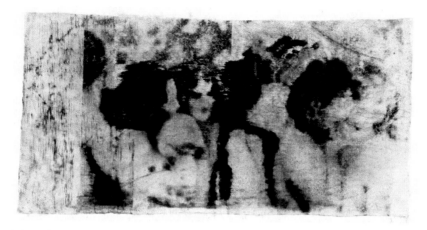

1.4 Bracha Ettinger, *Eurydice No. 17,* 1994–99. Oil and photocopic dust on paper mounted on canvas.

cessional trope of classical art in the moment of actual demise (*Eurydice No. 17;* figure 1.4). Not only a representation of the act of political murder, the photograph is itself historically indexical and, therefore, traumatic because of its chronotopic specificity. Roland Barthes wrote in 1961, long before his more extended reflections on the death at the heart of photography:

> Truly traumatic photographs are rare, for in photography the trauma is wholly dependent on the certainty that the scene "really" happened: *the photographer had to be there* (the mythical definition of denotation). Assuming this (which is, in fact, already a connotation), the traumatic photograph (fires, shipwrecks, catastrophes, violent deaths, all captured from "life as it is lived") is the photograph about which there is nothing to say; the shock-photo is by structure insignificant: no value, no knowledge at the limit, no verbal categorization can have a hold on the process instituting signification. One could imagine a kind of law: the more direct the trauma, the more difficult is connotation; or again, the "mythological" effect is directly inverse to its traumatic effect.[5]

Precisely because of its frequent insertion into certain mythological situations, such as Holocaust memorial museums and exhibitions, this photograph serves as a site of reclamation of its traumatic freight for Bracha Ettinger. It is a much-reproduced, almost iconic Holocaust image, an anonymous perpetrator photograph of the action of the *Einsatzgruppen* in Mizroc, Ukraine, during 1941, when following Hitler's advance into the Soviet Union, battalions of German soldiers and policemen cold-bloodedly murdered the entire Jewish populations of village after village, each day several thousands of men, women, and children. The photograph is both symbolic of a historical event that can be spoken of in such abstract terms, and one that is achingly subjective for Bracha Ettinger, as the archive of the destruction of European Jewry contains traces of her own obliterated family.[6] Yet this image indexes further the larger, terrifyingly modern, administrated industrial slaughtering that Adorno declared would henceforth be part of postmodern social and cultural normality: "The administrative murder of millions made of death a thing one had never had to fear in just this fashion. There is no chance any more for death to come into the individuals' empirical life as somehow conformable with that life. The last, the poorest possession left to the individual is expropriated. That in the concentration camp it was no longer an individual who died, but a specimen—that is bound to affect the dying of those who escaped the administrative measure."[7] Thus the condition for the artistic practice that founds itself in the space between two deaths in order to refuse the Orphic gaze of historical repetition by founding at that site another kind of gaze and gazing, another kind of connectivity, concerns precisely what has come philosophically to be the heart of our reflections on the attempted Nazi genocide: that its practices altered definitively not only the conditions of life by denying humanity to its racialized victims, but also the terms and experience of dying, and that this change redefines the very terms of our understanding of humanness and its subjectivities.[8]

The two paintings with which I opened here have, in fact, different photographic origins. The full-face *Eurydice No. 10* (figure 1.5) is extracted from a street photographer's snapshot taken on the streets of the Polish city of Łódź in 1938 (figure 1.6; and see figure 1.7). In the photograph, a modern Eurydice is a

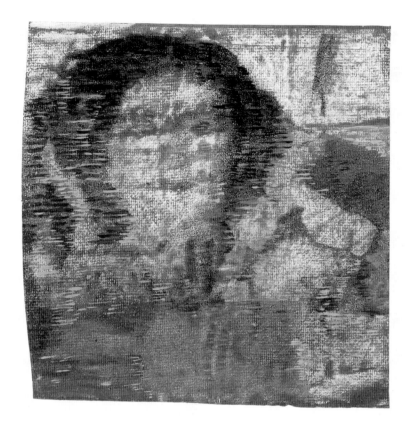

1.5 Bracha Ettinger, *Eurydice No. 10,* 1994–99. Oil and photocopic dust on paper mounted on canvas, 27.8 × 28.1 cm.

woman dressed in a stylish tailored suit—the epitome of the new woman—who strides confidently forward between two sharply dressed young men, her Orpheus and Amor. These newly nationalized Polish-Jewish Europeans confidently occupy the public thoroughfare from which they would soon be banished as the emancipatory promise of modernity was progressively and fatally withdrawn from Europe's Jewish populations following the election victories of the National

1.6 Installation shot: *Borderline Conditions and Pathological Narcissism,* Le Nouveau Musée, Villeurbanne, 1992, showing street photographer's photographs from Łódź, 1938.

Socialists (1933) and the military expansion of the Third Reich into Czechoslovakia (1938), Poland (1939), and Belgium, the Netherlands, and France (1940). These three modern Jewish citizens of a Polish republic would be disemancipated, forced to wear yellow stars,[9] herded into overcrowded ghettoes,[10] starved on four hundred calories a day, brutalized and systematically dehumanized before being transported for industrial murder.[11] Two of this trio escaped to fight with partisan groups and later emigrated to Israel. Their confident forward strides launch them, however, into an unprecedented historical abyss, an epochal rupture

1.7 Bracha Ettinger, *Mamalangue—Borderline Conditions and Pathological Narcissism, No. 5,* 1989–90, detail, ensemble of three elements. India ink, pencil, charcoal, and photocopic dust on paper, 122 × 40 cm. Le Nouveau Musée, Villeurbanne.

that lies between their moment and what the chronotope "After Auschwitz" sliced into their lives and the history of the world.[12] Thus the face in the photograph— itself the traumatic witness to the now impossible time and place that generated this uncanny record of a betrayed promise of modernity—becomes for the artist- daughter of this woman who would later, "after Auschwitz," become her mother, a screen for a longing, a yearning for recognition from a disintegrating, out-of-

focus, never-to-be-found returning gaze (figure 1.8). She longs to look back to the moment that the photograph denotatively indexes and to look back to a no longer existing world—"over there"—from which living beings have been severed in ways that make little sense of being alive when psychically you belong to a place that is not only dead—Jewish civilization in Europe—but the very ground of death in its most modern forms. This Eurydice has looked on death. Worse, she has, in fact, in some significant way already died. She was brought back and,

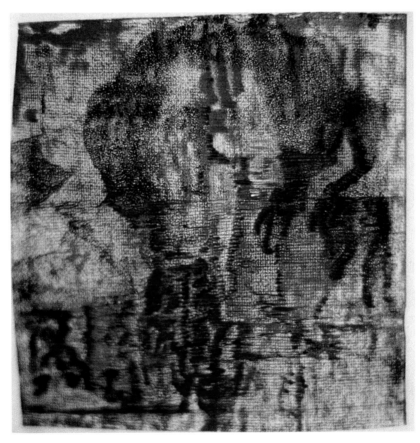

1.8 Bracha Ettinger *Eurydice No. 22,* 1994–99. Oil and photocopic dust on paper mounted on canvas.

living still in a resilient body, nonetheless refuses the human connection that the child needs to find itself within the mirror of human *being*.[13]

Thus the companion image, *Eurydice No. 9* (figure 1.9) is the artist's surrogate self-portrait, an *autistic* self-portrait that presents her through the face of a childhood toy, a doll. Its blank and beady eyes can stare out of its mouthless face, but it does not "see." It does not enter any loops of connectivity, any semantifying communicative exchange of looks, any humanizing, subjectivizing reciproc-

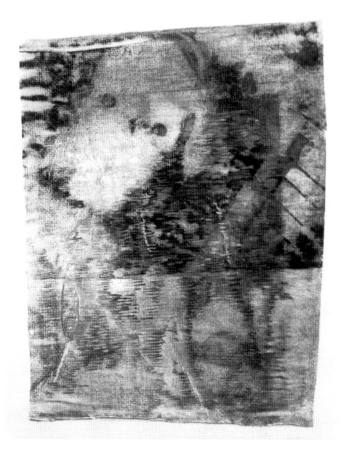

1.9 Bracha Ettinger *Eurydice No. 9,* 1994–99. Oil and photocopic dust on paper mounted on canvas.

ities. The artist tells us that she was born "anorexic" and, according to her mother, "mentally retarded" or "autistic," and she describes the daily violence of her mother's attempts to feed her, that is to keep her alive, while the child assumed and acted out, orally, from its long prenatal sojourn the emptiness that lined her survivor mother's living husk.[14] This death-in-life transfers itself from unseeing face to uncanny death mask of the artificial pseudo-person, the doll, in perfect, traumatic parody of the ideal dyadic figuring of mother and child.

These images are, however, bathed in a veil of color created by the pulsing repetition of tiny brush strokes that, returning repeatedly to the screen, weave a colored membrane across the impossible meeting point between the apparition on the screen of art and the incoming gaze of the artist, the gleaner of the Shoah's ashen harvest across whose caesura of human history the pictorial act invents an aesthetic beyond representation. The color builds its own secondary architecture at the place where the gross masses of the partial photocopied work deposited its trace in black grains.

The paint mark is a *touching* that appears as color in the field of vision. For color, in its vibration, is space-creating, and the space it creates is an affective threshold that reaches out to embrace the viewer in a thickening of what lies between viewer and image, now and then/them, that binds seer and seen, world and subject, image and psyche in sensed and imagined networks into which we can be precipitated via the pathways of the visual that are never, in the world of painting, at least, purely optical or perceptual. The inevitable exchange or continual transference between senses and between senses and affects, and between bodies of sense and affect, and between subjects of sense or affect is the very condition for the charge and contact we can name, in a non-Kantian turn, the aesthetic. Here, its violet freight is the color of grief, of Bracha Ettinger's *nichsapha,* or the *kisouphim*—the yearning, the longing that persists as the fabric of the artist's living because the tissue that marks the loss is not absolute.[15] Her parents are not dead. Yet, at some level, they are "not here."

There are people around her. They "live," however, with the long-since dead. The artist's mother tells her repeatedly that survivors appear to be here, but when alone or together, they are still living "over there," in the time before, with

the loved ones they have lost. The artist then says of herself: "Where will such a child have to go—psychically—to find her mother? Will she too have to live in the realm of the dead?"

To answer this question, we can turn first of all to the work of André Green, and his important paper on the subjective effect of maternal depression, "The Dead Mother."[16] Green offers a psychoanalytical reading of the effects on the child of being born to a depressed mother, who is, in effect, psychically or emotionally *dead* to the child. The dead mother refers to "an imago which has been constituted in the child's mind, following maternal depression, brutally transforming a living object, which was a source of vitality for the child, into a distant figure, toneless, practically inanimate, deeply impregnating the cathexes of certain patients . . . and weighing on the destiny of their object-libidinal and narcissistic future. . . . The dead mother . . . is a mother who remains alive but who is, so to speak, psychically dead in the eyes of the young child in her care."[17] The mother's melancholic face ceases to be the mirror of a living affectivity, but becomes a tomb: "The essential characteristic of this depression is that it takes place in the presence of the object, which is itself absorbed by a bereavement."[18] The mother's sorrow causes the loss of love in the child, which, Green argues, is synonymous with a loss of meaning. The loss of love is catastrophic. Nothing makes sense. But nonetheless, in that absence, the child identifies with the mother. The separation from that identification is not, however, the usual passionate affair. Killed but without hatred, what is left of the maternal object is a psychic hole that may be filled with various compulsions: to imagine and think, leading to the hyperdevelopment of artistic creativity or of intellectuality. Green states: "the quest for lost meaning structures the early development of the fantasmatic and intellectual capacities of the ego."[19]

In a feminist swerve through the art historical "museum of the imagination," the many *Eurydice* paintings that repeatedly return to a trio of faces from a photographic trace of the murder of European Jewry (cf. figures 1.3 and 1.4) can be linked, perhaps unexpectedly, with a representative of the classical tradition of Western painting. Raphael's *Fire in the Borgo* of 1516–17 (figure 1.10) uses the gestural, facial, and body language of Western figurative painting to represent the

1.10 Raphael, *Fire in the Borgo,* 1516–17, with three details. Fresco, 670 cm wide at base. Vatican Palace, Rome.

high drama of rescue from the terrible fire that threatened to engulf a section of Rome in the ninth century. In Raphael's large and dramatic composition, we can find echoes of the three faces Bracha Ettinger isolates and strokes in her paintings: an averted face, a face of desperate appeal and direct address, and the face of a mother concerned for the safety of her child.

One of these figures appears in the Mnemosyne Atlas created by Aby Warburg to trace a deep cultural memory inscribed into the artistic record by the recurring figure of the animated nymphae. Inspired by Nietzsche's *Birth of Tragedy,* Warburg took up the theory that the origins of pagan, classical art lay in ritual and not in mimesis. This theory blew apart the Winckelmannian idealization of the antique as the epitome of harmony, balance, and *grosse Stille.* Instead of finding monumental calm, Warburg focuses on the still-vibrant traces of the Dionysian agitation, passion, and emotional intensity that once animated the per-

formances of ritualized masquerades and sacrifices as human communities experienced the intense emotions aroused by the struggle for life and the cycles of life and death. These archaic, pagan actions, argues Warburg, remain in etiolated and amnesiac form in Western classical culture, lodged in what he calls the "pathos formulae": the gestural language of body and facial expression that was never a transcription of an empirical reality, but was the image form of a remembered psychic/emotional intensity sharing in, as Georges Didi-Huberman has recently argued, the structure of the symptom.[20] Raphael's painting—which I show in fragmented form to heighten our sense of the ways in which the emotions of terror, fear, desperation, and concentration (figure 1.10, details) are embodied and encoded—brings into focus an archive: the averted head, the face of appeal, the gestures of maternal anxiety. Their intensity contrasts with another paradigmatic

Raphael painting of the feminine, *Three Graces,* whose formal perfection enshrines an image of feminine beauty. Here, beauty is femininity only in the absence of any trace of emotional disturbance such as that registered as bodily movement or facial intensity. Each as vacuous as her sister, these three graces have, in effect, the deadly mask of the doll, as they stare as empty-mindedly as the spheres that symbolize their blank perfection (figure 1.11).

Between the agitation of the frenzied emotion of the *Fire in the Borgo* and the passive blankness on the doll-like faces of the *Three Graces,* Bracha Ettinger

1.11 Raphael, *The Three Graces,* 1504. Oil on panel, 17 × 17 cm. Musée Condé, Chantilly.

situates a trio she has found within a horrific artifact of genocide. In this suspect photographic register of the terrible procession to a horrible death, the artist returns again and again to a woman with her head averted: What does she look at?

> I want her to look at me! That woman, her back turned to me. The image haunts me. It's my aunt, I say, no, my aunt's the other one, with the baby. The baby! It could be mine. What are they looking at? What do they see? I want them to turn to me. Once just once, I want to see their faces. The hidden face and the veiled face are two moments calling to each other: moments of catastrophe. . . .

> Please look at me once. You are my dead aunt or you are my living aunt or you are someone I don't know. Lost, you do not stop raising questions in me. In painting, face to face, face to non-face. A moment before leaving again. Mother—I, my aunt could have been my daughter. . . .

> This woman has more to look at than watchers of painting . . . but what she looks at is inhuman.[21]

The artist has discovered infinite painterly means to refuse to abandon these women at the mouth of hell. As importantly, she thereby refuses to kill these gracious Eurydices once again with a naked, Orphic backward look at the genocidally originated archive that exposes forever the horrific moment before death, their looking onto and back from something worse than death, the calculated sadistic torture of dying thus. Not so much veiled but clothed in the grief colors of perpetual mourning and seeping longing, paint generates materially an affective connectivity through webs of brush marks on the screen between then and now, as the painter journeys to a moment forever suspended in our historical imaginations in a photographic stasis that marks the initiation of a historical process that would culminate in the chronotope "after Auschwitz."

1.12 Bracha Ettinger, *Untitled No. 2*, 1998–99. Oil and photocopic dust on paper mounted on canvas.

We come after this place and must not leave this place, and yet we journey to it (since "nach Auschwitz," in Adorno's original German, also means "toward Auschwitz") from across time that was created by what happened just after the moment suspended in the photograph's anteriority to the final act of massacre. Can their emotions be not *represented,* or *imaged* as in the painting by Raphael and the tradition based on Christian incarnation that it inaugurated and epitomized, but emerge in a truly modernist painterly move as a kind of materially invoked resonance of human connectivity and shareable fragilization, spread across the virtual, aesthetically conjured space that stretches out between then and now, them and us, there and here? Such a dimension of tenuous but vivid "inter-/trans-subjective co-affectivity" (to use Bracha Ettinger's expression) is materialized as space created by and within painting. The painting, trace of a prolonged attendance at this threshold between time and space, between life and death, does not become an image of emotion, figured as in the Western representational tradition as gesture or expression. Generating a perceptual pulse, a wave of intensity, painting becomes the incitement to an affectivity distilled from a history of art that has itself passed through the modernist turn to aniconism, as in Rothko's work, for instance. It has thus come about through the historical changes in art we call "high modernist abstraction" that were suspended in the late 1950s, awaiting the feminist moment to resume their engagement with the deepest matters art addresses. Bracha Ettinger's daring and knowing "return" in the late 1980s to the unfinished business of painting and its continual elaboration throughout the 1990s delivers a still-unharvested potentiality in that modernist moment in painting that actively resists the specular image and sees beyond the triumph of the gaze that, in the form of lens-based art forms, came to dominate as critical art since the 1970s and 1980s.[22]

TAKING A TURN TO THEORIES
OF THE FEMININE AND THE AESTHETIC

During a conference on the question of genius at the Institute of Contemporary Arts in London in June 1999—a topic raised humorously in Linda Nochlin's opening salvo of the feminist intervention in the fields of art, art history, and vi-

sual culture[23]—Bracha Ettinger cited Otto Rank's psychoanalytical reading of the myth of the hero/genius.[24] In the patriarchal legends of the genius, she concluded, the mother as a mythic figuration of creativity is either absent or is represented as an animal: "Between copulating and nursing, there is a void." Furthermore, Bracha Ettinger argues, this negated third possibility—the lacking or erased possibility of the duration, space, and relationalities of begetting—is then appropriated by the hero-genius and rewritten as the autistic myth of autogenesis. What holds the myth of the artist together is, therefore, the foreclosure of the begetter-mother principle, which Bracha Ettinger renames in psychoanalytical terms as the "archaic m/Other of the poetic Event and Encounter," that is an archaic resource of artistic activity itself.[25] Art and sexual difference are intimately bound together at their point of emergence. Yet in phallocentric terms, that co-emergence is reformulated so that an absolute patrilineality inserts itself. If the artist generates himself, he can take his place in the all-male genealogy of masculine genius. The murdered father is, according to her analysis of Freud's metapsychology, killed by displacement and resurrected through the hero to become the ever more symbolic guarantee of the masculine subject. By contrast, any participation of the feminine, the archaic m/Other, in the process of human becoming has been condemned by phallocentric thought to senselessness, meaninglessness, as a "Thing of no human significance."

The term "Thing" (*das Ding/la Chose*) here refers specifically to Lacanian psychoanalytical formulations of nonverbal intensities and traumas, in the Real that, by his definition, remain beyond any fantasy or thought. Yet they press upon the psyche and are the void around which its defining apparatuses are structured, as a vase is formed around and thus provides a form to the void, the vacuole within it.[26] The artist as Hero-Genius is the allegory in cultural forms of the ego structured by the Oedipal frame: "Born from no-womb, the artist-Genius inherits the idea of a god transferred into a man created by itself and then holding the power of creation."[27]

This still-active legend implies that any of us who participate as artists or thinkers, creative writers or intellectuals, in the mythic structurings of such a subjectivity that alone promise access to creative work are participants in a murder of the archaic m/Other or, rather, in this beyond-abjection foreclosure of the *feminine*.

———

To follow this argument, we shall need to reclaim radically the term "feminine" from its current debasement either as the signifier of the lacking, voided, castrated Other of the Same in phallocentric thought or, in daily parlance, as the term of the conventional gender characteristics of a binary sex-system, the stereotypical Eurocentric bourgeois Woman. We can call this the feminine to the power of the phallus:−f/P. In Bracha Ettinger's psychoanalytical thinking, the feminine signifies a still-unarticulated potentiality of subjectivity that is of particular and long-term interest to those minds and bodies thus designated by feminine to the power of the phallus (−f/P) but also to those who wish to transgress this limitation to the phallocentric imagination and to contemplate the rich and as yet unthought possibilities of there being a sexual difference, rather than an economy of the Same and its Other (in Luce Irigaray's helpful philosophical formulation). Thus working through Freud's brave perplexity and admitted failure in theorizing femininity and feminine desire—his question, "What does woman want?"[28]—and through Lacan's life-long return to the question of the impossible sexual relation premised on a sexual difference not imaginable by phallocentricity, Bracha Ettinger reclaims the word that feminists seem most to censor, and proposes a radical new theorization of the feminine through a new signifier, the Matrix, and its figure, metramorphosis. I shall refer to this as the feminine: F/m . . . , the ellipses indicating even further possibilities as yet awaiting a signifier to expand the nonunitary Symbolic.

Kaja Silverman has argued that the revolutionary eruption of a renewed feminist impulse in the 1970s was a moment at which what Kristeva identified as "the maternal-homosexual facet" found representational and institutional support in a women's movement that desired to know more of the feminine.[29] She names this "oppositional desire." What we have seen since that intensely affectionate moment, it could be argued, has been the resurgence of deep ambivalence toward any theoretical engagement with the feminine as a potential principle of radical difference beyond that oppositional no-difference delusively proposed by the phallocentric system, in which the feminine is only thinkable in binary partnership with the masculine. The crucial moment in feminist thought was daring to think about a subjectivizing difference between subjects that is not premised

on gender, man/woman, but for instance, mother/daughter, woman/girl, adult/
child, and so forth.

Silverman tracks precisely that swerve from a delighted moment of articu-
lation of the maternal feminine in Kristeva's early work to a more guarded and
defended resistance and reinstallation of the paternal facet. Yet neither Silverman
nor Kristeva, valuable as their insights have been, dares to think beyond the
Oedipal model laid down by Freud. Thus their engaging and convincing contri-
butions to feminist thought, while renegotiating it, remain within the frame-
work of the –f/P phallic model of a femininity defined by and from its opposing
and symbolically privileged masculine. While attempting to find a trace of the
maternal-homosexual facet, both Silverman and Kristeva theorize on the basis
of the necessity of the absolute loss of and severance from the archaic m/Other,
a limit-case that Bracha Ettinger's work decisively breaks through. She realigns
the archaic m/Other to continue to play through equally constitutive processes
of phallic modeling of the speaking subject. She imagines a way to think the sex-
ual subject as nonidentical with the speaking subject created by castration. Hence
her profound realignment of sexual difference and creativity, both arising from
some domains of subjectivity not entirely covered or thought by the phallic
model, however vital that model is for other dimensions of subjectivity. Sexual
difference, meaning both difference and sexual/sexuating/eroticizing, can be
thought both beyond and before "gender" and in relation to a feminine psychic-
symbolic logic not defined in relation to the phallic.

After thirty years of feminist work in art and art history, how many woman
scholars in art history would unembarrassedly name themselves feminists, define
their work as feminist, desire it to be seen as such? Increasingly that framing of the
project is on the wane. It is flushed by other philosophical and theoretical colors
and a frequently asserted opinion either that the feminist project has done its work
and is now historically redundant or that it has become irrelevant in the face of
other, more pressing questions and revisions. Artists whose creative explorations
of a whole range of areas, themes, and issues were made possible by the dramatic
challenges to phallocentric hegemony launched by the feminist cultural revolution
in the 1970s now actively disown that legacy. They seem to fear its contaminating

"politics" and, worse, its dreaded lack of marketability. In the field of art which is now so critically transformed by the confident presence of so many women, we see the wholesale appropriation of the Hero–Genius myth by women who must, for their status as creators, disown this embarrassing filiation to anything that contains a trace of a maternal—and older generational—begetter and thus allows for a process of creation that is always several, connected, and co-productive.

The women's community of scholars is as structured by competitive individualism and intergenerational complexity as any that Adrienne Rich first dissected in her still relevant 1974 essay, "Towards a Women-Centered University."[30] Shoshana Felman has somewhat more poignantly pointed out in her autobiographical study of writing and sexual difference, *What Does a Woman Want?*, that key feminist writings have been produced in the absence of the mother: missing mothers who imaginatively lined the aching void around which writers such as Virginia Woolf elaborated their fictional worlds.[31] Woolf wrote of women writers writing back through their mothers, but Felman's insistence that these mothers were *dead* mothers brings into play another twist of this impossibility of imagining female creativity—in art as in academic practice—in relation to a living feminine genealogy. It is here that a momentary collision of the first two parts of this essay holds its paradoxical interface of art, life, and theory.

In the early 1970s the taboo was breached on declaring the term "woman" of any interest or value for art history. Since that challenge was laid down, the figure Woman has, however, been forced into its own form of an autogenetic position. The current negation of feminism in the name of more neutral investigation into diffused and nonsexually specified aspects of artists who are women is indicative that we have not breached the taboo on the archaic m/Other and with it the possibility of thinking "in, of and from the feminine."[32] Indeed, I am arguing that such thinking is increasingly censored or ignored.

Since 1992, my own theoretical engagements have taken a turn toward this problematic. Just as Catherine de Zegher laid it out in her epigraphs for the catalogue *Inside the Visible* in 1996, I find myself slung between two radically opposed feminist/psychoanalytical traditions: that of Julia Kristeva's radical negativity, in which the feminine is not on the plane of being:

———

> I would define as "feminine" the moment of rupture and negativity which conditions the newness of any practice.

and that of Bracha Ettinger's revolutionary theses on the Matrix and metramorphosis (to which I'll return later):

> The Matrix is a feminine unconscious space of simultaneous co-emergence and co-fading of the I and the stranger that is neither fused nor rejected. Links between several joint partial subjects co-emerging in differentiation in relations-without-relating, and connections with their hybrid objects, produce/interlace "woman" that is not confined to the contours of the one-body with its inside versus outside polarity, and indicate a sexual difference based on webbing or links and not on essence or negation.[33]

For Julia Kristeva, what is signified by the term "feminine" marks the limits of the phallocentric as the unsignified, unsignifiable otherness from which revolutionary change may be resourced in the struggle to move beyond anthropomorphic figurations of the split condition of subjectivity in general. Thus the feminine stands for an ungendered radical psycholinguistic otherness that must never be reduced to the religious or anatomically fixated fictions of identity: I am a woman. For Julia Kristeva such delusional claims are what trap feminism in the dangers of totalitarianist or humanist idealisms. The feminine, like the positionality of "the homosexual" or "the Jew," can only be a figure of transgressivity that destabilizes all dreams—tending toward the theological and dogmatic—of fixable identity.[34]

No question that this Hegelian model of creativity via negativity is intellectually compelling for a cerebral feminist afraid above all of the cozy, woolly, homely comforts of old-fashioned woman-identified feminist rhetoric. Kaja Silverman brilliantly plots a reading of Kristeva's writings to reveal a progressive renunciation of her early delight in the discovered domain of the *chora* and marks this negation as itself a symptom of something that needed to be explained. Silver-

man's solution is the proposition of the negative Oedipal complex, a negative in the photographic sense of inversion to the normative positive resolution that would anticipate a heterosexual alignment of the feminine subject. The negative Oedipal complex for the masculine subject—in which the father is an object of desire—shadows patriarchal institutions and all-male social practices sustaining what Irigaray names the *hommo-sexual* economy of the One Sex.[35] What is lacking for the feminine subject, irrespective of her sexuality, is the support for this homosexual-maternal facet at the level of a symbolically instituted desire. Silverman's move reveals the symptoms of another anxiety: any investment in the pre-Oedipal would involve some engagement with the maternal as corporeal begetter, as breast. The sound of the mother's voice and her desire are just about admitted to the theoretical pantheon, but not her womb, her fluids, her internal spaces, and certainly not her desires and fantasies generated around these sexually specific morphologies and subjectivity-transforming processes of encounter and event that are theoretically, fantasmatically, and for some experientially a decisive instance of feminine sexual difference.

At a point radically beyond the limit at which Kristeva and Silverman halt lies the work of post-later-Lacanian Bracha Ettinger, who has dared to ask why we cannot bear to think that anything of that foreclosed feminine spaces of encounter and event can be allowed to constitute our sense of the human. Brilliantly tracking the most daring of Lacan's late theory of trauma, fantasy, and the *sinthôme* to the point at which this "genius" also balked—a point where Woman-Other-Thing and Death are aligned—Bracha Ettinger, following Antigone or Eurydice, steps over that limit, which now becomes a threshold to new possibilities in feminist thought, to propose a nonphallic model of thinking, art making, and ultimately politics and ethics. This transgression of the deepest of phallocentric thought's narcissistic defenses encounters the revenge of recent feminist and now postfeminist theory's new censorship of the feminine, which is once again made unthinkable and unspeakable—if you want to be taken seriously, that is.

How can Bracha Ettinger do this? First, the mere mention of this possibility attracts to itself the anxieties generated by the structure that is being questioned. The phallic model cannot imagine a shifting severality of paradigms or

planes of subjectivity. It can only align subjectivity with the closed individual, the one: the discrete one-body with its clear boundaries and well-defined inside/outside polarity. Therefore, it is menaced at its core by the concept that subjectivity itself is a web that—before the very possibility of the one-gap-other structure is created by the cut that, accruing all to itself, will retrospectively gather all severances as castration—weaves itself between always partial and never known potentialities that become subjects in a co-emergent differencing. Let me repeat Bracha Ettinger's words:

> The Matrix is a feminine unconscious space of simultaneous co-emergence and co-fading of the I and the stranger that is neither fused nor rejected. Links between several joint partial subjects co-emerging in differentiation in relations-without-relating, and connections with their hybrid objects, produce/interlace "woman" that is not confined to the contours of the one-body with its inside versus outside polarity, and indicate a sexual difference based on webbing or links and not on essence or negation.

The most usual complaints I encounter when attempting to advance this model is that we cannot simply replace the existing phallic one with a matrixial model. Clearly no one was listening, since the concept of alternation is itself, precisely, phallic: one or its other, either/ or. The matrixial model is not about alternation or substitution. It concerns a shifting, *supplementary* subsymbolic possibility that, like (but also very unlike) Kristeva's feminine as negativity, is a means of transgression and transformation that, in its shifting and shifted severality, is however able to rise to the plane of thinking (Symbolic thought through words) as well as enhancing the range of the Imaginary (fantasy and image) that must underpin thought itself. There can be matrixial theories, but these theories are about a Symbolic that is both expanded by additional signifiers and transformed because this particular, additional signifier, the Matrix, initiates a different order/logic and economy than the phallus since it is a signifier not of a new One, another organ, but of a relational hybridizing, transsubjective spatiality and domain of re-

tuned resonance and shared affectivity to which we have unconscious access via the aesthetic when that dimension pervades art making and viewing.[36] What happens when we begin to allow ourselves to transfer certain recognized phenomenological insights about entwining of vision and movement, of seer and seen, of world and subject, onto the matrixial psychoanalytical plane so that our concept of the subject is not figured through this body or that body, a defined boundaried morphology, but through an assemblage of sensation, fantasy, and affect that registers co-emergence, co-fading, co-traumatization, co-poïesis on the basis of a transsubjective threshold? Note the care with which Bracha Ettinger's words are being selected. This is not at all about cozy symbiosis, fusion, or any comforting sense of community. The opening of subjectivity to a permanent co-other "fragilizes" aspects of subjectivity, which may or may not be activated depending on situation or responsiveness. Art may activate this intensity, not always, and not by form or subject, but only through momentary elements of contingent processes. This passageway, the matrixial passageway, is traumatizing, either painfully or blissfully, but at the level of event/encounter which can never be entirely predicted. This marks this theory's enormous distance from the rigid structuralism of what passes in cultural studies for Lacanianism. This theory cannot predict a spectatorial situation such as governs feminist film theory, for the event/encounter of the transsubjective moment is never institutionalizable.

The matrixial critique of phallocentrism is that the phallic functions only by the negation of the begetting m/Other that stands not for the Mother as opposed to the Father of the Oedipal triangle, but for the space of co-becoming that is heavily loaded toward a sensitized, fragilized jointness-in-separateness. At a recent lecture, the social geographer Doreen Massey outlined her current principles: that space is relational; that space is thus composed of all the relations within it; that space is, therefore, inherently the site of multiplicity and co-determinacy. Her project was to transcend the emptied concept of space that is traversed by the linearity of time, progress, history, modernization, development that must, therefore, leave certain peoples, places, and experiences "behind," rendering them archaic, underdeveloped, traditional, historical, of the past. Conceived clearly to deal with critical issues in the social sciences, and ecological and

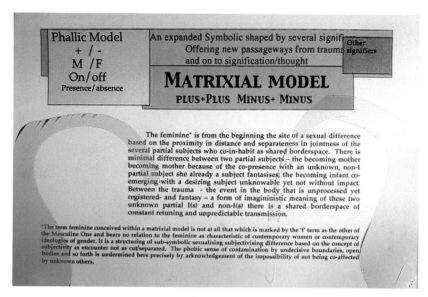

The feminine* is from the beginning the site of a sexual difference based on the proximity in distance and separateness in jointness of the several partial subjects who co-in-habit as shared borderspace. There is minimal difference between two partial subjects – the becoming mother becoming mother because of the co-presence with an unknown, non-I partial subject she already a subject fantasises; the becoming infant co-emerging with a desiring subject unknowable yet not without impact. Between the trauma - the event in the body that is unprocessed yet registered- and fantasy – a form of imagininistic meaning of these two unknown partial I(s) and non-I(s) there is a shared borderspace of constant retuning and unpredictable transmission.

*The term feminine conceived within a matrixial model is not at all that which is marked by the 'f' term as the other of the Masculine One and bears no relation to the feminine as characteristic of contemporary women or contemporary ideologies of gender. It is a structuring of sub-symbolic sexualising subjectivising difference based on the concept of subjectivity as encounter not as cut/separated. The phobic sense of contamination by undecisive boundaries, open bodies and so forth is undermined here precisely by acknowledgement of the impossibility of not being co-affected by unknown others.

1.13 Griselda Pollock, *Diagrammatic Scheme: A Matrixially Expanded, Supplemented Symbolic.*

global politics, her principles echoed what I think Bracha Ettinger is attempting to introduce on the level of philosophical/psychoanalytical speculation on the subject and art. What Bracha Ettinger has theoretically named a phallic concept of the subject privileges time, making the subject a blank space traversed by a development or accumulating logic built on a series of cuts and erasures that retrospectively redefine any stages or structures that precede them as archaic, ancient, surpassed, superseded, and ultimately beyond the limit of the thinkable: cast out as the exterior void against which the boundaried shape of the singularized subject is plotted.

If we conceive the subject as always and already *in potentia* a relational spatiality, and assume that such spatiality is inevitably pluralized and multiple, we are not thinking of a postpartum mother and baby. We are being invited to image the being transformed by what is happening, the subjectivity of a fantasizing adult undergoing its becoming and transformation through the co-presence of a

stranger, an unknown, not-yet subject who none-the-less affects the becoming-mother-subject at levels from the physiological to the most elaborately fantasmatic and symbolic. Anyone who has ever had a miscarriage will know that there does not have to be a baby or even a visible sign of a pregnancy for its loss to be as emotionally catastrophic as any death of a known loved one, and yet what does this profound mourning grieve, but the fantasy that has already been inspired by this "event" of becoming through the coming of a not-yet-other? The affects of this fantasy are as "real" as any that are caused by an actual other. Thus, in the structure of one kind of co-eventing that is pregnancy, a definitive change will occur through the internal never-to-be-fixed exactly, when the I becomes partner to the non-I. The point is that here, alone, the two cannot be imagined independently of each other and the relativity of the two produces a hybridized common borderspace in their fantasy/later-to-become fantasy worlds that is several from its inception but is never composed of two discrete entities.

Furthermore, this severality is nongendered and utterly non-Oedipal; that is to say, it has nothing to do with the production of Oedipal sexual markers of Man/Woman via Father/Mother. Hence this offers an important model for thinking sexuality without the imposition of the heterosexualizing familial paradigm. Yet this severality is sexual in any psychoanalytical sense of the word, and because there is a minimal difference in this severality, in the matrixial encounter that is neither symbiosis nor fusion, it does give rise to a *sexual difference from the feminine*—from what by this token is the feminine but not as the opposite of the masculine. The feminine is then understood as this "originary" subjectivizing frame of a severality, of subjectivity as, *ab initio, encounter* rather than *cut*. This is not to say that it gives rise to masculine versus feminine subjects, gendered or Oedipally sexed. It is to argue that this distinctive encounter of partialities in the matrixial intimacy lays down affects and sensations that could become constitutive of certain libidinal pleasures and rapports *were they to be transported via fantasy and signifier into the speaking, imagining, and thinking subject.*

This potentiality must and can only be defined as feminine since, at the level of the real, it is the effect of the encounter with and in the sexual specificity of female body as the phenomenological support of the already feminine de-

siring, fantasizing subject. Bracha Ettinger simply invites us to follow through some of the potential implications of allowing ourselves to recall—at the level of theorization—not something that is utterly inconceivable, but only that which our current well-policed, even censored theorizations of subjectivity and sexuality have annulled in favor of the phallus as the unique generator of being/meaning/difference.

This theory is not about valorizing the womb as opposed to the penis. Matrixiality is precisely not about organs, which, whether they are penis (Freud), umbilicus (Bronfen), or placenta (Irigaray), are phallic concepts/objects. This is not about shifting from patriarchal to matriarchal politics. This is not about Mummy and her babies. This is about lies, or naive or abusive silencing. This is about a cover-up. This is about the active diminution of the potential for human thought to deal with aspects of itself and its worlds by a systematic foreclosure. This foreclosure of the begetting m/Other rapport can be shown, by its own self-accounting, to be the condition of the phallic order's imposition of an absolute hegemony of the phallic One with all its implications for our thinking of gender, race, and human/animal divisions in terms of precisely that -/-, that mark of division and opposition of the One and its Other.

No wonder feminists are threatened, because the matrixial model imagines a nonmaternalist value for the begetting m/Other space: Is there another structure already available to us through which the difference of the feminine subject from the feminine subject can be imagined? No. Difference is always imagined as difference between masculine and feminine. This definition has been thoroughly criticized by lesbian theorists, who are often led to reject psychoanalysis itself. Or this leads to Kristeva's notion that we are aiming ultimately for a postanthropomorphic concept of difference: not sexual difference, but the neutral inscription of symbolic castration inside every subject. But "neutral" here again enacts phallic as the One, that is, the one that we can show emerges as the One by the suppression of any sense/meaning to sexual difference, i.e., a difference that would arise from sexual specificity. Now, with the ideas of matrix and metramorphosis, the difference of the feminine subject from the feminine subject is being articulated.

—

The very fact of being born, as we mostly still are, from the physical forms of sexual reproduction (this does not mean the sex act, but from conception in and carrying in a female body) means that every subject has been in contact with the sexual specificity of the feminine body, with a psychically infused corporeality, whatever the status of its parenting (single parents, gay couples, surrogacy, insemination, adoption, etc). In that joint space where borders and thresholds are mutually invested there is also an encounter that we can call difference. The matrixial difference is sexual in any definition of the term not only through its bodily intimacies and exchanges of fluids but also through its potentials for investing its nonverbal intensities later with libido and desire. It is also psychically sexualizing insofar as it leaves traces of these intensities that will later be garnered and reinscribed in fantasy and thought. For Lacan, there was no sexual rapport, because he claimed nothing of the feminine could be reported and, therefore, there was no feminine sexual difference in the realm of human *meaning*. (He could not theorize it, but he knew it was what his theory never got to.) It is this comfortingly phallocentric claim that Bracha Ettinger, who translated the very late Lacanian seminars, contests. She says there are ways to theorize how there is a sexual difference *from* the feminine that is not secondary to the castration paradigm's rendering of the difference of the feminine as negative deficiency vis-à-vis the masculine One. She also argues that there are ways to theorize the semiotic means by which this sexual difference in, of, and from the invisible sexual specificity of the feminine can be diffused across the threshold of culture. She names the process of change and exchange in a matrixial web "metramorphosis." This concept leads her to theorize a matrixial gaze.[37]

The matrixial process of meaning "donation" differs from the phallic models to which we are accustomed. Phallic models are constructed on twin foundations: signification occurs in the absence and absenting/loss of the real. Signification is premised on a logic of the contradiction of presence/absence. The sign is always the symbolic substitute by means either of metaphoric replacement or metonymic contingency. Meaning is the melancholic acquiescence to loss.

Metramorphosis, curiously adumbrating and regendering difference, accepts a chain, a transpsychic webbing and borderlinking, across which meaning

suffuses in a never totally absented nor completely present transfer. What is lost to me may be held remembered and transferred in metramorphic linkings with co-emerging non-I's that are never not-me's and never nonhuman things. Thus the puzzle of artistic practices that utilize materials yet cause subjective affect and generate semiotic effects can be approached without romantic mystifications or expressionism:

> Knowledge is released from blanks and holes in the Real by the metramorphic process of webbing and wit(h)nessing, the metra-morphic process of exchange of affect and phantasm, based on conduction of/in trauma or jouissance-in-jointness, and a metra-morphic process of transmissions-in-transformation of phantasm, initially between a becoming-subject and a becoming-m/Other to be, but more generally between I in co-emergence with an uncog-nized non-I (which can be considered plural-several, partial and dif-fracted "woman"), release knowledge from blanks and holes in the Real. Swerving and contacting themselves becomes a kind of knowledge; they are, in a spiraling movement back and forwards, the inscriptions of traces of borderlinking. We can consider them traces of a matrixial *sinthôme* that releases/creates/invents/reveals, from the feminine side, potential desires whose meaning which does not depend on a signifier, will be revealed in further encounters. The feminine weaving tells us the story of decentralized severality, of un-predicted occurrences, of nonsymmetrical reciprocity, if we can read between the threads.[38]

Bracha Ettinger goes on from there to argue that this matrixial *sinthôme* may not yet describe what man is to a woman, but it can intimate what feminine differ-ence is to a woman subject. The difference here is not the result of having/not-having an organ, but of a psychically charged and semantifiable relation to the similar-yet-not-the same. Because this theory allows for several tracks to coexist without knocking each other out, it is possible to read those events, stages, and

traumas on which phallocentric theory has charted the making of the neutral but in effect masculine subject as the making of *the* subject *tout court* as having different valences both for masculine and feminine subjects, but differently. Thus what corresponds to weaning for a masculine/neutral subject may be traced in the feminine as separation-in-jointness with a never absolute loss that was also never fantasized as an absolute presence. The breast was never just an organ but, as a matrixial *objet a,* it is theorizable as a webbed space of co-emergent fantasies which are never absolutely lost since that space is held in potentia for a woman subject as a possible phantasm that may recur in the real of pregnancy and maternity or may find sublimated forms in other social, aesthetic ethical practices: teaching, research, friendship, art.

Once we accept the psychoanalytical model that enables us to conceive of how the materiality of the corpo-real and its intensities and trauma rises through fantasy and signification into thought, we no longer need to be afraid of mentioning these "spaces" and relations that are so obvious and profound that only the depth and exclusiveness of the phallocentric order's self-protecting negation can explain the fact that we feel embarrassed to raise them in serious theoretical discussion. An entire imaginary and symbolic system rests on morphological associations with the penis and penetrative sexual growth, detumescence and thrusting, visibility/invisibility (to the exclusion of the duality of the testes and the tripleness of the scrotal+penile assemblage). I think we should allow ourselves the chance to supplement this corpo-realized imaginary with the radically extended concept of relational transsubjective spatiality that allows what Bracha Ettinger calls "the invisible sexual specificity of the feminine" a formative effect: "It is not only that feminine sexual difference traverses every subject. In the human, transitivity itself is matrixial sexual difference."[39] This statement has two implications for me here. One is that if we can show that artistic practice and experience are premised upon subjective transitivity, then we must assume that art is deeply linked in its poietic dimensions with the sexual difference of and from the matrixial feminine. Secondly, the concept of the artist itself changes:

The Matrix is a psychic space where the m/Other-other-Thing-Encounter is not eliminated, and the object is not entirely lost. In the aesthetic layer, the "awakening" of the object toward the subject becomes possible with scission, the link to the archaic m/Other-Encounter-Event is always maintained in some aspects and on a certain level between no-Thing and some-Thing. In the matrixial borderspace another artist appears: a *she*.[40]

Thus we are theorizing an artist in the feminine not through any concept of social gender or psycholinguistic positioning. This artist in the feminine is linked to a different kind of gaze that the artwork traps or supports:

In this sphere it is possible to describe the arising of the gaze or the voice in the artwork without making it a phallic ghost, and without reanimation castration anxiety. . . . Since metramorphic swerving is a sexual difference based on webbing of links and not on essence or negation, I call this interlaced subjectivity that is not confined to the contours of one-body with its inside versus outside polarity "Woman." This gives rise to an idea of an artist as working through traces coming from others to whom she is borderlinked.[41]

What is significant is that the working of the artwork is what then produces the artist in the feminine, rather than the preexisting status of the maker who confers "her" femininity on the work: a problem for any advanced theoretical notion of art as text, as productivity.

The artist who opens pathways and deepens metramorphoses in the matrixial field turns then into a woman when she wanders with her . . . erotic antennae in a psychic space and in a world where the gaze is a veil, a trail of an event or borderlink. . . . The artist-woman channels anew trauma(s) and jouissance(s) coming from non-I(s) that are linked to her. She bifurcates, disperses and rejoins anew but-

in-difference their remnants and traces and she acts on the border-line, transcribing it while sketching and laying it out and opening it wide to turn it into a threshold and to metramorphose it into a borderspace.[42]

Thus there are not "artists" and "*women* artists," that is, at some ontological level. Furthermore, this theory is not about the fact that there may be artists either purposively performing feminist interventions or ignoring any question of gender at any level of their practice. Bracha Ettinger theorizes an Encounter-Event that is the matrixial woman-artist that is not an identity or a person, but an affect and an effect. She posits this as a *discovered* structuring in the art experience, contingent upon the effects of "artworking" (a neologism akin to dreamwork) that may, in its signifying practice, spread onto the threshold of culture, that is otherwise and often necessarily structured by the phallic Imaginary and Symbolic, a metramorphosing transitivity that does not depend on the foreclosure of the feminine, and its association with death and the inhuman. Rather it allows the not-yet-human, the not-yet-life, the no-more-life, some kind of co-emergence and co-fading in interlacing subjectivities rendered fragile by wit(h)nessing with/within uncognized foreign elements that allow limits to become thresholds: i.e., poietic shifters of meanings and subjectivities.

It is vital to stress that Bracha Ettinger's theorization resulted from painting. This origin is vital to grasp because the whole of the movement of the 1970s and 1980s was represented rightly or wrongly as a movement in the other direction from the then-mystical antitheoretical concepts of the aesthetic toward a Hegelian covenant between art and philosophy: conceptual art in various forms, most obviously, but in the critique of representation and institution to the now-prevalent critique of theory posed by Deleuzian theorists of art after philosophy and after representation.[43] The idea I am working with arises from a genesis in a painting practice that itself is rooted in a historical fragilization of the Jewish and feminine historical subject who must at any serious level experience its existence as *after* death. Trauma became a hot theoretical subject in the second half of the twentieth century after its historical incision into the fabric of Western culture

and world society through the Holocaust, Hiroshima, and other recurring catastrophes. The trauma of the industrial genocide of millions on ethnic grounds of Jewish or Romany identity, compounded by the torture and enslavement of political dissidents and homosexuals, arrived at a level of theoretical and philosophical debate that runs the risk of commodifying trauma as a careerist gambit. The trauma theorists were briefly the high flyers of the late 1990s. In the light of September 11, the notion of trauma has been realized in dramatic and pervasive forms on a global scale. It has perhaps become possible to come a little closer to being open to the traumatic legacy of the Holocaust survivors and their generations as people who live with/beside death and yet who live with the "before-death" of a world that is mourned as more real than anything that happened after the incalculable and inconceivable mass murder. The horrors of the deaths of traumatically terrorized people in the twin towers give the current American world some idea of what it feels like to experience the assault of someone else's willingness to inflict sadistic death on you just because you are you: American, Jewish, Roma, or Sinti.

Bracha Ettinger's painting practice is one single moment of traumatic culture, that is, a culture of subjects fragilized by encounter across the normally simple and absolute boundary of life/death. If traces of trauma can be transmitted both laterally and vertically, collectively and historically, our notion of the subject's definitions and boundaries must be reconsidered. Trauma's transmission can be traumatizing. Yet the fact of such dispersal, the erosion of the cut as finite division, the boundary, the limit, is also the promise of some co-creation of futurity, in lieu of perpetual abandonment at the threshold of dying, and of some kind of transformative processing, of that which can exist beyond me but yet process for me something I can no longer process.

THE MATRIXIAL GAZE

In 1963, moving on beyond the role of the specular in his signature theory of the mirror phase, Lacan retheorized the gaze via a reading of Merleau-Ponty as *objet a*. Beyond Lacan's *objet a*—which Bracha Ettinger's theory redefines as a phallic

objet a because it is predicated on the economy of castration and loss—Bracha Ettinger posits a gaze as a matrixial *objet a*. She first defines the Lacanian *object a* that indicates certain psychic, subjectivizing processes that can only be named sub-symbolic and preimaginary.

> The *objet a* is the part-object and archaic Other/mother [m/other is the later formulation] linked to non-Pre-Oedipal impulses, *forever unattainable,* whose lacking being is created during the primal split of the subject, when language blurs its archaic modes of experience, and when discourse, introducing the laws and orders of language, nestles in their place and constitutes them as *forever unattainable.* The *objet a* resides on the borderlines of corporeal, sensory and perceptive zones, but it eludes them all, itself being a psychic entity produced and lost according to the lanes carved by libidinal energy invested in the drives. It is a borderline mental inscription of the residues of the separation from the partial object.[44]

The postulation of the *objet a* is, therefore, theorizing a residue, a trace in the psyche of that which the not-yet-subject (for, without the initial separations, the *objet a* registers as trace in the psyche; there is no subject) experienced in sensory, corporeal, perceptive, hence not-yet-semiotic but potentially semiotizing terms only as a *partial* object: as something that carries something of the Thing, Lacan's name for the unsymbolizable yet registered corporeal, the traumatic Real, toward the level at which it can become something for the subject, i.e., that which is lost or that from which the subject emerges as its scarred relict: "According to Lacan's late theory of phantasy, subjectivity is not only the effect of the passage between the signifiers of language, but it is also the effect of basic separations which instigate the subject to desire unconsciously both the lost part-object—the lost archaic Real Mother/Other—and the unreachable symbolic Other."[45] Drawn by desire both back toward that which *objet a* traces as a lost before-the-subject and forward, as it were toward the impossible promise of the (cultural) Other that calls the now desiring subject into being from the side of Language and the signifier,

through which some hope of substitution and secondary restitution is promised, the Lacanian subject of this late theory is generated both by the signifier and a psychic scar or trace that might only be intimated via non/beyond-Oedipal, non/beyond-linguistic meaning, by affect-generating aesthetic processes. For Lacan, the gaze thus redefined moves from active to passive registers: as lost, the gaze is what the now-lacking subject comes to desire. To be clear: there is what Bracha Ettinger clarifies as the Oedipal gaze, mastering, unifying, "a conscious, alienating instrument of power, in the service of the ego."[46] Then, after 1963, Lacan posits the gaze as *objet a,* suggesting that in the field of the scopic drive, the gaze is the nothing beyond appearance for which the subject formed through accumulating severances and "cuts" unconsciously yearns. Thus it is not to be satisfied by "seeing" an "object," but rather longs for something that is closer to a kind of visual affectivity: "We look for the gaze, we are longing for it, we desire to be looked at by the gaze [hence it is associated with a certain passivity, a certain suffering] but the gaze is hidden from us."[47]

Bracha Ettinger writes,

> Some traces of *it* are caught up in the work of art; when the lacking *objet a* bursts forth and assumes an image, it is not a duplication of another representation, it is not an illustration of that which had already been observed or thought. When the *objet a* is incarnated— the Other is knocked out, the signifying meaning (in language) disappears and goes into hiding, the specular image is driven aside and faded away, and so, an artwork, linked to unconscious desire and divorced from narcissistic identity, can be conceived. The *dodging-regression impossible encounter* with the "hole" in the Real via art, where *it* acquires an image *for the first time,* is a borderlink of resistance and liberty, which shakes the borderlines of culture into becoming thresholds and draws openings towards new concepts that will retroactively account for *it*.[48]

Bracha Ettinger moves from Lacan's theorizations of this gaze as *objet a,* which may flicker through the artwork, in order to track, in psychoanalytical and philosophical studies, the widespread interest in understanding the most archaic spaces between the not-yet-humanized as a subject and the human (subjectivized by the insistence of the signifier and the insertion into the signifying chain). Piera Aulagnier, Wilfred Bion, Jean-François Lyotard, Pierre Fédida, Christopher Bollas, and many others have worked on the not-yet-theorized psychic space of the earliest of maternal/infant relations and maternal processing of undigested infantile conditions and experiences. But all still remain limited, in their theoretical imaginations, to the postbirth moment, the implicit separateness of the One and Other. All seem to conceive this archaic set of relations and transitional or transformational objects only as neutral, or androgynous.

Bracha Ettinger's transgressive move is to drag into theoretical possibility the trace of a corporeal, sensory-registering, data-collecting, imprinting zone of a prenatal borderspace that is, from its inception, several, plural, joint without fusion, intimate without symbiosis, and yet differentiated without rupture or repulsion. This is a prism in the registers of the traumatic Real and those of Imaginary and Symbolic elaboration as fantasy and idea, from which may emerge transsubjective shared affects, traumas, and fantasies of no predictable meaning. Through the always retroactive effect of subsequent subjective structurations and semiotic resources, this treasury of possibilities can find screens upon which affect-laden intimations of connectivity and shifting, volatile experiences of fluctuating distance-in-proximity and differentiation-in-co-emergence may be momentarily received by "eroticized aerials of the psyche." Here emerges another matrixial "gaze." It is still Lacanian in its nonspecular indexicality of psychic connectivity and loss. Yet it is post-Lacanian in its stress on connectivity and its refusal of absolute loss by a stress on slippage between the scopic and tactility, transference, shareability, transitivity. In naming this meaning-creating mobility "metramorphosis," Bracha Ettinger brings it into cognition from its ever-presence in the processes of painting.

This prism of metramorphosis and the Matrix is not the return to the womb, and has nothing to do with the post-Oedipal and gendered ways we think

or speak of bodies or of parent figures. The Matrix—a signifier just as is the Phallus, not a symbol of anything or any organ—brings into thought the always-already several, psychically inscribed traces of a shared borderspace, a connectivity of difference-in-jointness that must by this logic be called "feminine." This feminine is not an attribute of women or woman, concepts and identities created within the phallocentric logic of a sexual differentiation of Man and its Other. Nor is it an essence derived from a naturally gendered body. It is feminine in principle and logic as a subjectivizing potential traced in several part-subjectivities, awaiting its arousal and transmutation through processes and practices, fantasies and evocations, signifiers and thoughts. It is a logic of "subjectivity as encounter" that works not through cuts and fusions, through presence and absence, but through constant retunings and shiftings that can emerge into a certain of visibility at the level of certain kinds of artistic, notably though not exclusively, painting practices at certain historical moments and only unpredictably:

> The matrixial (object/*objet a* of the) gaze is between shared *thing* and lost object, belonging to plural-partial subjectivity. If in relation to the *objeu* (Fédida) what we call meaning is created by presence-absence relation where the *fort-da* can be understood as the discovery of meaning as absence and repetition of absence/presence, in the matrixial stratum of subjectivization modeled on the feminine/*pre-natal* relations we cannot speak of alternation between presence/absence but, instead, of continual attuning and re-adjustments of distance-in-proximity.[49]

Just as Jacques Derrida attempted to help his readers to think of *différance* by reminding them of words such "resonance" or "turbulence," so too the Matrix brings into signification neither something nor nothing, but the vibrance of diffusion of humanly registered affect, sensation, and protomeaning that is transmissible, incitable, or opened in an aesthetic encounter. Thus the matrixial gaze takes us beyond the Foucaultian/Oedipal model of the gaze as instrument of knowledge, power, and position. It equally traduces Lacan's self-revision of the

role of looking in the mirror phase that leaves the subject definitively scarred by that which creates the subject through loss. It builds on the idea of the operative, unknowable psychic traces or inscriptions, the gaze as *objet a,* to enable critical thinking in aesthetics and art history to transcend the dominance of the Oedipal gaze (operative in cinema and photography) and even the gaze as phallic *objet a* (possible in video) and to resume some of the modernist intimations of painting as nonspecular yet working on us subjectively "inside the visible."

> The matrixial *gaze* is linked to a feminine One-less desire which is not limited to "women-only." It is a subjective-*objet-a* that emerges within a *singular* plurality and partiality, within a *singular* borderspace with its borderlinks and borderlines, where co-emergence in differ- ence is born out of unconscious eroticized aerials of the psyche invested in and from a matrixial stratum of subjectivization. With metramorphosis, we move from lost (by "castration") object/Other to unconsciously transformed by metramorphoses relations-without- relating between I and non-I.[50]

Bracha Ettinger challenges feminist theory that has both made productive use of Oedipal theories of the gaze (notably in film theory and art history) and become too attached to that model of the gaze as the only way to think about visual field. The retheorization of gaze via this later Lacanian detour can be specified both in the realm of painting and in nonspecular terms, opening the in- terspace of visibility and tactility, corporeality and visuality. The gaze becomes less a line of sight than a diffused mesh both swerving through the painting and between painting and its viewer, that may or may not be activated in any one viewing encounter, opening onto a possible co-creation or poïesis:

> The *objet a* is a poïetic aesthetic object not in the sense of objects to *look at* or *listen to* while "influence" flows from the artwork to the spectator, but as objects participating in the act of creating that which will *look* at us, where activity is not a control, but a bringing

into being, and where passivity is not a subjugation but a donation that allows for exposure. . . . As matrixial, it is not only a remnant, exposed in the present, of a subjacent past . . . but *also a glimpse of the forever future* to be created in the now.[51]

CONCLUSIONS

The professional issue of being a woman-gendered artist may not be as difficult as it once was, at least institutionally. There are certainly women artists winning some professional recognition. Linguistically and structurally, however, let no one feel falsely confident. The question of sexual difference matters hugely, whatever many of our distinguished company say.[52] But what matters is not labels on art or artists. The artist/woman is not the same as a woman who is an artist, since "woman" used merely as a gender qualifier assumes already known social definitions of gendered subjects within the existing modeling of social and heteronormative psychosymbolic identities. Julia Kristeva disposed of that error in 1974 when she declared that "woman" was not, not in the realm of being, that is, did not designate an identity. What I am interested in is what is not yet knowable or is hardly acknowledged of sexuate and sexuating specificities that can be theoretically entertained only through the disciplined rigor of psychoanalytical thinking about the aesthetic, that is, the origins of artistic creativity and its processes and affects. This dimension, which Bracha Ettinger perceives, beyond the final limits and foreclosures of Lacan's and Freud's most persistent tracking of the archaic formations of subjectivity, she thus names as "feminine." This matrixial proposition of a *feminine* that is beyond the phallus and its rendering of the feminine as merely the negated cipher of a phallic positivity might be made intelligible by those artists who dare to work to discover what might be "in, of, and from the feminine," rather than remaining in fear of finding themselves locked in, or out, because phallocentrism cannot allow us to imagine a way of thinking or being outside its powerful hegemony.

Much of this article has been theoretical, and readers may at this point wonder about the paintings with which I opened. What I have been tracking is

the journey through the thickets of theorizations that enable us to articulate in the otherness of language what happens in the event that, after modernism, we understand as painting "in, of, and from the feminine" in the historical chrono-tope "after Auschwitz." Yet, as the penultimate quotation above insists by using the word *"singular"* twice, the knowledge that theory delivers with a communicable clarity is not always the affect of the artwork. The artwork creates a singular encounter in its moment. That remains lodged in historical, art historical, and local/contingent specificity and depends in each case upon a viewer's own history, generation, geography, and singular response-ability to the work's particularity. I do not want to, and cannot, according to this theory, generalize from the paintings about art or women. So there is no interpretation to recover or offer in conclusion. The work was itself a "theoretical object" calling for a thinking about what its work as art deposits, proposes, invites.[53]

> Artists continually introduce into culture all kinds of Trojan horses from the margins of their consciousness. In that way the limits of the Symbolic are transgressed all the time by art. It is quite possible that many work-products carry subjective traces of their creators, but the specificity of works of art is that their materiality cannot be detached from ideas, perceptions, emotions, consciousness, cultural meaning, etc., and that being interpreted and re-interpreted is their cultural destiny. This is one of the reasons why works of art are symbologenic.[54]

Yet, in doing what Bracha Ettinger herself has done, transplanting the event from what happened in her artwork to another territory, psychoanalysis, theoretical elaboration does enable us to reflect in a creative way about the questions that were originally posed in Linda Nochlin's opening conjunction of feminist questions and art's histories. What difference would (sexual) difference make to our thinking about and/through making art?

NOTES

1. For a profound discussion of the meaning of series in this artist's work, see Brian Massumi, "Painting: The Voice of the Grain," in *Bracha Lichtenberg Ettinger: Artworking, 1985–1999* (Ghent: Ludion, 1000), pp. 8–32.

2. Jacques Lacan discussed Antigone in Seminar VII, *The Ethics of Psychoanalysis, 1959–1960,* ed. Jacques-Alain Miller (London: Routledge, 1992), pp. 243–290. For another commentary, see Bracha Lichtenberg Ettinger, "Transgressing-with-in-to the Feminine," in Penny Florence and Nicola Foster, eds., *Differential Aesthetics: Art Practices, Philosophy and Feminist Understandings* (London: Ashgate, 2000), pp. 185–210. See also Griselda Pollock, "The Aesthetics of Difference," in Michael Ann Holly and Keith Moxey, eds., *Art History, Aesthetics and Visual Studies* (New Haven: Yale University Press and Clark Art Institute, 2002), pp. 147–174.

3. Bracha Lichtenberg Ettinger, *Que dirait Eurydice* (What would Eurydice say) (Paris: BLE Atelier, 1997), pp. 30–31.

4. For the source image, please consult Robert Neumann and Helga Kopper, *The Pictorial History of the Third Reich* (New York: Bantan Books, 1961), p. 191.

5. Roland Barthes, "The Photographic Message" (1961), in his *Image-Music-Text,* ed. S. Heath (London: Fontana, 1977), pp. 30–31.

6. During Operation Barbarossa, Hitler's invasion of the Soviet Union, special units of soldiers and policemen followed the advancing army and systematically destroyed the Jewish populations of Lithuania, Ukraine, and other areas, murdering villages of two to three thousand people by shooting in a matter of days. For an account of the speed of these direct killings, see Yaffa Eliach, *There Once Was a World* (Boston: Little, Brown, 1998), and Christopher Browning, *Ordinary Men* (New York: Harper Collins, 1992). It was the perpetrators' own revulsion at this daily atrocity that pressed the Nazis to search for more industrial methods of mass murder.

The artist's family lived in Łódź and experienced the ghettoization and the selections of a related policy of genocide in Poland.

7. Theodor Adorno, "Meditations on Metaphysics," in *Negative Dialectics,* trans. E. B. Ashton (New York: Continuum, 1982), p. 362.

8. See reflections upon this issue in Giorgio Agamben, *Remnants of Auschwitz: The Witness and the Archive* (New York: Zone Books, 1999).

9. Pope Innocent III at the Lateran Council of 1215 instituted the compulsory marking of Jewish clothing.

10. The ghetto is an enclosed settlement of Jewish populations that was initiated in Venice in the late sixteenth century. Allocated an island near the iron foundry, the *geto* in Venetian dialect, the Jewish populations of Europe increasingly gained at least a right of permanent settlement for which they usually had to pay considerable taxes and fees. Some historians see this move as the beginning of a modern era in contrast to the constant fragility of existence in the medieval period, with its periodic mass expulsions. For example, in 1290 the Jewish communities of Britain were expelled, and in 1492 there was a mass expulsion from Spain after almost twelve hundred years of a Jewish presence.

11. For an outsider's account of the conditions in the Warsaw ghetto, see Jan Karski's testimony in Claude Lanzmann's *Shoah Second Era,* 1985.

12. The concept of chronotope, from the Greek terms for "time" and "space," originates with Bakhtin but has recently been used to explain the paradox of Adorno's phrasing "After [temporality] Auschwitz [location]"; see Michael Rothberg, *Traumatic Realism: The Demands of Holocaust Representation* (Minneapolis: University of Minnesota Press, 2000), pp. 25–58.

13. For further reading on the nature of parenting after the traumatic experiences of the Holocaust, see Dina Wardi, *Memorial Candles: Children of the Holocaust* (London: Routledge, 1992).

14. "When I was little I didn't eat anything. They called it *infantile anorexia.* In shared and silent despair, my mother cruelly saved my life in daily, sadistic gestures: food." Bracha Lichtenberg Ettinger, *Matrix Halal(a)-Lapsus* (Oxford: Museum of Modern Art, 1993), p. 85; reprinted in *Bracha Lichtenberg Ettinger: Artworking, 1985–1999.*

15. For a fuller discussion of *nichsapha* and color, see my "Nichsapha: Yearning/Languishing the Immaterial Tuché of Color in Painting *after* Painting *after* History," in *Bracha Lichtenberg Ettinger: Artworking, 1985–1999,* pp. 44–70.

16. André Green, "La mère mort," in *Narcissisme de vie, Narcissisme de mort* (Paris: Editions de Minuit, 1983), pp. 222–253; Green "The Dead Mother," in *On Private Madness* (London: Hogarth Press, 1986). On Green's work, see Gregorio Kohon, *The Dead Mother: The Work of André Green* (London: Routledge, 1999).

17. Green, "The Dead Mother," p. 142.

18. Ibid., p. 149.

19. Ibid., p. 152.

20. Georges Didi-Huberman, "*Dialectik des Monstrums:* Aby Warburg and the Symptom Paradigm," *Art History* 24, no. 5 (2001), pp. 621–645. The symptom is a complex formation of contradictory impulses susceptible to transformations, displacements, and inversions. As dynamic processes, they thus need decipherment, not iconological categorization.

21. Bracha Lichtenberg Ettinger, *Matrix Halal(a)-Lapsus,* pp. 67, 68, 85.

22. For my discussion of the turn to lens-based media in art in the 1980s, see my "Rencontre avec l'histoire: stratégies de dissonance dans les années 80s et 90s," in Jean Paul Ameline, *Face à l'histoire* (Paris: Centre Georges Pompidou and Flammarion, 1996), pp. 535–541, and Griselda Pollock, "Painting as a Backward Glance That Does Not Kill: Fascism and Aesthetics," *Renaissance and Modern Studies* 43 (2001), special issue on Fascism and Aesthetics, pp. 116–144.

23. Linda Nochlin, "Why Have There Been No Great Women Artists?" in Elizabeth C. Baker and Thomas B. Hess, eds., *Art and Sexual Politics* (London: Collier MacMillan, 1973), p. 7.

24. Bracha Ettinger, "Weaving a Woman Artist with-in the Matrixial Encounter-Event," *Theory, Culture and Society* 21, no. 1 (2004), pp. 69–94—a special issue dedicated to Ettinger's theory and painting practice.

25. Ibid., p. 69

26. "The *Thing* is traumatic and aching, and we do not know where it hurts or that *it* hurts. It struggles unsuccessfully to re-approach psychic awareness, but only finds momentary relief in symptomatic repetitions or by subterfuge, in art work, where its painful encapsulation partly blows up." Bracha Lichtenberg Ettinger, "Traumatic Wit(h)ness-Thing and Matrixial Co/in-habit(u)ating," *Parallax* 5, no. 1 (1999), pp. 89–98, 89. Lacan's full discussion of the Thing occurs in *The Ethics of Psychoanalysis.*

27. Ettinger, "Weaving a Woman Artist with-in the Matrixial Encounter-Event," p. 71.

28. I acknowledge here Jane Flax's important paper "The Scandal of Desire: Psychoanalysis and Disruptions of Gender: A Meditation on Freud's Three Essays on Sexuality," *Journal of Contemporary Psychoanalysis* 40, no. 1 (2004).

29. Kaja Silverman, "The Maternal Voice," in *The Acoustic Mirror* (Bloomington: Indiana University Press, 1988).

30. Adrienne Rich, "Towards a Woman-Centered University," in her *On Lies, Secrets, and Silence: Selected Prose 1966–1978* (London: Virago, 1979), pp. 125–155.

31. Shoshana Felman, *What Does a Woman Want? Reading and Sexual Difference* (Baltimore: Johns Hopkins University Press, 1993), pp. 121–151.

32. See my essay, and those of Catherine de Zegher and Bracha Lichtenberg Ettinger, in de Zegher, ed., *Inside the Visible: An Elliptical Traverse through Twentieth Century Art in, of, and from the Feminine* (Cambridge: MIT Press), 1996.

33. Quoted in ibid., p. 3.

34. For a fuller discussion of this position, see "Dialogue with Julia Kristeva," *Parallax,* no. 8 (1996), pp. 12–13, a special issue on *Julia Kristeva 1966–1968: Aesthetics, Politics, Ethics,* edited by Griselda Pollock. In that issue is an English translation of her "Experiencing the Phallus as Extraneous, or Women's Twofold Oedipus Complex," originally to be found in Kristeva, *Sens et non-Sens de la révolte* (Paris: Fayard, 1996).

35. Luce Irigaray, "Women on the Market," *This Sex Which Is Not One,* trans. Catherine Porter (Ithaca: Cornell University Press, 1985), p. 170.

36. Let me be clear. By "aesthetic," I am not thinking of some timeless standard of canonical beauty in the Kantian sense; I am referring to those artistic practices that touch on nonverbal intensities through noncognitive means. Thus some art quite genuinely aims to be or ends up being nonaesthetic and works according to other more cognitive or linguistically based signifying processes that semiotics particularly helps us to read. But there are affects—in the psychoanalytical sense that address dimensions of subjectivity such as pain, pleasure, desire, trauma—and these dimensions are what psychoanalysis connects to aesthesis.

37. Bracha Lichtenberg Ettinger, *The Matrixial Gaze* (Leeds: Feminist Arts and Histories Press at the University of Leeds, 1995).

38. Ettinger, "Weaving a Woman Artist with-in the Matrixial Encounter-Event," p. 88.

39. Ibid., p. 86.

40. Ibid., p. 88.

———

41. Ibid.

42. Ibid., p. 89

43. For a clear explanation of the relation of Bracha Lichtenberg Ettinger's theories to Deleuze, see her "Trans-subjective Transferential Borderspace," in Brian Massumi, *A Shock to Thought: Expression after Deleuze and Guattari* (London: Routledge, 2002), pp. 215–239. For a Deleuzian reading of her painting, see Massumi, "Painting: The Voice of the Grain," pp. 9–44.

44. Ettinger, *The Matrixial Gaze,* p. 1.

45. Ibid.

46. Ibid., p. 11.

47. Ibid., p. 1.

48. Ibid., p. 15.

49. Ibid., p. 47.

50. Ibid., p. 50.

51. Ibid., p. 48.

52. I am indirectly referring to Rosalind Krauss, *Bachelors* (Cambridge: MIT Press, 1999), in which she argues against any special pleading for women artists.

53. For a discussion and elaboration of artwork as theoretical object, see Mieke Bal, *Louise Bourgeois' Spider: The Architecture of Art-Writing* (Chicago: University of Chicago Press, 2001).

54. Bracha Lichtenberg Ettinger, "Matrix and Metramorphosis," *Differences* 4, no. 3 (1992), p. 196.

1.14 Virginia Woolf photographed in her mother's dress. Maurice Beck and Helen Macgregor, *Vogue*, May 1926. © The Condé Nast Publications Ltd.

LISA TICKNER

For my daughter—of course—Ellie Nairne

VANESSA BELL

Let me begin with these two images. One, a photograph of Virginia Woolf, wearing her mother's dress in *Vogue,* May 1926 (figure 1.14).[1] (In January, revising her plan for *To the Lighthouse,* with its portrait of her parents as Mr. and Mrs. Ramsay, she'd written that "we are handed on by our children.")[2] Two, *The Red Dress* (c. 1929) (figure 1.15) by her sister, Vanessa Bell, in effect a kind of composite self-portrait: Bell in the guise of her mother, Julia Stephen, as she appears in a photograph by her great-aunt, Julia Margaret Cameron (figure 1.16). (The photograph is plate 19 in *Victorian Photographs of Famous Men and Fair Women,* published with introductions by Woolf and Roger Fry in 1926.)[3]

Woolf and Bell's father Leslie Stephen was a "Famous Man."[4] His library and example as an eminent writer were of inestimable value to Virginia, who was embittered but perhaps also emancipated by her exclusion from the Cambridge education of her father and brothers. (In *A Room of One's Own,* musing on "how unpleasant it is to be locked out," she considers "how it is worse perhaps to be locked in.")[5] Their mother Julia was a "Fair Woman"—Leslie's "saint," a paragon of womanly virtues and a noted beauty painted by Watts and Burne-Jones.[6] This was a more equivocal heritage for the artist-daughter.

1.15 Vanessa Bell, *The Red Dress,* c. 1929. Oil on canvas, 73.3 × 60.5 cm. Photograph courtesy of Brighton Art Gallery. © 1961 The Estate of Vanessa Bell, courtesy of Henrietta Garnett.

1.16 Julia Margaret Cameron, photograph of Julia Jackson (later Duckworth, later Stephen), c. 1866. Plate 19 in *Victorian Photographs of Famous Men and Fair Women,* with introductions by Virginia Woolf and Roger Fry (London: Hogarth Press, 1926).

Julia Margaret Cameron, on the other hand, offered a rather unusual in-
stance of Victorian, middle-aged, matriarchal creativity, ruthlessly pursued. Ten-
nyson referred to her "wild-beaming benevolence," and Annie Thackeray to the
"marked peculiarity" of all seven Pattle sisters in "their respect for their own
time": "They were busy with their own affairs, and anything they undertook they
followed up with absolute directness of purpose."[7] This "masculine" ambition
and focus was combined—in Carol Armstrong's view of Cameron—with an en-
gagement with photography "as something altogether different from technical
mastery, pertaining, rather, to the domestic, the incestuously familial and the
feminine; as something like hysteria—the hysteria of the mother."[8]

When Vanessa moved her siblings to Bloomsbury on the death of their fa-
ther in 1904, she wrote to Virginia: "I have been hanging pictures in the hall. . . .
On the right hand side as you come in I have put a row of celebrities: 1. Her-
schel—Aunt Julia's photograph. 2. Lowell. 3. Darwin. 4. father. 5. Tennyson.
6. Browning. 7. Meredith—Watts' portrait. Then on the opposite side I have put
five of the best Aunt Julia photographs of Mother. They look very beautiful all
together."[9] On the right, the Famous Men; on the left, the Fair (Dead) Woman,
structuring the sisters' heritage through masculine intellect and feminine beauty,
except that the mediating term is the photographer herself (famous and a
woman).

Woolf claimed: "we think back through our mothers if we are women"
(seeing the tradition of "great male writers" as a source of pleasure but not of
help).[10] She meant elective rather than natural mothers, in whom the nurturing
roles might be reversed.[11] Feminine creativity required the murder of "the An-
gel in the House," the internalized imago of their dead mother, Julia, the em-
bodiment of purity, deference, and chronic unselfishness.[12] But Bell, like Woolf,
could draw on Julia Margaret Cameron's photographs of their mother (her niece
and namesake) as a way of memorializing her while staking a claim to a specifi-
cally matrilineal artistic heritage.

MEDIATING GENERATION: BLOOM AND BOURDIEU

Woolf wrote that "books are descended from books as families are descended from families. . . . They resemble their parents; yet they differ as children differ, and revolt as children revolt."[13] This statement (almost) anticipates Harold Bloom, the American critic who argues that generation is a matter of Oedipal rivalry and "creative misreading." In Bloom's terms, the "anxiety of influence," successfully negotiated, ensures the fertility of a vigorous, evolving, patrilineal genealogy. He describes this relationship as a "battle between strong equals, father and son as mighty opposites, Laius and Oedipus at the cross-roads" in which "major figures . . . struggle with their strong precursors, even to the death."[14] How then are women to "think back through their mothers"?

Several of Bloom's feminist critics have appealed instead to the myth of Demeter and Persephone.[15] Demeter, mourning the loss of her daughter to Hades, negotiates her return for three seasons of the year. Loss is assuaged with the advent of time: both linear time (the mother ages, the daughter matures) and cyclical time (the seasonal sequence of growth and decay). Demeter's creativity is restored with Persephone's return. The earth blossoms. The Freudian model of oedipal rivalry is replaced by an object-relations model of selfhood. Similarly, Woolf doesn't struggle to free herself at the crossroads (mother and daughter as mighty opposites). She seeks attachment, not separation. A sense of kinship with her "strong precursors" reveals and preserves the heritage that forms and enriches her. She gives birth retrospectively to "Judith Shakespeare," the poet's sister, who "lives in you and me, and in many other women," and who, with effort on our part, will come finally to creative life.[16] As Ellen Rosenman puts it, the daughter's creative self lies *through* the precursor's self, "the situation deemed by Bloom to be intolerable to the male artist."[17] For his part, an unrepentant Bloom insists, "The strongest women among the great poets, Sappho and Emily Dickinson, are even fiercer agonists than the men. Miss Dickinson of Amherst does not set out to help Mrs. Elizabeth Barrett Browning complete a quilt. Rather, Dickinson leaves Mrs. Browning far behind in the dust."[18] No doubt both positions are overidealized and overdetermined: the son's struggle to the death on the one

hand, the daughter's filial reciprocity on the other. It might help to consider the question of attachment or rupture not as a *gendered* distinction, but in terms of a *historical* contrast in modes of production.

Dante's encounter with Virgil, as Gabriel Josipovici points out, was a source not of Oedipal rivalry but of wonder and delight: "Are you, then, that Virgil, that fount which pours forth so broad a stream of speech? . . . You are my master and my author. You alone are he from whom I took the fair style that has done me honor."[19] Dante was writing in a craft tradition, before the Enlightenment and early romanticism, when the "substantial categories" of state, family, destiny, and ultimately craft production itself were eroded. From that point, tradition and the capacity to go on had to be remade locally and contingently, in the rediscovery of trust, whereas in the craft tradition the artist "thinks of himself as a maker, not a creator; as a supplier of something that is needed by the community, not as the unacknowledged legislator of mankind." Homer, Dante, Shakespeare, Bach, Mozart, and Haydn were "firmly embedded in a craft tradition" (though Shakespeare and Mozart were already exploring the corrosive effects of a breakdown of trust); Milton, Blake, Wordsworth, and Beethoven were not.[20]

Josipovici argues that "a craft implies a tradition into which you are inducted by a master; in which you serve your apprenticeship; and in which you in turn become a master. It implies that what you are doing when you practice your craft is, if not necessary to society, at least sanctioned by society. Weaving carpets if you are a female member of a nomadic tribe in Eastern Turkey is a craft tradition."[21]

The anonymous weaver of Turkish kelims or Navajo blankets was trained by her mother; women *artists* in the craft tradition were trained by their fathers or not at all. When the workshop was a family business, a talented daughter could sometimes help out.[22] But the rising academies moved to exclude women, and studio apprenticeship, still a necessary complement to academic instruction at the time of David, was modeled on the pattern of father and sons.[23] Asking, rhetorically, "Why have there been no great women artists?," Linda Nochlin famously concluded that "the fault lies not in our stars, our hormones, our menstrual cycles, or our empty internal spaces, but in our institutions and our education."[24] As the craft tradition crumbled and academic authority waned, larger numbers

of women than ever before were trained in public and private art schools here and abroad.[25] But despite this or because of it, emphasis shifted from the biological division of labor (men create, women procreate) to women's *psychological* inadequacy as virile, autonomous, even revolutionary artist-agents. Much of the new aesthetic depended on an (often noisy) plundering of self. In avant-garde rhetoric the Academy, mass culture, commerce, and fashion—all the old enemies—were variously characterized as "feminine" or effete. This is the *historical* context for Germaine Greer's response to Nochlin's question: "You cannot make great artists out of egos that have been damaged, with wills that are defective, with libidos that have been driven out of reach and energy diverted into certain neurotic channels."[26] (This is not, in fact, true, and Anthony Storr's *The Dynamics of Creation,* among other texts, attempts to outline the relations between various kinds of neurosis and artistic activity.)[27]

Vanessa Bell was on the cusp of what the sociologist Pierre Bourdieu calls the autonomizing aesthetic field.[28] As a young woman, she studied at the Royal Academy, admired Watts, and poured tea for Meredith and Henry James. Scarcely a decade later she exhibited with the postimpressionists, bought a Picasso, and dedicated herself to "significant form." Her first solo exhibition was in 1922 (at forty-three). She wouldn't have made a living from sales alone. Consider by contrast Rachel Whiteread, whose acknowledgments to sponsors and benefactors bear witness to the institutionalization of modern art: the Arts Council of Great Britain, the Greater London Arts Association, the Elephant Trust, the Henry Moore Foundation, ACME Housing, Artangel, Tarmac Structural Repairs (an award-winner under the Business Sponsorship Incentive Scheme), the Public Art Fund (New York), Beck's Beer, The British Council, and the dealers Karsten Schubert and Anthony d'Offay. She won the Turner Prize at twenty-nine, and at thirty-three became the first woman to represent Britain (alone) in the Venice Biennale. *None* of which is to detract from the originality and resonance of her work, only to indicate—and particularly in the case of a sculptor, whose public potential is tied to practical difficulties of labor, materials, and space—how individual agency is intricately entwined with that web of socio–aesthetic–economic relations that now constitutes the cultural field.[29]

What women have needed is the revision of actual or perceived forms of experiential, discursive, and psychological difference—that is, freedom from constraints on their social opportunity ("our institutions and our education"), and from the delimiting effects of mythic narratives of creativity allied to narcissistic cultural investments in the Artist as an infantile idealization of the Oedipal Father (who has then to be struggled with and overcome).[30] De-idealization here is connected to the de-masculinization of creative potential. There is in fact a great deal of psychoanalytic literature on gender and creativity that needs revision, now that the critical mass of women's work is sufficient to undermine its founding premises—and in particular the assumption that what women are recognized in existing terms as having achieved is a measure of their potential under any conditions of production or evaluation.[31]

Bloom deals in time, in genealogies, in "strong precursors" and "the anxiety of influence." Bourdieu deals in space, in the relations of the cultural field. Bloom's model is the family tree, Bourdieu's the map. In terms of "mediating gender and generation," the first is too exclusive (canonical males); the second too inclusive (an only hypothetically mappable social and psychic space of agents, works, institutions, social relations, and "conditions of possibility"). As an image of generation, we might take a third model—Deleuze and Guattari's "rhizome"—instead. In *A Thousand Plateaus,* they argue that "evolutionary schemas may be forced to abandon the old model of the tree and descent." The rhizome is "an anti-genealogy": multiple, diverse, heterogeneous, generative, resistant to hierarchies, and productive in its channeling of desire.[32]

This is the first generation in which women artists have grown up with both parents. This fact eases, if it doesn't eradicate, the anxiety of influence, which for women may be the anxiety of finding oneself a motherless daughter seeking attachment, as much as it means rivaling the father while trying to please him. Finding (real and elective) artist-mothers releases women to deal with their fathers and encounter their siblings on equal terms. Feminism fought for our right to publicly acknowledged cultural expression; it also insists on our place in the patrimony, as equal heirs with our brothers and cousins. Deleuze and Guattari are against the tree, against descent: "The tree is filiation, but the rhizome is al-

1.17 Bruce Nauman, *Space under My Steel Chair,* 1965–68. Concrete, 45.1 × 39.1 × 37 cm. Collection Geertjan Visser, on loan to the Rijksmuseum Kröller-Müller, Otterloo. © 2001 Artists Rights Society (ARS), New York / DACS, London.

liance, uniquely alliance."[33] Within the autonomized cultural field, relations in cultural space become more pressing, more determinant, than the authority of the line. This isn't absolute, of course, but there is a compression of reference such that synchrony wins out over diachrony, siblings over grandparents. Impossible now to imagine a modern commission for one of those cycles of great artists of the past that Francis Haskell discusses as indices of national taste.[34]

Women appropriate and misread their fathers and struggle with their brothers, too. Writing on Rachel Whiteread makes obligatory reference to Nauman's cast of the *Space under My Steel Chair* (1965–68) (figure 1.17) as the founding moment of "negative space" and "a kind of parent-object" for Whiteread's 1995 *Untitled (One Hundred Spaces)* (figure 1.18). Nauman himself is playing off Johns and Johns off Duchamp. But clearly *One Hundred Spaces* is an homage to Nauman and a wry allusion to the critical literature and its search for origins. It's almost a par-

1.18 Rachel Whiteread, *Untitled (One Hundred Spaces),* 1995. Resin, 100 units, size according to installation. Installation view, Carnegie Museum of Art, Pittsburgh. Photograph by Richard Stoner, courtesy of Anthony d'Offay Gallery, London.

ody of the assumption that women elaborate, color, and interpret, rather than originate structure and form. Briony Fer's description would take some bettering:

> The neutral inert surfaces have been rendered invisible and visible instead is a scintillating surface against the light. It is decrepit but dazzling, worm-eaten but ravishing. . . . Color . . . seems to flaunt itself as such, and so overcomes the grid, overcomes even the effect of the cast. . . . The laborious process has its own patina—more like a half-sucked sweet, glistening here, matt there. Some of the semi-transparent blocks are milky blue-white, others are iridescent like shot silk or two-tone, almost fluorescent as a pungent, intense pink appears at the edge of a transparent orange block. . . . Light is trapped inside and the illusion is that the object emanates light.[35]

What has been won here is not a place in a separate, parallel, maternal line so much as the right to inhabit, appropriate, or "swerve" from the example of fathers and brothers as well as mothers and aunts. The swerve is the first of Bloom's six categories of response to the "strong precursor," in which the artist acknowledges but adjusts the trajectory of the earlier work in "a corrective movement"; the second is the fragment, the token of recognition that invokes the terms of the parent work before completing it "in another sense, as though the precursor had failed to go far enough."[36] Both of which *One Hundred Spaces* does, of course. This is how generation is mediated here, not through a line of unbroken maternal production, but not through murderous rivalry either. Hélène Cixous claims that we *become* womanly through writing womanly texts.[37] If gender is at issue here, it's not as a given but as a discovery in the interplay, the forward-and-back, of "thinking through our mothers" and projecting what we can be: "proceeding from the middle, through the middle, coming and going rather than starting and finishing" (Deleuze and Guattari again).[38]

RACHEL WHITEREAD: WITNESS AND LOSS

Rosalind Krauss remarks that Whiteread's work "is continually moving through a funerary terrain, a necropolis of abandoned mattresses, mortuary slabs, hospital accoutrements (basins, hot-water bottles), condemned houses."[39] The critical responses to her work converge on the themes of witness and loss. Reference to death masks, to the archaeological casts of Pompeian bodies dissolved from the volcanic ash that "molded" them, to photography as a comparably indexical, negative-to-positive commemorative process: these are standard tropes in the Whiteread literature.[40] This gravitational pull back to "witness and loss" is not so much wrong as limiting and exhausted. It masks Whiteread's formal and technical inventiveness and what David Batchelor rightly calls the "ecstatic" as well as "melancholy" qualities of more recent works.[41] I'm going to look finally at casting,[42] parentage, and "monuments" in the context of "mediating generation."

Casting

In *The Poetics of Space* (a book Whiteread admires), Gaston Bachelard writes that when a poet polishes his table "with the woolen cloth that lends warmth to everything it touches, he creates a new object; he increases the object's human dignity; he registers this object officially as a member of the human household."[43] Whiteread's process does the reverse. The object, recast, or defined in negative by the solidifying of matter around and under it, is "made strange"—uncanny— unhomely in the Freudian sense.[44] No longer a function or extension of the body, it's expelled from the human household into the world of "Please do not touch." This is because the "inside-outness" of casting has psychic as well as phenomenological effects. Physical and psychic processes of ingestion and expulsion, introjection and projection, first sketch the boundaries of a bodily "I." (As Bachelard puts it, "Being is alternately condensation that disperses with a burst, and dispersion that flows back to a center.")[45] Casting as a kind of anatomy lesson produces uncanny sensations in a viewer positioned in the impossible space *between* inside and outside, or facing a work that anthropomorphizes the spaces of occupation. Making *House* (figure 1.19), Whiteread says, "was like exploring the inside of a body, removing its vital organs."[46]

Whiteread discovered her project through discovering its means.[47] It begins with *Closet* (figure 1.20), the plaster cast of a wardrobe interior, covered in black felt. And it begins with regression: "I have a very clear image of, as a child, sitting at the bottom of my parents' wardrobe, hiding among the shoes and clothes, and the smell and the blackness and the little chinks of light. . . . [These were] happy places, I suppose, where you went and dreamt. Places of reverie. And where you'd mutilate your dolls, cut their hair and everything."[48]

This is a recognizably Kleinian scenario of aggression and reparation. The aggression projected in mutilating the dolls is present, residually, in the essentially reparative acts of preserving, casting, binding, and re-membering in Whiteread's oeuvre. (She's said of *Ghost* [figure 1.21] that it was a "plaster cast for a room, built up inch by inch . . . like covering a broken limb.")[49] These are strategies that Mignon Nixon identifies in a Kleinian reading of feminist work which focuses

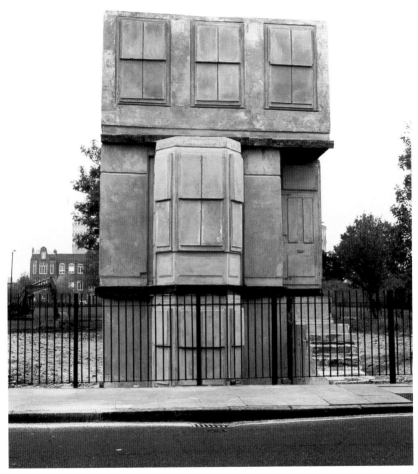

1.19 Rachel Whiteread, *Untitled (House),* 1993. Commissioned by Artangel. Sponsored by Becks. Photograph by John Davies, courtesy of Anthony d'Offay Gallery, London.

1.20 Rachel Whiteread, *Closet,* 1988. Wood, felt, and plaster, 151.2 × 113.4 × 50.4 cm. Photograph courtesy of Anthony d'Offay Gallery, London.

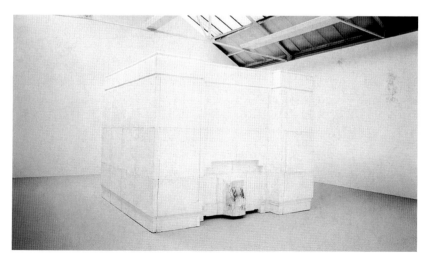

1.21 Rachel Whiteread, *Ghost,* 1990. Plaster on steel frame, 270 × 318 × 356 cm. Saatchi Collection, London. Photograph courtesy of Anthony d'Offay Gallery, London.

not on a Freudian or Lacanian understanding of Oedipal gendering, but on pre-Oedipal (and hence ungendered) aggression in the field of infantile fantasy. The foremother here is Louise Bourgeois, whose delayed reception Nixon credits to "the current generation of feminist artists," which has "received and re-examined the investigation of the drives as a project of feminist art."[50] She's a Judith Shakespeare, in other words, brought to publicly recognized creative life through the work of the daughters she has also inspired.

GENERATION

Whiteread says that recent works "don't have that residue of everyday life on them so much": "They have a sense of shape, form and color, they don't have a sense of shape, form, color, and oh-is-that-granny's-fingerprint-underneath-that-table."[51] More icon, less index. More absorption, less theatricality.[52] In interviews, she has mentioned the influence of Carl Andre and Vito Acconci, but two different parents come to mind.[53] Isn't *Untitled: One Hundred Spaces* by Nauman out of Eva Hesse (by *Space under My Chair* out of *Repetition Nineteen III* [figure 1.22])?

Krauss describes *Space under My Chair* as "taking the by then recognizable shape of a Minimalist sculpture" while being nonetheless "the complete anti-minimalist object."[54] Eva Hesse's antiminimalism, while retaining an investment in repetition and modularity, stressed process, crafted surfaces, elements of figuration, and springy or translucent materials like rubber and resin—all of which undermined the rational and industrial attributes of Morris or Judd and led to an anxiety about the "feminine" gendering of "eccentric abstraction." (Hesse wrote in her journal in 1965: "Do I have a right to womanliness? Can I achieve an artistic endeavor and can they coincide?")[55] Nauman's cast, according to Krauss, doesn't take the "anti-form" route out of minimalism, shattering and disbursing matter but, more deadly, "the path of implosion or congealing," not of matter, but of space.[56] All that is air turns solid. Hesse opts for translucency. Lippard speaks of an "inner glow" and Fer of "buckets of light."[57] *One Hundred Spaces,* cued by Hesse, takes Nauman's *Space under My Chair* and (literally) re-casts it:

1.22 Eva Hesse, *Repetition Nineteen III,* 1968. Nineteen tubular fiberglass units, 48 to 51 cm high × 27.8 to 32.3 cm diameter. The Museum of Modern Art, New York. Gift of Charles and Anita Blatt. Photograph © The Museum of Modern Art, New York. Reproduced with the permission of the Estate of Eva Hesse.

multiplies it, jellies it, gives it that iridescent sucked-sweet brightness, renders it simultaneously grave, funny, and sublime.

And yet the patterns of affiliation are more fluid than this. Whiteread's work is calculatedly "and-and" and "neither-nor." Casting is neither carving (virile) nor modeling ("feminine"), neither fully form (sculpture) nor fully surface (painting), not quite abstraction or figuration, reproductive yet inventive, simultaneously iconic and indexical (like the photograph), and this *undecidability*—the collapsing of these oppositions—is, as Fer points out, what Whiteread's work most fully *is*.[58]

MONUMENTS

A monument is "a structure, edifice, or erection intended to commemorate a notable person, action, or event."[59] "Monumental" means massive and permanent, historically prominent, conspicuous, enduring. Monuments are "masculine" (with rare exceptions). First, men make them.[60] Second, the notable persons, actions, and events are chiefly male. Third, they incline to the heroic in theme and tone (even or especially when drawing on allegories of the female form).[61] Fourth, they belong in what Julia Kristeva calls "linear time"—the time of history and narrative—whereas women have been associated with "cyclical time" (the time of repetition) or "monumental time" (the time of eternity).[62]

Virginia Woolf said, "I doubt that a writer can be a hero. I doubt that a hero can be a writer . . . the moment I become heroic, I become shrill and hard and positive."[63] The rhetoric of heroism has proved inadequate to the traumas of the twentieth century, in which men, women, and children were indiscriminately slaughtered. No lyric poetry after Auschwitz. The proposal for what was commissioned as Whiteread's Judenplatz memorial (figure 1.23) to the Jews of Vienna grew out of local distaste for Alfred Hrdlicka's "grandiose scheme of writhing marble nudes."[64] The difficulties of adequately registering the Holocaust have created a genre of antimemorials at the same time as Whiteread's generation has grown up in a landscape of artist-mothers informed by feminism.[65] One way of marking the difference between the Statue of Liberty, say, and *House,* is to see *House* as a shift from the "masculine" iconography of the phallic mother to a more "feminine" or

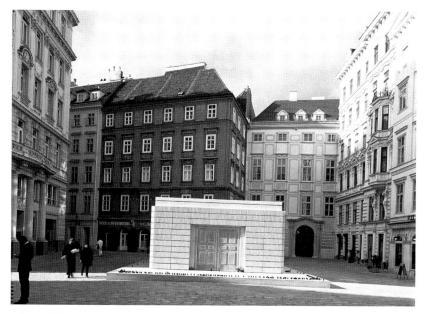

1.23 Rachel Whiteread, *Holocaust Memorial,* unveiled 2000, Judenplatz, Vienna. Concrete. Photograph courtesy of Anthony d'Offay Gallery, London.

feminist memorializing of domestic space. Another is to see it as signaling a breakdown in the cultural association of women with "cyclical" and "monumental" time, and their symbolic reinsertion into the space of "linear" time that all humans occupy and in which monuments are actually commissioned and produced.[66]

The trajectory from *Ghost* to *House* to Judenplatz now seems inevitable, but on the rebound from difficulties in Vienna, Whiteread made *Water Tower* for a public art project in New York (figure 1.24). This time she "wanted to make something that was more like an intake of breath."[67] *Water Tower* is quite unforthcoming, sometimes scarcely visible. It doesn't heckle. It summons the idea of a monument without marking a site of any obvious significance. It sits comfortably, if a little exotically, among its siblings, implying—as in the writing of Studs Terkel—that what's worth remembering is under our noses and over our heads: the labor and ingenuity of ordinary people and the unpredictable beauty of functional things.[68]

1.24 Rachel Whiteread, *Water Tower,* 1998, West Broadway and Grand Street, New York. Resin cast of the interior of a wooden water tank, 340.4 × 243.8 cm diameter. A Public Art Fund project, June 1998–June 1999. Photograph by Marian Harders, courtesy of Anthony d'Offay Gallery, London.

Postscript

In 1975 Carolee Schneemann published an essay called "Woman in the Year 2000." How can I resist it quoting it?

> By the year 2000 . . . our future student will be in touch with a continuous feminine creative history—often produced against impossible odds—from her present, to the Renaissance and beyond. In the year 2000 books and courses will only be called "Man and His Image," "Man and His Symbols," "Art History of Man." . . . By the year 2000 feminist archaeologists, etymologists, Egyptologists, biologists, sociologists will have established beyond question . . . that women determined the forms of the sacred and the functional . . . evolved property, sculpture, fresco, architecture, astronomy and the laws of agriculture—all of which belonged to the female realms of transformation and production.[69]

Well, perhaps not quite. But there's an old saying: "I'm a soldier so that my son can be a politician so that his son can be a poet." Perhaps Pat Whiteread is a feminist artist so that her daughter doesn't have to be. Rachel: "When things change, they become part of the fabric of life rather than something one has to constantly fight against."[70] "And, when people ask if I see myself as a female artist, or whether my work has a part in feminist history, I don't think I'm political in that sense. I see myself as a sculptor and as an artist and I think that my mother, her mother and their grandmothers worked incredibly hard for my generation to be able to do what we do."[71]

"Thinking back through our mothers" acknowledges this, along with the heritage of exceptional women. It may be, finally, a necessary condition for releasing the *use*-value of the paternal tradition—enriched, reworked—in forging the culture that is the daughter's bequest.

NOTES

This is an extended version of my paper for the Gender and Generation session of the Comité International d'Histoire de l'Art conference, London, 2000. I should like to thank the session organizers, Marcia Pointon and Sigrid Schade, for their interest and support; Carol Armstrong for inviting me to give the paper again at Princeton; Adrian Rifkin and Alex Potts for their comments on the original draft; and Jennifer Thatcher at Anthony d'Offay's, Rachel Whiteread, and Briony Fer, among others, for help with the illustrations. Following its presentation at the Princeton conference, the present version was published in *Art History* 25, no. 1 (February 2002). My title is borrowed from Marianne Hirsch, whose book *The Mother-Daughter Plot* is subtitled *Narrative, Psychoanalysis, Feminism* (Bloomington: Indiana University Press, 1989). Hirsch is writing about the novel, "the optimal genre in which to study the interplay between hegemonic and dissenting voices" (p. 9). This won't quite work for the image, of course, which isn't "polyvocal" in quite this way, or for those forms of modernism in which the *son*'s dissent has been institutionalized. I've nevertheless held these terms in mind in exploring the changing relations of gender and generation—in both senses—first in a painting by Vanessa Bell, and then as they are reconfigured and given monumental form in works by Rachel Whiteread.

1. Studio photograph by [Maurice] Beck and [Helen] Macgregor, *Vogue*'s chief photographers in this period. Woolf sat to them in 1924 and 1925. A full-face, three-quarter-length version was taken at the same sitting. See *The Diary of Virginia Woolf*, ed. Anne Olivier Bell assisted by Andrew McNeillie, vol. 3, 1925–1930 (London: Hogarth Press, 1980), p. 12, entry for Monday, 27 April 1925: "I have been sitting to Vogue, the Becks that is, in their mews, which Mr. Woolner built as his studio, & perhaps it was there he thought of my mother, whom he wished to marry, I think." (The studios at 4 Marylebone Mews had been built in 1861 by the pre-Raphaelite sculptor Thomas Woolner, who proposed to Julia Jackson but was refused.) See also Elizabeth P. Richardson, *A Bloomsbury Iconography* (Winchester: St. Paul's Bibliographies, 1989), p. 291 (where the photograph is dated 1924).

2. Woolf's note on her plan of the ten chapters of *To the Lighthouse,* cited in Juliet Dusinberre, *Alice to the Lighthouse: Children's Books and Radical Experiments in Art* (Basingstoke: Macmillan, 1987), p. 146. Woolf wrote in "A Sketch of the Past" that until she wrote *To the Lighthouse,* "the presence of my mother obsessed me. I could hear her voice, see her, imagine what she would do or say as I went about my day's doings . . . when it was written, I ceased to be obsessed by my mother. I no longer hear her voice; I do not see her. . . . I suppose that I did for myself what

psycho-analysts do for their patients" (*Moments of Being,* ed. Jeanne Schulkind [London: Grafton Books, 1989], pp. 89–90).

3. *Victorian Photographs of Famous Men and Fair Women* was published by the Hogarth Press (London, 1926). (Fry discusses this particular photograph on p. 13.) On 2 June 1926, Woolf wrote to her sister about one of her paintings based on "the Aunt Julia photograph" in the opening exhibition of the London Artists' Association (*The Letters of Virginia Woolf,* ed. Nigel Nicholson [London: Hogarth Press, 1977], vol. 3, p. 271). In August 1921 Bell had asked Duncan Grant to "bring Aunt Julia's portrait" to Charleston, where she hoped to paint from it (perhaps this was the same picture); see Bell to Grant, August 3 [1921], in *Selected Letters of Vanessa Bell,* ed. Regina Marler (London: Bloomsbury, 1993), p. 254. In 1929 she referred to copying a Cameron photograph of her mother, probably for this painting of *The Red Dress,* exhibited in 1934 and now in the collection of Brighton Art Gallery. Both Bell and Woolf resembled their mother physically, but if anything Bell has rounded and softened her features in *The Red Dress,* making them closer to her own as a young woman. On the Stephen sisters' maternal heritage, see Elizabeth French Boyd, *Bloomsbury Heritage: Their Mothers and Aunts* (London: 1976); Diane F. Gillespie and Elizabeth Steele, eds., *Julia Duckworth Stephen: Stories for Children, Essays for Adults* (Syracuse, N.Y.: Syracuse University Press, 1987); and Martine Stemerick, "Virginia Woolf and Julia Stephen: The Distaff Side of History," among other essays in Elaine K. Ginsberg and Laura Moss Gottlieb, eds., *Virginia Woolf: Centennial Essays* (Troy, N.Y.: Whitston Publishing, 1983).

4. Sir Leslie Stephen was a prodigious essayist, editor, and biographer, from 1882 the editor of the *Dictionary of National Biography.*

5. Woolf, *A Room of One's Own* (1928; Harmondsworth, Middlesex: Penguin, 1973), pp. 25–26.

6. In her diary, Woolf recalls meeting a friend of her mother's, who described her as "the most beautiful Madonna & at the same time the most complete woman of the world" (*Diary,* 4 May 1928, vol. 3, p. 183). She was venerated by her husband, who considered that man unfortunate "who has not a saint of his own" (Leslie Stephen, "Forgotten Benefactors," 1896, included in *Social Rights and Duties,* 2 vols. [London: S. Sonnenschein, 1896], quotation vol. 2, p. 264). After her early death, Julia was memorialized as the embodiment of an idealized maternity in Leslie Stephen's *The Mausoleum Book,* ed. Alan Bell (Oxford: Clarendon Press, 1977). Paintings, portrait-busts, photographs, and drawings of Julia are listed in Richardson, *A Bloomsbury Iconography.* Appendix A lists twenty-eight photographs of her by Julia Margaret Cameron. One plate

is inscribed "My Favorite Picture of All My Works. My Niece Julia" (April 1867); another, of Julia in mourning after the death of her first husband, Herbert Duckworth, "She Walks in Beauty" (September 1874). Julia Stephen had been the model for the Virgin in Burne-Jones's *Annunciation*, completed in 1879 when she was pregnant with Vanessa. William Rothenstein remembered Vanessa and Virginia "in plain black dresses with white lace collars and wrist bands, looking as though they had walked straight out of a canvas by Watts or Burne-Jones" (quoted in Boyd, *Bloomsbury Heritage*, p. 36).

7. Annie Thackeray's essay on "Alfred, Lord Tennyson and His Friends" is quoted by Boyd, *Bloomsbury Heritage*, p. 87: "our philistine domestic rule, by which, from earliest hour in the morning, the women of the house are expected to be at the receipt of custom, to live in public, to receive any casual stranger, any passing visitor, was utterly ignored by [the Pattle sisters]." Cameron was recalled by others as alarmingly energetic, imperious but sociable, dressed in dark clothes stained with chemicals (Tennyson is quoted on p. 21).

8. Carol Armstrong, "Cupid's Pencil of Light: Julia Margaret Cameron and the Maternalization of Photography," *October*, no. 76 (Spring 1996), pp. 115–141 (quotation p. 119). See also p. 138: as for Roland Barthes, in *Camera Lucida*, "Cameron's conception of photography fell under the sign of the Mother": "But the other side of these photographs' story of sexuality is . . . [that they lean] so heavily on the female side of the family as to exclude memory of its masculine aspect and its heterosexual foundations."

9. Vanessa Bell to Virginia Woolf, 1 November 1904, Berg Collection, New York Public Library, quoted in Christopher Reed, "A Room of One's Own," in Christopher Reed, ed., *Not at Home: The Suppression of Domesticity in Modern Art and Architecture* (London: Thames and Hudson, 1996), pp. 147–160 (quotation p. 148). Reed discusses the sisters' "liminal position between [patriarchal and matriarchal] traditions" visualized here.

10. Woolf, *A Room of One's Own*, p. 76.

11. It was I think Alan Bennett who added a gloss to Philip Larkin's famous line, "They fuck you up, your Mum and Dad," to the effect that "unless of course they *don't* fuck you up and you want to be a writer, in which case you're *really* fucked." Artists are on the whole not nurtured by Angels.

12. Or so it seemed to Woolf, and seems to me. See the chapter on "Vanessa Bell: *Studland Beach*, Domesticity and 'Significant Form'" in my *Modern Life and Modern Subjects: British Art*

in the Early Twentieth Century (New Haven: Yale University Press, 2000). A rather different argument is advanced by the art historian and analyst Rozsika Parker in "'Killing the Angel in the House': Creativity, Femininity and Aggression," *International Journal of Psycho-Analysis* 79 (1998), pp. 757–774. She points out that the "angel" is made to represent "creative inhibition, functioning both intrapsychically and interpersonally," forbidding "spontaneity, independence, aggression and desire"; but that Woolf overlooks the angel's potentially positive role in representing a concern with the work's impact on the reader or viewer: "Rather than annihilating the angel, the task of those engaged in creative endeavor is to . . . allow an element of aggression, assertion and ruthlessness into the relationships that determine creativity without losing the critical awareness of the conditions of reception that is the positive attribute of the angel" (pp. 757, 758).

I'm very grateful to Rozsika Parker for sending me a copy of her paper after my book was in press. It sent me back to two earlier texts, D. W. Winnicott's *Playing and Reality* (London: Tavistock, 1971) and Rozsika Parker's own *Torn in Two: The Experience of Maternal Ambivalence* (London: Virago Press, 1995). From the perspective of (the adult's past as) the child, Winnicott locates the origins of creativity in play and the emergence of play in the "potential space" between mother and baby. (This is the precursor of the potential space between adult and environment in which cultural activity takes place.) From the perspective of the mother, Parker claims "a specifically creative role for manageable maternal ambivalence": that is, she argues that the successful management of the guilt and anxiety provoked by conflicting emotions of love and hate provides creative release (pp. 6–7).

13. Virginia Woolf, "The Leaning Tower," *Collected Essays II,* p. 163, quoted in Ellen Bayuk Rosenman, *The Invisible Presence: Virginia Woolf and the Mother-Daughter Relationship* (Baton Rouge: Louisiana State University Press, 1986), p. 134.

14. Harold Bloom, *The Anxiety of Influence: A Theory of Poetry* (New York: Oxford University Press, 1973), pp. 11, 5. Bloom means "anxiety" in the strong, Freudian sense: "When a poet experiences incarnation *qua* poet, he experiences anxiety necessarily towards any danger that might *end* him as a poet. The anxiety of influence is so terrible because it is both a kind of separation anxiety and the beginning of a compulsion neurosis, or fear of a death that is a personified superego" (p. 58). On Bloom, see Louis A. Renza, "Influence," in Frank Lentricchia and Thomas McLaughlin, eds., *Critical Terms for Literary Study* (Chicago: University of Chicago Press, 1990), pp. 186–202. Renza acknowledges that "the flight patterns of all texts are determined by the psychic crosswinds deriving from other texts" (p. 196), but suggests that Bloom's

theory "seems to displace the source of anxious literary production and reception from culture-specific ideological circumstances to the theatre of timeless psychic forces" (p. 197).

15. On feminist uses of the Demeter-Kore or Demeter-Persephone myth in literary studies, see Annette Kolodny, "A Map for Rereading: Or, Gender and the Interpretation of Literary Texts," *New Literary History* 11 (1980), pp. 451–467; Ellen Bayuk Rosenman, *The Invisible Presence,* pp. 138–139; Mary Jacobus, *First Things: The Maternal Imaginary in Literature, Art, and Psycho-analysis* (New York: Routledge, 1995), pp. 16–18.

16. Woolf, *A Room of One's Own,* pp. 48–50; pp. 111–112.

17. Rosenman, *The Invisible Presence,* p. 139.

18. Harold Bloom, *The Western Canon: The Books and School of the Ages* (London: Macmillan, 1995), p. 34. In Bloom's view it will take more than a feminist idealization of femininity to "change the entire basis of the Western psychology of creativity, male and female, from Hesiod's contest with Homer down to the agony between Dickinson and Elizabeth Bishop." There are strong women poets—Sappho, Emily Dickinson, Bloom's biblical "J" (perhaps Bathsheba, "fully the rival of Homer and Dante, of Shakespeare and Milton")—but the masculine Oedipal trajectory seems to hold for them too. Bloom claims to have been travestied by the "six branches of the School of Resentment: Feminists, Marxists, Lacanians, New Historicists, Deconstructionists, Semioticians," but in truth he veers between seeing the anxiety of influence as a relation between writers and a relation between texts.

19. Gabriel Josipovici, *On Trust: Art and the Temptations of Suspicion* (New Haven: Yale University Press, 1999), p. 80. Nicholas Penny also seems to doubt the murderous nature of family rivalries in the craft tradition. Reviewing titles on the High Renaissance in the *London Review of Books* ("Nymph of the Grot," 13 April 2000, p. 19), he writes:

> When we read of a painter "embracing the counter-maniera" we are bound to think of an act akin to taking Holy Orders or reversing a political allegiance, but surely it wasn't like that. In as much as artists were aware of adopting or rejecting a style, they saw themselves more like members of a family, dissociating themselves from a foreign branch, revering and reviving a grandfather's achievements, rejecting a father but working alongside an uncle. Models taken from religious or political practice, or from the "movements" to which artists . . . have

belonged during the last century, do not help us to assess the ideological implications of stylistic change.

20. Josipovici, *On Trust,* pp. 102, 103.

21. Ibid., pp. 1–2. This broad-brushed distinction between modes of production carries overlapping historical, geographic, sociological, material, and gendered connotations: romantic and modern versus premodern; Western versus non-Western; high versus popular; art versus craft; "masculine" (Oedipal, competitive, innovative) versus "feminine" (pre-Oedipal, cooperative, interpretative). Most of these are gathered together in his opening example. It chimes with Woolf's assertion that "Anon . . . was often a woman" (*A Room of One's Own,* pp. 50–51) and her interest in an unegotistical and communal culture.

22. One example of such a father-daughter dynamic is that of Artemisia Gentileschi; see Mary Garrard, *Artemisia Gentileschi: The Image of the Female Hero in Italian Baroque Art* (Princeton, N.J.: Princeton University Press, 1989). See also the discussion in chapter 5 of Griselda Pollock's *Differencing the Canon: Feminist Desire and the Writing of Art's Histories* (London: Routledge, 1999). Recent work on the psychology of creativity, influenced by object relations theory, suggests that the "internal father" is essential to female creativity, and that fathers nurture it by stimulating and welcoming their daughters' often physical excitement and by sharing in their endeavors. While the woman artist was, for social and ideological reasons, exceptional, the craft tradition could nevertheless foster such relations, particularly where sons were lacking, untalented, or indifferent. On the psychology of creativity in women writers, see Susan Kavaler-Adler, *The Compulsion to Create: A Psychoanalytic Study of Women Artists* (New York: Routledge, 1993).

23. See, for example, Thomas Crow, *Emulation: Making Artists for Revolutionary France* (New Haven: Yale University Press, 1995). Crow calls his study of David and his followers "a history of missing fathers, of sons left fatherless, and of the substitutes they sought"; a history of painter-sons whose "passionate imagination of antiquity brought them, over and over again, to the troubled territory of filiation and inheritance"; a history of studio brothers concerned to "seize their artistic patrimony" and make their mark on the turbulent years in which "a king who embodied all patriarchal authority was put to death, and a republic of equal male brotherhood proclaimed." Crow suggests that David's own needs meshed with those of his (fatherless) pupils to suffuse the studio with a more than conventionally familial charge, but that most studios in this period were spaces of an almost exclusively masculine sociability, which "only confirmed an in-

creasing masculinization of advanced art" in which artists were asked "not only to envisage military and civic virtue in traditionally masculine terms, but were compelled to imagine the entire spectrum of desirable human qualities, from battlefield heroics to eroticized corporeal beauty, as male" (pp. 1, 2).

24. Nochlin's much-cited essay, "Why Have There Been No Great Women Artists?" (1971), is quoted here from Linda Nochlin, *Women, Art and Power and Other Essays* (New York: Harper & Row, 1988), p. 150.

25. In the "craft" tradition—we should probably include the Academies here with the artisans and journeymen—few women trained as artists; but where they did, its certainties of meaning, value, patronage, and purpose embraced them too. (Exclusion was more emphatically social and institutional than it was discursive and psychological.) As so often, women were let in at the point that men were getting out: Woolf wrote to their brother Thoby in 1901, as Vanessa took the entrance examination for the Royal Academy Schools: "Privately I dont [sic] think anyhow there can be much doubt. The Schools are very empty, so they will let in bad people." Virginia to Thoby Stephen, Wednesday [July 1901], *The Letters of Virginia Woolf,* ed. Nigel Nicolson, vol. 1 (London: Hogarth Press, 1975), p. 43.

26. Germaine Greer, *The Obstacle Race: The Fortunes of Women Painters and Their Work* (London: Secker and Warburg, 1979), p. 327. These lines from her concluding paragraph are given special prominence on the dust jacket. In the main body of her text, Greer goes on to acknowledge the "neurotic" nature of much Western art, while maintaining that "the neurosis of the artist is of a very different kind from the carefully cultured self-destructiveness of women."

27. Anthony Storr, *The Dynamics of Creation* (London: Secker and Warburg, 1972). Freud himself claimed that psychoanalysis had clarified the "internal kinship" between the artist and the neurotic as well as the distinction between them. See Freud, "A Short Account of Psychoanalysis" [1923], The Pelican Freud Library, vol. 15, *Historical and Expository Works on Psychoanalysis* (Harmondsworth, Middlesex: Penguin, 1986), p. 180. Storr attempts to analyze the relations between different kinds of neuroses and particular forms of creative activity or creative expression. At the same time he acknowledges that psychoanalysis rarely distinguishes between good and bad art or between a work of art and a neurotic symptom. See also Susan Kavaler-Adler, *The Compulsion to Create,* in which Emily Dickinson—one of a handful of great women poets in Bloom's canon—is discussed as one of the most "arrested" and unwell artists. Some analysts discriminate between "authentic" creation, which facilitates psychic development, and

"factitious" creation, which helps maintain the ego's defense against reality: Janine Chasseguet-Smirgel sees "factitious" creativity as one means by which "those who have not been able to project their Ego Ideal onto their father" grant themselves their missing identity, and yet, because paternal capacities and attributes have not been introjected, "find it difficult to be the father of a genuine work" (*Creativity and Perversion* [London: Free Association Books, 1985], pp. 69–70).

28. See in particular Pierre Bourdieu, *The Rules of Art: Genesis and Structure of the Literary Field,* trans. Susan Emanuel (1992; Cambridge: Polity Press, 1996); and *The Field of Cultural Production,* a collection of translated essays by Bourdieu edited by Randal Johnson (Cambridge: Polity Press, 1993). On the social economy of modernism, see Robert Jensen, *Marketing Modernism in Fin-de-Siècle Europe* (Princeton: Princeton University Press, 1994). The emerging institutions of Bourdieu's "autonomous aesthetic field"—from the Salon des Refusés of 1863 to the various secessions and avant-gardes before 1914—while trumpeting schism and change, were ambiguous in their gendered effects. The educational and exhibition opportunities opening up to women were those of a crumbling craft tradition in the process of being replaced by a new emphasis on expressive intensity and "significant form." In the galleries of promotional dealers, among the vociferous avant-gardes, in high-profile monographs and retrospective exhibitions, women were largely absent or marginal, and in critical discourse "feminine" and its cognates were terms of abuse.

29. The circumstances under which Bell and Whiteread came to a practical sense of their artistic identity were necessarily different. After the Second World War, modernism was increasingly institutionalized. In the last twenty years, new corporate, charitable, and private sources of funding have emerged and specialist magazines have proliferated. Women have filled the art schools on more equal terms. Unlike Bell, who found Professor Tonks at the Slade a most depressing tutor, Whiteread was taught by women as well as men, and worked as an assistant to a talented woman sculptor, Alison Wilding. The role models were there. And now computer indexing (there are entries for Bell and Whiteread on *The Art Index* and in *Art Bibliographies Moderne*), has itself become a powerful new tool for "thinking back through our mothers" and keeping their work from historical amnesia. The art market was always commercial, by definition, but it's a big leap in real terms from Bell's prices to the $167,500 that Whiteread's dealer, Anthony d'Offay, paid at Sotheby's in 1997 for *Untitled (Double Amber Bed)* (1991)—four times its estimate. (See *Artnews* 96 [December 1997], p. 46.)

30. Griselda Pollock (drawing on Sarah Kofman), *Differencing the Canon,* pp. 13, 16: "The canon is fundamentally a mode for the worship of the artist, which is in turn a form of masculine narcissism" (p. 13). "The question then is: could we invert it, and insert a feminine version? Mothers, heroines, female Oedipal rivalry, female narcissism and so forth? Would we want to? Or would we try to side with Freud in the move into an adult rather than an infantile relation to art by wanting to disinvest from even a revised, feminist myth of the artist, and address ourselves to the analysis of the riddle of the texts unencumbered by such narcissistic idealization?" The chance of *social* access to a craft tradition that might have nurtured women was compromised with the *ideological* rise of the Artist-Hero, the heightening of Oedipal tensions and the conflation of creativity with procreativity. As Sarah Kofman puts it: "Society takes the artist to be the father of his creation, and the artist, wishing to believe himself the father of his works, wants to be his own father. Society therefore grants full license to the artist to show that he is subject to no external constraints, that he is free and fully his own master, that like God, he is self-sufficient" (Sarah Kofman, *The Childhood of Art: An Interpretation of Freud's Aesthetics,* trans. Winifred Woodhull [New York: Columbia University Press, 1988], p. 95). There is not much chance of a foothold for a woman artist in this quasi-theological patrilineage, ideologically speaking, though the vexed question of how "femininity" might figure in the chance play of "biological forces, psychical forces, and external forces" (Kofman, p. 169), which in their interaction produce life and art, remains an open one.

31. See, for example, Phyllis Greenacre, "Woman as Artist" (1960), in *Emotional Growth: Psychoanalytic Studies of the Gifted and a Great Variety of Other Individuals,* vol. 2 (New York: International Universities Press, 1971), pp. 575–591. She is inclined to take Nochlin's question as a fact requiring psychological rather than social explanation, concluding that girls are "more readily blocked in materializing artistic creativity . . . both through the nature of the castration complex and the special exigencies of the oedipal conflict" (p. 591).

32. Gilles Deleuze and Félix Guattari, *A Thousand Plateaus: Capitalism and Schizophrenia,* trans. Brian Massumi (1980; London: Athlone Press, 1988), pp. 10, 11. Deleuze had already described his early work on Western philosophers in terms that read like a homosexual (but fecund) parody of Bloom's Oedipal rivalries, displacing the "anxiety of influence" onto the "strong precursor": "What got me by during that period was conceiving of the history of philosophy as a kind of ass-fuck, or, what amounts to the same thing, an immaculate conception. I imagined myself approaching an author from behind and giving him a child that would indeed be his but

would nonetheless be monstrous"("I Have Nothing to Admit" [1977], quoted by Brian Massumi in his foreword to *A Thousand Plateaus,* p. x).

33. Deleuze and Guattari, *A Thousand Plateaus,* p. 25. The "Tree or Root as an image, endlessly develops the Law of the One that becomes two, then the two that become four. . . . Binary logic is the spiritual reality of the root-tree" (p. 5), whereas the rhizome is "an anti-genealogy" assuming "very diverse forms, from ramified surface extension in all directions to concretion into bulbs and tubers" (p. 7). Its desirable characteristics include its heterogeneity and mode of connection (any point of a rhizome can be connected to anything other, and must be); its multiplicity and diversity; its self-generative capacities; its ability to comprehend different—viral or technological—evolutionary schemas; its resistance to structural or hierarchical models (command trees or centered systems); and its productive channeling of desire.

34. Francis Haskell, *Rediscoveries in Art: Some Aspects of Taste, Fashion and Collecting in England and France* (London: Phaidon Press, 1976), pp. 9–16.

35. Briony Fer, "Treading Blindly, or the Excessive Presence of the Object," *Art History* 20 (June 1997), pp. 268–288, quotation pp. 285–286. This essay extends a brief account of Whiteread's work at the end of Fer's book *On Abstract Art* (New Haven: Yale University Press, 1997). I have not done justice to the richness of Fer's discussion of Hesse and Whiteread in my brief quotations. Whiteread has worked hard to exploit the poetic potential of a range of demotic materials unusual in fine art: plaster, resins, different colors and consistencies of rubber—*Untitled (Black Bath)* as though hewn from a lump of coal, *Untitled (Orange Bath)* marbled like warm flesh or onyx.

36. Bloom, "Synopsis: Six Revisionary Ratios," in *The Anxiety of Influence,* pp. 14–16. Each "ratio" is assigned a name from esoteric classical sources. *Clinamen*—a swerve: the poet acknowledges but adjusts the trajectory of an earlier poem in "a corrective movement" to that which it should have taken. *Tessera:* a fragment or token of recognition enables the poet to retain the terms of the parent poem while meaning them "in another sense, as though the precursor had failed to go far enough." *Kenosis:* a break from the precursor, "a revisionary movement of emptying," which seems a kind of humbling but which in fact deflates or empties out the precursor-poem. *Daemonization:* the later poet opens himself to a power in the parent poem in fact deriving from sources beyond it, so as "to generalize away the uniqueness of the earlier work." *Askesis:* a "movement of self-purgation," of curtailing, in which the later poet "yields up part of his own human and imaginative endowment," separating himself from others including the

———

precursor, so that "the precursor's endowment is also truncated." *Apophrades:* "the return of the dead"; the later poet holds his work open to the precursor in such a way as to produce the uncanny effect of reversing the heritage, "as though the later poet himself had written the precursor's characteristic work."

37. Cixous is cited in Pollock, *Differencing the Canon,* p. 123.

38. Deleuze and Guattari, *A Thousand Plateaus,* p. 25.

39. Rosalind Krauss, "X Marks the Spot," in *Rachel Whiteread: Shedding Life,* exh. cat., Tate Gallery Liverpool (London: Thames and Hudson, 1997), pp. 74–81 (quotation p. 76). Whiteread admits to having been preoccupied with death. Interviewed by Lynne Barber, she said that she didn't really want to talk about it, but acknowledged that "there was a period when I made a lot of work that was obviously very connected with it" ("In a Private World of Interiors," *Observer,* 1 September 1996, pp. 7–8). Her father died of a heart condition in 1989, soon after she left the Slade, and a couple of months before she made the first "bed piece" called *Shallow Breath.* By this point she had experienced an unusual number of deaths in her circle (about ten). "I try not to think about it too much." Like most artists, and understandably, she doesn't want the value and meaning of her work to be constrained by a biographical reading.

40. Krauss (ibid., p. 76) suggests that "Barthes has already written the outlines of a critical text on Whiteread's art, in his own consideration of photography as a kind of traumatic death mask." And in conversation with Fiona Bradley, Whiteread spoke "about casting in terms of removing a surface from one thing and putting it on to another, of 'taking an image'" (invoking death masks, and photography). See *Rachel Whiteread: Shedding Life,* p. 14.

41. David Batchelor in the *Burlington Magazine,* December 1996, pp. 837–838.

42. Casting has a lowly place in the repertoire of sculptural techniques. Carving, modeling, and even construction are seen to require the active and inventive deployment of resistant materials. Casting was traditionally a technical process of duplication, of transcribing surfaces or producing multiple copies for clients or the studio. Cast courts, as Rosalind Krauss points out ("X Marks the Spot," p. 80), "do not pretend to have the repleteness of a work of art" but "are signposts pointing elsewhere" (usually to ancient Rome or Renaissance Italy). Whiteread's casts also "point elsewhere," to the ordinary objects from which they're made and the human processes that use and mark them. Whiteread is extraordinarily attentive to surface—she retains the marks of the pathologist's knife on the mortuary slabs and encourages rust to bleed through

the plaster of *Ether* like scum in the bath. But the imprint of daily activity, morbid or mundane, is subservient to the overall impact of forms claiming "the repleteness of a work of art."

Some women artists have, perhaps subliminally, found in the use of unpretentious materials or techniques a disguise or disclaimer for aesthetic "presumption." Casting might then appeal precisely *because* it's a way of generating something with (apparently) minimal intervention. Casting—an ear, a chair, a room, a house—suggests a nonstyle style, a transaction between surfaces rather than the expression of a personality. It has nevertheless become Whiteread's signature (and scanning the plaster surfaces, I wonder if the combination of White + Read is mere coincidence).

43. Gaston Bachelard, *The Poetics of Space,* trans. Maria Jolas (1958; Boston: Beacon Press, 1994), p. 67. In the course of this passage, the subject shifts gender: "The housewife awakens furniture that was asleep. . . . A house that shines from the care it receives appears to have been rebuilt from the inside. . . . In the intimate harmony of walls and furniture, it may be said that we become conscious of a house that is built by women, since men only know how to build a house from the outside, and they know little or nothing of the 'wax' civilization."

44. This is often referred to in shorthand as "negative space." It isn't, of course; space isn't "negative." It's the positive materialization of space enclosed by or surrounding an object by making a mold of it. The mold itself becomes the artwork. There's always an interplay of positive and negative. Mostly the stress is on the strangeness of the negative. Sometimes, as with the baths (such as *Ether,* 1990), the negative underside of the bath echoes the original surface so that it reads like a larger and more sepulchral positive. In either case, space flows on and around the initiating object. Limiting the shape of the mold—shaping the new work—is an aesthetic decision, sometimes a controversial one. See, for example, Tom Lubbock's attentive but reductive critique, "The Shape of Things Gone," *Modern Painters* 10 (Autumn 1997), pp. 34–37: "The good works of Rachel Whiteread are few and these: *Ghost* (the room), *House* (the house), *Torso* (the hot-water-bottle)" (p. 34). He excludes the other works as exploiting redundant, arbitrary, or "under-motivated" spaces.

Various writers discuss Whiteread and the "unheimlich." Anthony Vidler, contributing to *Rachel Whiteread: House,* ed. James Lingwood (London: Phaidon Press, 1995), p. 71, notes: "the causes of uncanny feelings included, for Freud, the nostalgia that was tied to the impossible desire to return to the womb, the fear of dead things coming alive, the fragmentation of things that seemed all too like bodies for comfort." All of these themes arise in responses to *House,* partly because of the way in which it seemed to incite but also to cancel the memory of

lived social relations (in glaring contrast, as Doreen Massey points out, with the efforts of heritage sites to "animate" the past [ibid., p. 43]). Margaret Iversen lists further components of the uncanny in art (and refers to *Ghost*) in "In the Blind Field: Hopper and the Uncanny," *Art History* 21 (September 1998), pp. 409–429.

45. Bachelard, *The Poetics of Space,* "the dialectics of outside and inside," pp. 217–218.

Neville Wakefield, "Rachel Whiteread: Separation Anxiety and the Art of Release," *Parkett,* no. 42 (December 1994), pp. 76–82, points out that *Valley* and the bath pieces posit "the absented body as extending into a domestic arterial and venous system similar to, and indeed connected to, its own" (p. 79): the corporeal flows of the body, with their psychic analogues, mesh with the mechanics of household plumbing and environmental water and sewage systems, electricity and gas supplies, information highways.

46. Whiteread began by making casts of parts of her body as a student, before deciding that "Everything we use has been designed by us and for us, and for me that is much more interesting than replicating our physical tangibilities" (Christoph Grunenberg, "Mute Tumults of Memory," in *Rachel Whiteread,* exh. cat. [Basel: Kunsthalle Basel, 1994], p. 15). On "the space of release," see Wakefield, "Rachel Whiteread: Separation Anxiety," in which he notes that Whiteread uses sophisticated silicon releases, microns thin, and that the space we're presented with as viewers is "an impossible space, viewed from a position we could never assume, the space between object and cast, the space of release" (pp. 76, 78). Mark Cousins points out that it's very difficult to "read" the inverted detailing of cast constructions: "It is as if perception wants to travel in the opposite direction from the intellectual knowledge of what is being represented, of what has been cast. Perceptually it is as if we demand to read the object as the exterior of a solid construction." (Cousins, "Inside Outcast," *Tate,* no. 10 [Winter 1996], pp. 36–41, quotation p. 37.)

Whiteread compared the process of casting *House* to "exploring the inside of a body" in a very interesting interview with Andrea Rose: "We spent about six weeks working on the interior of the house, filling cracks and getting it ready for casting. It was as if we were embalming a body" ("Rachel Whiteread Interviewed by Andrea Rose, March 1997," in *Rachel Whiteread: British Pavilion, XLVII Venice Biennale, 1997* [London: British Council, 1997], pp. 29–35, quotation p. 33).

47. Whiteread has in different contexts credited Edward Allington and Richard Wilson with showing her how to cast. See the Lynn Barber interview, "In a Private World of Interiors," pp. 7–8: "It was just incredibly liberating that you could make an impression in sand and pour

molten metal into it and then you had an object. I liked the simplicity and the directness of it . . . you're also changing something that exists. . . . That's what I like, that you can subtly change people's perception of the everyday."

48. Quoted in "In a Private World of Interiors," pp. 7–8. See also Bachelard, *The Poetics of Space,* p. 79: "Every poet of furniture . . . knows that the inner space of an old wardrobe is deep. A wardrobe's inner space is also *intimate space,* space that is not open to just anybody. . . . In the wardrobe there exists a centre of order that protects the entire house against uncurbed disorder." (Bachelard seems to be thinking of a linen-closet or *armoire.*) And on the relation of memory to art, see Kofman, *The Childhood of Art,* p. 78: "though it is true that the work of art bears the traces of the past, these traces are not to be found anywhere else . . . the work does not translate memory in distorted form, but rather constitutes it phantasmally."

49. "Rachel Whiteread in Conversation with Iwona Blazwick," in *Rachel Whiteread,* exh. cat., Van Abbemuseum (Eindhoven: Stedelijk Van Abbemuseum, c. 1992), pp. 8–16, quotation p. 14.

50. Mignon Nixon, "Bad Enough Mother," *October,* no. 71 (Winter 1995), pp. 70–92 (quotation p. 91).

51. "In a Private World of Interiors," p. 8.

52. Figurative and metaphorical references, and surfaces marked by human gesture, are a kind of heresy in minimalism, but what Whiteread shares with minimalist sculpture is a concern with the phenomenological encounter between viewer and work.

53. I've focused on "elective" parents here, but it's significant that Whiteread's mother, Pat, is herself an artist. As a child, Whiteread was taken on many trips around England with her parents. Her father, a former geography teacher, would point out glacial formations in the natural landscape. Her mother would stop the car to photograph the industrial desecration of the landscape for her political collages. Her father taught Whiteread "to look up," and her mother set an example of drive and tenacity.

The references to Andre's and Acconci's influence are from Whiteread's interview by Iwona Blazwick, p. 9: Andre ("Mainly through the confidence of placing something, having the confidence to put a white block in the middle of the floor and let it be simply a white block"); Acconci, more surprisingly, as an influence on Whiteread's floor pieces through his masturbatory *Seed Bed* (in *Rachel Whiteread,* exh. cat.). Andre's minimalism is that of a "mascu-

line" rationality adapted to the use of industrial surfaces, geometric form, and standardized units; Acconci's performance art depends on a "feminine" (or effeminate) exploitation of the exhibitionist body. Bringing them into contact produces an interestingly hybrid aesthetic: the gestalt of a quasi-minimalist form that nevertheless registers the contingent traces of human presence; and the suggestion of figurative reference, narrative, even theatricality in objects and surfaces pressed by the casting process into the semblance of modernist form. *House,* as Anthony Vidler points out, is less like its Victorian original than like the modernist prototypes of Loos, Rietveld, Le Corbusier, and Mies; see Anthony Vidler, "A Dark Space" in Lingwood, *Rachel Whiteread: House,* p. 68. (Vidler also points out that architectural schools have, since the 1930s, used solid plaster models of interior spaces to demonstrate the history of spatial types and to demonstrate by implication the "purity" of a history of architecture understood as a history of manipulated space rather than period styles.)

54. Krauss, "X Marks the Spot," p. 74.

55. Hesse is quoted in Lucy Lippard, *Eva Hesse* (New York: New York University Press, 1976), p. 34. *Eccentric Abstraction* was the title of an exhibition organized by Lippard and including Hesse at the Fischbach Gallery, New York, 20 September to 8 October 1966. There is now extensive literature on Hesse, but for an account of the problematic relations between gender and modernism, see in particular Anne Middleton Wagner, *Three Artists (Three Women): Modernism and the Art of Hesse, Krasner and O'Keeffe* (Berkeley: University of California Press, 1996).

56. Krauss, "X Marks the Spot," p. 74.

57. Briony Fer (who also quotes Lippard), "Treading Blindly," pp. 278, 279.

58. Fer, *On Abstract Art,* p. 162. Talking about the floor pieces, Fer suggests that Whiteread's work "falls somewhere between abstraction and figuration," an opposition that collapses as she "stages the abstract in its phantasmatic dimension." Fred Orton borrows from Jacques Derrida in discussing the "undecidability" of Jasper Johns's *Flag* (1954–1955): see chapter 2, "A Different Kind of Beginning," in Fred Orton, *Figuring Jasper Johns* (London: Reaktion Books, 1994).

59. According to the *Shorter Oxford English Dictionary.* The function of monuments is to carry the past into the future, beyond the vagaries of human memory. Or perhaps we make them so that we *can* forget. Robert Musil remarked, "There is nothing in the world as invisible as a monument. . . . Like a drop of water on an oilskin, attention runs down them without stopping for a moment." Quoted in Lingwood, *Rachel Whiteread: House,* p. 11 (in Lingwood's introduction).

60. Rozsika Parker and Griselda Pollock have a telling quotation from "Du rang des femmes dans l'art," *Gazette des Beaux-Arts* (1860), in *Old Mistresses: Women, Art and Ideology* (London: Routledge and K. Paul, 1981), p. 13: "Male genius has nothing to fear from female taste. Let men of genius conceive of great architectural projects, monumental sculpture, and elevated forms of painting. In a word, let men busy themselves with all that has to do with great art. Let women occupy themselves with those types of art they have always preferred, such as pastels, portraits, or miniatures." An admired exception is the monumental work of Maya Lin.

61. See Marina Warner, *Monuments and Maidens: The Allegory of the Female Form* (London: Weidenfeld and Nicolson, 1985), p. xix: "Often the recognition of a difference between the symbolic order, inhabited by ideal, allegorical figures, and the actual order, of judges, statesmen, soldiers, philosophers, inventors, depends on the unlikelihood of women practicing the concepts they represent."

62. Julia Kristeva, "Women's Time," trans. Alice Jardine and Harry Blake, in *The Kristeva Reader,* ed. Toril Moi (Oxford: Basil Blackwell, 1986), pp. 187–213.

63. Virginia Woolf, speech before the London/National Society for Women's Service, 21 January 1931, in Mitchell A. Leaska, ed., *The Pargiters* (London: Hogarth Press, 1978), pp. xxxix, xliv. A shorter version was published as "Professions for Women" in Michèle Barrett ed., *Virginia Woolf: Women and Writing* (London, 1979), pp. 57–63.

64. Robert Storr, "Remains of the Day," *Art in America* 87 (April 1999), pp. 104–109, 154, quotation p. 108. Hrdlicka's five-part *Monument against War and Fascism* in the Albertinaplatz is illustrated and discussed in James Young, *The Texture of Memory: Holocaust Memorials and Meaning* (New Haven: Yale University Press, 1993), pp. 106–112. One of its most controversial components is the street-scrubbing Jew (after the Anschluss, local Jews were made to scrub anti-Nazi graffiti from buildings and cobblestones). Unheeding pedestrians used it as a bench so that it had to be defended against insult with barbed wire. See also Adrian Forty and Susanne Küchler, eds., *The Art of Forgetting* (Oxford: Berg, 1999), which refers to Whiteread's Judenplatz memorial, pp. 12–13.

65. Whiteread considers Maya Ying Lin's Vietnam Veterans Memorial in black granite, inscribed with the names of 58,000 American soldiers, "profoundly moving . . . one of the few great contemporary memorials" (interview with Andrea Rose, p. 31).

———

66. In Kristeva's view, the "corporeal and desiring space" is now available for the "parallel existence or the intermingling of all three approaches to feminism, all three concepts of time" (in *The Kristeva Reader,* p. 188).

67. See *Looking Up: Rachel Whiteread's Water Tower,* ed. Louise Neri (New York: Public Art Fund, 1999), pp. 166, 167. Roberta Smith says it relates to its neighbors "as a translucent, freshly shed snakeskin relates to a snake." The project has the following dedication: "This project is dedicated to my father, Thomas Whiteread (1928–1988), whose interest in industrial archaeology enabled me to look up."

68. Studs Terkel, U.S. oral historian, is the author or compiler of various collections including *Working: People Talk about What They Do All Day and How They Feel about What They Do* (London: Wildwood House, 1975), and *Coming of Age: The Story of Our Century by Those Who've Lived It* (New York: New Press, 1995). Woolf, "Women and Fiction," reprinted in Barrett, ed., *Virginia Woolf: Women and Writing,* p. 44: "But of our mothers, our grandmothers, our great grandmothers, what remains? . . . It is only when we can measure the way of life and the experience of life made possible to the ordinary woman that we can account for the success or failure of the extraordinary woman as a writer [an artist]."

69. Carolee Schneemann, in *More than Meat Joy: Complete Performance Works and Selected Writings,* ed. Bruce McPherson (New Paltz, N.Y.: Documentext, 1979), pp. 198–199.

70. Quoted in Carey Lovelace, "Weighing In on Feminism," *Art News,* May 1997, p. 145.

71. Andrea Rose interview, p. 33.

What is the work of the writer? To carry knowledge forward, conscious of the burdens, yes, but not all knowledge is burden: some of it is treasure. The work of the writer involves pointing to the treasure, designating the treasure, inevitably reshaping its gold into more words. Not everything can be saved. But something will be. The writer knows that one always works with others' treasure, and with the help of others, other people, others' books, others' art. The artist knows this too. In the cycles of time, those given gifts give them in turn. In this, women are no different from men.

　　We are here to respond to our treasure formally. Some of those who have given their gold to us are here this morning. But they themselves have not finished working, they are still reshaping the gold in the idea too. Linda Nochlin looks back on the idea of greatness as ideology, that construction, that theatrical flat in the mind. Griselda Pollock returns to the difference in vision through the matrixial gaze now. Lisa Tickner circles back to the work of the Victorian daughters; there is always more to think back through them. Yvonne Rainer keeps the gold moving in the gesture and through the directness of breath in the word. They all are working with the highest ambitions (not-for-profit): they seek the gold that is wisdom.

Carol Armstrong has brought us all together today in order to focus on this, for which we must thank her. But she has also set before us a very real and pressing question. She has asked us to assess the relation between artist and writer, but much more specifically (and this is what gives her formulation of the question its finesse), she has asked the feminist modern art historian and critic to discuss the work of the living woman artist. These are two very distinct positions. So, as a way of beginning the day, let me describe these positions briefly, and from these two points ask a question.

Feminist art history was an Anglo-American form in its first incarnation. It was also written as history in its first incarnation, as social art history, as Marxist art history. This was important. Feminism began as a *social* project. The shadow of the social project—you have just seen it—still falls into these talks: does not the premium that Courbet placed on public art, the lesson of the Vendôme column, inform Linda's idea of how the monument should function today? Do not the "existing modeling of social and psycho-symbolic identities," as Griselda puts it, presume some institutional standards, some social definition, some wall, against which the linguistic and psychic structures, like crazy vines, overgrow? Does not the question about education, the question that swings so beautifully out of Linda's classic essay, to live again in Lisa's, does not the question about the education given by our mothers and fathers assume Althusser's Ideological State Apparatuses (NB, Whiteread's sponsors) and Foucault's disciplines? But most feminist art history does not now see itself as socially motivated.

By the early 1980s, feminist art history had mutated, in part because of the force of feminist film theory. Griselda Pollock's paper exemplifies the new order. Today its conceptual center can be located in Lacanian psychoanalysis. This feminism, when it looks outward, can be censorious. Nonetheless, it has produced certain intellectual advantages for the discussion of desire. Its very difficulty has given it the status of an organized knowledge, something like a science, which has enabled university departments to see it as completely respectable. With this conceptual center, feminist art historians have won their place in the most rigid of the knowledge economies. To have done this in the space of one working generation is remarkable. We are proud. But we should understand by this that feminism has become a profession.

———

Professions these days are required to display specialization, technical grasp, expertise. University feminism has produced a community of speakers for itself that is eloquent, supremely refined, and closed. For the purposes of pursuing a specialty, this is good: but this tiptop has in fact returned us to another order of kitchen: the profession of feminism is specialized, one of the classroom professions, but it is divided away from the rest, a separate sphere of women's work. The intellectual effects of this situation can and should be discussed, but this conference has handed us a different problem. For the beautifully accomplished and distinguished group brought here today has been asked to address the work of the contemporary artist, the sister artist who lives somewhere else. She does not harbor the same ambitions exactly; she does not see the work of art to be so strictly a professional object. Works of art, by and large (or should I say great works of art?), do not exist to become professional objects.

Much of the work written from the university about contemporary art assumes that the role of the critic in the contemporary art world remains much the same as it was in the days of Clement Greenberg. That is a false assumption. Where is the artist? Nowhere very secure. To see things in their proper place, we must leave the classroom.

On to the living artist, then. The past ten years have seen a quantum shift in the media and visual pitch of our culture as profound as the one that led to abstract modern art. This one is shifting away from the fine arts into the new as well as the most ordinary of media and into a cross-cultural zone that is too quickly called global. To review this kind of change as if one could completely understand it would be naive, especially since it is pushing away from the hierarchies of form and explanation that for the past thirty years have been dominant. One sign of the change is that the discussion—intellectual but not necessarily professional, not necessarily in English—no longer emanates from New York. There is no center point of emanation; the lines and subjects of discussion shift. Panels, biennials, interviews, bars, magazines all contribute to the flow of a discussion that may or may not ever be written down. The change in the situation, and in our perception of it, is substantial: assumptions cease to be common; distinctions of all kinds are breaking down. The field of contemporary art exists obscured by a very real confusion.

———

Practically speaking, it is no longer possible to construct or impose the view of contemporary art through the single practice of *criticism*. This includes modernist criticism. As evidence one could cite the exclusion of the Anglo-American models of modernism from consideration at the last Documenta. (They will also be excluded from the next.) One can note that conversations in the inner circles of *October* turn, worried, around the topic of obsolescence. One can have any number of conversations with people close to the workings of the art world and quite quickly see that the criticism that used to direct the uninitiated and advise the collector, the criticism that saw itself as the leading authority and final judge, has lost its function, its purchase, its hold. This confusion should not be mistaken for stupidity or decadence; it merely produces the conditions for a shift now, the kind of shift that needs to be thought through in the broadest way, as a shift in roles, in concepts, in objects. How does one *know* the present? This one is not transparent; its art not transparent either. To see is not to know.

This is not a change that precludes the presence of the past. Nor is it a change that renders the feminist advance obsolete. But, practically speaking, it is no longer possible to construct a full view of contemporary art through the single experience of *women*. As Lisa and Linda have shown, the work of Rachel Whiteread is setting its terms very broadly, casting insides into outsides that lie exposed to the air, to the view, to the world. It is a work with the elements for the elements by someone who likes to consider the presence in her work of someone else's past, someone *unlike* herself, someone external. Their work, their treasure, their touch, finds its trace, its perpetuation in her casts. Her work is hers and theirs. It exists as an open, a very open surface. One would be hard-pressed to see her objects as subjects. One is hard-pressed to find the words that define them.

Virginia Woolf spent hours writing in her notebooks about such problems. "I have the restless searcher in me," she began:

> Why is there not a discovery in life. Something one can lay one's hand on and say 'This is it?' My depression is a harassed feeling—I'm looking; but that's not it—that's not it. What is it? And shall I die before I find it? Then (as I was walking through Russell Square last

night) I see the mountains in the sky: the great clouds; and the moon which is risen over Persia; I have a great and astonishing sense of something there, which is 'it'—It is not exactly beauty that I mean. It is that the thing is in itself enough: satisfactory; achieved. A sense of my own strangeness, walking on earth is there too: of the infinite oddity of the human position; trotting along Russell Square with the moon up there, and those mountain clouds. Who am I, what am I, and so on: these questions are always floating about in me; and then I bump against some exact fact—a letter, a person, and come to them again with a great sense of freshness. And so it goes on. But, on this showing which is true, I think, I do fairly frequently come upon this 'it'; and then feel quite at rest.[1]

Back in the 1970s, one of the many lessons I learned from Linda Nochlin was this: the strict modernist argument often keeps one from seeing the beauty and the complexity of the relation of the work of art to the world. The modernist argument has assumed the existence of unified fields that can be diagrammed by a unified field theory. It has wanted to become a self-fulfilling prophecy. It stands in the way of realism. If one requires a more complex idea of the field, indeed if one asks that art be seen inhabiting fields, even discontinuous, undisciplined fields, then obviously there is much more to do and say. But one has to break with the idea of hyperspecialization. One has to be ready for the broad, *unknown* discussion. As women, whether as writers or as artists, we cannot be restricted to the experience of women, just as men cannot be restricted to the experience of men.

Which brings us back to the gold, that thing Virginia Woolf was calling "it." The first phase of feminist criticism, the phase when the social project was still visible, the phase when the concerns of the past and the present were being thought together, the phase when feminist criticism was history too, lies there, a vein that can still be mined. We shall need it in order to consider the art of our time, the movement of the work of art out into the world, with the world. The very last point of Lisa's paper dips back and returns with an extremely important

question, and it is her question that I'd like to put on the table: Is it not time to consider just how the feminist releases the paternal tradition? Can we, as feminists, see how to acknowledge and use the treasure of men?

In his last book, Gilles Deleuze turned to Woolf's notebooks as he worked through the definition of aesthetic work. Not like formal thought, he said, it aims to conserve a block of sensation, a *petite sensation,* like a house whose frame is being lifted from it. For all this Deleuze went to Cézanne, to Merleau-Ponty, to many, and to Woolf. Without any qualification, he used her treasure. "Saturate every atom," he quoted her approvingly.[2] "Saturate every atom." The key word here is hers and it is "every."

NOTES

1. Virginia Woolf, *The Diary of Virginia Woolf, Volume III: 1925–1930,* ed. Anne Olivier Bell (London: Hogarth Press, 1980), pp. 63–64.

2. Virginia Woolf, quoted in Gilles Deleuze and Félix Guattari, *Qu'est-ce que la philosophie?* (Paris: Minuit, 1991), p. 163.

MARTHA ROSLER

Martha Rosler, *Cleaning the Drapes,* from the series *Bringing the War Home: House Beautiful,* 1967–72. Photomontage.

AN IMAGINARY TALK ON WOMEN ARTISTS AT THE END OF THE MILLENNIUM

Women artists at the millennium, a fine subject for discussion, is also a minefield. The millennium itself is a vexed concept, and not simply because we Americans tend to date it uncertainly. Nor is it only because of the Eurocentric, Christiancentric perspective it presupposes, though that itself frames us. I will begin with the "backdrop," or setting—that is, history itself. At a conference held in 1999—a conference, moreover, celebrating the thirty-year anniversary of Linda Nochlin's potent, landmark essay, "Why Have There Been No Great Women Artists?"—we felt entitled to express optimism and to consider the millennial dreams we harbored, as women, as feminists, as people, as artists and to hold the festering problems momentarily in abeyance.

I confess that even at the millennium, my assessment of "women artists at the millennium," while uninflected by the present feelings of crisis and chaos, was not all that cheery. The relationship between feminist insurgencies and the institutionalized art world had passed through a number of stages since the late 1960s, when the women's art movement took shape. There were periods of challenge and confrontation, offense and defense, acceptance and backlash. There were inevitable schisms in the visions of what the participation—the full participation—of women in the art world would mean. There was the inevitable disclaiming of the term "feminism" in the art world, where the word retained its good reception perhaps longer than in mainstream social discourse (in the United States, at any rate). What came to be called identity politics offered a platform for the inclusion of artists who would describe themselves as members of groups with distaff positions, as Others in the mainstream with neither full acceptance nor respect nor political power. Following the space opened up in art discourse by feminism—itself following the lead of the social movements and antiwar activities of the insurgent sixties—the voices of those within these groups (recast as personal and group identities) found accommodation.

By the 1980s, the art world was well used to "politicized" practices and discourses. The 1960s had seen an artist's exodus from mainstream institutions, the overthrow of the reigning aestheticist paradigms, the multiplication of formal strategies, and the formation of artists' collectives. The mainstream art institutions had re-

grouped by the end of the 1970s, opening their gates a bit wider to practices not founded on aestheticism but rather on an array of discursive practices, and commercial dealers had soon followed suit. Most of these practices were brought to the art world by feminist artists.

When the dimensions of the AIDS epidemic emerged in the early 1980s, art world institutions, like the performing arts, were able to mobilize. The art world also was able to accommodate artists and works centered on anti-AIDS activism; this, together with feminism, was the closest that the art world came in recent years to providing a platform for wider social mobilization. Anti-AIDS activism not only helped legitimize art aimed outward from the art world to the rest of society, it helped legitimize collective activity, which had been an important element in women artist's practices and among certain young artists, the generation of the 1980s, including a number in New York.

Performance as a genre of art was developed by West Coast women in the early 1970s, after a spark ignited by Allan Kaprow, who had, ten years earlier, been a main organizer of New York "happenings" before moving west. Performance developed numerous inflections. It became a collective form in which a number of performers originated and honed the work, or it was a form developed and carried out by a single performer. But most often, a woman performing solo nevertheless was part of a cohort of like-minded performers or of a supportive audience. In other words, performance art grew out of a collective practice. The quasi-therapeutic insights of the consciousness-raising group were brought to bear in performance art, and also in other forms of art, for women insisted that the formalist alibi of much late-modernist art simply obscured a world of sexist presuppositions. That some male artists, especially on the West Coast, adopted some of the forms developed by women seemed promising; feminist artists were attempting to do nothing short of helping to remake the paradigms of production, criticism, and distribution of art, refounding it on entirely other ideas than those then driving the game. (One could write volumes about the changes in the reception of these forms in terms of the gender of the makers.)

Extra-institutional forms like video, quickly and enthusiastically adopted by women artists, had already helped extend art beyond the modernist "white cube." By the 1980s, "public art," until then a sleepy field of monuments and statuary, came un-

Martha Rosler, *Small Wonder,* from *Body Beautiful, or Beauty Knows No Pain,* 1966–72. Photomontage.

Martha Rosler, "Letter K," from *Semiotics of the Kitchen,* 1975. Still from black and white videotape, 6 minutes.

season's greetings from
our house to your house

5'4'' x 119 lbs.
framed & reframed

Martha Rosler, *5'4" x 119 lbs.*, 1977, from the series of holiday cards *From Our House to Your House.*

der fire from alienated publics. New public art, pointedly abandoning phallocratic monumentality and temporal reach, adopted casual, ephemeral, and pop-culture forms, such as commercial billboards and flyers. In this moment of a new linguistic and iconic address in art, more women were at the top of the apex than at any previous time.

With the collapse of the Soviet Union at the turn of the 1990s, changes in geopolitics brought about changes in the art world. An empire's worth of East Bloc artists cast about for new ways of working, thinking, and selling themselves, competing against people much more sophisticated at developing appropriate identities in a market economy. Accelerating capitalist expansion, or globalization, provoked a new series of conflicts underlining the emergent geopolitical divide: global South against North rather than East against West. In the 1990s, Europe's new cultural turn was based on a different worldview from that exhibited by the hawkish United States (and also different from its heroic "backlash" painters of the early 1980s). Its new attitude of inclusiveness nodded toward its immigrants and its former empires, and the Documentas of the 1990s reflected this, introducing a new subject, postcoloniality. Identity was trumped by postcoloniality as the one-idea shibboleth of the art world. The international art world drew away from feminism, AIDS activism (if it even had much of a presence outside the United States), and the U.S. reading of

Martha Rosler, from *The Bowery in two inadequate descriptive systems,* 1974–75. Photo-text work.

identity politics. Postcoloniality is of limited resonance in the United States, which has owned up to few or no colonies; and identity is still the functional everyday of many art world selections. But feminism is not. "Feminist art" has a small constituency; women artists had prudently stopped identifying themselves as feminists by the mid 1980s. This effectively rendered feminist art into a style, sharing the fate of "political art." The lack of agitation by women artists, aside from the continuing, raucous, but symbolic interventions of the Guerrilla Girls, means that the disappearance from important exhibitions of a great many women, and of a robust articulation of a female subjective position, is not greeted by an outcry.

```
stewed
boiled
potted
corned
pickled
preserved
canned
fried to the hat
```

Young women artists may typically be numerous (and most art programs consistently enroll more women than men), but by the time women reach middle age, the number who are actually included in exhibitions drops. If they live long enough, a few women artists are rediscovered; seen no longer as "women" but as "old women," they lose their sexual hold but gain a different kind of gendered power, presumably that of the virago. In the event, young European curators now claim that including women is no longer a necessary consideration. (The Swiss-born artist Thomas Hirschhorn, whose work tends to center on the intellectual milestones of Western art and philosophy, has not included any women in his historical homages; I have not

seen any eyebrows raised over this exclusion.) The Europeans have said (for the umpteenth time) that they don't need women, while the Americans, I am guessing, have not, but the number of women in U.S. shows is declining nevertheless. We have outworn our welcome.

As we neared the end of the millennium, while I was working on a series of shows, a woman museum director caustically pointed out to me that women are curated by women. I had never considered the question, but I realized that she was right: most (but certainly not all) of the solo shows I have had were arranged or suggested by women. By far the largest number of interviews that people have done with me have been done by women; the younger the interviewer, the more likely it is to be a woman. (So I am still a woman artist.) I have a series of photos of women, mostly quite young, sitting across from me with a pad and pencil or a tape recorder. I was taken aback and then irritated by the curatorial gender divide, but the interview

Homeless: The Street and Other Venues (detail), in the exhibition cycle *If You Lived Here . . .* at the Dia Art Foundation, New York, 1989, organized by Martha Rosler.

Martha Rosler, *Watchwords of the Eighties,* 1981–82. Performance.

Martha Rosler, *Untitled (Salt Lake City, Utah),* 1983, from the series *In the Place of the Public: Airport Series* (1981–).

business has, instead, made me happy. It suggests that young women continue to look to older women as still having something to say—something they want to hear.

More recently, a man who runs an alternative space in New York City told me that he has asked five different women curators, European and American, to recommend women artists, and so far each woman, he said, had failed to do so but rather recommended a male artist. Hearing this, I realized that I too had stopped thinking about mentoring women in quite this way, although as a teacher I always feel that that is a special intergenerational responsibility, and a special pleasure.

Martha Rosler, *Williamsburg Bridge,* from the series *Rights of Passage,* 1995–97.

I want to return to the premise that the art world reflexively seeks cover under the banner of one reigning idea. The rigid categorization that follows upon this has led to women artists' exclusion from shows devoted to historicizing the first genera-tion of conceptual artists because these women were identified as feminists, which would place them in a different pigeonhole of a show. The question of identification as "feminist" is itself interesting. I have remarked that most women artists, like all kinds of women, long ago stopped calling themselves feminist, thanks primarily to the discrediting of the term and the concept by the mass media and right-wing po-litical commentators. Avoiding the label of feminism is a strategy, conscious or not, and does not necessarily speak to the content of one's work, character, or attitudes and beliefs. But it does impede criticality and cohesiveness. In the past, with a gen-eral feminist and progressive or activist consensus, feminist artists could take their core orientation for granted while addressing content that does not speak to femi-nism and women's issues exclusively or even at all—on the surface. Without this con-sensus as backdrop, the issue becomes flattened, the subtext, context, or even point of view invisible.

Martha Rosler, *New Jersey Mall,* 1999, from the series *Transitions and Digressions* (1983–).

It is important to recall, ceaselessly, that feminism has represented, at its best, not women demanding simply a high place at the table. Women did not demand to be knighted or anointed as kings. I claim confidently that, as a body and as individuals, women artists were working, fighting, and theorizing to produce a significant art, an art of criticality, an art of open-ended questioning and a recognition of difference. Women artists are tarnished, and in most instances slandered, by the suggestion that the first time around, in the foundational moment of the late 1960s through the 1970s, women were agitating only for themselves: white, middle-class women. I know that this was more untrue than true of the radical feminist movement of that era and is, sadly, the same kind of unfriendly criticism leveled at most political movements. In most respects we are looking at a blanket explanation for a vexedly complex set of circumstances. If exclusivism has turned out to be functionally (though not rhetorically) more true than untrue of women artists agitating for inclusion in art world discourse and institutional practice, it is not for want of trying. Through agitation of numerous kinds, women changed the art world decisively—at least for several

Garage sale element of *Three Transient Tenants at the Central Terminal,* installation by Martha Rosler at Moderna Museet, Stockholm, 2002.

decades—drawing on the vitality and inspiration of the social and political movements of the late 1960s and 1970s. Now, as feminism is being historicized, the open-endedness of its logic is being remembered as a closed demand for the admission of women, one by one by one.

For the moment, it seems that the agenda of globalism and counterglobalism will be taken to be arguing persuasively for the identification of difference as post-coloniality rather than as arguing for a broader social vision in which women artists are fully represented and in which political activism as articulated through art is also consistently represented. But at this moment, a moment of tremendous reinscription of social activism onto the world stage, activist and noncommodified art is finding its most robust expression outside normal art world venues, on the Internet and, once again, in the streets. I would like to argue for a newly reopened definition of art that transcends not only the boundaries of nations but also the boundaries of genres and genders.

II SPACES

Duchess of Nothing: Video Space and the "Woman Artist"

Ewa Lajer-Burcharth

The drawer squeaks as I open it slowly, both cautious and excited by the promise of its mysterious content. There they are, the objects of my curiosity and desire: my mother's nylon stockings. Delicious and frustrating at once, they make my five-year-old body feel awkward, almost too "real" to handle such sheer evanescence. But I can't resist: pulling off my thick cottons, I try the nylons on and, holding them up with my hands, stroll tentatively across the room. And there it comes—swish, swish—that surprising sensation of a delicate breeze, as if, with each step, my legs were enveloped by the elusive *air of femininity* that I cannot comprehend, cannot yet have—but can it be *had* at all?—and which is, needless to say, totally fascinating.

I am beginning, indulgently, with this personal anecdote not because of its obvious performative dimension—the little girl rehearsing womanhood by assuming its attributes—but rather because of the sense of delightful nothingness that it provided, the experience of a deeply elusive nature of "femininity" encapsulated for me by this childhood episode.

For no apparent reason, this very recollection came to my mind as I tried to think of the link between recent video-based installations of several young women artists. It was not, to be sure, a fascination with the nylon stockings, but rather a persistent emphasis on femininity as something other than *identity,* be it

in the essentialist *or* performative sense of the word, something less familiar, more difficult to grasp, something that cannot be so easily assumed, let alone becoming one's "own."

Such a shift of conceptual emphasis away from identity is, of course, not entirely surprising. It may be linked to a broader phenomenon of reaction to some radical developments in feminist (mostly American) discourse of the 1990s, especially to the conceptual assault on the very category of "woman" as an ontologically suspect, if not entirely ungrounded assumption.[1] Largely beneficial, this assault also generated urgent need for some new definitions. "What *is* a woman?" has become a question of renewed relevance on the threshold of the twenty-first century, as the title of a recently published book by the feminist theorist and literary critic Toril Moi, for one, indicates.[2] Addressing a certain impasse in which feminist theory found itself after Judith Butler and the by-now nearly ubiquitous fascination with performativity, Moi has suggested a critical return to Simone de Beauvoir. While I will not exactly follow this recommendation—I think that the work of the women I will discuss here largely offers its own terms—I would agree that, to begin with, de Beauvoir's notion of a woman as a *situation* rather than a body may be useful in looking at the work at hand.[3]

For the body, though not exactly absent, is clearly no longer the motivating trope in these most recent visual productions. At their conceptual core is rather the question of space. This renewed interest in space is, I think, precisely a symptom of many women artists' more or less programmatic withdrawal from the aesthetics of identity and their interest in pursuing different, as yet unscripted, scenarios of self-definition.

Notwithstanding the long philosophical tradition associating space with femininity, space cannot be defined as a feminine *attribute*.[4] It is not something that can be assumed or "taken on"—and, in that sense, it cannot be "owned"—but it is, as these artists' practices diversely point out, *inherent* in any act of self-definition. Space is no doubt something that we cannot live without, but far from assuming it as a given, the artists I have in mind investigate this premise, visualizing what must be recognized as new kinds of connections between space and subjectivity. These connections forfeit the predictable routes of gender: the work

under discussion does not seek to map out some segregated zones of feminine experience, such as, for instance, the "spaces of femininity" depicted by women impressionists with a consistency that had much to do with these artists' restricted experience of the nineteenth-century city.[5] At stake in the current productions is rather a question of how a "woman," and particularly an artist who happens to be a "woman"—purely provisional or hypothetical as this category may be—could be defined as a *subject* of space, a question inseparable, as we shall see, from the task of reimagining the relation between subjectivity and vision. My case in point is the work of Pipilotti Rist, Jane and Louise Wilson, and Sam Taylor-Wood.

Woman—in general, and her relation to space in particular—has always been at the core of Pipilotti Rist's work, the very subject of her vision. We have been plunged underwater to follow Rist in the sea of her (auto)erotic fantasy (*Sip My Ocean,* 1996), accompanied another young woman on a Zurich street joyfully smashing the windshields of parked cars with an iron flower (*Ever Is Over All,* 1997), and witnessed other acts of feminine spatial insubordination in the Swiss artist's by now notorious video-based productions. In a series of installations shown last year at a New York gallery, though, the spatial dimension of her work came to the fore in a particularly interesting way.[6] In these works, Rist invaded the idea of a domestic interior with a series of subtle and witty visual interventions.

At first, the simulated domestic layout seemed ordinary enough: you were led inside by a kitchen door, proceeded through a living room, a bar, and two other rooms, to end up in a bathroom. This ordinary house, though, was turned into a home of fantasy, a site of projection, at once visual and psychic, produced from a rather intriguingly feminine point of view.

I will focus here on just two spaces. In the installation *Regenfrau* [Rainwoman] *(I Am Called a Plant),* made originally in 1998–1999, a giant female nude was projected onto a faux kitchen wall, the image hovering over sink and stove, neither merging with it nor separate from it (figure 2.1). In choosing such a location for her projection, Rist engaged with a long tradition of critical representations of femininity and/as domesticity, from Louise Bourgeois's trenchant

2.1 Pipilotti Rist, *Regenfrau (I Am Called a Plant)*, 1998–99. Video installation (projection on kitchen unit). Courtesy of the artist and Luhring Augustine.

Femme-Maison (1947) to Martha Rosler's hilarious deconstruction of a woman as a domestic creature in her 1975 video *Semiotics of the Kitchen*. Rist's approach, however, is significantly different. Taking on the notion of bondage—both in terms of traditional confinement of the woman within the domestic space and in the sense of scopic captivity under the camera's (presumably masculine) gaze— her projection paradoxically generated a visual poetics of buoyant femininity profoundly *un*related (though not unfriendly) to masculinity, that is, released from the binary opposition of gender.

Lying immobile like a corpse at the edge of the water, under the rain, the orange-wigged head, magenta lipstick, and purple nails punctuating the soggy ground, Rist's image seemed at first sight to represent not an unbound but a simply abandoned woman. Yet, somewhat incongruous with her spectacular abjection was the peculiar mode in which the woman's body was shown, with the camera gently brushing against it, up close but unseeing, a crawling, sniffing look that seemed to be saying, "I am all mouth," and that brought to one's mind an infant crawling on its mother's body in search of a nipple.[7] Instead of any controlling male gaze you might expect from such a vision of the female body, you found the disoriented and needy touch of a dependent object. The oneiric sounds of a harmonica oozing out from the loudspeakers enhanced the mesmerizing strangeness of this sight, while the woman's slightly moving lips defied her immobilized, corpselike appearance. At a certain point in the projection, which ran in a continuous loop, the "abject" woman got up and left—she clearly wouldn't stay put under any gaze. Her voluntary exit from view reemphasized the destabilized subject/object, viewing/viewed distinctions produced by the peculiar camera movements vacillating between extreme close-ups and dramatically distanced views.

In *Himalaya's Sister's Living Room,* images beamed from projectors hidden in furniture appeared like veils of daydreams resurfacing in unexpected places: on a sideboard, an image of the artist herself standing at the window of a skyscraper, her face pressed against the windowpane; behind a plant, an ear inspected against the sunlight; on a side table, the legs of a female cyclist; on another, a woman gesticulating on top of a snowy mountain; elsewhere, a rather massive man striding naked on the Autobahn (figure 2.2). These objects generating visions reminded

2.2 Pipilotti Rist, *Himalaya's Sister's Living Room*, 2000. Video installation (seven projections surrounded by furniture and objects). Courtesy of the artist and Luhring Augustine.

one of speaking furniture in eighteenth-century libertine novels, such as Crébillon's sofa narrating the amorous trysts that took place on it, though the iconography here was not erotic in a traditional sense. There was a kind of love, though, in Rist's gaze, in the gently swooping or endlessly looping trajectory of her camera that embraced its objects without seizing them, and that produced a subtle visual disequilibrium, often hilarious (as in the volleying, from-the-bottom takes of a female cyclist's legs projected on a table, or in the swinging views of Rist herself shown from the outside at a window of a highrise building).

This erotic gaze defined itself, then, in terms of perpetual movement, though what mattered was not the movement per se, nor the metonymic energy of displacement usually associated with desire, but a certain kind of *relation* to the

body it produced. This relation may be seen as an effect of swinging back and forth between two imaginary positions of Mother and Daughter, or, to put it differently, as the look of a daughter who, borrowing her mother's loving eyes, sees herself as alternately the subject and the object of her own gaze. The peculiar, circulatory movement of Rist's camera thus described a visual field similar to the space of early psychic experience wherein the subject/object boundaries are still porous, a fluid matrix of archaic relations and exchanges between the mother's/daughter's bodies as the locus of origins of a woman's self. Interrupting the physical boundaries of things to inscribe them with her quirky dreams, Rist's imagination, at once filial and maternal, thus redefined the very idea of a woman's interiority as an exclusively *intrafeminine* space.

Although the female body was featured quite prominently in these projections, what I would like to emphasize is the use of the camera as the means of disincarnation, taking a woman out of her body, and out of herself as it were, a playful but critically important extension of the problematic of femininity into space.

Such seemed also the main purpose behind Rist's public projection *Open My Glade,* presented concurrently with her New York gallery exhibition on the giant NBC screen in Times Square (figure 2.3). In it, Rist flaunted bits of her own body—her made-up face squashed against the glass, as well as some of the images from her gallery installation—creating a disruptive island of grotesque corporeality within the dense visual forest of billboard advertisements. Rist's facial distortions reminded one of Ana Mendieta's earlier self-disfigurations performed against a glass pane, while the urban context of her intervention evoked, albeit more distantly, Valie Export's 1970s bodily interactions with architecture in the city. But Rist's emphasis was somewhat different from Export's in that she intervened not in the city per se as much as in the visual fabric of commercial fantasies that overwrite the face of architecture in the postmodern urban context. Flattened and deformed by the screen, Rist's face articulated the tremendous pressure of cultural image-flow—and of the global capital that generates it—on the presumed privacy of one's "own" body (and self), but also that body's relentless counterpressure, its more or less desperate, at once tragic and comic, attempts at self-extension and disruption of this at once constraining and seductive

2.3 Pipilotti Rist, *Open My Glade,* 2000. Video installation (one-minute video segments shown on the NBC Astrovision by Panasonic videoscreen in Times Square, New York, 6 April–20 May 2000). A Project of the Public Art Fund. Photograph by Dennis Cowley, courtesy of the artist and Luhring Augustine.

flow. Ultimately, what the screen visualized was not exactly a body but rather a set of grimaces quasi-detached from their physiognomic basis, a spectacular lique-faction of bodily boundaries presented as the effect of violence produced by the subject's inevitable immersion in the flow of (commercially generated) desire.[8]

This is also what distinguished Rist's work from Ana Mendieta's earlier performative acts. The latter were based on the assumption of a body that pre-existed, and survived, the artist's confrontations with the "mask" of identity metaphorized by the glass. Rist's work, on the other hand, envisioned not a mask but a *screen*—understood not only literally but also conceptually, as the site of subjective self-definition in the era of spectacle—a screen that cuts *through* the subject, inscribing it from within, as it were. What made this projection more in-triguing was precisely its inscription within an urban context. By using such an

emphatically public location, Rist shifted emphasis from the image per se to the space in which images take hold of the subject, the material space of culture as the imaginary site of even the most intimate subjective processes of self-definition, and particularly of the subject's negotiations with the force of culturally generated desire—including the desire *for* the image. Her projection thus offered a provocative vision of individuality as a mere residue—not a mask but a smear on the screen of the urban spectacle.

The recent work of Jane and Louise Wilson, on the other hand, confronts us with a visual space that seems at first strikingly impersonal, devoid of any subjectivity. Unlike Rist's, the Wilsons' cameras move with an inexorable, quasi-mechanic exactitude, and there are almost no people appearing in their work; instead, the artists explore the eloquence of the architectural space itself, in particular, the spatial structures of institutional and political authority. I will focus on their three recent installations featuring some notorious Eastern European establishments: *Stasi City* (1997), filmed in the defunct headquarters of the former East German secret police in Berlin; *Star City;* and *Proton, Unity, Energy, Blizzard,* both made in 2000 in the half-abandoned establishments of the formerly Soviet, now Russian, space program.[9]

The condition of possibility upon which the Wilsons' vision is predicated—in both the logistical and the aesthetic sense of the word—is, needless to say, the demise of the Iron Curtain and the concomitant dissolution of the geopolitical distinction between East and West, which rendered these high-security places either obsolete or financially stricken and radically scaled down, and thus accessible to the artists' perusal.

The format of these three installations is similar, each consisting of two corner projections situated across the gallery space, with four close-loop tapes running simultaneously on each of the four large screens. Such an arrangement may connote entrapment—this is what Adrian Piper's well-known 1988 installation *Cornered* insisted upon explicitly—but the Wilsons' purposes are different: they use the multiple screens to generate a complex, disjunctive, and somewhat disorienting rather than literally cornering visuality. Their mode of filming and ed-

iting contributes to this effect in a crucial way, with plunging shots on one screen juxtaposed with a panning movement of the camera on the other. Bracketed by the screens, your visual perception is at times stretched in at least two different directions, as the same space is being presented from different points of view.

In *Stasi City,* you are pulled into the evacuated innards of the East German bureaucracy, with the camera lingering on the abandoned offices, silent phones, useless typewriters, blank monitors, and empty chairs in the interrogation rooms (figure 2.4). Padded doors line the endless corridors, wherein absent steps still resonate. Some parts are in visible decay, such as the operation room of the prison hos-

2.4 Jane and Louise Wilson, *Stasi City (Double Doors Hohenschönhausen),* 1997. C-print on aluminum (edition of 3), 71 × 71 in. Courtesy of 303 Gallery, New York.

pital that was part of the Stasi complex, with blue paint peeling off from its walls and some ominous surgical instruments strewn on the floor. Accessed through the Wilsons' randomly ferreting, somewhat anxious gaze, other rooms, though in good shape, are no less ominously void. The camera plunges in and out of them, as if to pursue some forgotten, invisible "suspect." But what generates a sense of relentless tension or suspense is not just the look of these spaces but the disjunctive relation between them, as they move in and out of sync with one another on each screen.

Thus, for example, the long tracking shots of the endless corridors on one screen are contrasted with the vertical motion of the camera on the other, where the small doorless elevator moves up and down with a thudding noise (a view evidently reminiscent of Joan Jonas's experimental classic of the 1970s, the *Vertical Roll*). A pair of female legs in sensible shoes and what appears to be a skirt of a uniform are shown momentarily in the elevator coming down. A sense of some lingering threat, an unresolved mystery, pervades these spaces. It is as if the artists summoned these spatial memories of surveillance and inquisition to conduct their own interrogation.

At one point in the projection, the mysterious object of this relentless visual pursuit—or its absent subject—appears finally delivered, the suspense broken by a cut-off view of unspecified legs dangling in space, as if someone was left hanging or else suspended in the air, with a pillow floating on another screen (figure 2.5). This levitating motif reminds one of the key scene in Andrei Tarkovsky's *Solaris,* the moment of poetic release from the narrative of entrapment and conflict, when the film's protagonists are suddenly lifted and begin dancing in the air, defying the logic of their space.

The truncated limbs may of course be seen as a synecdoche for what had originally been going on in these spaces of inquisition and, presumably, torture (in a mode similar, say, to the way in which the motif of a dancer's cropped legs hanging from the balcony in Manet's *Masked Ball at the Opera* has been seen to epitomize the status of the represented scene as a *Fleischburse*).[10] But it is also, as Manet's canvas has suggested as well, an obvious trope of artistic arbitrariness. The dangling legs signal, then, the presence of the artists as authors in this vision—"we are here!"—but, in doing so, they pose agency as a problem rather

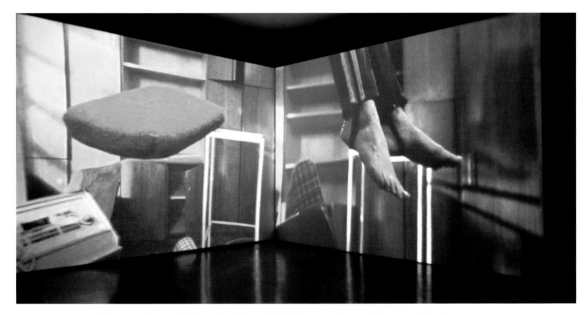

2.5 Jane and Louise Wilson, *Stasi City,* 1997. Video installation. Photograph by Theo Coulombe, courtesy of 303 Gallery, New York.

than a given. Articulated in their truncated form is an abbreviated question: "Who?" which may be developed as "Who exactly is doing the seeing here, and where does this seeing subject reside, inside or outside this visual space?"

This is to say that the Wilsons' elaborate installation has as much to do with the Stasi headquarters and its gruesome symbolic legacy as it does with artistic subjectivity, that is, with the idea of the artist as a *symptom* of the thus constructed space. The uncanny mood of the projection may be seen precisely in terms of anxiety about the elusive authors of this vision, both familiar and yet difficult to locate, or strange. The question is, again, what *kind* of subjectivity is at stake here and what does this definition of the author as a sort of uncanny ghost haunting these empty spaces do to the idea of the artist as a woman (or, in this case, women)?

As a trademark of the Wilson sisters' work, the corner projection (and the split vision it provides) has been recognized as a direct reference to the fact that the artists are identical twins. They certainly must have been aware of such potential eloquence of the double screen, as they were surely deliberate in their choice of the pair of dangling legs (which, we are not surprised to learn, actually belong to one of the Wilsons) as another, clearly ironic stand-in for their twinned artistic persona. Yet, regardless of whether this was what indeed motivated the Wilsons to adopt such a format, I would suggest that its effects point beyond the artists as persons to the notion of difference as the defining mechanism of subjectivity, the *re*articulation of which has been one of the key issues at stake in their work. Thus, it must be noted that, though twinned, this vision is not exactly *doubled*. The views offered on each screen are emphatically *not identical* to one another: they do not quite converge at the seam; there is always a sense of internal *divergence* or disjunction, a sense of tension between them that prevails.

The subjectivity implied by this disjunctive topology is internally split and *nonidentical* to itself, yet this nonidentity does not suggest a split, say, along the line of conscious versus unconscious: both views are grounded in the real world, and if the Wilsons' mode of filming bestows upon them a dose of irreality, it is in equal measure on each screen. Nor is this nonidentity or *non-self-identical visuality* articulated in clearly oppositional or complementary terms that could be read in terms of gender. Difference, importantly, amounts here to neither gender nor sex. Articulated in spatial terms, it may or may not be played out on the body, which functions here, rather ironically, as a kind of residual signifier—the rest—and is, in any case, emphatically only female (i.e., the female legs in sensible shoes emerging from under the skirt on the elevator versus the other female limbs, in training pants and shoeless, suspended in space). The male body, you will notice, makes no appearance here. As far as it is embodied, difference is then a matter of far more elusive distinction between two women, two artists, two artists *as* different women rolled into one artistic persona.

Neither bodies nor other explicit self-references appear in two other installations, titled *Star City* and *Proton, Unity, Energy, Blizzard*. The former was filmed in the main training center for Russian cosmonauts located north of

Moscow; the latter depicts the cosmodrome Baikonur in Kazakhstan, once the rival site to NASA's Cape Canaveral, now a monument to the loss of power and the technological impoverishment of the post-Soviet Russian state. Some spaces are so desolate and rundown that it is unclear which are still operating and which have been abandoned (though not long ago, as a newspaper report attests, the site was used again to launch the spacecraft *Soyuz* with a French woman astronaut, Claudie Haigneré, accompanied by her two Russian colleagues).[11]

The artists turn the cosmodrome into a melancholy space. As in the case of the Stasi headquarters, we are led through the empty rooms—the locker room, the conference room, the control room with its antiquated panels with built-in telephones and monitors, the cosmonauts' training rooms, etc. The near-absence of people enhances the effect of melancholy, epitomized by the view of the cosmonauts' suits lying on the shelves like skeletons in the catacombs. In another shot, filmed with an eerie beauty, a training spacecraft—the replica of the notorious *Mir*—is shown immersed in an indoor pool like a giant sinking ship.

What is most striking, though, is the dynamic aspect of this mournful vision. Again, each screen pulls us in a somewhat different direction as the Wilsons' cameras zoom in and out of spaces, glide along the often rusted surfaces of the machinery, or float like a body in an antigravity chamber. In a sequence epitomizing this dynamic tension, one screen shows a training pod resting on a tiled floor like a giant phallus, while the other, produced by the camera that was mounted on top of it as it spun around to simulate gravity force, enacts the spinning movement (figure 2.6). The soundtrack of humming, clanking, and whirring machinery, with some occasional muffled voices, emphasizes the syncopated visual rhythm of the whole projection.

This visual poetics of dereliction, again somewhat reminiscent of Tarkovsky's vision of a neglected space station in *Solaris,* may be seen to serve a similar purpose: that of creating the visual grounds for critical reflection on the nature and purposes of spatial conquest in the post-cold war era, an era which, as we have witnessed recently, may have already become complicated in new, spatially quite unpredictable ways. Critics noted the unusual emotional power of the projections when they were shown in New York in the fall of 2000. For our purposes,

2.6 Jane and Louise Wilson, *Star City,* 2000. Video installation. Photograph courtesy of 303 Gallery, New York.

it must be recognized, though, that this effect implies an insistent though apparently missing subject that exceeds the sphere of cosmic explorations to which the projection overtly refers. In other words, what is at stake in this fiercely original vision is also a production of a nuanced view of *artistic* subjectivity as a function of spatial difference. It was already clear enough in the *Stasi* projection, but it is strikingly evident in these two installations. It is precisely the vigorous dynamism of the envisioned space, in the virtual absence of the body, that invites us to recognize the internal work of difference, neither in deconstructive terms (tempting as it may be to see the doubling effect of the screens in terms of the Derridean supplement) nor in the *stricto sensu* psychoanalytic ones, but in relation to the Deleuzian notion of difference as an internal *force* acting against self-identity.[12] It is in this sense that the Wilsons' work provocatively redefines the notion of a "woman artist."

Sam Taylor-Wood's film-based installation *Third Party* (1999) also deals with an interior space, but of a different kind (figure 2.7). Here, we find ourselves in a thoroughly private realm, in the midst of a small party. The scale of its visual representation, though, is monumental. Several giant window-like screens appear on the gallery walls, each providing a glimpse of this social gathering. Most of the screens stretch on the wall from top to bottom; some are a bit smaller and were placed at slightly different levels as if to emphasize the resolutely fragmentary nature of this presentation. You feel as if you were visiting an aquarium, with its huge tanks displaying not fish but human beings engaged in the usual party activities: talking, drinking, dancing, flirting, and being bored. The contrast between the large scale of these spectacular tableaux and the provisional nature of the scenes they represent is striking.

 The first thing you see as you enter the room is a larger-than-life image of a middle-aged, chain-smoking woman, recognizable as Marianne Faithfull, once a well-known British pop star, now a Brechtian chanteuse, who surveys the scene and lets herself be observed from her armchair (figure 2.8). Across the room from her a couple flirts by a mantelpiece, with the man and the woman divided between two separate and angled screens (figure 2.9). On another wall, a

2.7 Sam Taylor-Wood, *Third Party,* 1999. Seven 16mm film projections with sound, transferred to DVD. Installation view. Courtesy of Matthew Marks Gallery, New York.

2.8 Sam Taylor-Wood, *Third Party,* 1999. Seven 16mm film projections with sound, transferred to DVD. Installation view. Courtesy of Matthew Marks Gallery, New York.

2.9 Sam Taylor-Wood, *Third Party* (film still), 1999. Seven 16mm film projections with sound, transferred to DVD. Courtesy of Matthew Marks Gallery, New York.

solitary bearded man can be seen trying to occupy himself, mostly watching TV. On the adjacent screen, a headless torso of a woman appears seated on a couch and animated by a conversation with an invisible partner. On the facing wall, a quasi-manic nymphet dances as if in a trance to loud music (with the "solitary bearded man" moving at a certain point from another screen to stand by and observe her while he downs a drink, each of these figures remaining deeply disconnected from one another) (figure 2.10). Lastly, on a smaller screen next to the nymphet, there is a still life of the party paraphernalia, the half-empty glasses, beer cans, and an ashtray filled with cigarette butts to which the hands of the party guests keep adding. Each of these scenes and/or motifs has been filmed separately by a different camera—the installation actually consists of seven distinct,

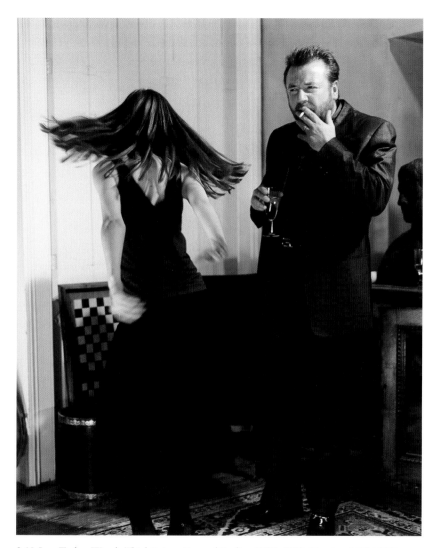

2.10 Sam Taylor-Wood, *Third Party—Ray and Pauline,* 1999–2000. C-print, 55¾ × 44¾ in. Courtesy of Matthew Marks Gallery, New York.

ten minute-long film projections that have been transferred onto DVD to facilitate their simultaneous showing—and, although they represent the fragments of the same situation and share the location, they lack unity. No evident narrative thread seems to link these discrete episodes together, nor do they cohere into a spatial whole.[13]

The sense of disconnection between the scenes corresponds to the internal disconnection of this somewhat disaffected social assembly, the party guests' radical nonbelonging with one another. But the installation's deliberately discontinuous structure suggests more than merely a fitting representation of the random and provisional nature of social encounters typical of a party. It is rather a certain *mode of viewing* that this structure suggests, and the prominence of Faithfull as the detached observer of the scene only confirms that. Yet what is at stake here is not exactly her gaze but that of the observer *implied* by this fragmentary vision, the invisible "third party" evoked by the title of this installation—and by the empty darkness at its core.

This darkness, I would argue, gives form to an absence at the core of this vision through which a certain understanding of a viewing consciousness is evoked, one that comes close to what Hume described some two centuries ago in the following way: "[W]hen I enter most intimately into what I call *myself,* I always stumble on some particular perception or other, of heat or cold, light or shade, love or hatred, pain or pleasure. I never can catch *myself* at any time without a perception, and never can observe anything but the perception. When my perceptions are removed for any time, as by sound sleep; so long am I insensible for *myself,* and may truly be said not to exist."[14] What Taylor-Wood's installation offers to view may thus be seen as a Humean theater of a woman artist's mind, where "several perceptions successively make their appearance; pass, re-pass, glide away, and mingle in an infinite variety of postures and situations. There is properly no *simplicity* in it at one time, nor *identity* in different; whatever natural propension we may have to imagine that simplicity and identity."[15]

Regardless of whether Taylor-Wood had Hume in *her* mind in making this installation, what matters here is that her work connects with a long tradition of philosophical doubt about a possibility of defining the perceiving subject as a

unified, continuous, and coherent whole, the rich discourse of *unknowing* the self, as it were, that reaches back to the eighteenth century and that *Third Party* has engaged here for at least one evident purpose, namely to offer a different and more nuanced view of female subjectivity.

For it is Taylor-Wood herself as the author and agent behind this vision, and, through her, the notion of female viewer as such, personified by Faithfull as an armchair *flâneuse,* that is being addressed and redefined here. This redefinition moves us away from the familiar subject/object dichotomies of the feminist discourse on vision of the previous decade (e.g., Laura Mulvey's classic argument about the woman as the object and man as the subject of the look, and its aftermath).[16] Through this spatial discontinuum, Taylor-Wood constructs a viewing woman as an agent of a visual knowledge forever incomplete. It is not just that this vision is fragmentary; it is also that it provides neither cognitive control nor possession of any kind. Despite their giant size, her party guests remain strangers to us, their physiognomies inexpressive and inscrutable. Most important, this disjunctive spectacle reveals the subject itself as, in a sense, dispersed, a loose aggregation of perceptions, an open-ended structure rather than a self-enclosed and stable entity. Instead of a unified seeing body, seven disembodied eyes may be seen evoked by these distinct and fragmentary views, each produced by a different camera. Thus, the projection proposes a woman as, indeed, a *subject* of vision but one that has little to do with the previous attempts at ocular and subjective empowerment of women encapsulated by the 1980s concept of female gaze. As the very figure of Faithfull—the unknowable and unknowing observer—suggests, the creative woman's look may be productively based in a certain dispossession.

The new woman artist, then, as the "duchess of nothing." The term comes from Sylvia Plath's "Poem for a Birthday," which describes a process of poetic self-generation through a metamorphic passage from one object to another, a constant movement in and out of the body—and in and out of language.[17] These borrowed words capture well, I think, the sense of the creative woman's new position in relation to the visible world conveyed by these installations. Materialized in these works is an elusive, contingent, and entitled, though emphatically *un*possessing, femininity—a woman who lays claim to space without having it.

NOTES

1. See especially the work of Judith Butler, *Gender Trouble: Feminism and the Subversion of Identity* (New York: Routledge, 1990), and *Bodies That Matter: On the Discursive Limits of "Sex"* (New York: Routledge, 1993).

2. Toril Moi, *What Is a Woman? And Other Essays* (Oxford: Oxford University Press, 1999).

3. As it will become clear, my conception of "situation" is primarily spatial and theoretically distinct from de Beauvoir's existentialist understanding of this term. See Simone de Beauvoir, *The Second Sex,* trans. H. M. Parshley (New York: Vintage, 1989), esp. pp. 714–715.

4. Luce Irigaray, among others, frequently discussed the philosophical tradition of association between space and femininity in which femininity is either the enigmatic ground or the matrix of masculinity, or else the darkness, an abyss from which male subjectivity emerges. In all cases it is envisioned as external to order, specifically to Logos, its uniqueness hinging on its expulsion from the realm of meaning. See Irigaray, *An Ethics of Sexual Difference,* trans. Carolyn Burke and Gillian C. Gill (Ithaca: Cornell University Press, 1993), esp. pp. 7–10. See also Elizabeth Grosz's useful essay "Architecture of Excess," in her *Architecture from the Outside: Essays on Virtual and Real Space* (Cambridge: MIT Press, 2001), pp. 151–166.

5. See Griselda Pollock, "Modernity and the Spaces of Femininity," in her *Vision and Difference: Femininity, Feminism and the Histories of Art* (London: Routledge, 1988), pp. 50–90.

6. The exhibition at the Luhring Augustine Gallery in New York in April to May 2000 consisted of a string of interconnected installations that may exist independently but on this occasion functioned as a domestic whole. They are *Regenfrau (I Am Called a Plant)* (1998–99); *Himalaya's Sister's Living Room* (2000); *Bar* (1999); *Extremities (Smooth, Smooth)* (1999); *I Couldn't Agree with You More* (1999); and *Closed Circuit* (2000). See my review of this exhibition in *Artforum* (September 2000), p. 172; see also Peggy Phelan, Hans Ulrich Obrist, and Elisabeth Bronfen, *Pipilotti Rist* (London: Phaidon, 2001).

7. Technically, what made this unusually close-up vision possible was the artist's use of a microcamera, such as those used in medicine for endoscopy or in sports.

8. One may indeed speak here of the Deleuzian "body without organs." See Gilles Deleuze and Félix Guattari, *Anti-Oedipus: Capitalism and Schizophrenia,* trans. Robert Hurley, Mark Seem, and Helen R. Lane (Minneapolis: University of Minnesota Press, 1983).

9. For the 1997 installation, see *Jane and Louise Wilson: Stasi City,* exh. cat., Kunstverein Hannover, Germany, 1997. See also the exhibition catalogue *Jane and Louise Wilson,* Serpentine Gallery, London, 1999.

10. See Linda Nochlin, "Manet's *Masked Ball at the Opera,*" in her *The Politics of Vision: Essays on Nineteenth-Century Art and Society* (New York: Harper & Row, 1989), pp. 75–94.

11. *New York Times,* 11 October 2001.

12. See Gilles Deleuze, *Difference and Repetition,* trans. Paul Patton (New York: Columbia University Press, 1994). For the distinction between Derrida and Deleuze on difference, see also Grosz, *Architecture from the Outside,* p. 62.

13. It is possible to reconstruct some vestigial trace of a jealousy plot, featuring the bearded guy as the frustrated partner of the woman who is shown on the other screen flirting with another man, as some interpreters have suggested. See Martin Hentschel, "Photography, Painting, Film: Sam Taylor-Wood and the Inflection of Art Forms," in Hentschel, ed., *Sam Taylor-Wood: Third Party* (Stuttgart: Hatje Cantz, 2000). Yet this plot is by no means clear, nor is it sustained by the structure of the installation.

14. David Hume, *A Treatise of Human Nature* (Oxford: Clarendon Press, 1978), p. 252.

15. Ibid., p. 253.

16. Laura Mulvey, "Visual Pleasure and Narrative Cinema" (1975), reprinted in her *Visual and Other Pleasures* (Bloomington: Indiana University Press, 1989). For some account of and engagement with its aftermath, see Kaja Silverman, *The Acoustic Mirror* (Bloomington: Indiana University Press, 1988), esp. chap. 1, and Linda Williams, ed., *Viewing Positions: Ways of Seeing Film* (New Brunswick, N.J.: Rutgers University Press, 1994).

17. Sylvia Plath, *The Collected Poems,* ed. Ted Hughes (New York: Harper Perennial, 1992), 131–138.

2.11 Agnes Martin, *Leaf,* 1965, detail. Acrylic and graphite on canvas, 182.9 × 182.9 cm.
© Agnes Martin, courtesy of PaceWildenstein.

The insignificant is as big to me as any,
(What is less or more than a touch?)

—*Walt Whitman*

If we die of repetition we are also saved and healed by it.

—*Gilles Deleuze*

A pencil track. A line is drawn across a white field. And another, repeating itself until a grid appears. Looking hard at Agnes Martin's *Leaf* (figure 2.11), we see infinitesimal differences in the lines and edges, but all of them are subordinate to the repetition of the grid. From a distance, the effect of the drawing is so faint that it looks as though it is about to disappear from view as an insubstantial mirage. The look of it is reminiscent of graph paper not only because of the familiar format but also because the dim pencil lines lack emphasis, barely registered traces across the field of vision. It is a surface that invites a contemplative gaze and bolts the viewer to it, as if the *work* of the work were to open onto an immaterial and meditative space. Agnes Martin liked to think it could, that the simplest of means could invite the possibility of revelation. She used various words to

describe the experience of boundlessness that art could give: "infinity," "joy," "bliss," "the sublime." To Martin there was nothing particularly feminine about her metaphysics. On the contrary, she identified with that most robust masculine tradition of metaphysics in Rothko and Newman (Rothko she knew, Newman she counted as a friend). Born in 1912, she was of the same generation as these artists. But her particular form of interiority is also distinct from theirs, her metaphysical subject differently imagined.

I concentrate on the word "infinity" because it opens onto this experience of boundlessness in the subject or spectator—and yet it is also a term grounded within the discourses of the 1960s, when "infinity" came to substitute for the word "sublime." It came to stand for the refusal of that aesthetic of revelation. It became a literalist watchword. Serial repetition could go on ad infinitum. "Quasi-infinity," Robert Smithson called it.[1] For Agnes Martin, on the other hand, it suggested the endless expansiveness of a transcendental subject. Martin always maintained something visionary, something that took vision beyond the merely literal. This could be all that there is to be said—that Martin's aesthetic vision is incompatible with that of a younger generation, except that younger generation of minimalists saw in her work something that resonated with theirs, that played into their concerns with the infinite repetition of a serial procedure. Judd said plainly in 1963 of a work that sounds from his careful formal description very much like *Dark River* (1961), "The field is woven,"[2] extricating Martin's grids from that contemplative space. Similarly, he had said of Kusama's *Infinity Nets* that they looked like "massive, solid lace,"[3] making the most of their literal surface quality (though no less than he wanted to reevaluate Newman in terms that saved him from the transcendent too). That Judd's critical purpose cut against the grain is clear from the persistent attempt by critics such as Lawrence Alloway to incorporate Agnes Martin among those "holistic" painters he dubbed abstract classicists.[4] The "hard-edge" category has also done little service for other artists such as Ellsworth Kelly, whose work was always more concerned with memory and the distractedness of experience than with classical color harmonies.

We could see the contemplative and literalist views of Martin as entirely contradictory. They are: but it is the contradiction that is most revealing about

her work—something in the work can somehow be both. How this came to be has much to do with her time in New York at the end of the 1950s. This was the point when, already in her late forties, she came to what we now think of as her trademark grid format. But she came to it in unexpected ways. Hard-won for sure, her visionary sense of infinity came from her working through of an aesthetics of the ephemeral and the everyday alongside a group of artists all working in the Coenties Slip district of New York near the docks and the water. One of the rare photographs of Martin at this time (figure 2.12), taken by Hans Namuth, show her on a rooftop in the city with Ellsworth Kelly and Robert Indiana, among others. Robert Rauschenberg and Jasper Johns lived nearby. This image conveys a kind of camaraderie in the social context of a cityscape that we don't often associate with Martin, who later retreated to the desert of New Mexico and who has come to embody the ideal image of the artist's solitude and enlightenment.

But it is by the docks and the water that I want to start: in 1957, in Coenties Slip, with the buildings of Lower Manhattan behind her. It was not the start for Martin, who already had one career as a teacher behind her (she had taught portrait painting in New Mexico). But the work she began to produce at this time relates to an aesthetics of the thrown-away that was prevalent in New York at the time. Ellsworth Kelly approached abstraction as if segments of color and shape were ready-made, while Robert Indiana was incorporating large found objects and materials from the docks, and so was Martin, admittedly on a rather different scale. Martin's assemblages from this time were small. *Water* is made of oil, wire, bottle caps, and wood. Strung up and down, the wire creates a literally striated surface between which the ground is glimpsed. Nine bottle caps fix the nodal points of a grid. Martin's later paintings abandon the ready-made materials and keep the format. Barbara Haskell has described her works that draw on found materials as "more like talismans."[5] She has said that Martin found them "too indebted to material reality" and abandoned them. This trope of renunciation, of a retreat inward to spiritual essence, prescient, even, of her later withdrawal to the desert, has come to dominate the way Martin is thought about as an artist.[6] Yet what could be more material than her concern with the medium, her laborious weaving of surface? There is something more like a trade-off of one

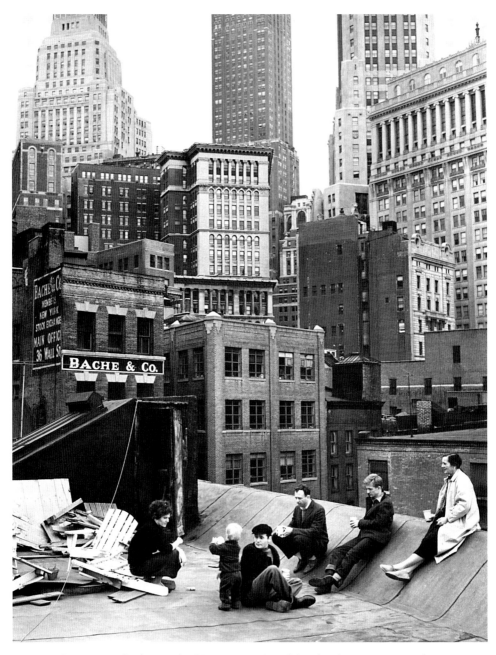

2.12 Hans Namuth, photograph of Agnes Martin (at right) with Jack Youngerman, Robert Indiana, Ellsworth Kelly, et al. on the rooftop of the Coenties Slip building, 1957. © 1991 Hans Namuth Estate. Courtesy of Center for Creative Photography, The University of Arizona.

kind of material for another. She would substitute the ready-made wire line for a drawn one—one that did not deploy the fragment but aimed at some kind of completeness—a sense of completeness she suggested by surrounding her grids with a border that, as Judd said, stopped them from being seen as part of an extended continuum.[7]

This move was crucial for Martin, but far from straightforward. Her work from the very early 1960s makes this clear. While the logic of the grid seems overwhelming, she nonetheless moves in several directions at once. The renunciation of the found elements is neither as sudden nor as revelatory as it seems. She continued to use these elements in works like *Untitled* (figure 2.13) from 1962, in which the pencil-drawn grid alternates with the tiny, shiny heads of brass nails that she has pierced through the canvas. But maybe the found quality persists; maybe she found pen and paper instead; maybe the template of the grid, once she found it, was ready-made enough.

In her drawings in black ink on paper from 1960, Martin played on these permutations in multiple registers. In *Untitled* of 1960 (figure 2.14) the outside edges of a square are repeated three times, making a distinct frame or border. Inside the square frame is a grid of rectangles (each twice the height of their width); the vertical lines of the grid are drawn over by shorter horizontals making seven broader vertical panels, the edges of which are uneven, making eight erratic bands of white. The balance between regularity and irregularity, precision and imprecision, accent and interval, is precariously maintained, just. This work is one of the earliest in the series, and Martin takes up a similar format in *The Dark River,* the large painting she made the following year. Others in the series alternate and interrupt the grid in a variety of ways, overlaying it with hieroglyph-type arcs and lozenge shapes or reducing it to Morse-like dots and dashes. The all-over covering of a surface is, it seems, made up of these essential discontinuities. The differences are endless; the grids are repetitive but never mechanical.

Martin certainly abandons the debris of the docks of her assemblages from the late 1950s. But in a way, I think she does not so much abandon its ethos so completely as substitute for it another kind of ephemera—and that is the ephemera and disposability of drawing itself. Conventionally, drawings are smaller

2.13 Agnes Martin, *Untitled,* 1962. Gesso, graphite, and brass nails on canvas, 30.5 × 30.5 cm. San Diego Museum of Contemporary Art, La Jolla, California. © Agnes Martin, courtesy of PaceWildenstein. Photograph by Philipp Scholz Ritterman.

2.14 Agnes Martin, *Untitled,* 1960. Ink on paper, 30.2 × 23.8 cm. Whitney Museum of American Art, New York. Purchase, with funds from the M. Anthony Fisher Purchase Fund and the National Endowment for the Arts. © Agnes Martin, courtesy of PaceWildenstein.

in scale than painting, and Martin's are mostly under ten inches square. They are in ink on paper, or in pencil, or crayon, or watercolor. Ephemeral, fragile, habitual, disposable. Resolutely opposed to the fragmentary, and yet somehow sharing its status. This is a move out of an aesthetics of the fragment and the ordinary while maintaining that sense of the partial and quotidian that underpinned it—self-contained things that come to embrace the infinite but resist becoming totalities.

In *Untitled* of 1963 (figure 2.15) Martin used red ink to trace a small, simple, regular grid, framed by a single line that leaves a definite border. As they terminate, the lines create tiny puddles of ink down the right-hand side and the bottom of the grid. These are literally differences at the margins, a series of terminal points. At times the lines are doubled or traced over, differentiating the thickness of the lines like an uneven weave. Ann Wilson has written of Martin's grids as "maps, calculations of the spaciousness of spirit."[8] But in a way what is calculated, like a mental diagram, are incalculable, infinite differences. Lines that escape geometry are for Deleuze "fugitives from geometricization"[9] (in French, the lines of perspective are called *lignes de fuite*—a term that embodies the contradiction; they both make and escape the system of perspectival construction). Outside the realm of perspective, the fugitive line becomes that which constructs and escapes the system, as lifelines from a commodity culture predicated upon obsolescence. This is a powerful idea. Using the simplest of means, there is something oddly archaic in Martin's medium: the line's residue on a page, the trace of ink across it, the tiny puddle at the end of a line, at the point of a line's termination. When she uses pencil in her painting *Leaf* over a light acrylic wash, the drawing looks hard on the monochrome white surface; yet it is discontinuous and furrowed, fading even as it covers the uneven ground of the canvas. It is almost as if it is the ghostly trace of something marginal and ephemeral. Not so much obsolescence as the act of disappearing.

So, what is it to substitute drawing for the ready-made? It is to use drawing as if it were a material, which is to say that graphite, or ink, or wash can create intense, if understated, material differences. It is striking that Martin does not draw a distinction between drawing and painting. On the contrary, she collapses it. The distinction instead is in her use of scale. Although the size of her paint-

2.15 Agnes Martin, *Untitled,* 1963. Ink on paper, 21 × 21 cm. Collection of Emily Fisher Landau, New York (Amart Investments LLC). © Agnes Martin, courtesy of PaceWildenstein.

ings has changed over the years, through the 1960s there was remarkable consistency in the two sizes she worked with: the small drawings, the larger paintings. Finding significance in the small, the infinitesimal, the merest shift of tone is common to both. At stake here is that which escapes the symbolic. Martin would see in this a spirituality resonant with Eastern forms of thought, where the infinite is expressed in a grain of sand or a blade of grass. She later wrote, "Look between the rain, the drops are insular,"[10] insisting on the significance of the in-

finitesimal difference between things: everything is in the interval. Curiously, there is also something Whitmanesque in this, as indeed there is in the style of her writing *about* her work—which I think needs to be read as a kind of poetic writing. In Whitman's poetry, the subject absorbs the manifold in perception. There is even something of the epic of Whitman's *Leaves of Grass* when she writes, "There is only the all of the all / everything is that / every infinitesimal thought and action is part and parcel."[11] This invokes a subject absorbing like blotting paper the infinite patchwork of life yet transformed inward by Martin to explore the subject's interiority. Repetition sets in train a self-reference so intense that it is like an interior monologue. No dream of camaraderie, but a dream of solitude.[12] This turning inward may also have been for Martin a necessary if uneasy trade. Imposing strict limits on her format enabled her to increase the play of difference within it. Rather than constraining difference, repetition allows for maximum difference, exacerbating, even, the multiplication of variables. When she began to use ink and watercolor washes in her small works from 1960, she added another register of difference while maintaining the grid format. In combination with pencil drawing, she was able to create a number of different opacities, the grid suspended across the field of wash, sometimes watery and very loosely worked. The washes tend to expand the surface area, while the marks of the schematic grid constrain it. Sometimes the dryness of graphite is offset by the once liquid strokes of colored wash. Henri Michaux had seen "this leakage from the line of my drawing . . . [as] a kind of dissolution."[13] But the leakage that seems most to interest Martin at this time is that of the edge. The blue wash seeps over the ink line containing the grid. Or more dramatically in *Wood 1* (figure 2.16) from 1963, the grid of black lines is not contained except by a broad band of wash, which extends irregularly on all four corners. Color often looks like a stain because what matters about it are the different textures and nuances it creates as a surface.

Martin would later say that looking at art was like "a simple direct going into a field of vision as you would cross an empty beach to look at the ocean."[14] This sounds simple but deceptively so. Vision is evoked as a kind of crossing. It is not simply looking at the vista before us, but a matter of entering into and moving across a field of vision. Distance—the kind of distance that maintains the

2.16 Agnes Martin, *Wood I,* 1963. Watercolor and graphite on paper, 38.1 × 39.4 cm. Collection of Sarah-Ann and Werner H. Kramarsky. © Agnes Martin, courtesy of Pace Wildenstein.

horizon in its proper place—is collapsed as a kind of limitless depth that engulfs us. The horizon cuts the sky, but it is not fixed and is always relative to the moving spectator. Robert Smithson would see it differently but maintain, "we are lost between the abyss within us and the boundless horizons outside us."[15] "Between" was memory, for Smithson, which became "a wilderness of elsewheres."[16] "Elsewhere" is a wilderness if you live in a city, like Smithson, an ocean if you live in

a desert, as Martin eventually would. Yet in Martin, there is something mythic in the solitary experience of the ocean, where the ocean is not only "formless" but "deathless."[17] It seems to me that Martin's writing is often misunderstood as if it were meant causally—when to invoke the ocean is to invoke in fact a fragment of memory—which may have some correspondence with the experience of art but was certainly not synonymous with it, let alone the cause or the subject matter of it. Martin even said at one point, "Experiences recalled are generally more satisfying and enlightening than the original experience."[18] Somewhat surprisingly she invokes the example of Wordsworth's daffodils which, as vivid memory, flash upon "that inward eye that is the bliss of solitude."[19] Recollection is somehow more vivid, or put another way, original experience is a pale reflection of its repetitions. Repetition is understood as a means not of deadening but of heightening experience, just as infinity is not opposed to the material trace so much as rescued through it.

Martin's place was never clear. There were those who always insisted that she resisted rather than succumbed to repetition—as if to insist on repetition would somehow reduce or misrepresent her. Lucy Lippard, commenting in 1972 on the number of women artists who had drawn on the grid, noted that "Agnes Martin's channels of nuance stretched on a rack of linear tensions which 'destroy the rectangle' are the legendary examples of an unrepetitive use of a repetitive medium."[20] On the contrary, I would want to claim that repetition was necessary to Martin, to create maximum difference, but also as the interminable work of the work. If, for Martin, looking was a kind of *looking for* a lost totality, one that was no longer possible, using means that demonstrated the contemporary impossibility of metaphor, then we can see her standing at a kind of cusp. She saw herself searching for an ideal, which she understood as a memory of perfection—and yet she saw memory as more intense than original experience.[21] I think her writing, which often takes the form of poetry, invoking as I have said a patchwork of memories of nature, demonstrates a kind of longing for a lost totality—whereas in the work we encounter its impossibility. The idea of infinity itself presupposes an incomplete subject, and the work of repetition is the impossibility of completion. This is the crux of it: the contemplative gaze as an infinite extension or unfolding

of memory. A temporary moment of completeness in unpropitious circumstances. What Martin does is to isolate something precarious—like the infinite differences of her grids—and make of them something temporarily cohesive, in a way that enables the loss of oneself, lost in the infinite fabric of surface. The repetition that has exacerbated difference also serves to hold it in place. After all, what would it be to see all those minuscule differences, *really* to see them? It would be like Borges's famous character Funes the Memorious who remembers too much.[22] To remember the veins on the underside of a leaf is one thing; to remember each and every leaf you have ever seen is another—a nightmare scenario. Repetition ensures some regulating pattern of recognition.

The thing about infinity is that it is not a thing: it exists only in the imagination. The point is less what infinity *is* than the operation that it names—an operation that is always uncertain about its object, that calls infinite what exceeds representation and so has to be abandoned. Infinity, after all, is not an object, but exists in the mind as that which is beyond representation. In Martin's scale of things, it's the play between the infinite and the infinitesimal that heads off and so refuses the idea of a single totality. Infinity precisely breaks the bounds of a totality. You could see Martin's grid as a kind of sieve—worlds fall through it. It is a utopian operation, of course, which points to the falling through of what Agnes Martin calls the "ego." It is an ideal space, but it's also actual and quotidian. The art historian George Kubler called actuality the void between events, the interval;[23] Smithson, deeply indebted, called it "a coherent portion of hidden infinity."[24] Actuality and infinity end up being something like the same, where that which falls below the threshold of the visible, or the noticeable, is exhaustively, endlessly, rehearsed. Martin's project is a fierce and relentless seeking out of a utopian vision beneath the threshold of the noticeable, in the least likely place, in the least prepossessing of materials. This is work of the highest ambition, on a par with the ambition of Rothko and Newman for the work art could do, but more akin than theirs, always, to an aesthetics of the thrown away or marginal, which was where she formulated her art.

I am not claiming that there were necessarily internal contradictions in the way Agnes Martin saw her work—the work, and what she says about it, are re-

ally strikingly consistent. In fact, the work has the extraordinary consistency of an interior monologue—its freedoms enormous, its constraints fierce—an essay in solitude only dramatized by the mythic dimensions of her own presumed "retreat" to New Mexico. But from where we stand now, the knot of her concerns are all the more remarkable, I think, because of the way they fit together—not *so* awkwardly, but not entirely seamlessly either: there is the utter concentration, first of all, and yet there is the errant, ephemeral behavior of drawing; it is a space of contemplation, of immateriality, and yet it is also a space of labor, repetitive and meticulous labor. Finally, as has been noted in the best discussion of Martin's work by Rosalind Krauss, there is a split register between the haptic and the optical.[25] While these conflicting registers of Martin's work have hardly figured in the critical literature, they have figured vividly in the way subsequent artists have worked over the field that Martin opens up.

If we take Martin's model as I have described it here, then we can see two rather different serial procedures emerging from it. Neither was a matter of searching for a lost totality. On the one hand there is Eva Hesse, who would produce a series of drawings in 1966 to 1967 in which she drew tiny circles on graph paper (figure 2.17). Martin, in fact, had rejected the circle very early on (*Cow,* her painting from 1960, was the last sign of it). Interviewed later, Agnes Martin said, "I don't like circles—too expanding?"[26] This was not the kind of expansion she wanted. The expansion toward infinity that she *did* want had nothing to do with the kind of hyperbolic addition and absurd inflation that interested Hesse. Hesse, on the other hand, was equally adamant that she didn't want her circles to suggest "life and eternity."[27] She didn't want the metaphysics that attached to the perfect circle; and in a way, my point has been that neither did Martin—she wanted a metaphysics of the ordinary. What she ended up with, I think, is something more radical than that—something in the work that is closer to what the French writer Georges Perec called the "infra-ordinary"—between and beyond the habits of the everyday, with echoes of a Duchampian friction.[28] Martin had begun with the ready-made in various guises (the grid as a "ready-made" format, bits and pieces as "ready-made" materials)—which became for her at the end of the 1950s a kind of eye of the needle through which she had to pass. I think what is inter-

2.17 Eva Hesse, no title, 1967. Ink on graph paper, 11 × 8½ in. Tate Modern, London.
© he Estate of Eva Hesse, courtesy of Hauser & Wirth Zürich London.

esting in the moves Hesse made slightly later is that she worked over some of these same elements, precisely the ones which Agnes Martin had relinquished. Most of all, Hesse restored the ready-made element that Martin had had to abandon—the ready-made "now" of simple graph paper. Hesse's drawings are also highly textured, using the sparest of means to overlay one opacity (of the circles) against another (the grid of the graph paper). There is a kind of blanking out of the subject in Hesse that is paradoxically made possible by Martin's sublation of self.

The other strategy to emerge has to do with the way a surface can be worked using means that are both spare and habitual: the laborious weaving of a surface—as if it were a labor of love. The obsessive aspect of that weaving is certainly there in Hesse—but also in the work of Hanne Darboven, who worked in New York from 1966 to 1968. Numbers, words, and dates fill Darboven's grids to the saturation point. Often using the simple, reduced means of pencil and paper, she copies out by hand vast sequences so that "The writing fills the space as drawing would."[29] And if a line from one of Darboven's works that is a letter to Sol LeWitt reads "writing writing"—as if "writing writing" were the fundamental operation of the work itself—then could we not see Agnes Martin "drawing drawing"? It may seem odd to invoke Darboven, whose material is language, in connection with Martin—who is usually regarded as an artist whose work is thought to resist language at pretty much every level. But maybe Martin's own writing, though not extensive, should alert us to her poetic shaping of words and phrases. And her titles: their invocation of nature has either been seen to support the landscape base of her work—or, conversely, has been seen to be an irrelevance. I must admit I have always tended to put them to one side. I mean here the titles of the large-scale paintings, not the small drawings—*Dark River, Leaf in the Wind, Night Sea,* and so on—the spate of titles she gave in the 1960s before she entered a period of calling everything *Untitled*. I think there is something peculiar about the way the titles relate to the work—which makes Martin look much more canny about language than she is usually assumed to be. Anne Wagner recently talked about Eva Hesse's titles (the kinds of titles like *Addendum* and *Accretion* that she drew from a thesaurus) and presented Hesse as an artist whose work is "afloat on a sea of language"—interested in the gap between ob-

jects and words, where titles are "additions" that are also part of the work itself.[30] I am not saying Martin is as knowing as Hesse on this, but there is a certain significance in her namings from this moment in her career—and it has nothing to do with the sublime, or with the work being *like* nature. Rather, there is a kind of equivalence and a dissonance of experience being conjured. Agnes Martin once talked about the underside of a leaf as "sublimely unemphatic."[31] The statement is certainly revealing about her work but has less to do with the sublime per se than with the matching of it with the "unemphatic." In that delicate tracery, as in the understatement of her drawing, Martin found an equivalence of experience. But I am sure it would be a parody to link that statement any closer to the painting *Leaf* with which I began, because the point surely has to be also one of dislocation. The titles may act as a further provocation to memory, not to a particular memory but to the vividness of isolated memories. If we recall the idea of an interior monologue, then we might think of the way threads of distraction weave through it. The titles often invoke words that stand for natural things at an interval between movement and stillness, the substantial and the insubstantial ("falling leaves," "flower in the wind," "falling blue," "dark river" . . .)—and it's the intervals that count rather than the things themselves. Of course, giving the larger works titles like this and calling the small drawings *Untitled* also registers another sort of interval or gap. Using pencil as her medium against the white acrylic ground in *Leaf* is to introduce something intrusive, ephemeral, modest, into painting—just as the titles do.

Of course I am not suggesting that Eva Hesse or Hanne Darboven were simply influenced by Agnes Martin—or that we should establish an exclusive lineage of women artists—but I do want to suggest that we should attend seriously to the model of abstraction that Agnes Martin managed to shape so rigorously and fearlessly—risking at every turn the very metaphysical subject she so desired. The fugitive quality of the work—the very antithesis of the classic qualities that have so often been claimed for it—stands as a token of the risks involved. As a consequence, infinity, in Martin's imagination, becomes a radical expression of art's possibilities—one that does not simply hark back to a past of metaphysical certainties but opens out a future of doubt. She stands for that moment of immanence, before the possibility of revelation is completely lost.

———

NOTES

Another version of this essay has been published in Briony Fer, *The Infinite Line: Re-making Art after Modernism* (New Haven: Yale University Press, 2004).

1. Robert Smithson, "Quasi-Infinities and the Waning of Space," *Arts Magazine* (November 1966), in Robert Smithson, *The Collected Writings,* ed. Jack Flam (Berkeley: University of California Press, 1996), pp. 34–37.

2. Donald Judd, November 1963, in his *Complete Writings 1959–75* (New York: New York University Press, 1975), p. 112.

3. Donald Judd, review, October 1959, in ibid., p. 2.

4. Lawrence Alloway, "Systemic Painting," in Gregory Battcock, ed., *Minimal Art: A Critical Anthology* (New York: Dutton, 1968), p. 45.

5. Barbara Haskell, "Agnes Martin: The Awareness of Perfection," in Barbara Haskell, *Agnes Martin,* with essays by Rosalind Krauss and Anna Chave (New York: Whitney Museum of Art, 1992), p. 103.

6. The exception to this is Rosalind Krauss's rich phenomenological reading of Agnes Martin in her essay "The /Cloud/," in Haskell, *Agnes Martin,* p. 155.

7. Judd, *Complete Writings,* p. 112.

8. Ann Wilson, "Linear Webs," in *Art & Artists* 1 (October 1966), p. 47.

9. Gilles Deleuze and Félix Guattari, *A Thousand Plateaus: Capitalism and Schizophrenia* (London: Athlone Press, 1988), p. 499.

10. Agnes Martin, "The Untroubled Mind" (1971), in Haskell, *Agnes Martin,* p. 18.

11. Agnes Martin in Haskell, *Agnes Martin,* p. 21.

12. This relates to the idea of the solipsistic that I have discussed in "Hanne Darboven: Seriality and the Time of Solitude," in Michael Corris, ed., *Conceptual Art: Theory, Myth, and Practice* (Cambridge: Cambridge University Press, 2004). It was Mel Bochner who first made the link between solipsism and subjectivity in minimalism in his brilliant essay "Serial Art, Systems, Solipsism," in Battcock, *Minimal Art,* p. 92.

———

13. Henri Michaux, in Catherine de Zegher, ed., *Untitled Passages by Henri Michaux* (New York: Drawing Center; London: Merrell, 2000), p. 63.

14. Agnes Martin, quoted in Wilson, "Linear Webs," p. 48.

15. Robert Smithson, "A Cinematic Atopia" (1971), in *Collected Writings,* p. 140.

16. Ibid., p. 138.

17. Agnes Martin, "Journal Excerpts," in Haskell, *Agnes Martin,* p. 26.

18. Agnes Martin, "What Is Real?" (1976), in Haskell, *Agnes Martin,* p. 26.

19. Ibid., p. 28.

20. Lucy R. Lippard from *Grids* (1972), reprinted in her *The Pink Glass Swan* (New York: New Press, 1995), p. 68.

21. Martin, "What Is Real?," p. 24.

22. Jorge Luis Borges, "Funes the Memorious," in his *Labyrinths* (Harmondsworth: Penguin, 2000), p. 93.

23. George Kubler, *The Shape of Time* (New Haven: Yale University Press, 1962), p. 17.

24. Robert Smithson, "Quasi-Infinities and the Waning of Space," p. 34.

25. Krauss "The /Cloud/," pp. 155–165.

26. Martin, "The Untroubled Mind," p. 14.

27. Eva Hesse in her interview with Cindy Nemser, in Cindy Nemser, *Art Talk: Conversations with 15 Women Artists* (New York: HarperCollins, 1995), pp. 182–183.

28. Georges Perec, sections from *L'Infra-ordinaire,* in his *Species of Spaces and Other Pieces* (Harmondsworth: Penguin, 1997), pp. 203–245.

29. Hanne Darboven, in Ann Goldstein and Anne Rorimer, eds., *Reconsidering the Object of Art, 1965–1975* (Cambridge: MIT Press, 1995), p. 102.

30. Anne Wagner, "Eva Hesse's Titles," paper given at Eva Hesse symposium, San Francisco Museum of Modern Art, April 2002.

31. Martin, "Journal Excerpts," in Haskell, *Agnes Martin,* p. 25.

2.18 Cecilia Vicuña, *Parti si pasión*, 1981. Pigment on pavement. New York.

Catherine de Zegher

Today, two months after September 11, it may seem too pointed to begin by bringing up an image that has been haunting me, but in a concise way it prefigures many issues I will speak of. It is an image of a work by the Chilean artist and poet Cecilia Vicuña, who has been living in New York for many years. The work dates from 1981 and shows a word drawn in three colors of pigment (white, blue, and red—also the colors of the American flag) on the pavement of the West Side Highway with the World Trade Center on the horizon. It reads in Spanish: *Parti si pasión* [Participation] (figure 2.18), which Vicuña unravels as "to say yes in passion, or to partake of suffering." Revealing aspects of empathy, connectivity, and compassion, the word spelled out on the road was as ephemeral as its meaning remained for the art world. Unnoticed and unacknowledged, it disappeared in dust, but becomes intelligible in the present. This precarious work tells us how certain art practices, in their continuous effort to press forward a different perception of the world, have a visionary content that is marginalized because of fixed conventional readings of art, but nevertheless is bound to be recognized. I will seek to uncover the latency of this kind of work in the second half of the twentieth century, work that is slowly coming to the fore and now understood because of feminist practice, but perhaps also because of an abruptly changed reality. Focusing on the work of two South American artists—Lygia

Clark (1920–1988) and Anna Maria Maiolino (born in 1942), both from Brazil—I will address the topic of "the relational as the radical."

In a woodcut from 1967 by Anna Maria Maiolino, two abstract figures, mouths wide open, without eyes, face a void. Across their massive shoulders they connect by crying out together, like parents of a lost child, the name *Anna* (figure 2.19). Insistently, beneath the carved elemental shapes in this woodcut, the name is repeated. Where above it is in white script in a speech bubble against a black background as the wood was incised and cut from the matrix, it now stands in black block letters, the remnant of the wood itself—just as are the howling mouths and the dark unexplored space surrounding the ghostly white busts. Maiolino began making woodcuts in the 1960s on settling in Rio de Janeiro. Born during World War II in Calabria, she had immigrated to South America at the age of twelve with her family, escaping postwar famine and poverty in south–

2.19 Anna Maria Maiolino, *Anna,* 1967. Xylograph (edition of 20), 26 × 18¹⁵⁄₁₆ in. Museu de Arte Moderna do Rio de Janeiro.

ern Italy, and had moved again from Venezuela to Brazil at eighteen years old. Dealing with the wounding difficulties a migrant inevitably encounters—one mouth too many and incomprehensible speech—Maiolino's work, from the very beginning, relates food to language and language to food. Attached to a vanished place and always feeling elsewhere, she belongs nowhere, except at the nexus of two othernesses, the having been and the endlessly deferred. Her life is filled with a resonance and reasoning cut off from the body's bittersweet memory of child-hood: the mother's tongue and breast. According to Julia Kristeva, once in a new land, "you experience as murderous those natives who never speak of your close relatives—sure, they were close in the past and elsewhere, unmentionable, buried in another language. . . . But, by the way, who is the murderer? The one who does not know my relatives, or myself, as I erect my new life like a fragile mau-soleum where their shadowy figure is integrated, like a corpse, at the source of my wandering?"[1]

Maiolino's early woodcut *Anna,* a self-portrait as a palindrome, seems to trace a split identity: Perhaps one becomes a stranger in another country because one is already a stranger from within? At once its verso and recto, *Anna* is double: positive and negative, black and white, absent and present, out and in. Divided in the middle, between languages, her realm would be of silence and muteness, if she had not chosen instead for it to be of mutation on a borderline conceived as an axis of mobility. This state of being implies choice, desire, surprise, breaks, and adaptations, but never rest or regularity. Living out a lost origin and the im-possibility of taking root, the artist soon comes to understand that her time is the present in abeyance: always at a new beginning, in action, in transition, where change happens. The new language, although Maiolino knows that she will never be part of it, overwhelmingly feels like a resurrection: new soil, new skin, new sex. In an attempt to join the separate parts of the traumatic division that is the migrant's condition, her work overflows with pathos, anguish, and energy. Settled, yet within herself, lacking confidence, the foreigner feels as though without self, living according to circumstances and others' wishes—she is other: "I" does not belong to "me," . . . do "I" exist at all? This fragmentation and parceling, threatening to bring her thought and speech into chaotic confusion,

drives Maiolino to a constant search for fusion, "in which there are not two beings, there is but a single one who is consumed, complete, annihilated."[2] Her neoconcrete drawing *Secret Poem (me +thou)* (1971) reveals, as it conceals, a beautiful synthesis of this errancy as being, as being-in-relation.

Etched in 1971 after her return to Brazil from New York, where Maiolino stayed for three years and learned about minimalism and conceptualism, *Escape Point* (figure 2.20) consists of horizontal lines finding their way out of an enclosing square, as if the mind were losing its geometrical homeland and the spirit drifting. A dialectics of division that governs all thought of inside and outside, positive and negative, runs through her work but is constantly being negotiated, since the space of separation between these simple diametrical oppositions of form, which are often inflected with hostility and alienation, is subject to reconnection within a process of transformation. Inside and outside, in the escapade of her imagination, are experienced as transiting the borderline indicated by A and B in her etching *Escape Point,* and are no longer seen in terms merely of their antagonism, but as multiplying in countless diverse nuances of reciprocity. This lesson in ontological amplification encourages Maiolino to experiment further with paper, which, no longer a surface for her figurative and abstract drawing, she begins to use as "space and body." As Maiolino explains:

> The matrix or plate used in the engraving process necessarily brings
> about our intimacy with the outside and the inside of the space of
> the impression. I was intrigued by the space at the reverse side of the
> paper: what is behind it, what is out of sight—the other space being
> that of the absent, the latent, the concealed. I began to print both the
> front- and backsides of the paper. Then, through cutting, tearing and
> folding, I was able to discover what was printed on the reverse and
> to incorporate it in the work together with the void left by the re
> moval of the paper cut or torn from it. As a result of this spontaneous
> and aggressive gesture, the cut and tear will then suddenly be sewn,
> out of repentance.[3]

2.20 Anna Maria Maiolino, *Escape Point*, 1971. Etching and transfer letters on paper (edition of 30), 27⅜ × 20⅛ in. The Museum of Modern Art, New York.

2.21 Anna Maria Maiolino, *Starry Sky,* 1976. From the *Drawing Objects* series. Thread on paper in wooden box, 10 ⁷⁄₁₆ × 12⅛ × 2⅜ in. Private collection.

The *Print Objects* and *Drawing Objects* of 1971 to 1976 (figure 2.21) show a fluidity, in which—as at a tide line—inside and outside are not abandoned to their geometrical opposition, but remain, however briefly, in ebb and flow between intimate and undetermined space. For Maiolino they suggest "the existence of *fullness in the empty.*"

The attempt to fuse dichotomies and explore the material's corporeity in two- and three-dimensional space would situate Maiolino's work close to art practices linked on the one hand to (eccentric) minimalism in New York, such as that of Eva Hesse (1936–1970), and on the other hand to those of neoconcretism in Rio de Janeiro. Although Maiolino was never exposed to the work of Hesse (another immigrant, also because of World War II), several aspects of the dimensional, the repetitive, the gestural, and the visceral in their oeuvre uncannily interconnect over time. Leaving the picture plane, the lines in Hesse's work gradually materialize as cords in her reliefs of the mid-1960s, such as *Tomorrow's Apples* (figure 2.22),

2.22 Eva Hesse, *Tomorrow's Apples (5 in White)*, 1965. Enamel paint, gouache, and mixed media on chipboard, 25¾ × 21⅞ × 6¼ in. Tate Gallery, London. © The Estate of Eva Hesse, courtesy of Hauser & Wirth Zürich London.

and in her later spatial wire pieces (e.g., *Right After,* 1969). The artist's desire to release the line into space as well as her reluctance to assimilate perfect geometric shapes in a grid provide insight into how she negotiates the binary in her work. Her circle drawings such as *Untitled* of 1967 (figure 2.23), outlined on semiobscured grids filled with concentric circles and graded in subtle washes of gray ink, borrow minimal abstract serial structures but rely on expressive facture to abrade their even finishes and regular edges. The ethereal degradation of grays often applied in the drawings and painted onto works in wood and papier-mâché, such as *Ishtar* (1965) and *Constant* (1967), again reflect this urge to undo contrasts. Through the fluent transition and dissolution of black-and-white colors into a set of relating nuances of gray, in which "the one color lets the other be," she explores "how perception can be imperceptibly changed," to use the words of Vicuña. A master narrative of the whole is intricately challenged as Hesse develops her work further: "In the late work, she caused parts to stand together, but not to do much more than stand together. Her point of view on systems was her perspective on how parts are to be *with* each other. The task was to create a complete whole that was not a false image or example of completeness or of wholeness. . . . For Hesse, gradually to exist was to *stand out and/or with* upon thresholds of the undecidable, uncertain, and uncomplete, with the courage to construct inconclusive experiences of visual moments in transition from meaningless materiality to—almost—*being together with in a whole.*"[4] In her work, often the seam would outline parts joined *with* each other evoking a transition to a whole, however impermanently, without completing the transition: parts placed near enough to each other to be with each other but not lost in each other. Made with the fugitive medium of latex, *Schema* and *Sequel* (see figures 2.31, 2.32) chart this relation and also the course from prescribed order to infinite variability, including the hemispheres themselves as they appear similar though all vary slightly due to inconsistent fabrication.

Then again, during the 1960s and early 1970s in Rio de Janeiro, Maiolino's encounters with Hélio Oiticica (1937–1980) and Lygia Clark clearly had an impact on the development of her work. Cofounders of the neoconcrete movement (1959–61), Oiticica and Clark reacted against their São Paulo counterparts who

2.23 Eva Hesse, no title, 1967. Ink and pencil on paper on board with nylon string, 14⅞ × 14⅞ × 1¼ in. Collection of Tony and Gail Ganz, Los Angeles. © The Estate of Eva Hesse, courtesy of Hauser & Wirth Zürich London.

embraced the early, or concrete, phase of constructivism in Brazil, which drew heavily on the mathematical abstraction of Max Bill, purely optical explorations, and ideas for "scientifically" integrating art into industrial society. Against what they considered to be a lifeless formalism, yet without leaving the language of geometric abstraction or the general concerns of constructivism, they proposed in the *Manifesto neoconcreto* "to look for an equivalent to the work of art, not in the

machine, or even the object as such, but . . . in living organisms."[5] Retaining some constructivist principles, such as the importance given to the material's properties and the perception of structures generated through their action, Lygia Clark revitalizes the geometry in an attempt to reveal its "processuality" by freeing "the line in the plane" from its supposedly inanimate condition to recover its vitality and to transform space. The emptiness of the seam between the planes in *Modulated Surfaces* (1958) becomes an actual "line-space," which she calls the "organic line." The two-dimensional plane, now pregnant from its fertilization by space and revealing the nascent presence of the relief, is outspread and distended to become a three-dimensional articulation. In *The Inside Is the Outside* (1963) (figure 2.24), Clark's proposal of the "organic" is concerned with the fusing of opposites—inside and outside, the subjective and the objective, the erotic and the ascetic—and is marked by the rebellion against the dissociating experience of what she calls the "empty-full" in subjectivity. As Clark already writes about the work *Caminhando* in 1963: "The act makes contemporary man aware that the poetic is not outside him but within him and that he had always projected it by means of the object called art."[6]

In the 1970s, Maiolino developed strategies from neoconcretism that, for a while, paralleled Clark's strategies related to one of modern art's most pressing issues: the reconnection of art and life. According to Suely Rolnik, their aim was to "liberate the artistic object from its formalist inertia and its mythifying aura by creating 'living objects' in which could be glimpsed the forces, the endless process, the vital strength that stirs in everything, and by freeing the spectator from his or her soporific inertia."[7] The works most connecting both artists are Lygia Clark's 1973 organized group experiments in Paris of *Cannibalism* and *Baba antropofágica* (figure 2.25) and Maiolino's super-8 film *In-Out (Antropofagia)* (figure 2.26), also from 1973, shot in Rio de Janeiro. Apart from linking food and language in saliva, their titles are inspired by the modern Brazilian theory of *antropofagia* (or cannibalism). In the 1920s, Tarsila do Amaral and Oswaldo de Andrade formulated this theory of a cultural melting pot, in which they meshed the modernist movement, first futurism and later primitivism, with an African heritage in their country. Amaral in her painting (*Antropofagia,* 1929) and Andrade in his

2.24 Lygia Clark, *The Inside Is the Outside*, 1963. Courtesy of Estate of Lygia Clark.

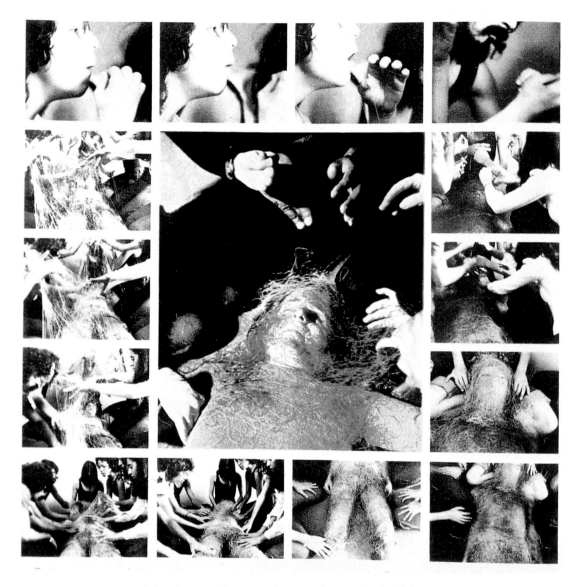

2.25 Lygia Clark, *Baba antropofágica*, 1973. Courtesy of Estate of Lygia Clark.

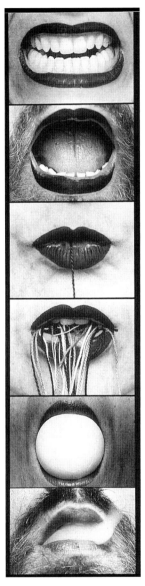

2.26 Anna Maria Maiolino, stills from the film *In-Out (Antropofagia)*, 1973. Black and white Super 8 film, transferred to video in 2000; 8 minutes 14 seconds. Collection of the artist.

Manifesto antropófago (1928)—declaring "Only cannibalism unites us"—searched for a hybrid national culture in which the spiritual, native, African, and European elements were brought together and appropriated in an act of devouring and digestion. Andrade's manifesto became the basic textbook of twentieth-century art in Brazil, including the neoconcretist movement and the social relevance of its art. In Clark's *Baba antropofágica,* the participants expel threads from cotton reels in their mouths, projecting "cannibalistic slobber" onto a reclining body: "In this ritual, bodies affect other bodies until their intertwined emanations form a mold of saliva-moistened thread about the affected body. While still damp, the mold is removed, like a placenta from some collective womb from which a new body is born, sculpted by all, . . . not through identification (each one 'becoming like the other') but through contamination (each one 'becoming another')."[8] In this exploratory in-between space of relation, Clark continues to make art using a conversational model of recognition and exchange that she materializes in a web of connecting lines or "relational objects."[9] In Maiolino's film the camera successively focuses on two alternating mouths, which occupy the entire space of the screen: a woman's and a man's. At the beginning, the mouth is gagged with adhesive tape, making it impossible to speak or eat; it is censored, but then it appears no longer gagged, attempting to articulate some speech—the utterance of a beginning language. A long black thread is swallowed and re-emerges from the mouth that ejects it in a vomit of colored filaments.

Touching upon the theory of antropofagia and reclaiming access to the body as a hybrid site of a permanent reinvention of existence, Clark increasingly explores the therapeutic potential of her artistic proposition through her "relational objects," with which, from 1976 to 1982, she treated many individuals in her studio, while Maiolino promotes subjectivity as relational, constituted from the vibrant dynamic of molding oneself in an encounter with the other through the pulsing life in all daily things and trivial gestures. Insisting on the idea of "living organisms" in regards to art, Maiolino took part in Oiticica's exhibition *Vagrant Myths* (1978) with two radical projects: *Monument to Hunger* (figure 2.27), consisting of two sacks, one of white rice and one of black beans, tied together with a ribbon and placed on a table in a square; and *Scatological State* (figure 2.28),

2.27 Anna Maria Maiolino, *Monumento à fome* (Monument to Hunger), in the exhibition *Mitos vadios* (Vagrant Myths), 1978.

2.28 Anna Maria Maiolino, *Estado escatológico* (Scatological State), in the exhibition *Mitos vadios* (Vagrant Myths), 1978. Toilet paper, newspaper, branches, and leaves against wall.

mounting various types of toilet paper to a street wall. The works evince activity at both ends of the alimentary canal, which flows as an imaginary line of transformation between them. In *Scatological State,* where the materials range from the most expensive to the cheapest toilet paper, a newspaper, and a plant leaf, Maiolino also points to the state of equality among us all, even if the State and its systems continuously try to institute hierarchy. The work deals ironically with the pretensions of the rich consumer and the market, which strives to confer status and differentiation through the most common bodily denominator. The digestive tract, which lies between in and out, and its capacity to transform can be likened to the artistic trajectory, and its unforeseeable becomings, as a commonalty, equal and accessible among all of us. Here art is not about an image or a sense of the world expressed by the artist in the transference of myths, but about the power of permanent creation in the sensing of self and the world, which every person, as a living being, eventually possesses. The dual work presented in the *Vagrant Myths* exhibition, invoking oral and anal somatic processes, seems to be crucial in Maiolino's approach to the body, as she connects what goes in and out of every body and exemplifies its ability to create through its orifices onto paper.[10] From the very beginning, *Glu Glu Glu . . .* , a painted high relief (1966) and engraving (1967; figure 2.29) with the same title, picture this idea in a divided scene: depicted in the upper part is the bust of a body with mouth wide open in front of food, and in the lower part an alimentary canal (in the high-relief) and a toilet (in the woodcut). These early works on paper anticipate the later works in clay from the 1990s as the explicit materialization of Maiolino's purpose to awaken the perception of the creative vitality in all, not only in the artist.

If Maiolino embraces the imperatives of neoconcretism, she also negotiates her practice through a complex set of permutations of neo–avantgarde art idioms in Europe and in the United States. The recognition of the body itself as force and energy sometimes gave rise to an art, gestural and magmatic, defining itself by action and the *informe.* In action painting and *l'art informel,* the materials of art were transformed by the artists' bodies spilling on and penetrating the canvas, as if to reach into the area of life itself. In postwar Europe, producing this art meant to incorporate one's own body and make manifest the convulsive and

2.29 Anna Maria Maiolino, *Glu Glu Glu* . . . , 1967. Xylograph, 26 × 18¹⁵⁄₁₆ in.
Edition of 20. Museu de Arte Contemporânea de São Paulo.

2.30 Piero Manzoni, *Achrome*, 1961–62. Bread on canvas. © 2002 Artists Rights Society (ARS), New York / SIAE, Rome.

chaotic movement of existential drives in order to find another dimension grounded in everyday experience. Departing from the antithesis of metaphysics and corporeality, of sublimity and contingency, Piero Manzoni (1933–1963) is one of those artists most clearly countering the claims, particularly of Lucio Fontana (1899–1969), for a space beyond matter. Reminiscent of Manzoni's *Achromes* (1961–62) (figure 2.30) with bread rolls and kaolin on canvas and also of Hesse's *Schema* and *Sequel* (figures 2.31, 2.32), Maiolino's clay sculptures, the *Others* series (1990–95) and the *Codicilli* series (1993–2000) (figure 2.33), result from quotidian gestures that are repeated over and over each day, without our being aware of them, driven by primordial impulses and vital actions in the process of life. At the start, her sculptural procedure follows the familiar casting method, developing in three phases: the object is molded in clay (a positive) to *execute* the mold (a negative) of the final form in plaster or cement (a positive). Shaped through this process, her reliefs come more and more to assemble signs of a new language as well as to resemble food displayed on a tray. Maiolino's molding ges-

2.31 Eva Hesse, *Schema*, 1967. Latex, 42 × 42 in. © The Estate of Eva Hesse, courtesy of Hauser & Wirth Zürich London.

2.32 Eva Hesse, *Sequel*, 1967–68. Latex, pigment, and cheesecloth, 30 × 32 in. © The Estate of Eva Hesse, courtesy of Hauser & Wirth Zürich London.

2.33 Anna Maria Maiolino, *Untitled,* 1993, from the *Codicilli* series. Cement (edition of 6, each unique), 16⅛ × 18⅛ × 2⅜ in. Collection of the artist.

tures, paralleling the tasks of *la cucina italiana,* increasingly manipulate the earth as dough. Slowly, the father's land and the mother's bread collapse into the fermentation of the abject I, as Kristeva formulates it: "Nausea makes me balk at that milk cream, separates me from the mother and father who proffer it. 'I' want none of that element, sign of their desire; 'I' do not want to listen, 'I' do not assimilate it, 'I' expel it. But since the food is not an 'other' for 'me,' who am only in their desire, I expel *myself,* I spit *myself* out, I abject *myself* within the same motion through which 'I' claim to establish myself."[11] In Maiolino's body of work, form is at once dynamically affirmed and annulled, "in search for an identification that never ends, thereby necessitating the action of another gesture to sustain desire." Seeking confirmation of a subjectivity within a multiplication of clay forms, the artist, in an endless repetition and proliferation of drives, now invades the space with an installation of which the resembling parts slightly differ, though formed from one and the same mold: *One, None, One Hundred Thousand* (1993).

Almost at the same time Maiolino starts to develop work in clay that results from the arrest of the casting procedure at the second phase. *The Shadow of the Other* (1993), *The Absent* (1993–96), *It's What Is Missing* (1995–96), and *In & Out* (1995) consist of the retrieved negative itself. The titles of these works refer to the existence of the opposite, the absent positive that has been separated from the remaining negative. They incorporate the nostalgia for the matrix, since they formed one body at a given moment during the process of making the molded sculpture. As in the *Print Objects* and the *Drawing Objects,* Maiolino repeats the attempt to make the other side, in this case, of the paper—the negative—active and participatory. The mold, usually forgotten and discarded, is "endowed with new value by the emphasis given to its generative properties, to the vacant space, in which the memory of the other exists in its not being there: the positive-present in absence."[12] Yet, in the 1995 works *Many* (figure 2.34) and *More Than One Thousand,* the clay is worked on site and left to dry without any mold. These works assimilate the first and third phases of the casting procedure, consisting only of the handmade positive forms, all the same and different, paradoxically propagating like preindustrial craft objects on an assembly line or excremental shapes from a geological eruption. According to Maiolino, "the topological accumulation of

2.34 Anna Maria Maiolino, *Muitos* (Many), 1995, detail, from the *Terra modelada* series. Clay, dimensions variable. Installation at the Kanaal Art Foundation, Kortrijk, Belgium.

these same/different forms, like the sight of a tilled field with its imprints of man and cultivation, is moving." The artist now identifies herself as the ploughwoman of language—the cultivator who steadily and laboriously cleaves, cuts, lifts, and turns over soil in preparing a seedbed and infusing the earth with a fecal fertilizer. The discharge in her work is in fact a matter of uprooting oneself from that clinging "remnant of earth." Maiolino's association of the earth's power—eschatological and scatological—to suddenly shift, split, and excrete establishes a connection to language and its subversion. As she maps the construction of the "I" across private and public spheres, she realizes that the politics of shit converge with the policing and cleansing of language in the construction of a centralized

capitalist state.[13] In many ways, the history of shit thus becomes the history of subjectivity, since the formation of the subject relates to language as well as to "the 'abject,' which designates that which has been expelled from the body, discharged as excrement, literally rendered 'Other.' This appears as an expulsion of alien elements, but the alien is effectively established through this expulsion. The construction of the 'not-me' as the abject establishes the boundaries of the body which are also the first contours of the subject."[14]

Awaiting disintegration (like the works of Manzoni and Hesse), the most recent clay formations appear as either chaotic heaps of clinging earthy remnants, or as perfectly well-organized items on tables and shelves. Depending on the size of the sculptural installation, this methodical arrangement of *informe* forms and minimal clots often resembles the storing of paste on trays in a domestic cupboard or industrial baking oven. Alternately, they recall the Sadean apogee of systematization in the display of scatological matter for consumption. Besides the reference to the manufacturing of ceramics, the analogy substantially covers the alimentary cycle from food to feces as the "basest" human products. In this digestive excursus from the nutritive to the excremental, the artist as molding is the medium between what goes in and out of the body. The casting mold is the palm of her hand doing as her will and the "will" of the material together indicate. It is within this action of the hand that positive and negative collapse. Like the rejected mold, which was once the generative and uniting matrix, Maiolino's body as mediating between in and out, between positive and negative, between chaos and system is, at the stage of presentation, outcast. Through her affirmation and abjection within the same motion, she not only externalizes the inner process of intestinal molding as a semiotic activity of creation accessible to everybody, but also, in living the point of mutation itself, she eventually succeeds in merging separate parts of self and other. The transformational linking and flexible interaction between both opponents of "inner" and "outer" allows, at this point, for a fusion that synthesizes the permanent process of reinventing subjectivity and its mode of existence. Investing the body by divesting the object, Maiolino seems to pick up Clark's assertion at the end of her life that "the art is the body."[15] Whereas Clark, before her sudden death, speaks and writes of this next phase in her work, Maiolino realizes it by making

each one of us aware of being "the living structure of a biological and cellular architecture,"[16] agitated by the dynamic of constant differentiation and fusion.

Following Kristeva's *The Powers of Horror: An Essay on Abjection,* Judith Butler argues: "What constitutes through division the 'inner' and 'outer' worlds of the subject is a border and boundary tenuously maintained for the purposes of social regulation and control. The boundary between inner and outer is confounded by those excremental passages in which the inner effectively becomes outer, and this excreting function becomes, as it were, the model by which other forms of identity formation are accomplished. In effect, this is the mode by which the Others become shit."[17] Questioning a binary distinction that consolidates the coherent subject, Maiolino's mediation blurs the borderline in her visualizing these excremental passages as transformational links between food and feces, inner and outer, positive and negative, black and white, empty and full, conceiving of creativity in the relation between self and other. Thus her work challenges the modalities based on the phallic paradigm of rejection or assimilation, aggression or identification, which shape how art is viewed as much as how societies treat immigrants. Indeed, again turning to Butler, it becomes clear that "the boundary of the body as well as the distinction between internal and external is established through the ejection and transvaluation of something originally part of identity into a defiling otherness. . . . To understand sexism, homophobia, and racism, the repudiation of bodies for their sex, sexuality, and/or color is an 'expulsion' followed by a 'repulsion' that founds and consolidates culturally hegemonic identities along sex/race/sexuality axes of differentiation."[18]

There have been, of course, many artists attempting to shift this phallic paradigm, such as Nancy Spero, Martha Rosler, and Mary Kelly, to name a few. Torn between an old, by now institutionalized language, part of an all-pervasive imperialism, and a new language, they have challenged the preconceptions of modernism by recognizing a great potential in notions of relation and connectivity in a larger understanding of what art can be—though first they had to state the self as woman in their work. Using words like matrix, pregnancy, relational objects, and empty/full, the work of Lygia Clark and Anna Maria Maiolino was for a long time perceived as ambiguous, but their experiments in art are now being recog-

nized. In Clark's case, the relational to the extent of healing was recuperated in psychoanalytical terms of therapy, which has imprisoned it for a while. Perhaps the artist herself was responsible for it, as in her last works she called herself a therapist and frequently used psychoanalytic concepts to interpret the experiences of the so-called patients who entered into her proposition of the structuring of the self. During the so-called session, the possibility of permanent creation was assessed in the person's sensing of self and the world. Being innovative, her artistic proposition had no other theory at the time than psychoanalysis to lean on for apprehending its radicality in regard to work with subjectivity within relation. Art critics did not recognize this turn in her work, nor did psychoanalysts. However, in reestablishing the link between art and life in the spectator's subjectivity, Clark's proposition bridges the separation between the artistic domain and psychotherapy. According to Rolnik, "Clark creates a territory, situated neither in the sphere of art as a department of social life specializing in semiotic activities, where access to the creative power of life is confined; nor in the sphere of therapy, specialized in treating a subjectivity separated from this power—it is a new territory."[19]

In a similar way, and consequently also running the risk of being seen as falling between two fields of experiment and knowledge, artist and psychoanalyst Bracha Ettinger has set out for herself the daring task of integrating both practices and developing a groundbreaking theory. In the elaboration of her work generated by this suspension, "the in-between" as the space of co-emergence, relational and fluid, became hers in theory and practice. This shifting experience and blurring of boundaries between the self and the other are embodied in her drawing, painting, and writing on trauma, memory traces, exile, and history as she considers the status of representation, the gaze, and the mark. Using a photocopy machine that she stops mid-run, the artist removes the image as it is still appearing from the process and works the residue of dusty ink from the copy into the paint. The textured images, often of family photographs, old newspaper photographs of Holocaust victims, and aerial views taken from different war archives, copied repeatedly to lose detail, evoke an impression of a past haunting the present—traces of lost generations. In her studio, the displayed works never seem to

settle, as she unhooks them from the wall, one by one, to rework each in a continuous reiteration. More recently, Ettinger has come to carry through this painting process during her practice as an analyst while she listens to her patients. In recognizing this "self-otherness," she traces, within layers of mark upon mark, the moment of thought being shared, as it belongs neither to the one nor to the other alone. Traces from this encounter are carried over into the conversation, traces not always from the trauma of the one who is in front of the analyst, but traces transmitted from the trauma of another in the patient's psyche. Her working method is not specific to a particular encounter with a person and goes beyond expressing these thoughts or feelings, since sometimes, over the course of several years, different traces from different encounters at different moments slowly accumulate on the same sheet of paper. In a way, she is securing the exchange and giving it a visual voice. Her practice has enabled her to theorize and name this new concept of the "matrixial" gaze alongside the phallic gaze. The matrix is "an unconscious space of simultaneous emergence and fading of the *I* and the unknown *non-I;* matrix is a shared borderspace in which *differentiation-in-co-emergence* and *distance-in-proximity* are continuously rehoned and reorganized by metramorphosis."[20]

Some artists treat the work of art less as an object and more as a process that "creates" the subject. They have submitted the complex structure of visual language to critical analysis, while also increasingly drawing on ideas of the relational that emerge in art-making. During the second half of the twentieth century up to the present, these artists have been reaching to bring about a shift away from the utter absorption of the modern individual toward this fluent space of relation where the being does not precede the becoming. The significance of their work lies in the continuity of issues that developed earlier, but that were covered over and denied any importance in art history. The spatial development of relation that the hand stages is also much linked to drawing, which is particularly suited to this visual and mental exploration, yet equally excluded from art history as a subservient medium until very recently. Drawing as a primary response to the surrounding world is an outward gesture that links our inner impulses and thoughts to the Other through the touching of an inscriptive surface with repeated graphic

marks. To begin with, the gesture itself is more important than the mark or the gaze. In the act of drawing, the extending of arm and hand away from the bodily axis seems to correspond to the very gesture involved in the first separation (and exploration) when the child reaches out to the departing mother. Enacting the marking gesture, the child follows the mother's movement as she leaves, and afterward, contemplating the answer of his gesture, identifies with the trace that this action leaves on the page: "Such an approach no longer presents the world as a projection of the body itself but as a projection of the maternal body from which every human being is originally separated."[21] A primal mode of image production, the drawn mark thus stages not only a separating but also a binding in the discovery of the trace—much as the seam, as mentioned above in my discussion of Hesse's and Clark's work, in drawing every separating gap (across three-dimensional space) is also a bridging space (across the two-dimensional page). According to this view, the graphic activity of the hand plays a role in attempting to reconstruct symbolically the lost dual identity. With his or her every gesture, the child secures the absent mother's echoing answer (Maiolino's *Anna*) and trusts the page with the internalized mother, which inhabits him or her. In this transaction, the structural relationship and the inscriptive game organized around separation and attachment are more important than any of their representations.

Informed at once by rupture and reciprocity, drawing constitutes a space of relation in which the thrown-out gesture conjures up a trace seemingly tied to this movement and used to retrieve the thought that has been cast out. This back-and-forth motion (of ebb and flow), this tossing and grabbing back, in which sheer kinetic release is substituted for the possibility of its representation, opens to processes of symbolization and contributes to the construction of a mental framework that produces and renews meaning. Such a mechanism requires the possibility for the containing form to be invested both as a metaphor for one's own body and the mother's body. The paper becomes that first container for gathering scattered sensations and thoughts cast and then retrieved. Contents and container, created in mutual reference throughout the work, reiterate the complexity of a coming-into-language that concerns our ability to respond, our personal responsibility. In the range of works shown here, the medium

is obviously not limited to drawing alone. Though only insofar as medium and form lie within conversational models, undoing the still overwhelmingly rigid conventions to exist in flux, are they significant. Working in a variety of media—including film, video, sculpture, painting, and installation, often with works on paper at the core—these artists offer a critique of an exhausted institutional modernism. In the case of Maiolino, her first pursuit of alternative forms of representation placed her squarely in the nexus of neoconcretism in Brazil, the neo-avantgarde in Europe (particularly in Italy), and minimalism in the United States, but she has gone on to promote subjectivity as relational, blurring the boundaries between self and other and inviting us to a borderspace between lives.

Whereas modernism's radical and inventive strategies were to be more and more dependent on alienation, separation, negativity, violence, and de(con)struction, the twenty-first century may well be developing a changed criticality increasingly defined by inclusion, connectivity, conversation, construction, constituting, and even healing attitudes. This aesthetics of relation and reciprocity surely results crucially, and in the greater part, from the work of women artists, but also from that of some male artists often denied recognition precisely because of their "feminine" approach to the world. If we want to work further in a context larger than the one defined by gender, it is about time to acknowledge all of this work together at the millennium, using new paradigms of the relational as radical being defined during the last decades by poststructuralist and feminist art practices. Or to paraphrase Kristeva (whom I mention in an epigraph to my book *Inside the Visible: An Elliptical Traverse of 20th-Century Art in, of, and from the Feminine*) in 1974: "I would define as 'feminine' the moment of rupture and [reciprocity], which conditions the newness of any practice," replacing at this time, thirty years later, "negativity" by "reciprocity."

NOTES

1. Julia Kristeva, *Strangers to Ourselves,* trans. Leon S. Roudiez (New York: Columbia University Press, 1991), p. 22.

2. Ibid., p. 9.

3. This quotation and all subsequent unreferenced quotations are from Anna Maria Maiolino in conversation with the author (1998–2001).

4. William S. Wilson, "Eva Hesse: On the Threshold of Illusion," in Catherine de Zegher, ed., *Inside the Visible* (Cambridge, Mass.: MIT Press, 1996), p. 431.

5. *Manifesto neoconcreto,* reproduced in Ronaldo Brito, *Neoconcretismo, vértice e ruptura* (Rio de Janeiro: Funarte, 1985), pp. 12–13.

6. Undated manuscript (c. 1963–64) in Lygia Clark's archives in Brazil.

7. Suely Rolnik, "Molding a Contemporary Soul: The Empty-Full of Lygia Clark," *The Experimental Exercise of Freedom,* exh. cat. (Los Angeles: MOCA, 1999).

8. Ibid.

9. Clark's relational objects were many and varied over time: cushions, a plastic bag filled with air or water, onion bags filled with stones or seeds, large seashells, nylon stockings with Ping-Pong balls at one end and tennis balls at the other, and many others, which she manipulated on the patient's body.

10. In this context, it is noteworthy to mention that once the child leaves the womb the digestive system awakens the erogenous zones around mouth and anus, while at the same time it brings along other stimulations, those of smooth internal muscles, and sensations of hunger and satiety. Also, the exchanges with the primary maternal environment incite investments onto other areas of the body proper. The child's hands play a critical role in the process of gathering these scattered sensations over the body and making sense of them. See Serge Tisseron, "All Writing Is Drawing: The Spatial Development of the Manuscript," in *Boundaries: Writing and Drawing, Yale French Studies* 84 (1994): 38.

11. Julia Kristeva, *The Powers of Horror: An Essay on Abjection,* trans. Leon Roudiez (New York: Columbia University Press, 1982), p. 3.

12. Esther Emilio Carlos, "The Memory of the Other," in Catherine de Zegher, ed., *Anna Maria Maiolino: Vida Afora = A Life Line* (New York: Drawing Center, 2002), p. 276.

13. Dominique Laporte, *History of Shit,* trans. Rodolphe el-Khoury and Nadia Benabid (Cambridge: MIT Press, 2000).

14. Judith Butler, *Gender Trouble* (London: Routledge, 1990), p. 133.

15. Lygia Clark, "L'art c'est le corps," *Preuves* (Paris), no. 13 (1973), pp. 143–145. Reprinted in *Lygia Clark,* exh. cat. (Barcelona: Fundació Antoni Tàpies, 1997), pp. 232–233.

16. Ibid., in Clark's words.

17. Butler, *Gender Trouble,* p. 134.

18. Ibid., p. 133.

19. Rolnik, "Molding a Contemporary Soul."

20. Bracha Ettinger, quoted in de Zegher, ed., *Inside the Visible,* p. 22.

21. Tisseron, "All Writing Is Drawing," p. 32.

In what follows, I explore a few places of intersection among the accounts of how "spaces" matter (and mean) in some recent art made by women that Carol Armstrong, Ewa Lajer-Burcharth, Briony Fer, and Catherine de Zegher have variously contributed to this volume and the conference with which it originated.[1] To one of those places we can give a name, a name both Armstrong and Lajer-Burcharth mention, and one that the motifs of de Zegher's paper—inside and outside, mother tongues, being all mouth—otherwise summon: Sylvia Plath. Lajer-Burcharth's title cites Plath's short poem "The Beast," composed in the autumn of 1959 as one of seven sections of her breakthrough work, "Poem for a Birthday." In the writing of "Poem for a Birthday," Plath found herself "to be dwelling on a madhouse, nature; meanings of tools, greenhouses, florists' shops, tunnels vivid and disjointed." She found herself dwelling *on* a space she once had dwelled *in:* a madhouse. Dwelling on, attending to, making something of, nature: "fruit . . . eaten or rotten," "pebble smells," "bean leaves," "worms [that] drowse in their silk cases"; dwelling on the meanings of tools: chisels, heated pincers, and "delicate hammers [to] doctor heads, or any limb";[2] dwelling on one space after another, spaces whose designation as greenhouses, florists' shops, tunnels vivid and disjointed, hardly captures their ways of housing the stuff of subjectivity in bodies and writing: sheds "fusty as a mummy's stomach," "halls . . .

full of women who think they are birds," "marrowy tunnels," "turnipy chambers," "a cupboard of rubbish," a "cellar's belly," "the stomach of indifference, the wordless cupboard," "the city of spare parts."[3] Sometimes Plath's spaces are persons, or the empty domains of persons (a husband is a "cupboard of rubbish," his wife, "Duchess of Nothing"); sometimes they are parts of persons ("mouth-holes crying their locations"). And Plath's spaces are often figurations of poetic writing itself, or of the situation of the production of poetic writing, a situation in which the writer's being a woman—being a daughter, being a wife, being a mother, being a poet trying out the voices of her male teachers—matters.[4] That, I suspect, is why we find ourselves speaking the name Sylvia Plath today.

Armstrong arrives at Plath in describing a risk of misreading that she understood herself to be taking with her curatorial juxtaposition of Francesca Woodman and Diane Arbus in the exhibition *Camera Women,* which was on display at the Princeton University Art Museum at the time of the Women Artists at the Millennium conference. As Armstrong puts it, some might see a "suicide corner" where she sought a pairing of houses made strange in photography (see figure 4.1). And her paper, too, means to see things differently, to provide a reading of the mythology of Woodman's career (rather than a "diagnosis" of the young photographer's lived experience and its supposedly symptomatic eruption in her art), and to embed that reading within an analysis of the unresolved self-reflexivity that characterizes the thematization of time and space in Woodman's photographic project, which, Armstrong argues, represents "the house as a kind of camera obscura," as well as "an uncanny structure, at once dead and gone, yet strangely animated and alive: a house as the space of disorder rather than domestic order, of detritus rather than cleanliness and neatness, of the female ghost rather than the housewife." "As with Woodman," she explains, "the ending of Arbus's life seems more comparable to that of a figure like Plath than of van Gogh. It makes the out-of-kilter aspect of the work seem precisely off-course and out of the mainstream: not the universal madness of a genius that confirms and supports a tradition of 'greatness,' but the irremediably particular, ruptural, aberrant madness of a gender-specific dis-ease." The effect of bringing Plath into the discussion at this point is double: first, it links Woodman to a poet whose writing

recent feminist scholarship (especially Jacqueline Rose's *The Haunting of Sylvia Plath*) has analyzed in productive relation to the myths as well as the actual conditions of Plath's life; and, second, it shows how a figure like Plath haunts *our* writing, how her words make the spaces in which we dwell uncanny, and in that sense available for writing again.

Lajer-Burcharth's paper approaches its end with an invocation of Plath: "The new woman artist, then, as *duchess of nothing*. . . . These borrowed words capture well, I think, the sense of the creative woman's new position in relation to the visible world conveyed by these installations. Materialized in these works is an elusive, contingent, and entitled, though emphatically *un*possessing, femininity—a woman who lays claim to space without having it." Lajer-Burcharth takes advantage of the resonant cleverness of Plath's words and transforms their meaning to make them speak to what she sees in the art of our present. In Plath's poem, a Duchess of Nothing acquires her title by marriage. Thanks to her union with a "cupboard of rubbish," she finds her bed in a fish puddle beneath a sky that's always falling. She keeps house in the "gut-end" of Time. And her weddedness to a creature of unkempt masculinity distinguishes the Duchess of Plath's poem from the figuration of "buoyant femininity profoundly *un*related (though not unfriendly) to masculinity" that Lajer-Burcharth sees in Pipilotti Rist's video work. As Lajer-Burcharth argues, for Rist as for Sam Taylor-Wood and for Jane and Louise Wilson, the houses we keep and our cupboards of rubbish are not to be personified but envisioned as disordered metaphors for a history of the present. The gut-end of time—our now—appears as a homely dwelling made alluringly (not to say teasingly) strange, an array of vacated institutional rooms, or a well-dressed stage for human interactions stripped of the cruel and tragic intensity of the ways in which persons come to know (and not to know) themselves, and others, in Plath's poetry. "To be dwelling on a madhouse, nature; meanings of tools, greenhouses, florists' shops, tunnels vivid and disjointed"—Plath's notes in connection with "Poem for a Birthday" show her dwelling on spaces, nature, and tools, and they offer an account of that dwelling that makes it a microcosm of the experience of history figured elsewhere in her poetry: "An adventure. Never over. Developing. Rebirth. Despair. Old women. Block it out."[5]

In Lajer-Burcharth's reformulation, the Duchess of Nothing as video artist encompasses her "nothing" with fresh irony. When she dwells (as Rist in some sense does) on the meanings of tools; when she dwells on tunnels vivid and disjointed (which might describe places like *Stasi City* and *Star City* as seen by the Wilson sisters' cameras—places whose present emptiness is meant still to register, in the first case, the systematic violation of intimate space, including the space of private conversation, and of the body, and, in the second, the dream of the state extended into outer space); when (like Taylor-Wood) she dwells on her own spectatorship of the banalities of ritualized leisure, Lajer-Burcharth's Duchess of Nothing addresses "a question of how a 'woman,' and particularly an artist who happens to be a 'woman' . . . could be defined as a *subject* of space."

As Lajer-Burcharth describes it, the Wilson twins' *Stasi City* (1996) "has as much to do with the Stasi headquarters and its gruesome symbolic legacy as it does with artistic subjectivity, that is, with the idea of the artist as a *symptom* of the thus constructed space." *Stasi City* evokes its authors as a double presence in the bodies of two women who, if they are twins, do not let us see them recorded in such a way as to reveal their likeness. For Lajer-Burcharth, the effects of the presence of the women in the video "point beyond the artists as persons to the notion of difference as the defining mechanism of subjectivity." The figure of the artist, she argues, appears "as a sort of uncanny ghost" who "haunts" the empty spaces of the obsolete institution of state-sponsored surveillance and secret-policing from which the video derives its title. And, I would add, it is as if the "City" appended to the abbreviation "Stasi" were meant to make the space it names available not only for haunting, but also for a kind of virtual, posthistorical *flânerie*.[6]

Shown in the Wilsons' signature double corner-projections, *Stasi City* opens with a glimpse of a grid of fluorescent overhead lights. The projections next present a woman in a black dress who briefly faces the camera while riding in an elevator that bears a sign indicating its capacity to transport two persons ("2 Personen"). The two-person elevator and its lone passenger rise alongside an identical second elevator in which no person rides (figure 2.35). The woman in the black dress soon turns her back on us as she sets off roaming through empty hallways and abandoned rooms. Also in the opening frames of the projections, a

2.35 Jane and Louise Wilson, *Stasi City,* 1997. Video installation. Photograph by Theo Coulombe, courtesy of 303 Gallery, New York.

second woman wearing a red, yellow, orange, and brown tracksuit moves around other areas of the Stasi complex as though conveyed through space on an invisible chair. The effects of this constellation of opening images are disconcerting, not to say vertiginous. The first woman travels through the irreal chambers and corridors of *Stasi City* as if by habit, the second as if by magic. "*Stasi City,*" Jane Wilson has said, "is actually a very historicized, almost archaeological investigation into a site, so it's not just about going into a location. It's about understanding the psychological dynamics of the building."[7] But how, in *Stasi City,* is what the artists have conceived of as "a very historicized, almost archaeological investigation" meant to result in our "understanding the psychological dynamics of the building" under investigation—how, in other words, are the work's professed historicism and psychologism to be understood in relation to one another, and what is their place within the artists' attempt at an archaeological investigation of the architectural space of the former Stasi buildings at Hohenschönhausen?

Watched continuously several times through, the sixteen-minute closed-loop video seems to suggest that, in and around the world of *Stasi City,* an affiliation or conspiracy of accident, habit, and magic determines the relation of bodies to spaces and, as if by extension, of viewers to works of art. Giant primordial-looking paint chips, blue on one side and white on the other, lie on a hospital room's floor alongside lengths of unfurled toilet paper, the former fallen from the ceiling and nearly seeming like a work of art produced, accidentally, by pseudo-organic processes of decay setting in after an epochal collapse (the photograph reproduced here as figure 2.36 hardly captures this effect, which is vivid in the video). We see rooms furnished with medical equipment, devices for listening in and watching over, and, incongruously, cheerily upholstered modern furniture, as if in *Stasi City* private space had been not merely invaded by but incorporated into the architecture of surveillance. The play of difference between the outfits the two women wear alludes to kinds of linguistic and social signification that appear otherwise to have ceased to function in the rooms; the colorful tracksuit stands out in relation to the plain black dress, and it might seem that the woman in the dress was once a part of the Stasi bureaucracy, or somehow had otherwise come to be at home in its headquarters. She appears to know

2.36 Jane and Louise Wilson, *Stasi City,* 1997. Video installation. Photograph by Theo Coulombe, courtesy of 303 Gallery, New York.

the institution's now-outmoded spaces as if from inside. Perhaps this sensibly dressed companionless woman has gone wandering, now senselessly, in search of a subject to observe or a prisoner to interrogate—or perhaps she has set about haunting the site of her own past interrogation or incarceration. The woman in the trendy, retro-styled tracksuit looks, by contrast, as if she belongs to a present in which tourism and its recording technologies now penetrate the decrepit institutions of the former Soviet bloc. (Since 1992, the Hohenschönhausen complex has been officially recognized as a memorial, and since 1994 it has been open to the public. Visitors for the year 2003 numbered 120,000.)[8]

Taken together, the presence of a single person in one of the twin two-person elevators and the absence of anyone at all in the other alert us at the outset of the similarly twinned double corner-projections to the possibility that the women should be seen as occupying "spaces" that are temporally and historically distinct; indeed, we might say that in pointing to the absence of co-presence in a space designed specifically to bear, and to convey, two persons at once, the elevator's "2 Personen" sign introduces not merely a theme but a structure in which the video's significance inheres; it is this theme, this structure, to which I take Jane Wilson to be alluding when she says that *Stasi City* is "about understanding the psychological dynamics of the building." The double set of corner projections displays traces of situations in which the presence of one person to another was systematically refashioned, in the scenography of Hohenschönhausen, as a kind of violence that emerged from the transformation of observation and conversation into surveillance and interrogation. Moreover, the psychosocial violence of surveillance and interrogation is shown here to have been variously actualized, extended, and concretized, spatially and physically, room by room, in the form of incarceration, bodily assault, and invasive medical procedures. At the same time, in the scenes of the tracksuited woman's solitary posthistorical tourism, the twinned projections reconfigure the potential relation of one subject to another as the perpetual nonencounter of fantastic, gravity-defying *flânerie*. The use of the two-person elevator as a vehicle for just one person—moreover, for one whose presence may be that of a historical ghost—figures, nearly allegorically, the corruption or destruction of co-presence effected by the practices of surveil-

lance, interrogation, and tourism that the video elsewhere invokes. The things the two women do with their bodies—riding alone in an elevator in an uncannily ordinary way, as though en route to a job that no longer exists but still stultifies (or to another, more intensive form of discipline); walking as if aimlessly but with seeming acclimation to the space and its once-secret passages; floating in a seated position, wearing an outfit designed for leisure—underscore the contrast between them and almost motivate it with identifiable social behaviors. In *Stasi City,* the rebirth of polyester tracksuits in 1990s fashion coincides with the reenchantment of the disintegrated spaces of the East German state as ruins to be visited as if in dreams, or for diversion. In the end, it's not clear what the place of the Wilsons' work is in relation to the coincidence it depicts.

A thermos floats as if in a gravity-free zone, then falls with a shocking thud that brings the video to a standstill in which a final shot of the front of the hospital room's white medical supply cabinet with its red cross heralds the end, or rather the interruption, of the work's projection (the loops of course continue). If, uncannily, the ceiling's grid of fluorescent lamps, the floor's littered surface, and the cabinet's upright door almost call to mind a range of modernist pictorial experiments in transforming—defying, refinding, reimagining—space (say, from Mondrian to Pollock to Malevich), the video's presentation of a thematics of travel by habit and magic through vacated, historically charged spaces announces that *Stasi City* as a work of art rejects the terms, or has abandoned the ambitions, that those modernist experiments carried in relation to our capacity to know, and to dwell in, the world. In *Stasi City,* the paint chips on the floor are mere traces of decay, and to the extent that they are pleasant enough to look at and interesting enough to think about, they are also, in the end, a presentation of the semblance of something like art as the contingent production of a work of nothingness that occupies a space in which surveillance and interrogation have defiled and displaced conversation as the ground of human relations, as if the appearance of fallen, peeled paint chips as something like art was both a register and a counterpart of the destruction of positive, communicative human interaction. At first a viewer might take the paint chips for scattered sheets of paper from an archive evacuated suddenly and violently; recognizing them as fallen flakes of pig-

ment, she might find them almost beautiful, like some kind of touching, nearly lyrical accident of self-generating quasi-aesthetic presence in a ruined interior; reflecting on those two apprehensions in relation to one another, she might soon lose interest in, or patience with, the choreography of their appearance in the projection. The grid with which the video's loop begins is similarly (deliberately) degraded: a sick-making pattern of gaseous light, it refinds a model structure of modernist utopianism in the banalities of the built environment of a now-defunct, once "real-existing" state. In all its ordinariness and usefulness as a sign of hope and aid, the red cross on display where medical attention might have been given cynically—in the wake, or during the course, of mistreatment—also calls up, in the video's closing frames, the specters of terror and nothingness that haunted modernism's dreams of a universal language.[9]

If the glimpse of a fluorescent grid in *Stasi City* initiates that video's reconfiguration of the vacated State Security Police compound as a dystopic space of somnambulistic wandering, the repetition of the grid in Agnes Martin's art strives to find abiding in that structure what Briony Fer alternately calls "a metaphysical subject differently imagined" and "a metaphysics of the ordinary" (figure 2.37). The surface of Martin's grids, Fer writes, "invites a contemplative gaze, bolts the viewer to it, as if the *work* of the work were to open onto an immaterial and meditative space," as if it "could invite the possibility of revelation" and deliver an "experience of boundlessness" that Martin has variously called "infinity," "joy," "bliss," and "the sublime." Noting, however, that "infinity" was also "a literalist watchword" of the 1960s, when "it came to stand for the refusal of [an] aesthetic of revelation," Fer discovers, in "an aesthetics of the thrown-away that was prevalent in New York" while Martin was living and working near the city docks in Coenties Slip in the late 1950s, an apparatus that might establish a productive tension rather than a mere opposition between "the contemplative and literalist views" of Martin's work. (Fer cites Donald Judd's formulation of the literalist view and Lawrence Alloway's of the contemplative.) In Martin's paintings of the early sixties that "aesthetics of the thrown-away" reemerges, transformed, as an "ethos" that embraces "the ephemera and disposability of drawing itself" rather than the actual foundness of the elements of assemblage. "But maybe," Fer suggests, "the

2.37 Agnes Martin, *The Tree,* 1964. Oil and pencil on canvas, 72 x 72 in. The Museum of Modern Art, New York; Larry Aldrich Foundation Fund (5.1965). Digital image © The Museum of Modern Art / Licensed by SCALA / Art Resource, New York.

found quality persists; maybe [Martin] found pen and paper instead; maybe the template of the grid, once she found it, was ready-made enough."

In its ready-madeness and regularity the grid was also manipulable, subject to subtle alteration by the work of Martin's drawing/painting hand: "what is calculated . . . are incalculable, infinite differences," producing what Fer calls, after Gilles Deleuze, "fugitives from geometricization": "Outside the realm of perspective, the fugitive line *[ligne de fuite]* becomes that which constructs and escapes the system, as lifelines from a commodity culture predicated upon obsolescence. . . . [In its use of] the simplest of means, there is something oddly archaic in Martin's medium." Martin's "archaism" reattaches to the grid and its repetition a link to lived experience that insists on "the significance of the infinitesimal difference between things" and of the "intervals" between them. Repetition intensifies those differences and literalizes those intervals; hence, for Martin, "experiences recalled are generally more satisfying and enlightening than the original experience." Arguing for the necessity of repetition to Martin, Fer claims that "looking was a kind of *looking for* a lost totality, one that was no longer possible, using means that demonstrated the contemporary impossibility of metaphor." In other words, Martin's lines, set out meticulously in grids and always refusing even the most minimally symbolic orthogonals of perspectival construction, evoke, in their archaism, a system of relations unlike (and as if prior to) the system of commodity exchange. The repetitions of Martin's grids stand against the necessary obsolescence of commodities and, as the logic of Fer's argument would suggest, "demonstrate the contemporary impossibility of metaphor" in part through that opposition to obsolescence, as if the repetitions of the grid and the labor that produces them were meant to repudiate but not to undo a debasement of metaphor inherent in commodity culture; as if Martin's repetitions were meant to sublate the debasement of metaphor in late-capitalist systems of exchange by maintaining the unmetaphoricalness of her pictures while deploying, in the grid, lines that become virtual figurations of the redemption or resuscitation of metaphor in a scene of human rescue—"lifelines from a commodity culture predicated on obsolescence," lines with which we might draw ourselves into a space in which repetition would not mean the experience of the ever-same. Regarding the

"invocation of nature" in the titles of many of Martin's major paintings of the 1960s, Fer argues for "a certain significance in her namings . . . and it has nothing to do with the sublime, or with the work being *like* nature. Rather, there is a kind of equivalence and a dissonance of experience being conjured. . . . The titles may act as a further provocation to memory, not to a particular memory but to the vividness of isolated memories." Demetaphorized but not unpoetic, Agnes Martin's "drawing drawing," "the *work* of the work," her "infinity," becomes, in Fer's account, "a space of contemplation, of immateriality, and yet . . . also a space of labor, repetitive and meticulous labor."

Among the artists whose works embody de Zegher's notion of "the relational as the (feminine) space of the radical," Lygia Clark and Anna Maria Maiolino seek "an equivalent to the work of art, not in the machine, or even the object as such, but . . . in living organisms" and in the things those organisms shape in the course of everyday life. We might say that in their work "Time's gutend" becomes the actuality of the digestive tract as a transformative passage between inside and outside, entrance and exit; and that keeping house there means finding what de Zegher calls "an artistic trajectory" that would "incarnate, within the work, life as a creating impulse, with unforeseeable becomings, equal and accessible [among] all of us." Ultimately, especially in Maiolino's work, a potential collectivity of making and molding comes into view, a utopian vision in which "a new body is born, sculpted by all . . . not through identification (each one 'becoming like the other'), but through contamination (each one 'becoming another')." Through self-affiliation to the earlier twentieth-century avant-garde concept of *antropofagia,* Clark and Maiolino aim to situate their artistic practices in direct relation to the body's taking in and making over of food. (In Sylvia Plath's poetry, eating often appears as a figure for the original, devouring force of introjection in human relations and the speech that instantiates them: "Mother, you are the one mouth / I would be a tongue to. Mother of otherness / Eat me. Wastebasket gaper, shadow of doorway.")[10]

The relational as de Zegher presents it engages both the relations of human subjects to one another and of artists to the materials in which they work. (This dimension of the art de Zegher discusses resonates with the invocation of "two

persons" on the twin elevators in *Stasi City,* an invocation echoed, as noted above, in the two sets of double corner-projections in which the video is shown, and in the double authorship of all the Wilsons' work.) Sometimes, as when spectators become not just participants but patients in the expanded work of art, the overlap of human subjects and artistic materials is absolute. Clark's work incorporates "relational objects" into the work of art as a therapeutic enactment, literalizing the healing function of the aesthetic object, and actualizing a transformed relationship between artist and viewer, both now actors in a scene of healing. Painter and psychoanalyst Bracha Ettinger also links therapy and art-making, which she calls "artworking" (figure 2.38).[11] As Brian Massumi has written, "art, for Ettinger, is inseparable from therapeutic practice."[12] Indeed, in her practice, painting has been made coincident, if not exactly coextensive, with therapy. In 1998, she began to receive patients in her studio and, given their consent, to produce paintings while listening to them. For Ettinger, creating works of art during psychoanalytic sessions "secures the exchange" between analyst and analysand by giving it "a visual voice."[13] "I have to be closest," she explains "to all the conditions that bring about my own openness, my floating attentiveness, fragility, and engagement. Painting is the best way, and the studio is the place where my desires get prepared for receptivity and transmissivity; it is the best space to wait in 'reverie' for the miracle and agony of encounter, even if it doesn't happen" ("Working-Through," 42). Ettinger conceives of her artworking, in the context of the psychoanalytic session, as an aesthetic supplement to the floating attentiveness of her analytical approach, a supplement that is itself produced more or less unconsciously. Before a session begins, she takes one of the paintings on which she has been working down from the studio wall and then writes or draws on it while she listens and responds to her patient. Pencils and colors and pigments are picked "unthinkingly," and "there is no particular intention, no particular order or rationale to choosing one or another [painting on which to work], no attempt at understanding, no discussion." "I do not pay much attention to this process," she continues. "It is much like the attention one might give to drinking a glass of water as you listen, or even, to breathing; it is marginal, yet intensive." Painting according to Ettinger's method approaches automatism; the

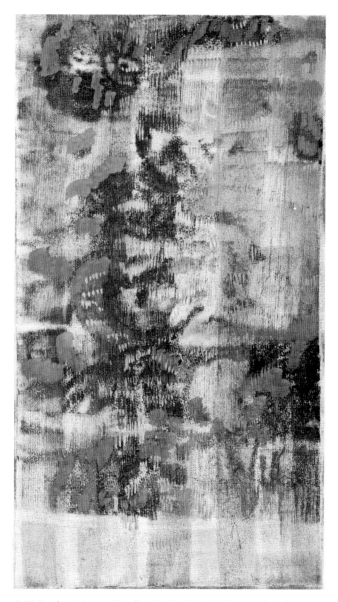

2.38 Bracha Ettinger, *Eurydice No. 29,* 1999–2001. Mixed media with oil on paper mounted on canvas, 11¼ × 20¼ in.

attention it demands is "like" that which an analyst might pay to drinking a glass of water, or to breathing, but it is also like the rather more complicated cognitive process of writing notes while continuing to listen: "Just as taking notes remains for other psychoanalysts in the margins of the analysis so does painting for me" ("Working-Through," 45).

According to Ettinger, among those patients in whose presence she paints, references to "the art making" are "as rare as any other reference to the conditions of receptivity of the analyst." But if "painting in itself doesn't alter [the] process of analysis," it does "infiltrate the space of transference and counter-transference" ("Working-Through," 45). Understood in matrixial terms, the "space" of transference and countertransference is a "borderspace" or "third zone" of "severality" that accommodates painting as a supplement to a psychoanalytic process that is itself modeled on processes of "metramorphosis" first recognized in painting.[14] Just as a "realization of encounter via the artwork penetrates into, impregnates and creates further encounters between the artist and the world, the artist and the object, the artist and the Other, artists and viewers,"[15] so a patient's experience of an analyst who paints as Ettinger does—and, more broadly, her experience of the space or the situation of analysis taking place in the psychoanalyst's painting studio—may come to echo those effects or that experience of the artist at work and in the world.

Ettinger's writings in psychoanalytic theory are extensive and complex, and this is not the place for a sustained engagement with them.[16] However, in an effort better to understand her paintings and the situation of their production, I do want to consider some aspects of how her work as a psychoanalyst has informed her theory and practice of art, and vice versa. Central to Ettinger's contribution to contemporary psychoanalytic theory are the related concepts of a *matrixial stratum of subjectivization* or *matrixial borderspace,* and *metramorphosis.* The matrix, she explains, "stands for *differentiation-in-co-emergence.* Here, the feminine/maternal web echoes both the infant's intrauterine existence and the female bodily specificity, and represents a dynamic *borderspace* of active/passive co-emergence *with*-in and *with*-out the uncognized other with neither fusion nor rejection. The matrix indicates existential ontogenesis and an unconscious inscription of trans-subjective experiences."[17] Etymologically linked to the Latin

word for "womb," this matrixial apparatus also relates to Freud's analysis of the uncanniness of fantasies of intrauterine existence in "The Uncanny" (1919),[18] and the matrix emerges as the space of what she terms—in a phrase refunctioned from the work of British psychoanalyst Christopher Bollas—"the earliest human aesthetic."[19]

In matrixial subjectivization, "aesthetics . . . precedes identity. . . . The self as identity is already an effect, not the cause, of the encounter" ("Working-Through," 48). Metramorphosis designates the process of matrixial co-emergence or what she sometimes calls, with reference to recent work in cognitive science, "co-poïesis."[20] Metramorphosis is a "creative potentiality" and a process that "gives sense" to encounters within the matrixial borderspace to the extent that "the results of its unpredictable actions are inscribed in unique encounters." Indeed, "the function of metramorphosis in the matrixial borderspace can be compared to that of metaphor and metonymy in the phallic arena."[21]

The coincidence and supplementarity of Ettinger's psychoanalytic and painting practices are thus predicated on an attempt to think outside or beyond the representational spaces and relations of metaphor and metonymy. As an analyst, Ettinger does not so much attune herself to modes of figuration in a patient's representational world as *dwell,* with the patient, and also, in effect, with her painting, in a new, virtually nonrepresentational space shaped or framed metramorphically, that is to say nonmetaphorically.[22] "Meaning" and "sense" emerge in this matrixial borderspace through modes of communication analogous to or derived from the "exchange of reverie" that Ettinger locates in the original relation of the "becoming subject" or "the late [or postmature] prenatal subject-to-be" and its "becoming-mother-to-be" or "m/Other-to-be."[23]

In making painting and psychoanalysis coincide, Ettinger aims to "engrave" the relational space of psychoanalytic work in an artwork conceived as "both a transferential trans-subjective object and a site for a transferential operation," a "transport-station of trauma," itself "like a traumatizing other" ("Working-Through," 57). Indeed, in Ettinger's studio, paintings approach a condition of virtual or partial personhood, "as if an object becomes a partial subject and communicates with us," and such that the artwork has a "potentiality for

hurting and healing."[24] "The artobject," in other words, "is not a living being, but it moves and participates in the psyche, and it is not the opposite of the subject." In the course of their production, paintings come into being as "trans-subjective objects" of the painter's automatistic manual involvement and erotic attentiveness: "there is an erotics of painting that is one with its machinics."[25] Paintings converse with one another, and a series of works becomes "a crowd"[26] that converses in turn with the viewer.

Practicing the painter's and the psychoanalyst's arts simultaneously, Ettinger "elaborate[s] traces of [her patients'] trauma via 'conversation-with-painting,' digesting these traces for them, in a way, getting involved with what they cannot digest alone, mixing their traces with [hers] and giving them back their own traces transformed" ("Working-Through," 43). Thus conceived, the analytic process is also transformative for the analyst, though always asymmetrically and often nonsynchronously, in relation to the patient.[27] Working in what she calls the "matrixial field," Ettinger strives in her art to allow "the originary matrixial transitive trauma some veiled visibility via a touching gaze that approaches it from within-outside, and makes us fragile via wit(h)nessing the trauma of the Other and of the world. We are hurt, but we are also solaced."[28] Among her notes published in the margins of the essay in which that last passage appears is an anecdote from Ettinger's own infancy: "When I was little I didn't eat anything. They called that infantile anorexia. In shared and silent despair, my mother cruelly saved my life in daily, sadistic gestures: food."[29]

"Mother," wrote Sylvia Plath, "you are the one mouth / I would be a tongue to. Mother of otherness / Eat me. Wastebasket gaper, shadow of doorway." Given, first, Ettinger's assertion that "the feminine-matrixial . . . is not the unintelligible and unperceivable par excellence, but a subjacent, sub-symbolic sensible and affective network also revealed in more elaborated, non-originary phenomena," and, second, her affirmation that there exists an "archaic figurality of the matrix,"[30] we might imagine something like a matrixial reading of the stanza cited above from the "Who" section of "Poem for a Birthday." Written in ambivalent tribute to a birth, those lines present, in the particularity of a child's (a daughter's) relation to her mother, the possibility of—or anyway the child's

wish potentially to engage in—a confusion of tongues:[31] one mouth opening it-
self to incorporate the tongue of another. "Mother of otherness / Eat me," de-
mands the child in her own voice, the voice of the otherness that has just declared
its willingness to be tongue to this mother, this one mouth, this one only. The
end of the line then presents a "Wastebasket gaper, shadow of doorway," as if,
given the mode of address in the rest of the stanza, the mother was at once a wit-
ness to history and an unbodied threshold, a "Wastebasket gaper" in relation to
the past, and a "shadow of [a] doorway" to a possible future.[32] As a "shadow of [a]
doorway," an index of the presence of a threshold, that mother is almost what Et-
tinger would call a "wit(h)ness," a figure who might admit her offspring to her
mouth, not (just) to devour her, but (at the same time) to make space for a child
to find a voice. The "severality" of meaning in Plath's stanza derives from its
metaphors and metonyms and thus from what Ettinger would call the "phallic
stratum" of its elaboration. What her conception of the matrixial makes appar-
ent in this instance is how that phallic stratum might be said to be transformed in
proximity to a matrixial stratum subjacent to it.[33]

For Ettinger, trauma structures the intersubjective, and indeed the histori-
cal, "encounter" or "event" in which the work of art "participates": "Affected and
effected by the work of art, the viewer participates in the redistribution of trau-
matic imprints and phantasmatic traces, giving him or her access to the wound of
the world"—all of which, in the end, has "therapeutic consequences" ("Work-
ing-Through," 46). "We participate," she writes, "in the traumatic events of the
other. What makes the difference is a certain awareness of this, and as a conse-
quence of it an opening up to possibilities for transforming the ways we join in
the traumatic events of others. Under the matrixial gaze, different aesthetic ideas
and other ethical problems then arise."[34] Much more could be said about the eth-
ical and aesthetic dimensions of Ettinger's unique contribution to contemporary
art and psychoanalytic theory. I happen, like Ettinger, to believe in a shared hu-
man capacity to communicate, subsymbolically, prediscursively, and hence non-
metaphorically, through "exchanges of reverie." At the same time, I find myself
unable (also I suppose unwilling) to set aside my desire for (and my dread of) the
formalizations of metaphor, or to see them consigned entirely—albeit figura-

tively, or rather symbolically, after Lacan—to a "phallic stratum." In other words, I still hold on to, or am held by, something like what W. J. T. Mitchell has called "ekphrastic hope."[35] That said, let me offer, by way of an ending, some lines by Sylvia Plath that capture, for me, some of the pleasures and rather less so the terrors (actual, remembered, potential) that frame the space of art:

> This is a dark house, very big.
> I made it myself,
> Cell by cell from a quiet corner,
> Chewing at the gray paper,
> Oozing the glue drops,
> Whistling, wiggling my ears,
> Thinking of something else.[36]

NOTES

1. This text was drafted as a response to papers by Carol Armstrong, Ewa Lajer-Burcharth, and Catherine de Zegher that were presented in a session called "Spaces" at the conference Women Artists at the Millennium, Princeton University, 9 November 2001. In preparing my remarks for publication I have extended some sections of my original response and reduced others. I have also made certain changes in accordance with the reconfiguration of the materials that appear in the present volume: although Armstrong's "Francesca Woodman: A Ghost in the House of the 'Woman Artist'" is now included in another section of the book, my essay retains some references to that paper as it resonates with Lajer-Burcharth's "Duchess of Nothing" and de Zegher's "The Inside Is the Outside: The Relational as the (Feminine) Space of the Radical"; and my remarks now also address Briony Fer's essay "Drawing Drawing: Agnes Martin's Infinity," which was written for the Princeton conference but not presented there. I retain throughout the more or less informal style of my original spoken response. Unless otherwise noted, all citations from Lajer-Burcharth, Fer, and de Zegher are taken from their contributions to this volume; none of those citations have been footnoted.

2. Sylvia Plath, cited in Ted Hughes, "Notes," in Plath, *The Collected Poems,* ed. Ted Hughes (New York: Harper Perennial, 1981), p. 289.

3. Sylvia Plath, "Poem for a Birthday," *Collected Poems,* pp. 131–137.

4. It hardly needs saying that the body of literature on Plath is colossal. I cite here two sources of particular relevance to these remarks: Jacqueline Rose, *The Haunting of Sylvia Plath* (London: Virago, 1992), and Langdon Hammer, "Plath's Lives," *Representations* 75 (Summer 2001), pp. 61–88.

5. Plath, cited in Hughes, "Notes," *Collected Poems,* p. 289. Here I have in mind, among other poems, Plath's notorious "Daddy," *Collected Poems,* pp. 222–224. See Rose, *The Haunting of Sylvia Plath,* pp. 205–238.

6. In his unfinished *Arcades Project,* Walter Benjamin proposes that, in the experience of the nineteenth-century *flâneur,* Paris "opens up to him as a landscape, even as it closes around him as a room." What Benjamin describes in "Convolute M: The Flâneur" as an "intoxicated inter-penetration" of spaces particular to the modern city, resonates with the strangeness of the space created in *Stasi City,* and with that title's conflation of interior and exterior. Benjamin, *The Arcades Project,* trans. Howard Eiland and Kevin McLaughlin (Cambridge: Harvard University Press, 1999), pp. 417, 423. The term "Stasi City" was first used by a West German journalist writing about the large, walled Stasi complex at Hohenschönhausen in suburban East Berlin shortly after the fall of the Berlin Wall in 1989; see *Jane and Louise Wilson,* exh. cat. (London: Serpentine Gallery, 1999), p. 9, and Louise Wilson, quoted in Jeff Simmerman, "The Ghosts of Paranoia," *Punchline Magazine* (2002), http://www.punchlinemag.com/ContentDisplay .php4?UID=401.

7. Jane Wilson, quoted in Simmerman, "The Ghosts of Paranoia."

8. See the website of the Gedenkstätte Berlin-Hohenschönhausen: http://www.stiftung-hsh.de/.

9. On this aspect of modernism, see the magisterial chapter "God Is Not Cast Down" in T. J. Clark, *Farewell to an Idea: Episodes from a History of Modernism* (New Haven: Yale University Press, 1999).

10. Plath, "Who," in "Poem for a Birthday," *Collected Poems,* p. 132.

11. Bracha Ettinger, *Artworking 1985–1999,* exh. cat., Palais des Beaux-Arts, Brussels (Ghent-Amsterdam: Ludion, 2000).

12. Brian Massumi, "Painting: The Voice of the Grain," in Ettinger, *Artworking,* p. 32.

13. Ettinger, quoted in "Working-Through: A Conversation between Craigie Horsfield and Bracha Lichtenberg Ettinger," in Catherine de Zegher and Brian Massumi, eds., *Bracha Lichtenberg Ettinger: The Eurydice Series* (New York: Drawing Center, 2002), p. 44. Hereafter cited parenthetically as "Working-Through."

14. "In my artwork, some idea of matrixial aesthetic object, link and hybrid encounter, and metramorphosic process infiltrated painting that later produced theory that in turn enabled me to re-interpret clinical observations." See Bracha Lichtenberg Ettinger, "The Feminine/Prenatal Weaving in Matrixial Subjectivity-as-Encounter," *Psychoanalytic Dialogues* 7, no. 3 (1997), pp. 389. See also Ettinger, "Trans-Subjective Transferential Borderspace," *Canadian Review of Comparative Literature/Revue Canadienne de Littérature Comparée* (September 1997), esp. pp. 633, 643–645.

15. Ettinger, "Art as the Transport-Station of Trauma," in *Artworking,* p. 92.

16. The range of psychoanalytic and philosophical thought that comes into play in Ettinger's work is extraordinarily broad, encompassing material from Freudian and Lacanian as well as British object relations theory, cognitive science, feminist theory and literary criticism, phenomenology, structuralism, and poststructuralism. (The briefest list of relevant names would have to include Wilfred Bion, Christopher Bollas, Christine Buci-Glucksmann, Gilles Deleuze, Shoshana Felman, Félix Guattari, Julia Kristeva, Jacques Lacan, Dori Laub, Emmanuel Lévinas, François Lyotard, Maurice Merleau-Ponty, and D. W. Winnicott.)

17. Ettinger, "Feminine/Prenatal Weaving," p. 379.

18. Ettinger, "The Matrixial Gaze," in *The Eurydice Series,* p. 91.

19. Ibid., p. 102.

20. See, for example, Ettinger, "The Feminine/Prenatal Weaving," esp. pp. 379, 401–402.

21. Ibid., p. 384.

22. This is not to imply that other aspects of what happens in the theory and practice of psychoanalysis go unrecognized in Ettinger's work. See, for example, "Working-Through," p. 62.

23. See Ettinger, "Feminine/Prenatal Weaving," pp. 397, 379.

24. Ettinger, "Trans-Subjective Transferential Borderspace," p. 639.

———

25. Ettinger, quoted in Massumi, "The Voice of the Grain," p. 10.

26. Ibid., p. 12. See also "Working-Through," p. 58.

27. See, for example, Félix Guattari, "From Transference to the Aesthetic Paradigm: Interview with Bracha Lichtenberg Ettinger," in *Canadian Review of Comparative Literature/Revue Canadienne de Littérature Comparée* (September 1997), pp. 615–616.

28. Ettinger, "Art as the Transport-Station of Trauma," p. 98.

29. Ettinger, *Artworking,* p. 98.

30. Ettinger, "The Matrixial Gaze," p. 108.

31. I allude here to a 1933 essay by Sándor Ferenczi called "Confusion of Tongues between Adults and the Child" [Sprachverwirrung zwischen den Erwachsenen und das Kind] that, given its engagement with what we might call the problematics of the representational, non-representational, and relational aspects of trauma, as well as its status as a text conceived by an analyst "immersing [himself] in a kind of scientific 'poetry and truth,'" would be interesting to read alongside Ettinger's work. See Ferenczi, "Sprachverwirrung zwischen den Erwachsenen und das Kind: Die Sprache der Zärtlichkeit und der Leidenschaft" (1933), in *Schriften zur Psychoanalyse,* vol. 2 (Frankfurt am Main: Fischer, 1982), pp. 303–313, and "Confusion of Tongues between Adults and the Child," in *Final Contributions to the Problems and Methods of Psycho-Analysis,* ed. Michael Balint, trans. Eric Mosbacher et al. (1955; New York: Brunner Mazel, 1980), pp. 156–166. Ferenczi's description of his immersion in scientific "poetry and truth" appears in a letter of 1 May 1932 to Sigmund Freud, and refers to the title of Goethe's autobiography, *Dichtung und Wahrheit.*

32. "Threshold" is a key term for Ettinger. See, for example, her "Art as the Transport-Station of Trauma," p. 115.

33. Ettinger, "The Matrixial Gaze," pp. 91, 109

34. Ibid., p. 111.

35. See W. J. T. Mitchell, "Ekphrasis and the Other," in *Picture Theory: Essays on Visual and Verbal Representation* (Chicago: University of Chicago Press, 1994), esp. pp. 152–159.

36. Plath, "Dark House," "Poem for a Birthday," *Collected Poems,* p. 133.

ANN HAMILTON

STILLS FROM *UNTITLED (ALEPH)*, 1992–93

FROM *FACE*, 2003

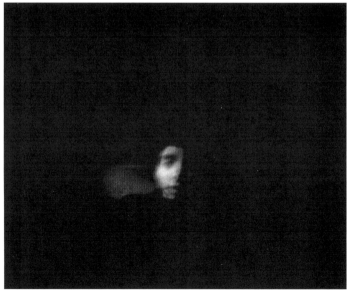

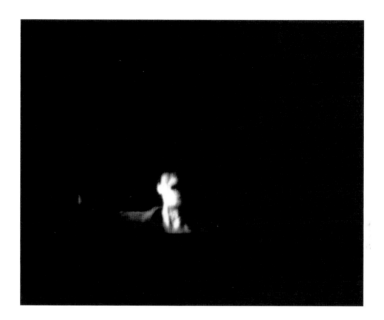

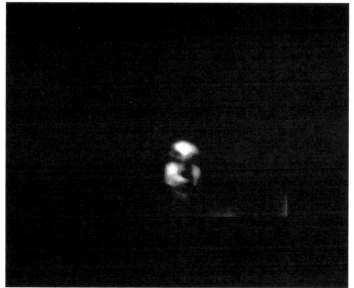

III SUBJECTIVITIES

3.1 Mona Hatoum, *Keffieh*, 1993–99.

Hairlines

───────

Tamar Garb

Women artists, since at least the early 1970s, have redefined the terms and conditions of making art.[1] Appropriating subjects, inverting stereotypes, and undermining assumptions, women have sought to redefine the erotic, the maternal, the feminine, the political, and the personal through an exploration of the very materials of which art is made, both actual and conceptual. At stake in this encounter has been a renegotiation of the relationship between the body (that sexually differentiated, aging, and transforming physical entity), desire (the set of motivations and impulses that propel the body forward and hold it back), and language (the means through which the subject makes sense of the relationship between the corporeal and the phantasmatic).

For women artists working in the context of an emergent feminist discourse on art over the last three decades, the self-critical encounter between the politically imbricated subjectivity of artist and viewer on the one hand and the inherited conventions and visual languages of art on the other have involved a redefinition and reappropriation of the very formal vocabularies through which feminine sexuality and female experience have historically been delineated and circumscribed. Take for example the case of "line," that apparently innocent visual signifier of formal control and order, constructed as masculine or at least as sexually indifferent and neutral in most accounts, and mobilized by classical

aesthetes, modern pedagogues, and politicians alike as a medium of rational communication.[2] While feminist theorists have exposed the gendered assumptions implicit in such formulations using language itself to reveal its hidden agendas, women artists have deployed the languages of art, line included, to undermine their conventional associations.[3] By infusing the abstract language of line with the physical presence of the bodily, line's claim to disembodied neutrality or to decorative self-referentiality, has been opened up to question.

Let us take the work of the Beirut-born Palestinian artist Mona Hatoum, now resident in Britain, for whom line is never a matter of political or sexual neutrality or bodily indifference. *Keffieh* (figure 3.1), a work of 1993 to 1999, comprises a black-and-white Arab headscarf, replete with traditional decorative designs, laid out on a table. What is extraordinary about this keffieh, though, is the fact that the linear patterning of the scarf is embroidered with long, waving strands of women's hair. Meticulously woven into the white fabric, the wavy lines conform to a traditional pattern, creating an undulating rhythm over the surface of the scarf, but their material makes them exceed their decorative function. Wisps of hair escape from the desired path, creating tiny lines that cannot be made to conform to the pattern. What is more, the artist has left the excessively long tendrils of hair spread in a random set of curves and sweeping gestures at the edge of the cloth, revealing their texture and disturbing the regularity of the design. Made to decorate a traditionally male headscarf, the embroidered hair brings the external signifier of female sexuality, usually covered in Arab society, into bodily contact with the potential male wearer of the scarf. The keffieh with its strong political connotations, standing for a resistant Arab and Palestinian masculinity, is here feminized through the appropriation of the decorative line by the traces of a woman's body. Made by the invisible hands of women (embroidery is traditionally a female craft in Arab society), this keffieh with its woven linear tresses makes visible the presence of women whose labor and bodies are conventionally hidden from sight. Registering the experience and bodily specificity of women, the ostensible decorative or formal function of these lines is subverted, and they signify as markers of the feminine.

3.2 Mona Hatoum, *Untitled* (graters), 1999. Silver gelatin print, 40.5 × 51 cm. Courtesy of Jay Jopling / White Cube, London.

Hatoum's installation at the Gallery, in which *Keffieh* was first shown, included a number of photographs among which was a large untitled print depicting domestic graters, a work of 1999 (figure 3.2). One of only two black-and-white photographs in the room, it resonated with the striking *Keffieh,* the curvilinearity of the black-and-white design of the one standing out against the rectilinearity and modularity of the other. Where *Keffieh* registers the unnerving bodily conjunction of female hair and male head-covering through the subtle appropriation of a traditional linear pattern, the photograph uses the formal echoes of the rectangular graters and buildings to set up the conceptual oppositions interior/exterior, domestic/public, feminine/masculine.

Deploying line in a way that is diametrically opposed to that of *Keffieh,* the untitled photograph is structured around a series of superimposed grids, from the graters themselves to the window frames, the horizontal patterns of the roof and the sober facades of the buildings. In this work Hatoum reveals her keen sense of the ordering modularity of modernity with its repetitive units and uniform regularity of appearance. Here a pattern of horizontal and vertical lines creates echoes and rhythms in which disproportionately large domestic graters dwarf skyscrapers, producing a discrepancy of scale that is both unnerving and sinister. While the graters and buildings rhyme suggestively, their iconic distinctiveness undermines the formal harmony set up by the horizontals and verticals of which they are composed. The untitled photograph highlights the theme of domesticity and the investigation of the notion of "home" that is so crucial in Hatoum's work. Modularity and rectilinearity are here mobilized to stand for what Hatoum calls "the 'grating' aspects of urban life," where the order of the interior and exterior march to a similar regulated beat, a depersonalized, alienated (if classically beautiful) set of formal relationships. Far from being a protected refuge from external forces, the interior mirrors them, and the domestic objects, silhouetted against the light, function themselves as windows through which the sunshine can enter in even, regulated quantities. The windowpane operates as a physical barrier between inside and outside, but the formal echoes between these spaces unite them conceptually and pictorially.

The transformation of domestic objects into sinister presences serves to undermine the traditional associations of "home" as a comforting refuge.[4] In *Homebound* of 2000 (figure 3.3)—an installation made of furniture and illuminated kitchen utensils connected by a lethal electric cord and screened off from the viewer by a set of horizontal lines forming a barrier—line structures the appearance of the installation, its decorative coherence, at the same time as functioning metaphorically. Sited behind a screen of parallel lines made of taut wire, the fabricated *unheimlichkeit* of *Homebound* is flattened into pictorial form. The installation functions as a stage set for a dangerous domesticity, which can be viewed only from the front through the systematic measuring mechanism of the horizontal lines that act as a protective screen while creating the effect of a prison

3.3 Mona Hatoum, *Homebound*, 2000. Kitchen utensils, furniture, electric wire, light bulbs, computerized dimmer switch, amplifier, and speakers; dimensions variable. Installation at the Tate Gallery, London. Courtesy of Jay Jopling / White Cube, London.

or world behind bars. The equidistant lines, which traverse the front and rear of the installation like so many ruled lines on a page, order and distance the scene, flattening it for the monocular vision of the spectator. Three-dimensional space is viewed as if through an optical device, a mechanism for translating the world of lived experience into a flattened pictorial system.

Sequestered behind the horizontal grid of stretched wire, the electric cord connects the utensils in a series of winding movements possessing the flamboyance of an art nouveau design. Stylized, excessive, decorative, Hatoum's inclusion of the draped and looped wires link the objects visually while facilitating the charge that animates them. The grid through which the work must be viewed competes for attention with the intricate curvilinear excesses of the connecting cord that is draped across the floor and furniture. Acting as a conduit of energy, the cord functions as the nervous system of the animated emptiness that is the domestic interior with its vacant cages, skeletonic structures, synthetic surfaces, and useless implements. Literally conveying a futile and demented energy to light bulbs concealed or contained by domestic objects and programmed to coordinate with excruciating noises (the amplified sound of the electricity coursing through the cables that connects the objects and emanates from a hidden sound system), this dangerous line registers as both sonic and visual, representing a force that animates the domestic while rendering it uninhabitable.[5] Here, Walter Benjamin's brilliant assertion that electric cord is the modern equivalent of art nouveau's curvilinear dynamism seems most apposite, because the sinuous line appears to contain the pulse of the piece, the nervous energy which both animates and enervates the modern.[6]

Hatoum deploys line in two registers in *Homebound*. One is formally related to the tense modernity of art nouveau's decorative and dangerous stylizations, the other suggests modernism's apparent evacuation of referentiality in the uniform repetitive structure of the grid. Hatoum therefore appropriates both the fanciful, oneiric aspects of modern linearity, beloved of the surrealists, and the rational systematic neutrality and modularity of the archetypal formalist grid. These two constructions of the linear are represented by two very distinctive works, each of which subsumes the body into a particular formal language. In

3.4 Mona Hatoum, *Van Gogh's Back,* 1995. C-print (edition of 15), 50 × 38 cm. Courtesy of Jay Jopling / White Cube, London.

Van Gogh's Back (figure 3.4), a photograph of 1995 which invokes the organic, body hair is represented as an abstract configuration of swirling lines with particular stylistic connotations, whereas in *Untitled (Black Hair Grid with Knots)* of 2001 (figure 3.5), the formal rhetoric of the grid is undermined by the nature of the material from which it is made: human hair.

Van Gogh's Back represents the fortuitous curvilinear patterning created by the confluence of soap and hair on a man's back, registering the rhythm and circular movements of the hand that has soaped and caressed him. Standing for the trope of drawing as caress conventionally associated with male artists and female models, these wet hairlines, while testifying to the manliness of this hirsute figure,

3.5 Mona Hatoum, *Untitled (Black Hair Grid with Knots), 2001.* Courtesy of Jay Jopling / White Cube, London.

transform his back into a decorative surface. Wittily invoking the swirling brush-strokes of the passionate Vincent, laden lines indeed, the back/body of the man functions as the canvas that bears the marks of the presence of another. It is her hand that has bathed him (the lines register her touch), and it is her camera that captures his image.

While touch is thematized in the photograph (the lines represent its residue), it is more immediately invoked in *Untitled (Black Hair Grid with Knots),* one of a few such small works made of knotted strands of human hair. Here there is none of the fortuitous decorative panache of *Van Gogh's Back* or any of the witty references to symbolism, art nouveau, and surface ornamentation that the work

suggests. Made like *Keffieh* of hair rather than depicting hair, the hair grid implicates the body in the line in a radical and transforming way.

Hatoum had used actual hair in a reprise of an art nouveau classic in a 1993 work entitled *Jardin Public* (fig. 3.6), a witty, punning Jugendstil chair that is feminized both stylistically, in terms of its overall decorative design expressed in the bent metal framework, and indexically, by the inclusion of a hairy triangle, a veritable *mont de Vénus*, which is woven onto its otherwise ordinary seat. Made from the artist's own carefully collected pubic hair, amassed over a very long period, *Jardin Public* (the aural joke with "pubic" and "public" is crucial) amounts to an artist's self-portrait that knowingly acknowledges the cultural inscription of the feminine. Reminiscent of Magritte's *Le Viol*, a parody of a portrait in which a woman's mouth is replaced by her pubic triangle, effectively silencing her, Hatoum's work places woman's sex exactly and literally where it should be: on her seat.[7] By using recycled waste material from her own body, Hatoum invites those who sit on "her" chair, carefully embroidered with her bodily detritus, to be potentially in touch with a desublimated self. At the same time, through using the curly tufts of her own pubes, she provides a stylistic echo of the decorative principle by which the chair is made. Body and chair are interwoven both physically and stylistically.

Hair, that residual human substance, is inserted into an alien context in order to register the subjectivity and sexuality of its maker or user. Loaded with references to custom and culture, sexuality and gender, hair as a signifier disturbs the stylizations and rhetorical devices of art by registering the obdurate physicality of the body. If the curling short tufts of pubic hair offer a witty reprise of curvilinearity, making the presence of the body literally felt in the decorative and ornamental linear abstractions of art nouveau, then the longer, straighter knotted hairs of the hair grids address the repressions at stake in the formalist fantasy of artistic autonomy embodied in the grid.[8] Here at the site of art's most persistent abstraction, the inclusion of body hair, overdetermined sign of the corporeal, seems to be profoundly subversive.

Tiny, about four-by-four-inches square, and ephemeral, the hair grids are fabricated of very little—just a few strands of discarded or plucked human hair

3.6 Mona Hatoum, *Jardin Public,* 1993. Painted wrought iron, wax, and pubic hair (edition of 3), height 88.5 × 44 cm. Photograph by Edward Woodman, courtesy of Jay Jopling / White Cube, London.

3.7 Mona Hatoum, *Untitled (Grey Hair Grid with Knots),* 2001. Courtesy of Jay Jopling / White Cube, London.

harnessed into shape, pulled into parallel vertical and horizontal lines. And they greatly resist such measured control, straining at a number of pressure points, creating darker accents where they come together and voids where they separate or drift apart, winding and undulating across the surfaces on which they rest like a series of waves. Made, as is *Untitled (Black Hair Grid with Knots),* from thick dark strands of hair that are stretched into shape, tied, and knotted, strand by strand, as if the hair is being straightened or disciplined into conformity, or, as in *Untitled (Grey Hair Grid with Knots)* (figure 3.7), from the coarser single gray hairs which Hatoum has been assiduously collecting for some years and which she keeps securely stored in a box, the hair grids are assertively handmade and intensely personal. Shown against a black ground, the glistening, culturally devalued gray fibers, in particular, seem to pick up the light and reflect it like silver threads caught in a filigree web. Made to signify as precious yarn, the scarce substance

from which a delicate structure is woven to be preserved and cherished, gray hair—usually the object of embarrassment, shame, and fear, often concealed, regularly plucked, resonant of aging, decay, and decline—is here elevated to the status of relic. Carefully preserved, venerated, enshrined, the hair functions as a memento. Transformed by the grid into art and yet unable as material to obey the rules of the grid, the hair lines speak of that which exceeds the grid: the temporal, the corporeal, the feminine.

Carefully crafted into shape, the hair grids are woven with a metal implement on a small ready-made wooden frame, studded with metal spikes that are evenly placed around its edges (figures 3.8 and 3.9). Hatoum then sprays the hair squares with hairspray before removing them carefully from the support. The hairspray serves to stiffen the fragile web and helps to retain the linear pattern of the grid. But too much hairspray results, according to Hatoum, in a rigid, unyielding structure, while too little results in a floppy, disheveled one.[9] The hair must be tidy but not too tidy, casual but not messy, arranged but not formal or stiff. Wispy and fragile, easily split or broken and difficult to thread, the hair only partially conforms to the stylist's pattern, defying her attempts to organize it into a series of straight, evenly spaced, vertical and horizontal parallel lines creating a unified, modular design. Hair, the least obedient of materials, as hairdressers know so well, has a life of its own and will only partially conform to control by curlers, tongs, chemicals, and frames. It is the geometric pattern and rational ordering of the familiar grid—that underlying unit and organizing principle of industrial design, do-it-yourself craft kits, and modernist practice alike—that is both suggested and undermined by the evocative uniformity of the pattern and unruly independence of each individual hair/line. And it is the feminine labor of hairdressing, weaving, knitting, and knotting that is so poignantly represented in the handmade, hand-sized hair squares.

In the instrumental economy of design, line is, as Molly Nesbitt has shown, without corporeality.[10] But the hair line is, *of the body*. Made of a bodily substance, fragile, uneven, and hard to control, these vertical and horizontal lines stand for the failure of the functional, wooden square to discipline the hair lines into a neat, orderly pattern—in other words, for the failure of the grid to control the somatic excess of the subject.

———

3.8 Mona Hatoum, Weave-It kit for hair grids.

3.9 Mona Hatoum, Weave-It kit for hair grids.

If the "hairline" in common parlance is the point of separation between the expressive physiognomy of the face and the matted materiality of the hair that frames it, then the hair line in Hatoum's hair grids functions too as a boundary, a point of demarcation between small, empty, irregular framed units, like so many blank faces, and the wiry points of separation that demarcate them and give to each its defining character. The character of the hairline confers individuality on the face. No two hairlines are the same. Each face has its own frame. The ruled lines of the mathematical grid, on the other hand, repress the particular, reveling in uniformity and consistency. Unable to do their work of measuring, ordering, and calibrating with precision and accuracy, they are rendered useless, even dangerous, when sloppily drawn or clumsily constructed.

Hatoum's hair grids, as her own snapshots reveal, were produced with the aid of a bought Weave-It kit, of the type widely available when Hatoum was a young girl and teenager. Accompanying the small wooden frame and metal implement was an instruction leaflet replete with diagrams, notes, and guidelines. The drawn lines of instruction are bold and definitive. They brook no hesitation, uncertainty, or floundering. They hold no ambiguity. With guidelines, clarity is of utmost importance. On the other hand, the hair grids, each of which stands alone, undermine the utilitarian function of the kit designed to help women to produce squares that could be sewn together to form larger pieces of cloth or coverings. Hatoum herself recalls that when she was a teenager in Lebanon, "these frames were very common." "I did a project," she told me, "with my Girl Guide troop where each girl had to produce several squares of woven wool using the frames. We then sewed all the frames together to make blankets that we gave to the poor."[11]

The hair grids can serve no such useful purpose. Like much of Hatoum's work, they invoke the utilitarian function and the domestic contexts in which they originate but gain their meaning from their refusal to be functional. Like strainers that are prevented from straining by being blocked with metal bolts or similarly plugged ladles that cannot ladle or serve, the hair grids are useless as components of a functional whole.[12] Suggesting at the same time as refusing the domestic and craft cultures to which they owe their origins, the hair grids allude

simultaneously to high modernist practice and to the unpicking of the grid already represented by the shaky ruled lines and haunting uniformity of the grids of Agnes Martin or the evocative repetition of evenly spaced units in an Eva Hesse ink drawing on graph paper in which lines seem, themselves, to be woven together to create a whole. Like Hesse or Martin, Hatoum uses the point zero of representation, the grid, but the unnerving quality of her material, human hair, as well as the process of weaving by which she arrives at her ephemeral objects and the fragile instability of their final appearance undermine any claims they might have either to modernist self-referentiality or the design imperatives of modernity.

Hatoum's hair grids do not represent her first juxtaposition of the organic, materiality of hair with the systematic framing formality of the grid. *Recollection,* an installation of 1995 located in the Béguinage of Saint Elizabeth in Kortrijk, Belgium, in which a community of women had lived and worked, comprised primarily of human hair. In addition to a large number of small hairballs that had been rolled in the artist's hands and scattered around the floor of the central room of the eighteenth-century building was a wooden loom with woven hair, stretched tightly over the central space so that the individual strands were still visible, either in orderly lines when pulled on the loom or as a fuzzy mass outside its borders (figure 3.10). Like the strands of hair at the edges of *Keffieh,* these stray hairs represent the remainder, those fibers left over when the design is realized, those elements that escape the system and are conventionally hidden from sight but are here left visible.

The small loom, like the Weave It kit, reveals the craft derivations of the grid. As Catherine de Zegher has shown, the grid originated "in the plain weave with its horizontal-vertical intersection of two separate systems of thread: the weft and the warp," and the grid's roots in craft and community are still resonant in the small, woven gray and black hair grids.[13] In *Recollection* the wooden loom is placed on a table in a room with the rolled hairballs scattered on the floor and individual strands of knotted hair suspended at six-inch intervals from the ceiling. Almost invisible, the hair strands share the spectator's space, brushing against the faces, clothes, and hands of those who enter the installation. Far from being a disembodied signifier or an abstracted representation, the barely visible hair line

3.10 Mona Hatoum, *Recollection*, 1995. Hairballs, strands of hair hung from ceiling, wooden looms with woven hair, and table; dimensions variable. Installation at the Béguinage of Saint Elizabeth, Kortrijk, Belgium. Photograph by Fotostudio Eshof, courtesy of Kanaal Art Foundation.

here insists on its own materiality and transgresses conventional boundaries to reach out and touch the unsuspecting viewer. The viewer responds with the body: brushing hair from the mouth or face, for example, or scratching a spot that has been stroked or tickled. All distance between artwork and viewing subject breaks down. Hairs intermingle, boundaries are broken, bodies touch. At the same time as negotiating the suspended hair-strands, the viewer of *Recollection* must look down to avoid kicking or standing on the hairballs strewn on the floor. Discarded waste matter is recycled as precious art material, the uncanny corporeality of the hairballs impinging on the viewer's freedom to occupy the space with

confidence or ease. Tentative, wary, awed, the viewer traverses the space in a heightened state of self-awareness and bodily discomfort.

Much of this discomfort is produced as a response to the material of the hair itself. A bodily waste product, in effect, hair is intimately tied up with the sexuality and subjectivity of the person from whom it has derived. Historically woven into bracelets or encased in precious lockets, hair has traditionally served as a memento or token of a lost or absent loved one. Drawn from the body to which it refers, it has connoted proximity and presence in the face of loss. The uncanny quality of the decorative hair lines in *Keffieh,* with which I started this essay, had something to do with their potential to touch the head of the wearer, to brush against his face and mingle with his own hair, causing a dissolution of boundaries. At stake too was the utilization of hair in an alien context, involving the transgression of conceptual boundaries and the dissolution of neat or sustainable categories.

Hair Necklace (1995), produced at the same time as *Recollection,* involves just such a transgression (figure 3.11). Here the carefully rolled hairballs which had functioned in *Recollection* as precious detritus, casually arrayed on windowsills, table, and floor as if by chance, are strung in the shape of a necklace and displayed on a headless bust in the window of the jeweler Cartier. The vitrine's unlikely juxtaposition of hairballs and headless shop model, art and jewelry, high fashion and body waste highlights the nature of all these categories and leaves nothing for granted.[14] Here the overarching formal referent that is subverted is the string of pearls or beads, a decorative line associated with female adornment, wealth, and privilege, now undermined by the uncanny associations of human hair invoking absence or even death.

Exceeding the framework of the grid, the fragile almost nothingness of human hair has the power to unnerve and disarm the subject. Beyond the grid or escaping its regimented operation is the world of the body. The hair grid, made as it is of a bodily substance, seeks to negotiate the gap between the body and language, the somatic and the symbolic. The geometric order of the grid and the unruly materiality of hair are impossible to reconcile. Where the grid stands for the sobriety of the conceptual and invokes the masculine, the necklace stands

3.11 Mona Hatoum, *Hair Necklace,* 1995. Artist's hair, Cartier bust, and leather, 31 × 22 × 17 cm. Courtesy of Jay Jopling / White Cube, London.

for the triviality of the decorative and suggests the feminine, but both the recti-linearity of the one and the curvilinearity of the other are rendered problematic by the use of human hair. Cutting through the binaries that structure meaning and representation is the hair line which refuses to signify as one or the other, as body or line, mind or matter. It is in the interface between these that its meaning resides.

<div align="center">Notes</div>

This paper is the result of long and productive conversations with Mona Hatoum. Her generosity and openness have been much appreciated. Thanks too to Briony Fer, with whom I try out all my ideas, and to Linda Nochlin, who has been my inspiration for the last twenty years.

1. Linda Nochlin's indispensable "Why Have There Been No Great Women Artists?" inaugurated the birth of feminist art history in the early 1970s and coincided with the emergence of a feminist critical discourse on art and culture in which women artists participated.

2. For an analysis of the uses of line in pedagogy and industrial language, see Molly Nesbit, *Their Common Sense* (London: Black Dog Publishing, 2000).

3. Crucial among feminist reworkings of the relationship between line and body has been the work of Carol Ockman. See her important *Ingres's Eroticized Bodies: Retracing the Serpentine Line* (New Haven: Yale University Press, 1995). For a discussion of the gendering of line and color in the nineteenth century, see Tamar Garb, "Berthe Morisot and the Feminizing of Impressionism," in T. J. Edelstein, ed., *Perspectives on Morisot* (New York: Hudson Hills Press, 1990), pp. 57–66. See also Briony Fer, "What's in a Line? Gender and Modernity," *Oxford Art Journal* 13, no. 1 (1990), pp. 77–88.

4. Many writers have commented on the subversion of the domestic in Hatoum's work. See, for example, L. Steward, ed., *Mona Hatoum: Domestic Disturbance* (North Adams, Mass.: MASS MoCA, 2001).

5. For a discussion of this piece in relation to a broader consideration of the idea of home and the domestic in Hatoum's recent work, see Tamar Garb, "Homesick," in *Mona Hatoum,* exh. cat. (Salamanca: Centro de Arte de Salamanca, 2002).

6. Benjamin puts it: "It may be supposed that in the typical Jugendstil line—conjoined in fantastic montage—nerve and electrical wire not infrequently meet (and that the vegetal nervous system in particular operates, as a limiting form, to mediate between the world of organism and the world of technology)." Walter Benjamin, *The Arcades Project,* trans. Howard Eiland and Kevin McLaughlin (Cambridge: Harvard University Press, 1999), p. 558.

7. For Hatoum's own account of this (and other) works, see "Michael Archer in Conversation with Mona Hatoum," in Michael Archer, Guy Brett, and Catherine de Zegher, *Mona Hatoum* (London: Phaidon, 1997), pp. 8–30.

8. The classic account of the grid as the point zero of modernist formalism is Rosalind Krauss, "Grids," in her *The Originality of the Avant Garde and Other Modernist Myths* (Cambridge: MIT Press, 1986), pp. 2–22.

9. My information comes from conversations held with Mona Hatoum in the summer of 2001.

10. See Nesbit, *Their Common Sense.*

11. Based on conversations held with Mona Hatoum in the summer of 2001.

12. Hatoum's works such as *No Way* (1996) and *No Way II* (1996) comprise domestic objects such as ladles and strainers that are deformed by being studded with metal bolts so that they can neither sift nor strain.

13. See Catherine de Zegher, "Hatoum's *Recollection:* About Losing and Being Lost," in Archer, Brett, and de Zegher, *Mona Hatoum,* p. 98.

14. For the historical use of hair in jewelery, see Marcia Pointon, "Materializing Mourning," in Marius Kwint, Christopher Breward, and Jeremy Aynsley, eds., *Material Memories* (Oxford: Berg, 1999), pp. 39–57; and Pointon, "Wearing Memory: Mourning, Jewellery and the Body," in Gisela Ecker, ed., *Trauer tragen, Trauer zeigen: Inszenierungen der Geschlechter* (Munich: Fink, 1999), pp. 65–81.

Mignon Nixon

The Transference of Love

> By what other signs can the genuineness of a love be recognized? By its efficacy, its serviceability in achieving the aim of love? In this respect transference-love seems to be second to none; one has the impression that one could obtain anything by it.
>
> —*Sigmund Freud, "Observations on Transference-Love"*

In "Observations on Transference-Love," Freud warns the would-be psychoanalyst not to fall for the woman on his couch. The analyst must be "proof against every temptation," for the woman under the impress of transference is prone to fall in love "as any other woman might, with the doctor who is analyzing her."[1] Transference is a displacement onto the analyst of unconscious desires formed in relation to others, particularly parents. "Composed of repetitions and copies of earlier reactions, including infantile ones," transference is a form of memory, but also a form of resistance: the analysand seeks to supersede symbolic interpretation by entering into a real love relation with the analyst.[2] For the analyst, as Freud explains (with some feeling), this invitation to a "union of mental and bodily satisfaction in the enjoyment of love" may be painful to decline.[3] "And yet it is quite out of the question for him to give way" to the countertransference by answer-

ing the demand for love directly; instead, he is obliged to help his patient "over-come the pleasure principle" and seek love in a "proper place."[4]

In the beginning, Freud viewed transference as an obstacle to the treatment's aim of bringing unconscious desire under conscious influence. Soon, however, he observed that the neurotic patient's capacity for transference could be exploited in the cure. Neurotic illness, Freud proposed, nurtured a heightened predisposition to transference on the part of the patient, whose repressed erotic impulses were easily directed to the figure of the analyst. He compared this revelation of sexual desire in the consulting room to the uncovering of the patient's body in a medical examination: by exposing the patient's demand for love—and exposing himself to desire—the analyst was able to investigate the symptoms at close hand.[5] Transference-love therefore did not hinder but actually advanced the analytic process.

Transference-love is a reenactment of the past. This in itself however reveals little about its special character. For all love, as Freud points out, is repetition, a new edition of an old desire.[6] What distinguishes transference-love is rather its potency, its unique "efficacy" for the subject, who uses the energy supplied by the transference to separate from the past and move into the future. In Freud's account, transference-love lays the groundwork for a prospective sexual relationship: the analyst aims to help the patient transfer the transference-love from the figure of the analyst to another. To do this, "he must keep firm hold of the transference-love" (because it is therapeutically powerful) "but treat it as something unreal" (because the treatment leads away from the analyst and toward "real life").[7]

Within the gendered logic of Freud's account, the male analyst teaches the female patient to articulate her desire symbolically rather than embody it symptomatically. He does this through his own example, refusing her offer of love and responding instead with interpretations of the transference. So far, Freud's theory of transference-love seems to reproduce patriarchal gender roles: his emphasis on libidinal transference from a female patient to a male doctor is in keeping with a gender hierarchy that privileges masculine authority in sexuality and in discourse. There is, however, another dimension to the transference I would now like to explore, and that is the way in which transference to the analyst facilitates the expression of women's ambivalence.

THE TRANSFERENCE OF AMBIVALENCE

These men [referring to teachers] . . . became our substitute fathers.
. . . We transferred on to them the respect and expectations attach-
ing to the omniscient father of our childhood, and we then began to
treat them as we had treated our own fathers at home. We confronted
them with the ambivalence that we had acquired in our own fami-
lies and with its help we struggled with them as we had been in the
habit of struggling with our fathers in the flesh.

—*Sigmund Freud, "Some Reflections on Schoolboy Psychology"*

The word "ambivalence" first appears in Freud's psychoanalytic writings in 1912, in a paper entitled "The Dynamics of Transference."[8] Reflecting on the role played by transference in shaping the psychoanalytic encounter, he marks the haunting of "affectionate transference" by aggression.[9] Often repressed, or masked by ex-aggerated deference, hostility shadows the singular esteem in which the teacher or analyst is held.

Freud advised countering the analysand's resistance (of which transference-love is one expression and aggressive transference another) with interpretation. His efforts to account for transference symbolically continue his formative work on hysteria. There, Freud theorized that the hysteric preserves repressed sexual impulses in physical symptoms. Having linked hysterical symptoms with sexual repression, he gradually devised the talking cure to transpose soma into symbol. In contrast to the earlier method of hypnosis (in which Freud first detected the powerful effects of transference), the patient was no longer simply acted upon by the doctor but was given scope to act: to speak, but also to resist. The talking cure, by eliciting the patient's active role in the treatment, therefore addressed a re-pression of ambivalence as much as a repression of sexuality. It created a structure for the articulation of the patient's ambivalence toward the father via the "substi-tute father" of transference: namely, the analyst.[10]

Here I would like to mark the distinction in Freud's account between the crucial role played by ambivalence in the formation of masculine subjectivity and its virtual absence from the construction of femininity. In the passage quoted above, from "Some Reflections on Schoolboy Psychology,"[11] Freud unfolds a nonclinical understanding of transference as a shared cultural experience, and of ambivalence as a help, a spur to creativity and intellectual development—for boys. Suggesting that ambivalence is anticipated and provided for in the Oedipal arrangements of patriarchy, he describes this cultural transference as a bond between men of different generations under patriarchy. Further, the ambivalence a boy acquires in his family, and transfers to his teachers and father figures, mirrors the Oedipus complex (even to the extent that both are divided between positive and negative aspects).[12] Freud's description of cultural transference therefore is symmetrical with the development of masculine subjectivity, and both are premised on the exclusion of women.

In Freud's account of transference, male patients' expression of ambivalence, combining libidinal and aggressive elements, corresponds to the Oedipal struggle. The treatment of female patients, however, gives recourse to no such model: the father-daughter relation stunts ambivalence rather than cultivating it. Freud's work is largely defined by this disparity, by the cultural repression of women's ambivalence. On the one hand, the talking cure intervenes in this repression as, at least in part, a technique for helping female patients articulate their ambivalence toward a powerful and dominating paternal imago.[13] Yet, although he recognized that ambivalence toward the analyst's authority played a central part in the talking cure, Freud skirted its role in shaping feminine subjectivity. His conception of transference remained oriented toward the libidinal, as Daniel Lagache observed in 1954, leaving "the negative transference and the transference of defense in the shade."[14] It is in the work of later psychoanalysts, notably Melanie Klein, that the import of negative transference in the clinical scene was tested in depth, and that the role of the maternal imago in triggering feminine aggression was broached.[15]

Nevertheless, Freud's female patients questioned and even defied his authority, entering into a dynamic relation with the analyst through transference-

resistance. The interpretation and working through of the transference in turn introduced the possibility of identifying with analytic authority, of taking on the role of disciple.

THE DYNAMICS OF TRANSFERENCE

> Whereas psychoanalysis uncovers the mirage inherent in the function of the one supposed to know, it also shows the prestige and affective charge of that mirage to be constitutively irreducible, to be indeed most crucial to the dynamic of all human interactions, of all human relationships founded on sustained interlocution.

—*Shoshana Felman,* Jacques Lacan and the Adventure of Insight

Since Freud, feminism has created new conditions of transference for women. It has even created situations in which women occupy both sides of the transference relation. These changes have enabled some to claim that transference is not (or is no longer) exclusively an effect of the patriarchal bond between generations of men, and that transference is (or is now) a universal dynamic.

In *Jacques Lacan and the Adventure of Insight*, Shoshana Felman movingly describes the psychoanalytic model of learning as disavowal of mastery. "Knowledge," she writes, "is not a substance but a structural dynamic": it is "essentially, irreducibly dialogic."[16] The Lacanian analyst or teacher "makes no claim to total knowledge."[17] Transference confers on the analyst or teacher the authority of the "one supposed to know," but it is the task of analysis to question this premise. The Lacanian analyst/teacher treats the fantasy of the one supposed to know as Freud advised the analyst to handle transference-love: by keeping firm hold of it, while treating it as something unreal (in Lacan's terms, a mirage).

Lacan's radical intellectual contribution, Felman argues, was to develop the analogy between learning and analysis, both of which are galvanized by transference. A decade and a half later, it is more conceivable that the type of sustained dialogue she portrays could be conducted between women, and that these

women might experience their relationship more as a "discursive human inter-action" than as a special circumstance within a still-sexist society. Yet the question remains: does sexual difference matter in the logic of transference?

In 1984, Joan Copjec argued that to exploit new conditions of transference demanded an analysis of "the way male-transference histories take their form . . . from their exclusions of women."[18] The Oedipal model of transference between generations of men, she observed, establishes the framework for discipleship and for "the anxiety of influence" as culture is transmitted and developed from one generation to the next.[19] Extending Linda Nochlin's earlier analysis of the art historical canon as a structure of exclusion, Copjec asserted that "the whole radical effect of feminism would not be the admitting of women, finally, into the existing disciplines, but the breaking up of the concordant epistemological fantasies which are their support and limit."[20] For Copjec, therefore, it was precisely the problem of sexual difference that defined what was at stake in transference for women. And Lacan's work, with its language-based account of sexual difference, facilitated the analysis of this transference-difference.

Although Felman saw the effects of transference as potentially universal (the scene of her study is, after all, the "university") and Copjec understood transference itself as an effect of sexual difference, both identified transference as a defining legacy of Freudian psychoanalysis, and located that legacy in the work of Lacan.[21] Copjec's article was published in a special issue of *October* devoted to discipleship. In her introduction to the issue, Copjec pointed to transference as a term through which to heal the split between theory and practice, and to exploit the political potential of psychoanalysis: a potential that rested in the ability of psychoanalysis to account for subjective experience not only in theoretical terms, but on the basis of its own history. The "Discipleship" issue of *October* was one of several projects of the period that brought the history of psychoanalysis and its clinical methods to the fore in an effort to reveal the discipline's own "epistemological fantasies."[22] Writing in the 1980s, Copjec and Felman, together with, Jacqueline Rose, Jane Gallop, and others, addressed the question of transference at the peak of Lacan's reception into Anglo-American academic discourse (an event that coincided with the entry of greater numbers of female academics into

American universities). Now able to occupy the master's side of the transference relation, and to write from that perspective, some women were free to identify with Lacan's abiding interest in "the power held by the analyst" and to explore the potential for more psychoanalytically based models of teaching and scholarship.[23] Felman seized on the *dia-logic* of transference as a dynamic founded on "the position of alterity" in the interlocutor as an alternative to patriarchal fantasies of mastery.[24] Copjec stressed that psychoanalysis, as a political analysis, was obliged to analyze the master-disciple relationship on which psychoanalysis itself is historically based as a structure by which the subject is instantiated in a master society.[25]

For both Copjec and Felman, transference was the pivot of the psychoanalytic model as it opens onto a broader cultural field. And yet, despite being "coextensive with the very field of psychoanalysis," transference is a pointedly neglected dimension of its history.[26] This remains the case today in historical and cultural criticism, where those who invoke psychoanalysis give a wide berth to transference—wary, perhaps, of the concept's association with a clinical practice that is often seen to be discredited or obsolete. Indeed, it is a given of contemporary criticism that the theory and practice of psychoanalysis are separable, that psychoanalytic theory has achieved autonomy from the clinic. This division (in psychoanalytic terms, this splitting), however, has given rise to an academic psychoanalysis that is, with some justification, dismissed in much contemporary cultural theory. For extramural psychoanalysis—psychoanalysis beyond the clinic—has sought credibility in academic discourse at the cost of the relational, (inter-) subjective dimension that once galvanized its challenge to academic and cultural authority.[27] It was by laying hold of transference and analyzing it in its full cultural expression, at its diverse sites of articulation, that psychoanalytic feminism aimed to rethink and reshape pedagogy. Today it is the disavowal of praxis that secures the place of psychoanalysis in the academy.

Peter Osborne has stated the problem very clearly, observing that "the object of a psychoanalytical cultural analysis cannot be cultural messages (texts/objects/practices) alone."[28] Circling back to debates instigated by psychoanalytic feminism in the 1980s, he has argued that the task of psychoanalytically based criticism is not exclusively interpretive, but must take account of the intersub-

jective encounter in which psychoanalysis is grounded. For Osborne, the crucial question is how the intimate "communicational dimension" of psychoanalysis—a dialogue between two individuals—might be projected into a cultural matrix given that there is, as he maintains, "no apparent equivalent to the analyst/analysand relationship" in cultural experience.[29] He cites Jean Laplanche as the psychoanalytic theorist most profoundly engaged with this question today. Laplanche points out that what is distinctive in psychoanalysis is not transference, but the analysis of transference. Transference itself exists before and after analysis. It is there "before an individual analysis, and before the historical creation of analysis," and it survives the termination of any individual analysis—only to be transferred to other sites, other relationships. "Perhaps the principal site of transference, 'ordinary' transference, before, beyond or after psychoanalysis," Laplanche observes, would be "the multiple relations to the cultural."[30]

The survival of the artist as a pivotal figure in postmodernism, beyond the putative death of the author, in itself evidences the role transference plays in establishing, and sustaining, a dynamics of viewing. To put it another way, transference has survived the poststructuralist attempt to dissolve it. Instead, the poststructuralist critique of authorship has generated, in Laplanche's terms, a "transference of transference"—a transferential movement that spirals away from its *idée fixe* (the analyst, the author) and toward other objects, other spaces. Is there, then, anything in this transference of transference that is specific to the figure of the "woman artist"?

The emergence of the "woman artist" as a figure of transference even as the role of the author came under erasure in postmodernism has often been interpreted as a theoretical regression. For the "woman artist" reactivated transference precisely at the moment when authorship was, in poststructuralist terms, on the verge of death. But if, as Laplanche contends, transference is structural to subjectivity and to culture—and therefore cannot, as Freud argued, be resolved or dissolved, but only transferred and transformed—then the "woman artist" might be seen as a creative effect of transference in culture.[31] The emergence of new figures of transference might be seen to instigate new transferences: rather than the death of the author, it might be possible to imagine the transformation of authorship.

———

The relationship between viewers and the work of a contemporary artist is precisely one founded on what Felman calls "sustained interlocution," on an intersubjective dynamic structured by questioning. The artist instigates questioning through a body of work, or a sustained artistic practice: *a body of work,* or a practice that extends over time, because if one condition for establishing transference in the analytic scene is a pattern of interlocution, this also seems to obtain in the dynamics of viewing. Taking the dynamics of transference in the analytic situation as a logic through which to reflect on this question, I would like to suggest that transference offers an alternative to the theoretical discourse of identification that has recently prevailed when subjectivity has been at stake. The model of transference can restore a productive critical distance between artist and viewer: a rigorous formality in the context of a "serviceable" intimacy.[32] Because transference is relational and dynamic, but also historical, it offers a framework through which to explore the historical formation of the "woman artist," and to consider ways in which the discourses of feminism and postfeminism are now contested among generations of women.

THE SHE-FOX: TRANSFERENCE AND THE "WOMAN ARTIST"

In 1982, Louise Bourgeois (born 1911) was the first woman to receive a full-scale retrospective exhibition at the Museum of Modern Art. Then aged seventy, a French-American artist with historical links to the surrealist avant-garde and to feminism, Bourgeois embodied the "woman artist" as a figure who provokes transference. She assumed this role punctually—at the moment when such a figure was needed, when transferences to "women's art," instigated by feminism, seemed to demand a focus. Moreover, Bourgeois's art, which since the 1940s had been critically engaged with the history and practice of psychoanalysis, and with the history and practice of feminism, now began to investigate an analogy between the dynamics of viewing and the dynamics of transference:

> The material was there taking all that room and bothering me, bothering me by its aggressive presence. And somehow the idea of the

mother came to me. This is the way my mother impressed me, as very powerful, very judging, and controlling the whole studio. And naturally this piece became my mother. At that point, I had my subject. I was going to express what I felt toward her. . . . First of all I cut her head, and I slit her throat. . . . And after weeks and weeks of work, I thought, if this is the way I saw my mother, then she did not like me. How could she possibly like me if I treat her that way? At that point something turned around. I could not stand the idea that she wouldn't like me. I couldn't live if I thought that she didn't like me. The fact that I had pushed her around, cut off her head, had nothing to do with it. What you do to a person has nothing to do with what you expect the person to feel toward you. . . . Now at the end I became very, very depressed, terribly, terribly depressed.[33]

So Louise Bourgeois recounts the process of making *The She-Fox* (1985; figure 3.12), a black marble statue of a headless, multi-teated animal regally installed on a thick cushion of stone. The muscular haunches support a massive, canted upper body shorn of forelimbs and burdened with two pairs of swollen teats, spherical tumescent promontories rising toward a long vaginal slit in the elongated throat of the beast. Pocked with chisel marks, the stone's dark surface gleams at the throat where the pitted gash is laid: rough broken by smooth and smooth by rough. Surmounting the square solid neck is a polished block, planted firmly like a crown, the head displaced to the foot, where a miniature portrait is carved fetish-like into the hollow of the right haunch.[34]

In her account of *The She-Fox,* Bourgeois compares the aggressive presence of "the material" to a powerful maternal imago that commands the studio. Her description might be taken (might indeed have been adapted) from Melanie Klein's reports of the psychoanalytic play technique, a clinical method Klein devised to recast Freud's principle of free association for the treatment of children, and in which Bourgeois holds a long-standing interest.[35] The role of the analyst, as Klein conceived it, was to provoke negative transference, or a transference of aggression, by constructing "total situations" in the analytic setting, where a

3.12 Louise Bourgeois, *The She-Fox,* 1985. Black marble, 179.1 × 68.6 × 81.3 cm. Private collection, Chicago. Photograph by Lee Stalsworth, courtesy of Cheim & Read, New York.

complex of anxieties and fantasies could be played out.[36] A room provided with simple equipment and materials such as paper, pencils, and paint became the scene of intensive physical activity. "Often a toy is broken," Klein wrote, "or, when the child is more aggressive, attacks are made with knife and scissors on the table or on pieces of wood; water or paint is splashed about and the room generally becomes a battlefield."[37]

In Melanie Klein's account, the beginnings of transference lie in the earliest months of life, in the vicissitudes of the aggressive drives. For Klein, therefore, transference is not exclusively a displacement of sexual desire onto another, but an enactment of aggressive fantasy that targets, above all, the mother. For little

girls, she contends, the mother takes on, in fantasy, the role of "the primal per-
secutor," an "attacked and therefore frightening mother" who exacts vengeance
for the assaults visited on her in fantasy by the child.[38] Klein offers the example
of Rita, a little girl who in the course of one session "blackened a piece of paper,
tore it up, threw the scraps into a glass of water which she put to her mouth as if
to drink from it, and said under her breath 'dead woman.'"[39] The child's fears of
revenge from the mother-persecutor, Klein suggests, are magnified by her fear of
destroying the loved object together with the hated one. Anxieties arising from
what Klein calls the paranoid-schizoid position give way to the guilt and despair
of the depressive position, in which the subject repents of the damage inflicted
on the maternal body in fantasy. "We can fully appreciate the interconnection be-
tween positive and negative transferences," Klein contends, "only if we explore
the early interplay between love and hate, and the vicious circle of aggression,
anxieties, feelings of guilt and increased aggression, as well the various aspects of
objects toward whom these conflicting emotions and anxieties are directed."[40]
This is the crux of Kleinian ambivalence, which Klein relates not to the Oedipus
complex, but to an earlier and deeper fusion of the life and death drives.

In *The She-Fox,* the effects of gouging and chiseling are violent and sus-
tained ("weeks and weeks of work"), then countered by a vigorous campaign of
polishing. This figure does not, then, bear the marks of charged activity as plainly
as earlier sculptures—figures such as the Personages, the artist's first sculptural
works. *Portrait of C.Y.* (1947–49; figure 3.13), for example, is a square wood post,
five and a half feet tall, punctuated by three acts of cutting: the top is pierced by
a rectangular slot; a cluster of nails is driven into the shaft at the level of the mouth
or heart; and the corners of the post are filed and honed from the midsection
downward to the sharpened lower tip. Precariously balanced on its narrow end,
the figure itself assumes a stakelike sharpness. The nails driven into the shaft, a
metonymic repetition of this lancet shape, are the work's most salient feature, de-
claring it at once an object of aggression and an aggressive object. The violence
of *The She-Fox,* by contrast, is stylized and sublimated: a carefully carved wound,
a panoply of chisel marks. In recent years, a related sculpture, *Nature Study*
(1984–94; figure 3.14), has often been installed at the entrance to exhibitions of

3.13 Louise Bourgeois, *Portrait of C.Y.*, 1947–49. Painted wood and nails, 169.5 × 30.5 × 30.5 cm. National Gallery of Canada, Ottawa. Photograph by Allan Finkelman, courtesy of Cheim & Read, New York.

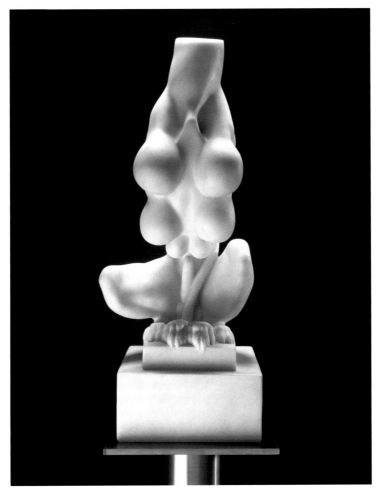

3.14 Louise Bourgeois, *Nature Study,* 1984–94. Pink marble, 87.6 × 44.5 × 38.1 cm.
Photograph by Allan Finkelman, courtesy of Cheim & Read, New York.

Bourgeois's work, and a similar figure can be seen in photographs of the artist's Brooklyn studio (figure 3.15), its distinctive profile assuming a kind of totemic clarity in the vast space of the former clothing factory. The centrality of these figures in Bourgeois's late work seems to declare an affiliation with the maternal imago as—in defiance of patriarchal convention—a figure that sustains ambivalence and aggression.[41] As such, *The She-Fox* might be understood not simply as an object produced, like *Portrait of C.Y.,* with the "help" of ambivalence, but as a figure in which the creative power of ambivalence is now securely lodged.

3.15 Louise Bourgeois's studio, Brooklyn, July 1999. Photograph by Christopher Burke.

ARTICULATED LAIR: TRANSFERENCE SPACE

The French philosopher and psychoanalyst Julia Kristeva has ob-
served that motherhood makes passions circulate. I would say that it
is ambivalence, in particular, that makes passions circulate, as well as
firming boundaries, forcing reflection, provoking separation and
unification, and thus providing a spur to individuation for both
mother and child.

—*Rozsika Parker,* Mother Love/Mother Hate

Articulated Lair (figure 3.16) is a very different sort of work from *The She-Fox,* al-
though the two pieces were made around the same time. A simple architectonic
construction, its perimeter is defined by hinged steel screens eleven feet high.
Entry is by way of one narrow arched door, egress by another. The hinged gaps
in the screen make it porous to its surroundings, admitting shafts of light to trace
a radiant web across the floor. Inside, a low stool implies solitude. Carved wooden
batons hang from the ceiling by strings like utensils, suggesting a place where
tasks are done—where the viewer might do some work.

Bourgeois's work is often *about work,* adapting objects to a kind of psychic
bricolage. *Articulated Lair* recalls a much earlier piece, *Quarantania I* (1947–53;
figure 3.17), which concerns, in particular, the work of mothering. At the cen-
ter of the group is *Woman with Packages,* a figure from Bourgeois's first sculpture
exhibition, here surrounded by four variations of a figure type called the *Shuttle
Woman.* The circle leans in around its chief figure, the woman with packages,
balanced on the tapered tip of a slender pole and encumbered by three low-slung
sacs, appendages suggestive of pregnancy and maternal devoir. Formally, the
packages invert the Personages, turning figure upside down to make object. And
this formal economy implies a psychic one by which, as object-relations theory
expresses it, subjectivity is produced through the projection and introjection of
objects, the first of which are parts of the mother's body.

A discourse that developed out of the psychoanalysis of children, object-
relations theory lays special emphasis on the mother-infant dynamic in the for-

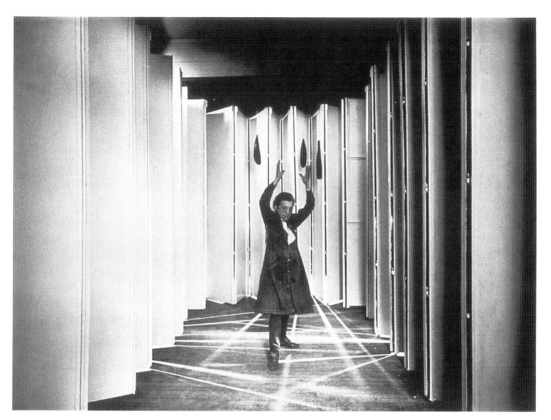

3.16 Louise Bourgeois, *Articulated Lair,* 1986, with artist inside. Painted steel, rubber, and stool, height 335 cm. The Museum of Modern Art, New York. Photograph by Peter Bellamy.

3.17 Louise Bourgeois, *Quarantania I,* 1947–53. Wood, 158.4 × 29.8 × 30.5 cm. Whitney Museum of American Art, New York. Photograph by Peter Moore.

mation of subjectivity. It is not traditionally concerned with the subjectivity of the parent. Klein, for example, describes the baby's ability to tolerate ambivalence toward the mother as an achievement, while *maternal* ambivalence is reduced to a repetition of this primary ambivalence, "a re-experiencing of feelings a woman held in relation to her own mother during childhood."[42] Such a description, as Rozsika Parker has observed, fails to take account of the adult woman's difference from a child: it neglects the development of her ambivalence through transference. (For women in the role of mother, Parker suggests, a developed capacity for ambivalence might be of particular "help.")

Ambivalence requires transference relationships. The discourse of transference in post-Kleinian psychoanalytic feminism has been enriched by feminism's efforts to imagine and to instigate new transference situations. In Bourgeois's art, the representation of women's ambivalence as a help, a spur that makes passions circulate—but also firms boundaries and facilitates individuation—is pivotal.[43] *Articulated Lair,* a structure that both contains the viewer's body and is permeable to the surrounding environment, might be seen as opening up a transferential space for the viewer. (Bourgeois would later call such space, with reference to an extensive and ongoing series of works, that of the "cell.") A photograph by Peter Bellamy of Bourgeois posing inside *Articulated Lair* takes on the character of a demonstration. Standing amid the floor's bright web, arms lifted high above her head in a gesture of inauguration, she seems to embody the role of the "woman artist" as an agent of transference.

Postscript: Postfeminism

Freud's article "The Dynamics of Transference," Laplanche observes, "is a big disappointment if one hopes to find anything in it about 'dynamics' in the modern sense of the term: a dynamic movement internal to transference."[44] For psychoanalytic feminism in the 1980s, it was the dynamics of transference in Laplanche's sense of the term—"dynamics as movement, as evolution, as the changing relation of forces, as 'dynamism'"—that counted.[45] For feminism, the potential of transference to transform culture was its principal attraction. Yet the "adventure

———

of insight," as Felman called the Lacanian project, ultimately calcified into or-
thodoxy. In academic discourse, psychoanalysis was restabilized as a system of in-
terpretation, split off from its transferential, intersubjective dimension.

If the dia-logic of transference no longer seems to structure feminist cul-
tural criticism, this may be because the transferential energy that powered it has
been dispersed. Perhaps the entry of "women artists" into the art world and of
female teachers into academia stimulated new transferences, and countertrans-
ferences, that have since been absorbed into a settled pattern of interaction. Cur-
rent debates around postfeminism, however, suggest that a new dynamic, a new
dynamism, may now be forming. "One notices a *milieu* less when one is plunged
in it; more so when it is rather briskly altered or when one leaves it," notes La-
planche, describing transference as "the very *milieu* of analysis, in the sense of its
surrounding environment."[46] Feminism changed the art world and the univer-
sity by provoking new transferences, and deployed the dia-logic of transference
to analyze its own effects. Contemporary challenges to historical feminism, tak-
ing the form of generational struggle between women—now occupying both
sides of the transference situation in significant numbers—have altered the envi-
ronment once more. Postfeminism has triggered a new transferential movement,
and demands analysis as such.

In two recent projects, Silvia Kolbowski (born 1953) has incorporated the
intergenerational and intersubjective dynamic of transference. In both *an inade-
quate history of conceptual art* (1998–99; figure 3.18) and *Like Looking Away*
(2000–02; figure 3.19), Kolbowski places herself in the role of listener, so that the
viewer encounters the artist through the texture of her unseen presence. The role
of the artist in both works is to provoke transference, to set transference in motion.

For the first of these projects, Kolbowski invited sixty artists to take part in
compiling a kind of oral history of conceptual art. She began by inviting each
artist to describe a conceptual work, "not your own, of the period between 1965
and 1975, which you personally witnessed/experienced at the time." Of the forty
artists who responded, twenty-two have so far participated in audio recording
sessions with Kolbowski who, as well as recording the artists' statements, video-
taped their hands as they spoke. In the installation, the enlarged projected images

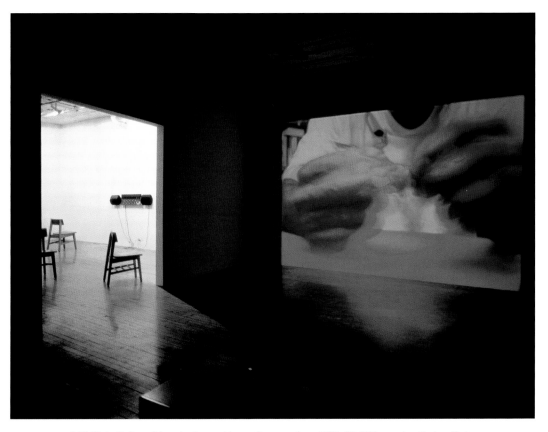

3.18 Silvia Kolbowski, *an inadequate history of conceptual art,* 1998–99. Video and audio installation, 55 minutes. Photograph by Takahiro Imamura, courtesy of American Fine Arts, Co.

of the gesturing hands play soundlessly, discontinuous with the unfolding narratives. Adding to the drama and mystery of the exhibition, respondents were asked not to refresh their memories by researching the works they described, not to reveal the artist or title of the chosen work, and not to disclose their own identities.[47] "I like telling people about it, because I like it a lot," one contributor observes of her selection, "but I don't think I actually saw it." "I guess I should ask myself why this stuck in my mind all these years, over thirty years," reflects

another. "It's easy to remember, it's easy to remember, it's easy to remember," chants one speaker, as if to will the act.

In her letter to the artists, Kolbowski defined conceptual art as encompassing "actions documented through drawings, photographs, film, and video; concepts executed in the form of drawings or photographs; objects where the end product is primarily a record of the precipitant concept, and performative activities which sought to question the conventions of dance and theater."[48] One effect of this inclusive definition, as Alexander Alberro has noted, was to privilege "the most transitory manifestations of the movement, those most likely to have left 'inadequate' traces and thus most dependent on the memory of direct witnesses for insight into their initial receptions."[49] "An inadequate history," after all, might be another name for psychoanalysis itself, whose subject is constructed in repression—in forgetting as much as in remembering. Kolbowski's description, however, also served to contest received histories of conceptual art, recasting its practices in terms that, as she has noted, "allow for an inscription of women artists into the history of conceptual art"—and into its transference-histories.[50]

Kolbowski has emphasized the way in which *an inadequate history of conceptual art* plays both on and against the conventions of conceptual practice. The hand, for instance, famously cancelled as a marker of the artist's presence in conceptual work, returns as a signifier of history and generational difference. The creasing and gathering of skin functions as a sign of age, a bodily measure of the distance between the historical moment of conceptual art and the time of these recollections. That the narratives themselves are subject to the vicissitudes of personal history, to memory, is underscored by discrepancies between the artists' firsthand accounts and documentary evidence. For one purpose of the project, Kolbowski has said, was to evoke for a younger generation of artists and art historians revisiting the history of conceptual art the inadequacy of personal memory as historical evidence—to demonstrate the fragmentary, contingent authority of recollection: "I thought that if I asked artists to speak from memory about conceptual projects from the past, the recountings would include both valuable recollections and the fallacies of human memory. It seemed that these

fallacies, the stutters of memory, so to speak, could trouble the fluidity of the return."[51] Another effect of the project, however, is to demonstrate the ways in which histories—personal histories, art histories, social histories—are constructed through transference.

Significantly, Kolbowski positions herself between generations, in an intermediary role between the older conceptual artists whose stories she records and the younger artists and historians who are meant to receive them. In so doing, she places herself on either side of the transference relation. Kolbowski's own artistic practice, while grounded in certain tenets of conceptual art, is historically and intellectually aligned with later postmodernist debates, and with the social, political, and theoretical territories of feminism and sexual difference that are substantially neglected in conceptual art, or more precisely in its dominant histories. For this project she implicitly assumes the Oedipal role of the disciple—the listener—only to subvert it, exposing the inadequacy of these elders as figures of authority, but also, crucially, demonstrating their disavowal of mastery, their willingness to disclaim the "total knowledge" of the one supposed to know. Here, then, the dialogic dimension of Lacanian transference, as Felman described it, finds expression in a work of art and history that also evidently endeavors to break up the epistemological fantasies of Oedipal transference in art/history, as Copjec envisioned.

For *an inadequate history of conceptual art* is both a work of history and a work of art. It cuts across the disciplinary limits of art and history, and disrupts the generational positions marked out by Oedipal transference. Even as she assumes the role of the listener, which is classically the position of the Oedipal subject, or disciple, in transference, Kolbowski also takes the part of the listener-*analyst,* the one who provokes transference. It is the overlapping of these two positions, disciple and analyst, that creates a new and more unstable transference situation. The transferential scenario of this work, however, is only obliquely apparent to the audience. Attention shifts between the artists who speak and the agency, unseen and unheard, that collects and orders these recollections. The figure of the artist is only partially perceived—as a voice, an image of gesturing hands, or, in the case of Kolbowski herself, the effect of a silent presence. In *an inadequate history*

3.19 Silvia Kolbowski, *Like Looking Away,* 2000–02. Video, photography, and audio installation, 25 minutes, dimensions variable. Courtesy of American Fine Arts, Co.

of conceptual art, the audience receives an implicit invitation to encounter the artist not only as an object of transference or a figure of authority in history, but as a figure who provokes movement and change in the transference situation.

Kolbowski elucidates this potential of the artist to provoke transference in a more recent project, *Like Looking Away,* for which she interviewed ten young women, aged eighteen to thirty-four, about their attitudes toward shopping. In the resulting installation, a single actress's voice performs the edited interview material as a series of monologues, from which all references to shopping have been excised. Photographic portraits of the interview subjects, made while the women were listening to playbacks of their own voices, accompany the audio installation. "I think the first thing I feel when I think about it is fear," one speaker begins. "I hate it." For another, "It's kind of a little secret I have." Here Kolbowski emphasizes the play of transference and countertransference: the process by which the listener-analyst attends to, and transforms, the other's narrative, repeating it back to the speaker in an edited form that is both hauntingly familiar and disconcertingly foreign.

Such recasting of speech is crucial to the psychoanalytic dynamic. For it is the awareness that the other's speech is always different from one's own (even when the words are substantially, even exactly, the same) that gradually estranges the analysand from her or his own speech, and makes it possible to accept that estrangement. As Laplanche expresses it, "external alterity refers back to internal alterity."[52] The analysand encounters the unconscious, the internal unknown, through the other. In *Like Looking Away,* photographs of the interview subjects, taken while listening to audio recordings of their own voices, serve as one marker of self-alienation. Transformed into enigmatic monologues performed by an actress who replicates, as closely as possible, the inflection, tone, and affect of ten individual speakers, the edited interviews evidence what Laplanche calls the "primordial split" at the heart of transference. *Like Looking Away* only dramatizes the splitting inherent to any intimate dialogue.

The analytic scene is only one transference situation in which a woman might today encounter another woman's difference—another woman's ambivalence—but it is one in which "external alterity refers back to internal alterity"

in a particularly concentrated way. More broadly, *Like Looking Away* suggests that the dynamic of cultural transference, as an ambivalence played out between women, has exceeded the imagination even of those feminist theorists of the 1970s and 1980s whose work first exposed both the historical conservatism, and the potential radicalism, of transference. "If we interpret a transferential movement, it is not to attack it as a defense, nor to resolve it; it is in the end to make it evolve, to help in its evolution," observes Laplanche.[53] This might be a productive position from which to begin thinking about what postfeminism offers the history of "women artists" at the millennium.

<div align="center">NOTES</div>

1. Sigmund Freud, "Observations on Transference-Love," in Aaron H. Esman, ed., *Essential Papers on Transference* (New York: New York University Press, 1990), pp. 43, 37.

2. Ibid., p. 44.

3. Ibid., p. 46.

4. Ibid., pp. 46, 44.

5. Ibid., p. 45.

6. Ibid.

7. Ibid., pp. 43, 46.

8. Sigmund Freud, "The Dynamics of Transference," in Esman, ed., *Essential Papers on Transference,* p. 33. See also the entry on ambivalence in Jean Laplanche and J.-B. Pontalis, *The Language of Psycho-Analysis,* trans. Donald Nicholson-Smith (New York: Norton, 1973), p. 26.

9. Freud, "The Dynamics of Transference," p. 33.

10. Freud's first theory of hysteria was that it was an effect of paternal seduction. On Freud's transfer of the sexual impulses to the daughter, see Jane Gallop, *The Daughter's Seduction: Feminism and Psychoanalysis* (Ithaca: Cornell University Press, 1982), chapter 9, "Keys to Dora."

11. Sigmund Freud, "Some Reflections on Schoolboy Psychology," in *The Standard Edition of the Complete Psychological Works of Sigmund Freud,* ed. James Strachey (London: Hogarth Press, 1953–1974), vol. 13, p. 244.

12. See Laplanche and Pontalis, "Transference," in *The Language of Psycho-Analysis,* p. 458.

13. Jessica Benjamin argues that Freud's practice of psychoanalysis constituted "an ongoing effort to remove the analyst from the position of coercive authority and to enfranchise the patient." Benjamin, *Shadow of the Other: Intersubjectivity and Gender in Psychoanalysis* (New York: Routledge, 1998), p. 11.

14. Daniel Lagache, "Freudian Theory and the Theory of Transference," in *The Work of Daniel Lagache: Selected Papers, 1938–1964,* trans. Elisabeth Holder (London: Karnac Books, 1993), p. 139.

15. See Melanie Klein, "The Origins of Transference" (1952), in *The Selected Melanie Klein,* ed. Juliet Mitchell (New York: Free Press, 1986). Klein's paper is discussed below.

16. Shoshana Felman, *Jacques Lacan and the Adventure of Insight: Psychoanalysis in Contemporary Culture* (Cambridge: Harvard University Press, 1987), p. 83.

17. Ibid., p. 84.

18. Joan Copjec, "Transference: Letters and the Unknown Woman," *October* 28 (Spring 1984), p. 76. This issue of *October* was entitled "Discipleship: A Special Issue on Psychoanalysis," and was edited by Copjec.

19. The phrase "anxiety of influence" is Harold Bloom's. Copjec devotes a significant section of her article to an analysis of Bloom's account of the formation of the literary canon. See Bloom, *The Anxiety of Influence: A Theory of Poetry* (Oxford: Oxford University Press, 1973).

20. Copjec, "Transference," pp. 76–77. Linda Nochlin, "Why Have There Been No Great Women Artists?" (1971), in her *Women, Art, and Power and Other Essays* (New York: Harper & Row, 1988).

21. Copjec writes: "The intervention of Lacan in psychoanalytic theory is above all an intervention in the theory of the transference." Copjec, "Transference," p. 66.

22. See, for example, Charles Bernheimer and Claire Kahane, eds., *In Dora's Case: Freud-Hysteria-Feminism* (New York: Columbia University Press, 1985).

23. Felman's book is dedicated "to my students," Copjec's essay "to my women colleagues."

24. Felman, *Jacques Lacan and the Adventure of Insight,* p. 83.

25. Copjec, "Discipleship," *October* 28 (Spring 1984), p. 6.

26. Copjec, "Transference," pp. 68, 67.

27. Laplanche uses the term "extra-mural psychoanalysis" in "Transference: Its Provocation by the Analyst," in *The Language of Psycho-Analysis,* p. 221.

28. Peter Osborne, "Dialogue with Psychoanalysis," in *Philosophy in Critical Theory* (London: Routledge, 2000), p. 118.

29. Ibid.

30. Laplanche, "Transference: Its Provocation by the Analyst," p. 222.

31. Freud's theory that the resolution of the transference marked the successful end of the analysis has long been subject to critique and rethinking, most intensively, in recent times, by Laplanche.

32. Freud, "Observations on Transference-Love," p. 45.

33. Louise Bourgeois, taped interview with Jennifer Dalsimer, 4 September 1986 (Archives of American Art). Bourgeois offers a more detailed description of the piece in Jerry Gorovoy and Pandora Tabatabai Asbaghi, *Louise Bourgeois: Blue Days and Pink Days* (Milan: Fondazione Prada, 1997), p. 176.

34. "Then under her haunches is a kind of nasty place, and there I placed myself. That is to say I put a statue that used to be called *Fallen Woman.*" Bourgeois quoted in Gorovoy and Asbaghi, *Louise Bourgeois,* p. 176.

35. On Bourgeois's dialogue with Klein, see my *Fantastic Reality: Louise Bourgeois and a Story of Modern Art* (Cambridge: MIT Press, 2005).

36. Klein, "The Origins of Transference," p. 209.

37. Melanie Klein, "The Psycho-Analytic Play Technique: Its History and Significance" (1955), in *The Selected Melanie Klein,* p. 41.

38. Klein, "The Psycho-Analytic Play Technique," p. 48.

———

39. Ibid., p. 49.

40. Klein, "The Origins of Transference," p. 207.

41. "I have been inhabited by a ferocious mother-love; in that way the *She-Fox* is also a self-portrait." Bourgeois, quoted in Gorovoy and Asbaghi, *Louise Bourgeois,* p. 176.

42. Rozsika Parker, *Mother Love/Mother Hate: The Power of Maternal Ambivalence* (New York: Basic Books, 1995), p. 18.

43. See the epigraph of this section.

44. Laplanche, "Transference: Its Provocation by the Analyst," p. 217.

45. Ibid.

46. Ibid., pp. 217, 216.

47. The work has been exhibited at several sites, including American Fine Arts, Co., New York (1999); the Oliver Art Center, California College of Arts and Crafts, Oakland (2000); the Whitney Biennial (2000); and Western Front in Vancouver (2002).

48. Press release, American Fine Arts, Co., September 1999.

49. Alexander Alberro, "Silvia Kolbowki, American Fine Arts, Co." *Artforum* (December 1999), pp. 148–149.

50. Silvia Kolbowski, email to author, 12 May 2003. Kolbowski cites, for example, the exhibition *L'art conceptuel: Une perspective,* organized at the Musée d'Art Moderne de la Ville de Paris in 1989, and its catalogue, as an official history from which work by women was largely excluded, noting that this show "set the tone for the 'return'" of conceptual art in contemporary practice. *L'art conceptuel: Une perspective* presented the work of thirty-two artists, of whom three were women. The contributions to Kolbowski's *an inadequate history* are almost evenly divided between women and men. On the exclusion of specifically feminist work from official histories of conceptual art, see Helen Molesworth, "House Work and Art Work," which appeared alongside a print version of Kolbowski's project in *October* 92 (Spring 2000).

51. Silvia Kolbowski, "an inadequate history of conceptual art," *October* 92 (Spring 2000), p. 53.

52. Laplanche, "Transference: Its Provocation by the Analyst," p. 220.

53. Ibid., p. 217.

3.20 Rosemarie Trockel, *Untitled*, 1989. Photocopy on paper, 26.5 × 19.9 cm. Öffentliche Kunstsammlung Basel, Kupferstichkabinett, inv. 1990–351.

Anne Wagner

Like many artists before and around her, Rosemarie Trockel has perfected an approach to drawing that knows exactly what it aims to disavow. Her drawings—in the last two decades she has made many more than a thousand—vividly conjure figures both human and animal, yet nothing in her way of proceeding bespeaks a careful honing and husbanding of a range of graphic skills—unless by "skill" we mean time spent mastering how lines operate to look dumb and cartoon-like; or what an ordinary ball-point or poster paint can do when put to use on a pad of cheap paper; or how a photocopier can be made to breed false hybrids—odd male/female overlays—or asked to run overtime so as to force it to yield up the faint ghost or spirit that lies lurking inside, as the copy machine hums and judders along.[1] One such wispy, even spooky persona emerges as a pseudo-magical image, the shroud of Turin updated so as to take its place among the so-called miracles of a recently concluded photomechanical age (figure 3.20). No wonder this particular ghost has been summoned: Trockel loves reproduction, and reproductions. She likes mutants, mimics, and cartoons. The same with photographs. She never draws from life. Instead her work feeds itself on the cheap and cheesy; it settles for daubing and smearing more often than it goes in for subtle description; it is never averse to a pun. She seeks out analogy and resemblance wherever they might be found. Urn/womb, baguette/penis: the more banal the better,

it must be said. All of this results in works that, although they do observe the technical conditions of drawing, in using the requisite media, formats, and scales, still display a pretty strict avoidance of familiar graphic pleasures and thrills. What all these works share of *drawing* as "signature marking," that is to say, is their maker's studied effort to dodge or duck the look of skill—this while insisting on the relevance—even the necessity—of sticking with bodies as subjects, if art is to be able to put pressure on bodily politics in any way at all.

Such pressure is the force of Trockel's art. She knows, like other artists of her generation, that politics are bodily; that bodies give politics their material physical site. Without bodies, there would be no need of politics: they are its object, they are where are registered its final effects. Such knowledge is of course one urgent argument in favor of figuration: figuration as preferred tactic, in other words, rather than as the vehicle of artistic identity, selfhood, or skill. In what follows, I aim to focus on what I am calling a kind of de-skilled figuration, a disfiguration, if you will. Figuration and disfiguration: these terms will matter in what I have to say. To be sure that they do, let me say at the outset that I am speaking of both figuration and its undoing in a somewhat technical, if also a traditional way. I use the term not simply as a code word for a mode of depiction—abstraction's other, the means to make bodies appear—but so as to try to mine its stronger rhetorical force.

For figuration, rhetorically speaking, is above all the transmutation of ideas into images—the means by which ideas and beliefs are given concrete and palpable form. That form matters, certainly; it is a matter of agreement and convention, but what matters even more is how figuration registers—often to conventionalize, sometimes to deaden—what is at stake in ideas and beliefs. Yet figuration is not only or merely deadening, for it is the figural capacity of representation that puts meaning in question, and keeps it in play. It is via their awareness of figuration in this sense—in light of the endless traffic between the stabilities of convention and the potential openness of meaning—that Trockel's best works, drawings among them, make their point. She knows this very well— even insists on it, with tongue in cheek. I think this is part of why she draws. Look for example at a second specimen drawing, to make that insistence clear.

It's a portrait of sorts, as so often is the case with Trockel's drawings: someone, probably male but possibly female, stands in profile, with the bust format miming a traditional portrait type—in fact it "figures" it, we should now be ready to say (figure 3.21). So far, so good: in fact, speaking of tradition, it is clear that this personage is a version of Pinocchio. He is long-haired, dressed up, without his master Gepetto, but still lying lustily: or so we conclude from the length of his nose, which has grown long enough, phallic enough, to empty all the language from its familiar balloon. Speechless, he is now only a body that lies.

His nose, I said. The word fits until we notice that this telltale organ has its seat or source in the figure's eye. Who or what is lying? Words or vision? Puppet or artist? Which is which? Which one should we trust? This, then, is the question that Trockel's drawing figures, even while it also figures a funny little long-

3.21 Rosemarie Trockel, *Untitled*, 1985. Acrylic on paper. Musée National d'Art Moderne, Paris, Cabinet d'Art Graphique.

haired quasi-legend who is phallic in his deformation, though not in his ultimate rhetorical force. And as for us, what are we to make of figuration when it is full of such willful distortions and odd effects, when its parables circle so insistently around a mistrust of various types and patterns of speech? What do we learn from looking at its forms? And what might we learn that is useful to a politics of looking in which we might put some trust?

There are three things I have to do to answer this string of questions. First I need a focus: for Trockel's politics, I am saying, are located in and conveyed by means of what is an insistently figural art. Second, I need an argument that will make politics a matter of looking in particular, an experience broached and catalyzed visually, through an encounter with a chosen set of forms. Lastly, I need to offer some kind of reading of exactly what notion of politics—of the politics of representation—is figured forth by the forms in question: all the better if I can make this a politics that feminists might find useful and relevant, and that even has some helpful role at the present time. For never were politics more necessary on a day-to-day basis; so much seems sure.[2]

First things first. As a focus, I want to take not one but two series of drawn works: they were done a bit more than a decade apart. Both groups are portrait collections, and as such they display the same basic set of conventions, even though were we to speak of means of execution or uses of medium, the two groups would not be all that close. Yet like other commentators before me, I too see them as linked.[3] The earlier set comprises ten small images: each shows the face of a monkey or ape done in ink and gouache on a notebook page (figures 3.22 and 3.23). Each is now untitled, or rather they are collectively untitled: in the 1980s, however, the group as a whole was called *Hoffnung* (Hope), with that poignant label replacing still earlier titles assigned to individual works in the series—terms like "Fear," for example, and "Disarray."[4] Not that such disquiet can securely be read in these faces, however hard we stare them in the eye. This we must do—it feels inevitable—thanks in no small part to Trockel's insistence on cropping and placement: these are portrait conventions that summon snapshot and mug shot; her figural language tacks all too knowingly between the effects of easy intimacy and those of intrusive control. And her use of gouache and a blunt,

3.22 Rosemarie Trockel, *Hoffnung* (Hope), 1984. Series of 10 drawings; gouache, watercolor, ink, pastel, and crayon, 29.8 × 20.2 cm. Statens Museum for Kunst, Copenhagen, Kobberstiksamlingen.

3.23 Rosemarie Trockel, *Hoffnung* (Hope), 1984. Series of 10 drawings; gouache, watercolor, ink, pastel, and crayon, 29.8 × 20.2 cm. Statens Museum for Kunst, Copenhagen, Kobberstiksamlingen.

dryish brush lends each body a physicality—a dense furry presence—that is no less convincing given how matter-of-factly each creature is worked up. It's hard to think of a set of her drawings that looks more handmade. But above all we look so intently on account of what the artist has done to conjure ten pairs of dark and deep-set eyes. She uses brushed splotches, sometimes a slight flush of color, white highlights, and white-ringed backgrounds, with each of these operations insisting we stare into black.

As she herself did, as a necessary part of bringing each portrait to life: these are drawings that were clearly much looked at and into while they were being drawn. Brigid Doherty has noted in an unpublished paper how much that process seems antiphotographic—the term names what is polemical about how these pictures look.[5] Absolutely: we can even extend Doherty's key observation, so as to insist on what the antiphotographic means for both Trockel's process of production and her practice of portraiture. Notice how a real sense of nonimitativeness, noninstantaneity is offered in each imagined visage, in what is flat, direct, and local in each inky passage, as well as in how each portrait claims and holds the page. Each does so as a matter of convention—as an imitation portrait—as well as by surrendering volume, space, and depth. We can supply no sitters to this context, nor are these likenesses. Invention and imagination are pressed into service, in aid of a counterfeit. All this is the more noteworthy given Trockel's declaration to an interviewer in 1988: "I am interested in the monkey as man's imitator—or as an imitator pure and simple, on its own."[6] Such an assertion seems perfectly straightforward on the part of an artist for whom imitation as an artistic procedure is almost always to be preferred. Except here: to be interested in monkeys as mimics is not to mimic another image in which a monkey appears; it is rather to imagine or invent a set of humanoid simians as portrait conventions might make them appear. Trockel summons them directly, as opposite numbers, full of vital presence, if not personhood. All of this is managed via figural choices, or by means of what Harry Berger Jr. has taught us to see, when sitters are present, as the "fictions of the pose."[7] Yet in this case, with no one posing, we confront fictions *tout court*.

Perhaps what is special about this procedure will look obvious if we make a single comparison. It links Trockel's apes with a famous forebear: this is the woodcut of the disappointed and sulky chimpanzee with which, in 1872, Charles Darwin illustrated the discussion of monkeys and apes in *The Expression of the Emotions in Man and Animals* (figure 3.24). The image was "drawn from life" with "extreme pains," we read, by one Mr. Wood.[8] As for the chimp's pains, they stemmed from being offered an orange that was then whisked away. Hence his curling lip. Hence too, however, Darwin's remarkable insistence that men and animals share the same expressions—both pout when sulky, both tremble in fright—and his use of those findings to bolster a theory of human evolution from animal ancestors in the deep past. All this is well and good, but when it comes to depiction, Darwin's

3.24 "Chimpanzee Disappointed and Sulky—Drawn from life by Mr. Wood." Wood engraving reproduced from Charles Darwin, *The Expression of the Emotions in Man and Animals* (1872), p. 139.

chimp—a distant kinsman, so his own logic shows—is still a specimen to be tested and toyed with, a creature that is handled and rendered rather more like a thing than a self. Whereas Trockel, by contrast, forces the format of empathy, without quite supplying it: surely the apes are made to offer a kind of person-hood—just one that we don't quite understand. Why are these creatures smiling? Are they smiling? Are they looking? Is this not the moment to summon John Berger's reading of the impact of the animal's wary gaze when it looks at a man? "Man," he writes, "becomes aware of himself returning the look. The animal scrutinizes him across a narrow abyss of non-comprehension. This is why the man can surprise the animal. Yet the animal—even if domesticated—can also surprise the man."[9] Following Berger, then, it may be that looking at Trockel's simians places us in this category of "Man."

A decade after her monkey drawings, in the winter of 1994–95, Trockel showed another suite of portraits as the focus of an exhibition in Vienna.[10] These are the works I want to compare with her portraits of apes. I suppose one reason for doing so is because questions of family, of subjectivity, are likewise at issue here. Again her figural mimicry matters to our sense of what—how much or how little—any one portrait can do. The show consisted of five groups of images—five plaster masks, each with its own set of drawings (I shall keep to the draw-ings)—with each group corresponding to five separate people: father, mother, older and younger sisters, and the artist herself. Each grouping deploys a separate graphic look and language. And as earlier commentators have been quick to no-tice, the tone is vaguely clinical and therapeutic, as if a single troubled patient were being set different exercises that would show us how she *feels* about her nearest and dearest.[11] Bad, is the answer; or so these regressive portraits seem to say: here is drawing as a kind of acting out. Take Father, for a start (figure 3.25). Quite faceless, he's all and only hair and beard: if he is present behind the blank surface, then he lurks there speechless, mute as a wall. Mother, by contrast, is all organs, all expression (figure 3.26): popping eyes, polyp nose, pursing mouth; this last feature could do double duty as an anus, and the whole visage has some of the frantic extruded anxiety of a work by the eighteenth-century Viennese sculptor Franz Xaver Messerschmidt—though when he sculpted, he was depicting his

3.25 Rosemarie Trockel, *Untitled* (Father), 1995. Acrylic on paper.

fantasy demons rather than real flesh and blood.[12] Or maybe, speaking of demons, the gist of the image is that Mother can never get enough of things, enough sensations, though her senses run overtime, full speed ahead. The more she gets, the more she withholds: or so say the puckers of her all-too-anal mouth.

The characterizations continue from parents to offspring: there is the older sister, for example, with her manic linear repetitions, tight and punctual as a minimalist's doodle (figure 3.27): the image conjures someone who is strictly marking time. And here is the younger sister, with her face made up, quite literally, of cotton-ball inkblots (figure 3.28): now it is Rorschach, not Messerschmidt, who comes at once to mind—if, that is, we are prepared to imagine the good doctor sitting at a dressing table daubing his tell-tale blotches into a semblance of a female self. The joke is funnier if you think of rouge or powder, not merely as pigments,

3.26 Rosemarie Trockel, *Untitled* (Mother), 1995. Charcoal on paper.

3.27 Rosemarie Trockel, *Untitled* (Older Sister), 1995. Charcoal on paper.

3.28 Rosemarie Trockel, *Untitled* (Younger Sister), 1995. Charcoal on paper.

but as different means to make a stain. (That this self is merely a semblance seems to me suggested by the openings in the drawn surface, which let through the sheer emptiness behind.) Last is Trockel's own self-image: she too is made of lines, in one portrait overlaid thickly in a welter of opposites—read "conflict"—and in a second image knitted together as a loose, loopy fabric with not one but several unraveling ends (figure 3.29). In neither image can we be quite certain what we are looking at: is this hair, for example, or a face that has been hidden or repressed?

What strikes me, in looking back and forth between these two sets of images—between the family of apes and the family of man and woman—is the calculating way Trockel suspends and relocates our expectations of what might be seen in a portrait, as well as of what portraits might be used to show. Her concerns do indeed take up those very matters with which portraiture has traditionally been engaged. For a statement of at least some of the issues, look no further than F. W. J. Schelling in 1802, as he tries to find terms in which to understand "the true artistic value of a portrait." "If portraiture," writes Schelling, "turns the interior of the figure towards the outside and renders it visible it would then admittedly have to be limited to such subjects in which symbolic significance is seen to inhere."[13] There are, I think, two things that follow from this statement, at least where Trockel is concerned. What Schelling helps us get in focus is, first of all, just how aggressively Trockel uses the portrait to put the project and mechanisms of interiority into hard reverse. She seeks out exactly that symbolically significant site, the social unit of the family (her own family, moreover, in its regulation nuclear formation), where, so our best authorities tell us, the self is formed and deformed. She even goes so far as to borrow, for her chosen terms of depiction, modes of drawing that mimic a whole range of art therapies devised to rehabilitate, even liberate, the modern self from the inevitable familial damage and distress. Yet to depict the family through such parodies is to put in question the whole project of self-investigation, self-mapping, and self-healing, and thus to show that same project as what bars us from knowing and depicting other selves. Can the self become the strict function of some curative program; do we risk seeing others as pure effects, all distorted and blotchy, of the analyses and therapies that figure them forth? At the very least, Trockel seems to be saying that

3.29 Rosemarie Trockel, *Untitled* (Self), 1995. Charcoal on paper.

knowledge of the self—to say nothing of self-expression—is not the same as, nor to be confused with, knowledge of another person. And she seems resolutely pessimistic that art *can* lead to any very great knowledge of another person, any great rendering of psychic truth. I think that it is right to read her pessimism as an argument with such standardizing figurations, and I understand that argument to be political in its main aims.

The second thing that I want to take from Schelling is a greater sense of what is polemical about Trockel's decision to make portraits of apes. It is certainly right to see that particular project, like its later complement, in light of Schelling's key proviso: portraits have value, he stipulates, if their inbuilt exteriorizations of interiority limit themselves to "such subjects in which symbolic significance is seen to inhere." Trockel's *singerie* series troubles Schelling's stricture while observing it: how much this is the case becomes evident when we acknowledge not just what is consistent, and insistent, in their manner of depiction, but also the images the series does *not* include. Around the margins of the final set of portraits collect other drawings where the carefully calculated format of the series—the tight cropping, the neck-and-shoulders framing—was not observed. Hence the exclusion, I am saying, of such oddly personal and eroticized depictions as the melancholy portrait of a female simian, whose head leans languidly against her upraised arm (figure 3.30). The image reminds us of the verdict offered by Melitta Kliege that for Trockel, "monkeys feature as substitutes for human beings or as portraits of the artist." I am not contesting this assertion in each and every instance; it seems possible that the languid female portrait supports her case. Yet what is striking, given the general logic of likeness and substitution that motivates the *Hoffnung* series, is how nimbly the works in that series stop short of assigning to animals human qualities or attributes. They do not exteriorize, and what might be inherent is open to debate. These apes, that is to say, stay animals—they look at us as others, and this is how we look at them. A line is drawn, in other words, between self and other; nor could anyone be quite certain, on the basis of these images, who is aping whom. I think that it is in view of such suspensions of projection and identification (such sentiments are both solicited and cancelled) that Trockel finally chose a title for these images: this is why she called them *Hope.*

3.30 Rosemarie Trockel, *Untitled,* 1984. Watercolor on lined paper, 29.8 × 20.2 cm. Gallerie Stampa, Basel.

Yet why should hope lie here? The question returns us to the issues of figuration and disfiguration we mapped at the start. The hopeful dream involves devising a mode of depiction that can undo fallacies—in particular the fundamental fallacy of the figurative (in the age since Schelling): the idea of "turning the interior toward the outside." Or the idea that outsides are only worth representing insofar as they (potentially or actually) give onto an inner invisibility, a depth with an "identity"; a depth that can answer us back in our own chosen terms. On the contrary, Trockel takes the figural, shows its limits, and sometimes even makes it stop short. We come face to face with our assumption that what gives a material body "significance" is an interior depth and invisibility, as well as with our sense that it is this unseen depth that "answers" us and makes the other "one of us." These assumptions are what figure us—viewer and object—as one and the same.

In Trockel's work the confrontation can be subtle—a last-minute refusal—or one of high dramatics: I want to end this essay on the latter note. So let me close by summoning two more works by Trockel. The first is simply a mirror, nothing more (figure 3.31). The mount is silver, the shape traditional: a perfect prop for some fun with art and vanity! Or so we think, as we look in the mirror to catch a glimpse of ourselves staring back. There we are, there *you* are, at least for a moment, until you move just a few inches this way or that. The result is immediate: what was once a mirror goes smokily transparent. The viewer's gaze finds no reassuring reflection. Instead it travels right through, to the mirror's mount—its backing—and to the supporting wall.

Trockel's trickery should be enough to send anyone scrambling for a title. And she has obliged. *Profumo:* title as time machine: rocket back to one of the great scandals of Britain in the swinging (as opposed to the radical) 1960s, when John Profumo, minister of war, met his downfall for having had sex with Christine Keeler, who was also having sex with a Russian naval attaché. The charge as leveled (and denied) was that secrets, as well as sex, were being exchanged. The issue, in other words, was whether sex could be traded or marketed without politics inevitably forming part of the mix. Good question, and not an irrelevant one for a tricky two-faced mirror, one made by a woman, to figure as its own. It

3.31 Rosemarie Trockel, *Profumo,* 1990. Two-way mirror and silver frame.

brings other questions in its wake. Is the artwork itself a mirror or window? Does it show the self or the other? Does it stage sex or politics? Why must it be named for a man? The answers, of course, depend in every instance on your chosen point of view. Take a look at your *answers,* moreover, and for a moment they will seem less than transparent: they will show you yourself.

Such strings of questions are Trockel's meat and drink; she aims to build them into her work. Yet we will not then find in her art any very comforting suggestion that our stance is or should be open to some endless play of difference or position. Her mirrors are more pragmatic than comforting, and they always work two ways. This was true in the case of the mirror in her *House for Pigs and People,* the work with which I want to manage both an ending and summation of my claims (figure 3.32).

Consider only its structure, as it figures the brief of the piece. Inside a small barracks of a building, made by Trockel and Carsten Höller as their contribution to Documenta 10, is a mirrored partition. On one side, pigs; on the other, people. The former go about their business within their walled compound, while inside the ramped interior the latter watch. The former see a mirror (or so we imagine), the latter a window (of this we can be sure). Their roles are never exchanged. The mirror/window sees to that. And it generates other disjunctions too: the set-up is oddly interrogative, even punitive, as well as performative and theatrical: the pigs behave like pigs, presumably; they are "natural" actors, we can only assume. Nor do they know (again, presumably) that they are being seen (again, we imagine they would not care). On the other side, the watchers also produce familiar behaviors: they act like watchers, that is. Yet their roles have been made awkward and odd. They do not sit, or even stand; instead, they recline in a tilted burlesque of leisure, like Romans taking in a spectacle or beachgoers staring at the waves. And as if this were not awkward enough, the experience also involves self-consciousness. The window made it possible to watch other watchers as, at the far end of the compound, they too peered and craned. "Watching pigs alive," writes one commentator on the installation, "must remind the gaze that it is always life which is at stake. That one should look at a distance. With caution. With respect. And with the thoughtfulness that might create room for one's own survival. In all its vulnerabil-

3.32 Rosemarie Trockel and Carsten Höller, *A House for Pigs and People,* 1997. Mixed media. Installation at Documenta 10, Kassel. Courtesy of Barbara Gladstone.

ity."[14] Yes, certainly: yet all of this is asked of a set of city dwellers—art tourists, really—who are taking a break at an expo by reclining and looking at pigs.

To look at a distance: for me the phrase names the key difference of Trockel's art—its disfiguration. Or so I have been terming the ways and means it finds to effect the undoing of a key premise of the figural mode. The phrase names not only her effort to maintain a distance from any guarantee of inwardness as a form of knowledge art can offer, but also her undermining of those models of looking that seem always in search of yet another self, or something very like one. Trockel puts our assumptions concerning likeness and connection under ironic and questioning stress. And the difference enforced by her various effects of distance are what disfigures and refigure habitual processes of thought. Yet Trockel knows full well that this model of difference demands and is balanced by a necessary closeness—a cohabitation, even, in the same house. Think of her antiportraits hung in rows to decorate its concrete walls. We are all inside together—family, apes,

pigs—in a space where it is enough to display a body, an exterior, for others to be asked to keep a distance, and to look with respect. No happy reversals are offered by this model of the social, evidently, yet if we are the ones who have to serve there as lookers, it seems equally certain that we are forced to consider exactly where in the set-up we ought to be standing, and what our posture might enable and convey.

<div align="center">NOTES</div>

1. Among recent considerations of Trockel's drawings are Jonas Storsve, "Métamorphoses et mutations," *Rosemarie Trockel: Dessins* (Paris: Centre Pompidou, 2000), pp. 5–19; and the ambitious and useful catalogue *Rosemarie Trockel: Bodies of Work 1986–1998* (Cologne: Oktagon, 1998), assembled on the occasion of a 1998 traveling exhibition of Trockel's work. Particularly relevant are the essays by Melitta Kliege and Sebastien Egenhofer. For further citations of these texts, see below. Presented initially at the Hamburger Kunsthalle, and then at the Whitechapel Art Gallery, London; the Staatsgalerie, Stuttgart; and M. A. C. Galeries Contemporaines des Musées de Marseille, the show (and particularly its catalogue) adhered to a presentation of themes and media that the catalogue credits as the conception of the artist herself. See also my "Trockel's Promise," *Drawing Papers* 18 (2001), unpag., and Hanne Loreck, "Storia Universale? Rosemarie Trockel's Works on Paper," *Art on Paper,* May/June 1999, pp. 32–36.

2. These words were written in mid-September 2001. Although I have left them unchanged in the published version of this paper, I think that the politics of difference and distance are now even more urgent than they were then.

3. The relation is proposed by several critics who contribute to the 1998 catalogue, *Rosemarie Trockel: Bodies of Work 1986–1998.*

4. Storsve, *Dessins,* pp. 10–11.

5. Doherty's paper, "Faces, Apes, Houses," was presented on the occasion of a panel discussion on Trockel held at the Drawing Center, New York, in February 2001. I am grateful to her for sharing a copy of that manuscript with me.

6. Quoted in "Rosemarie Trockel, endlich ahnen, nicht nur wissen: Ein Gespräch mit Doris von Drateln," *Kunstforum* 93 (1988), p. 216, as cited by Storsve, *Dessins,* p. 10. Also cited by

Melitta Kliege, "The Power of Expectation," in *Rosemarie Trockel: Bodies of Work 1986–1998,* p. 63, n. 1; for Kliege, Trockel uses the monkey "as a means . . . to reflect and recognize herself as a human being and an artist." In my account, the monkey as the figure of imitation offers Trockel the means to represent difference and distance—what is unknowable about another self.

7. The phrase was used by Berger as the title for his magisterial *Fictions of the Pose: Rembrandt against the Italian Renaissance* (Stanford: Stanford University Press, 2000).

8. Charles Darwin, *The Expression of the Emotions in Man and Animals* (1872; Chicago: University of Chicago Press, 1965), pp. 130–145. This long section on monkeys and apes, part of the treatment given "Special Expressions of Animals" in chapter V, reflects Darwin's sense of the many expressive analogies between humans and their near relatives. The origin of the sulky mood of the young chimpanzee depicted in Darwin's figure 18 is described on p. 140. It is followed by a description of the response of two young orangutans to a mirror, in which their frustrated efforts to touch and kiss their own reflections take pride of place.

9. John Berger, "Why Look at Animals?" in *About Looking* (New York: Pantheon, 1980), p. 3. I am grateful to Ann Hamilton, who pointed me toward this essay.

10. Held at the Galerie Metropol, the show presented only the works of this single series, under the title *Rosemarie Trockel: Gipsmodelle + Entwürfe.*

11. In her essay "The Power of Expectation," Melitta Kliege suggests that Trockel's mimicry focused in particular on "traditions already established in Vienna for describing and working through internal conflicts" (p. 63).

12. Ernst Kris's study of Messerschmidt remains the classic text. See his "A Psychotic Sculptor of the Eighteenth Century," in Ernst Kris, *Psychoanalytic Explorations in Art* (New York: Schocken, 1952), 128–150.

13. My citation slightly abridges a passage from F. W. J. Schelling, *The Philosophy of Art* (Minneapolis: University of Minnesota Press, 1989), p. 146.

14. Marlene Streeruwitz, "In the Next Millennium Everything Will Be Better. Then We Can Let the Pigs Watch Us," in Carsten Höller and Rosemarie Trockel, *A House for Pigs and People* (Cologne: Verlag der Buchhandlung Walther König, 1998), p. 49. With its essays by both artists and by a wide collection of international commentators, this book remains the essential source on the Documenta piece.

I have taken the rubric for this cluster of essays—"Subjectivities"—as the occasion for a referendum on feminism and psychoanalysis, a theoretical emphasis that had its heyday in feminist studies from the 1970s to the early 1990s. During this period, psychoanalytic feminism gave rise to some of the most interesting debates in the theory of the modern subject. The critique of Freud and Lacan had a major influence on ontology, which in turn reshaped the disciplines and changed the course of sexual politics. Drawing on work done in the 1930s by Anna Freud, Melanie Klein, Helene Deutsch, Joan Riviere, Karen Horney, and many others, feminist psychoanalysis challenged paradigms of phallic lack, egoic deficiency, pre-oedipal infantilization, passivity, perversion, hysteria, penis envy, compensatory narcissism, hyperdefensiveness, performative masquerade, fetishism, maternal pleasure, and the exclusion of feminine signifiers from the Symbolic order. In the seventies, the work of Julia Kristeva, Hélène Cixous, Michèle Montrelay, Luce Irigaray, Laura Mulvey, Jacqueline Rose, Juliet Mitchell, Parveen Adams, and Mary Kelly was particularly significant in refuting misogynist, heterosexist assumptions within Freudian and Lacanian psychoanalytic models. However, since the mid-1990s, this subjectivity feminism has become increasingly embattled: accused of being too straight, too white, too smug about assumptions of consensus;

too generationally rivalrous, unfashionable in an era of "postfeminism," deferential to phallocentric theoretical constructs, and insufficiently engaged with issues of race, postcolonialism, and public policy; too academic, and overly abstract. Much of this backlash can be traced to the general disfavor into which theory itself has fallen.

My response will not be a cavil about the restricted audience for theory, though I remain convinced that any considered attempt to assess the status of feminist subjectivity in the arts would necessarily entail a larger discussion of theoretical literacy in the public sphere. For my purposes here, I will simply surmise that in order to survive, feminist theory—especially psychoanalytically inflected theory—has had to fight for its life. It has responded to criticism by changing course and discursive style, as when a number of "theory" feminists, such as Nancy K. Miller and Jane Gallop, "went personal," dedicating their energies to memoirs or polemics. It has engaged psychoanalysis with race and postcolonialism, as in Gayatri Spivak's *Critique of Postcolonial Reason,*[1] Anne Cheng's *The Melancholy of Race: Psychoanalysis, Assimilation, and Hidden Grief,*[2] Jacqueline Rose's *States of Fantasy,*[3] Anne McClintock's *Imperial Leather: Race, Gender and Sexuality in the Colonial Contest,*[4] or my own *Continental Drift: From National Characters to Virtual Subjects.*[5] It has taken a biological turn, as in recent controversies around the gay gene, the psychology of transgender, or the bioethics of technological reproduction. It has reflected on its own imminent extinction, as a result of being absorbed in the welter of queer theory (the central issue of Mandy Merck's edited volume *Coming Out of Feminism?*),[6] or eaten by its own in the hardscrabble environment of institutionalized "women's studies" programs (an underlying theme of Wendy Brown's *States of Injury: Power and Freedom in Late Modernity*).[7] But it has also soldiered on, with new problems and approaches. Normative heterosexuality and the problematic reduction of kinship to family have occasioned a rethinking of the Oedipal paradigm by Judith Butler in her book *Antigone's Claim.*[8] Juliet Mitchell's *Mad Men and Medusas: Reclaiming Hysteria* attempts to "re-order" the Oedipus complex by assigning a whole new role to the "catastrophic displacement" induced by sibling rivalry. Here, the lateral relationship between siblings enlarges the parent-child axis in mapping the consti-

tutive dramas of subject formation, from affective attachments to the sublimation of murderous impulses.[9] And a new theory of transferential female genius has recently been developed by Julia Kristeva in her trilogy on Melanie Klein, Hannah Arendt, and Colette. Psychoanalytic feminism has also sustained itself by migrating out of the disciplines of psychoanalysis and literary criticism and into art practice and art history. As the contributions to this volume attest, visual feminism, inaugurated by Linda Nochlin, has played a key role in ensuring the afterlife of feminist theory.

Tamar Garb's essay on Mona Hatoum engages a problem endemic to feminist criticism since its inception, the issue of gender subjectivism in interpretation. Let it be said that gender essentialism has been much less controversial in legal determinations of sex discrimination than in discriminations of taste and aesthetic judgment. The history of criticism, since Kant, has evinced a marked resistance to "interested" criteria; criteria that would designate X a masculinist perspective, or Y a feminine one. And yet, it is very hard to do gender critique, feminist or otherwise, without these subjective categories. When Garb considers the case of line, for example, she typecasts it as masculine, or characteristic of a supposed gender neutrality that defaults to the masculine. This premise allows her to interpret Hatoum's *Homebound* as a domestic prison, or to see Hatoum's use of "dangerous curvilinearity" as a feminist trope. Her emphasis here brings to mind Catherine Ingraham's book *Architecture and the Burdens of Linearity,* which examines the masculine legacy of line: the bodily discipline of Pythagoreanism and the geometer's art.[10] Though Ingraham makes a conscious effort to steer clear of masculine/feminine binaries, and insists on the representational status of gender division, her arguments inevitably succumb to a certain literalness of gender stereotype. It is surely to Garb's credit that she assumes the burden of the binary without apology or hand-wringing qualification. Masculine and feminine are posed on an oppositional axis, with aesthetic categories ranged accordingly. Classical orders, universalism, the public realm, conceptualism, and rational line are placed on the male side, while particularism, the personal, materialism, craft, the private sphere, and the somatic occupy the female side. Garb focuses on where these oppositions reverse position. Characterizing drawing "as

[a] caress conventionally associated with male artists and female models," she reads Hatoum's *Van Gogh's Back* as an inversion of this convention, whereby the man's back becomes the canvas, bathed by the "touch" of the female artist. In Hatoum's *Grey Hair Grid with Knots,* she sees evidence of masculine line being pulled into feminine shape, as the artist reclaims a stigmatized sign of female aging— gray hair—using it to build a monument to the feminine, associated here with "the temporal, the corporeal," and "that which exceeds the grid." Garb concludes with the image of the hairy grid as a figure of the irreconcilability of masculine abstraction and feminine materialism. A figure of strange beauty, certainly, but where does this leave us theoretically? With a "complexity and contradiction" model that celebrates the ambivalence of unresolved difference? Or with a challenge to conventions that reduce gender in visual interpretation to subjectivist assignations of masculine and feminine? Can we develop a methodology that accepts sexual difference while refusing the claustrophobic stereotypes of gender difference? How does one devise an antiessentialist approach to the analysis of gender in visual media, and what would it look like?

If Garb's analysis grapples with the problematic way in which gender stereotypes underwrite theories of the feminine subject, Anne Wagner's discussion of Rosemarie Trockel illustrates how the notion of female subjectivity has been imbricated within definitions of the human. Like Garb, Wagner makes the assumption that interventions into bodily representation have particular relevence to feminism, and also like Garb, she approaches *techne* and medium in terms of gendered binaries. Where Hatoum feminized the tradition of line, Trockel, in Wagner's ascription, feminizes the medium of drawing, and she equates Trockel's undoing of *techne* with her use of "figuration as tactic." Figuration and its double, disfiguration, lead Wagner to questions of the animal and the human.

Wagner's reading of Trockel's female simians through the lens of Darwin's study of *The Expression of the Emotions in Man and Animal* brings to mind a bestselling French novel by Marie Darrieussecq titled *Truismes* (the English edition is entitled *Pig Tales*).[11] In its account of the metamorphosis of a French beautician into a sow, the novel is a send-up of medical stigmatizations of female nature propounded by nineteenth-century doctors such as Cesare Lombroso, who viewed

woman as lower on the evolutionary ladder than man. The protagonist describes how her body suddenly strikes her as "pneumatic," its rubbery elasticity and newly acquired fleshy contours announcing the pigness that will gradually install itself in her human form. Hormonal fluctuations, the desire to rummage for scraps in country fields, the prodigious growth of hind quarters, the appearance of fatty tissue burnished by a rose-colored epidermis, the sprouting of bristle— each stage of animal transformation is recounted as a descent into the hell of aggravated femaleness. Each stage is accompanied by desperate efforts to counteract the telltale signs of physiognomic disgrace with cosmetic correctives, thus tapping into societal taboos around aging and transgender operations.

Beyond their satire of the "female beast," Darrieussecq and Trockel question the hierarchies of being that place animals and women on inferior rungs. This critique implicitly proposes a trans-species model of subjectivity—one that honors the dignity of life rather than intellectual superiority—and which, along the way, redresses historic injuries endured by women and animals alike. These works also reveal how theories of the subject are currently beset by anxieties over the human in the age of the genome. And one can even draw out of Anne Wagner's argument the suggestion that psychoanalytic feminism might be well advised to consider ontology in relation to biogenetic or socially engineered gender formation.

In exploring the "bestial feminine," and its implications for how to rethink sex and politics, Wagner emphasizes gender resignification in feminist theory. Mary Kelly has followed this course in her work's examination of how the recent social phenomenon of women in the military regenders psychic models of defense, effectively resignifying manliness (see, for example, her *Mea Culpa* of 1992). And as Judith Butler has demonstrated, drag has resignified what Joan Riviere called "the masquerade of womanliness" by denaturalizing it, rehousing it under the rubric of gay and lesbian female impersonation. The Australian film *Priscilla Queen of the Desert* shows this clearly: high heels, feathers, sequins, lipstick, falsies, and wigs spawn a fantasy of unlimited object choices. The family romance of heterosexual difference (preserved in the film's subplot of marriage and paternity) recedes before the spectacle of polymorphously perverse regalia.

The real "heroines" of the picture are queer object choices that consecrate the feminine masquerade with mirth and pleasure.

This focus on spectacular good and bad objects points to the revival of object relations theory in psychoanalytic feminism (especially in Britain), and to the new Kleinianism at work in Mignon Nixon's essay on Louise Bourgeois. For Nixon, the psychoanalytic process of transference is clearly relevant to visual hermeneutics, for she reads "transference neurosis" in Freud, as a "facsimile edition" of unconscious processes. This gloss on Freud sparks questions that are not necessarily related to revisions of orthodox Freudianism: Is transference always at issue in visualization, in identification with an artist or a work of art? Is the work of art a copy of transferential desire, or is the copy the negative transference of an original? While Nixon does not really pursue this line of questioning, she does call for a psychoanalytical revision of art-historical influence paradigms in such as way as to allow them to "encompass the ambivalence of a negative attachment, or a negative transference." This affective approach advocates a reception theory of art that emphasizes loving or hating the object. In Nixon's reading, Louise Bourgeois's mutilated *She-Fox* or her use of damaged fantasy toys and monstrous transitional objects returns the viewing subject to the nursery, and to the pre-Oedipal battle of part objects.

Nixon joins Juliet Mitchell and Jacqueline Rose in mining the dark side of Kleinianism for alternatives to the Oedipus complex, and by "dark side" I refer to that portion of Melanie Klein's work that tracks the path of libidinal frustration on a regressive course of self-wreckage, social demolition, persecutory anxiety, and depression. Dubbed the "high priestess of psychic negativity," Klein, together with her disciple Joan Riviere, deployed a logic of negation and interiorized anxiety that in many ways seems crucial to understanding the complex motivations of femininity's turn away from itself.[12] Juliet Mitchell draws on this negativity in her anti-Oedipal model of sibling rivalry, in which lateral family connections or bonds of love among friends intercept and complicate the parent-child dynamic insisted on by Freud. Blocking "the fantasized merger with the mother," the arrival of a sibling, she argues, "bears death in train, for as well as murderous rivalry the child who was king is suddenly no one, annihilated, in danger of psychic

death."[13] In contrast to Mitchell, Mignon Nixon relies on Kleinian negation for a theory of "negative transference" framed as an "alternative to the theoretical discourses of genealogy and identification that have recently prevailed when subjectivity has been at stake." In the Kleinian school, negative transference might be discerned in the way in which feminism has become afflicted by self-critique—taken over by internecine warfare, intergenerational conflict, gynophobia,[14] or the self-hating contortions of postfeminism. While many might argue that this negative drive is not a good thing for feminism, others may see the agonistic embrace of the negative as a modernist form of *Bildung*. Mignon Nixon implies that negative transference is a form of invigorated feminism, an opportunity for a kind of intersubjective encounter distinct from genealogy or identification. Kristeva, on the other hand, sees great promise in genealogy. Drawing on the example of Hannah Arendt's first book, a biography of the Jewish *salonière* Rachel Levin, who was a minor player in Goethe's circle and whose letters were a germinative inspiration for Arendt's own passion for the thinking life, Kristeva allows feminist genealogy to, so to speak, beget female genius. And this female genius no longer comes at the price of actual childbirth. Though Kristeva submits that the "miracle of natality" has historically been an impediment to the realization of female genius, she now considers it to be an asset—an add-on to the new vocational confidence of women worldwide. "Though curled up like children in space and in the species, women," she writes, "are also able to work toward unique, innovative creations and to remake the human condition."[15] At first blush it may seem odd that a thinker like Kristeva, whose own name is virtually synonymous with radically semiotic accounts of female subjectivity, would endorse the romantic myth of genius, but seen in the broader context of rethinking transference and genetic destiny, genius may be as viable a means as any of guaranteeing the afterlife of subjectivity theory within feminism.

NOTES

1. Gayatri Chakravorty Spivak, *A Critique of Postcolonial Reason: Toward a History of the Vanishing Present* (Cambridge: Harvard University Press, 1999).

2. Anne Cheng, *The Melancholy of Race: Psychoanalysis, Assimilation, and Hidden Grief* (Oxford: Oxford University Press, 2000).

———

3. Jacqueline Rose, *States of Fantasy* (Oxford: Oxford University Press, 1996).

4. Anne McClintock, *Imperial Leather: Race, Gender and Sexuality in the Colonial Contest* (New York: Routledge, 1995).

5. Emily Apter, *Continental Drift: From National Characters to Virtual Subjects* (Chicago: University of Chicago Press, 1999).

6. Mandy Merck, Naomi Segal, and Elizabeth Wright, eds., *Coming Out of Feminism?* (Oxford: Blackwell Publishers, 1998).

7. Wendy Brown, *States of Injury: Power and Freedom in Late Modernity* (Princeton: Princeton University Press, 1995).

8. Judith Butler, *Antigone's Claim: Kinship between Life and Death* (New York: Columbia University Press, 2000). Butler writes: "The symbolic is precisely what sets limits to any and all utopian efforts to reconfigure and relive kinship relations at some distance from the oedipal scene" (p. 20).

9. Juliet Mitchell, *Mad Men and Medusas: Reclaiming Hysteria* (New York: Basic Books, 2000). See in particular pp. 23–26 and 40–41.

10. Catherine Ingraham, *Architecture and the Burdens of Linearity* (New Haven: Yale University Press, 1998).

11. Marie Darrieussecq, *Truismes* (Paris: P.O.L., 1996). English edition, *Pig Tales: A Novel of Lust and Transformation,* trans. Linda Coverdale (New York: New Press, 1997).

12. Jacqueline Rose, "Negativity in the Work of Melanie Klein," in *Why War? Psychoanalysis, Politics, and the Return to Melanie Klein* (Oxford: Blackwell, 1993), p. 153.

13. Mitchell, *Mad Men and Medusas,* p. 27.

14. See Apter, "Reflections on Gynophobia," in *Coming Out of Feminism?,* pp. 102–122.

15. Julia Kristeva, *Hannah Arendt,* trans. Ross Guberman (New York: Columbia University Press, 2001), p. xv.

MARY KELLY

THE BALLAD OF KASTRIOT REXHEPI

Installation consisting of 49 panels, compressed lint, 14 x 16 x 2 inches each; overall dimension 206 feet. Original score by Michael Nyman, performed live by Sarah Leonard and the Nyman Quartet, Santa Monica Museum of Art, California, 2001.

Above the main room they hide, six

, six nights, pressed to the floorboards, cautious as the ash around t

, below them soldiers stomping to the blunt beat of perfect solution

Fighting intensifies. Their panic mounts. No food

e distance, explosions.

nd Kastriot grows weak.

nd; does not scream, does not look back, but vows, "Always, always, al

Note:

The Ballad is composed of four stanzas which rework the legendary account of a Kosovar Albanian boy, eighteen months old, who is mistakenly left for dead during the expulsions by the Serbian military in Kosovo, April 1999. First rescued and given a name by Serbs, later cared for and renamed by Albanians, Kastriot is finally re-united with his parents, Afrim and Bukurie, after the NATO occupation, June 1999. The reunion is reported in the *Los Angeles Times,* July 1999.

IV IDENTITIES

Francesca Woodman: A Ghost in the House of the "Woman Artist"

Carol Armstrong

The young photographer Francesca Woodman, who jumped out a window in Manhattan in 1981 at the age of twenty-two, after about a decade of teenage work in Rhode Island, Rome, New York, and the MacDowell Colony, is the continuing topic of intermittent conversation among critics and art historians, mostly women, who take various stances, either implicit or explicit, on the question of the "woman artist." I want to take part in that conversation here, but I hope to do something other than simply position myself at one end or the other of the spectrum of interpretation that they have laid out, which runs from the feminist to the counterfeminist, and from the view that Woodman ought to be understood as the quintessential "woman artist," to the view that she, like others of her sex, should be counted as an artist, period, with no "woman" to qualify that designation.[1]

It is, of course, just that spectrum of interpretation that makes Woodman a good subject for discussion in this context, a prime case for us. At the same time, it is her oddity, the peculiarity of her work, its marginality in relation to existing criteria of "greatness," even of career formation—the fact that she was a "girl interrupted," not a *grande dame*—that leads me to find her interesting. There is now good cause to argue that there have indeed been "great women artists"— that, in fact, if we go back to the beginning of the contemporary scene, to the 1970s when Woodman was at work, we will find it increasingly rife with major

women artists.[2] Yet I want to argue for the beneficence of a certain kind of minorness, as exemplified in the art of Woodman: a minorness quite other and more eccentric than that of a "feminine" craft tradition, and yet nevertheless "feminine." And I want to do so against the grain of reading Woodman's work through her suicide.

Of Space, Time, Photography, and Suicide

This essay was originally part of the session devoted to "Spaces," and I am drawn throughout to the spatial aspect of Woodman's photography. But I am also intrigued by questions of time and timing: (1) the fact of Woodman's work taking place at the beginning of the thirty-year period that we have marked out as "contemporary," and thus its border position between then and now, between the old and the new situation of the "woman artist"; (2) its coincidence with 1970s feminism, of both the essentialist and the constructionist stripes, and thus its occupation of the liminal zone between two contrary paths of feminist argument; (3) its brevity and its earliness; and (4) its use of space—that of the house most often—of very old houses (inhabited by very young bodies) which resonate with the pastness of the attic and the basement—to present a specter of the past in the present in a peculiarly photographic way. In that last regard, space and time come together; the question is whether they do so in a way that might be peculiar to, or have something to say about, the "woman artist."

In 1981, just before her death, Woodman put together a publication called *Some Disordered Interior Geometries.* That is a title that describes some of her best-known work, of interiors, most often with her body in them, however vanishingly (figure 4.1). It is work that quite literally identifies her with the traditionally feminine space of the house, and which describes her body, whether figured as present in that space or not, as similarly an interior space, at once closed and open to the spaces beyond its dissolving edges and unclear boundaries, as an inside not securely distinct from its outside. It is work, moreover, that represents the house as a kind of camera obscura, letting light in through its apertures, less to make things

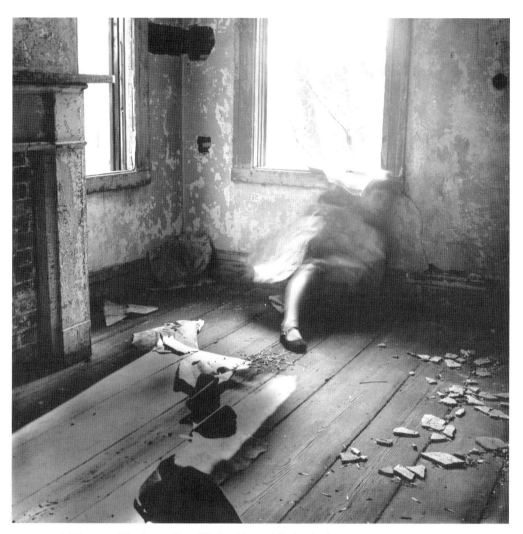

4.1 Francesca Woodman, *House #3,* Providence, Rhode Island, 1975–78. Princeton University Art Museum. Courtesy of George and Betty Woodman.

appear by the magic of the sun drawing than to show how they are subject to dis-
appearance by that same magic. But Woodman's work also represents that house
as an uncanny structure, at once dead and gone, yet strangely animated and alive:
a house as the space of disorder rather than domestic order, of detritus rather than
cleanliness and neatness, of the female ghost rather than the housewife—the
house, in short, gone awry.

Thus these photographs belong to their feminist moment—the moment
of *Womanhouse,* for instance, which predated them by only four or five years.[3] At
the same time, they situate themselves, by photographic means, in a literary rather
than a craft tradition—they have nothing much to do with "femmage"—that
harks back to that favorite domicile of the female writer, the gothic novel and the
ghost story, running from Jane Austen and the Brontë sisters on up to Joyce Carol
Oates, Anne Rice, and others.[4] And it is their peculiar, ghostly, time-worn spa-
tiality—their photographic spatialization of the literary topos of the "madwoman
in the attic"—that has led to one of the dominant understandings of this work,
as addressing the "nightmare of femininity," in which the female body is over and
over again engulfed by space, devoured by the house, at once subjected and lost
to the claustral confinement that was the feminine condition of our mothers and
grandmothers, if it is no longer necessarily our own.[5] In that understanding,
Woodman's work represents femininity as an affliction, one of those "dreams,
fears and idols" inflicted on the female sex that Simone de Beauvoir catalogued
so exhaustively in 1949, about a decade before Woodman's birth, in *The Second
Sex:* in which "cellars and attics," treated as allegories of the uncanny virgin body,
"no longer entered, of no use, become full of unseemly mystery; phantoms will
likely haunt them; abandoned by people, houses become the abode of spirits . . .
[they] imply some kind of marriage with the demon."[6]

I would rather see Woodman's haunted house as a ludic space, playfully de-
monic (and sometimes angelic) in its addressing of old myths of femininity, min-
ing a trove of images and ideas about woman, not as an inevitable victim, but as
a figure of irruptive difference. Yet that view seems to fly in the face of her sui-
cide, which helps to underwrite the nightmare reading of her work. Certainly
her spectral spaces often seem to be taken as predictors of her destiny as a *suicidée:*

not unlike the way in which the Provençal house of art history's most famous suicide, Vincent van Gogh, may be looked back at from the vantage point of hindsight, to foretell his death in its crooked, uneasy, animated, and fully "disordered interior geometries." As Griselda Pollock has shown with regard to van Gogh, we often like our artists as madmen, and go looking through their work to find confirmation there for that predisposition of ours.[7] I leave aside the question of the actual relationship between Woodman's work, her interior mental state at the time of working, and her eventual act of suicide—I can say nothing about that relationship except that it is indeterminable. But I raise the question of the suicide, both because I'd rather it didn't hover silently around in the background as it so often does, and because I want to ask a mythological question, namely, do we have the same liking for the mad*woman* artist? Does the mad*woman* artist have the same status in our mythologies of art? The beginnings of an answer can be found in the difference between the figures of van Gogh and Woodman: the answer is no, and it has nothing to do with a diagnostics of madness. On the other hand, it has much to do with the question of the "woman artist" that is our issue.

For as much as we may want to give an account of the thirteen-to-twenty-two-year-old Woodman as one of art's genius prodigies—à la Mozart or Picasso—the brevity and the student status of the "career" (it was hardly a "career") to which her suicide put a period, not to mention the exercise quality of the work she did do, makes Woodman's death look like a cutting-short, a question mark rather than a period or a culmination of a saga of tortured self-expression and prodigiously prolific output condensed into a short span of time—for van Gogh's career as an artist was really no longer in years than Woodman's was. As someone less than sympathetic put it to me, why should we care about an adolescent's (I think he may have meant an adolescent *girl's*) achievement?—we don't know what she would have done over the span of a lifelong career following a clear arc of development and maturation. Of course, this difference in the way we understand the shortness of time devoted to art has to do not only with gender but also with medium—with photography as opposed to painting—photography being a medium where brevity of career, small quantity of output, and minor and/or eccentric quality of statement are by no means exclusive to the suicide or the early death.[8]

So perhaps the better point of comparison would be with another pho-
tographer, not quite contemporary by our definition, whose suicide preceded
Woodman's by ten years: I mean Diane Arbus, whose interior shot of a *Retired Man
and Wife at Home in a Nudist Camp One Morning, New Jersey* of 1963 hung next to
Woodman's *House #3* of 1975–78 at the end of a wall in the exhibition *Camera
Women,* on view in the Princeton University Art Museum when the conference
Women Artists at the Millennium was held in November 2001.[9] (I was aware, by
the way, of running the risk of setting up a suicide corner, in which nothing else
but that could be thought. That was not my intention—it was rather the rela-
tionship between Arbus's and Woodman's houses that interested me, as well as the
interstitial position of Woodman's work between one era and another—but I ac-
knowledge that, like this essay, that corner may have been haunted by intimations
of suicide.) Arbus's work, too, exhibits an attachment to interior spaces, and to
the gothic—and where it makes its out-of-the-ordinary house ordinary in the
nudist colony photograph, elsewhere it makes ordinary spaces spookily extraor-
dinary, as in her emptied-out Levittown living-room at Christmastime. As with
Woodman, the ending of Arbus's life seems more comparable to that of a figure
like Plath than of van Gogh. It makes the out-of-kilter aspect of the work seem
precisely off-course and outside of the mainstream: not the universal madness of
genius that confirms and supports a tradition of "greatness," but the irremediably
particular, ruptural, aberrant madness of a gender-specific dis-ease. Again, this
quality has to do with the difference of photography as an art of self-expression
and subjectivity as much as the difference of gender. On the other hand, Arbus's
work is more locatable in relation to a period, a movement, and a sensibility—
the sixties, pop, camp—her ten-year output can be made to add up to an opus,
she is easily understood as one of the "greats" of the history of photography, and
her commitment to weirdness has made for a good, lurid life story, the stuff of
art historical legend.[10] Not so Woodman.

Woodman represents a special case, then, and a somewhat regressive one at
that. Besides looking back to themes and preoccupations of an earlier age, run-
ning from the Victorian to the fin-de-siècle melancholy, housebound woman,
her work also mines one of the countermainstream undercurrents of the history

of photography, in which the medium is understood as a magic not a technology, as involving evanescence and fragility rather than permanence, as devoted to poignance and unruliness and the spectral quality of the uncanny rather than the masterful statement, as a minor—not to mention weird—art rather than a monumental one, and finally, as undermining rather than confirming either the perspectival certainties or the modernist flatnesses of camera vision, or for that matter the tonal beauties of the "fine print."[11] It is in this way that Woodman's adolescent photography may be understood as belonging to a specifically photographic mode of art—it is neither a lineage nor a tradition, properly speaking—that aligns itself with the "feminine": not because it is a craft, or because it is low on the ladder of (post)modernist media and therefore subordinate to "great" (post)modern art, but because its investigation of the peculiar time and space of photography is at the same time an exploration of the tropic time and space of femininity, and vice versa.[12] And because its "madness" is the madness not of Woodman—not of that particular young woman—but of photography and femininity combined and equated with one another.

OF MODELS, MIRRORS, FEMININITY, AND FEMINISM

Woodman's work bears the traces of an earlier situation of the "woman artist" in many ways. For one thing, it harks back to a time when woman was positioned as art's mistress rather than one of its masters, as the model in the studio; in the case of photography, the figure before the camera as much as the one behind it.[13] Working as a model for others, repeatedly posing herself and her friends in art school for her own photographs, Woodman's work points to one of the most continuously normalized and naturalized facts of our visual tradition, be it art, cinema, fashion, advertising, or of course pornography—namely, that the woman's role is that of the model for the artist, even when she is an artist herself. One can think of so many examples: the most famous one would be O'Keeffe posing for Stieglitz. But of course, Woodman poses Woodman (and others) for herself, thus splitting her gaze and doubling her position(s), her occupation of photographic space, in a tendency that may be specific, though neither exclusive nor inevitable,

to her sex—which is just to say that we find it rarely in the work of men, commonly in the work of women.[14]

This doubleness of perspective is underlined by one of Woodman's other preoccupations, namely with the mirror. (Woodman even titled one of her earlier series featuring body and mirror thus: "A Woman/A Mirror/A Woman Is a Mirror for a Man.")[15] Her work includes images in which the mirror is alternately figured, in the interior, against an abraded, markedly tactile interior surface—to which the glossy optical rectangle of the mirror is at once attached and opposed—as a double and a blank, as an image and an absence of image, as a surface that mirrors the body and makes it appear twice, and as a surface that mirrors the surface of the photograph itself prior to its registration of the image, while marking the body with disappearance (figures 4.2, 4.3). Alternately, the body is a kind of hinge between mirror and interior surface, or the mirror is the hinge between body and interior, and that interior is alternately presented as a surface and a cornered space, at once darkly empty and materially full. Either way, Woodman's figuration of woman-plus-mirror recalls a long-standing thematic tradition associating woman with mirror in an iconographics of vanity, narcissism, and voyeurism.

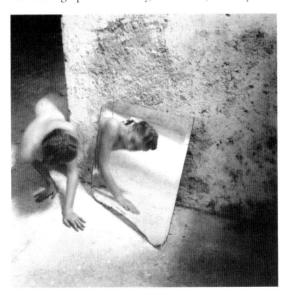

4.2 Francesca Woodman, *Self-Deceit #1,* Italy, 1977–78. Courtesy of George and Betty Woodman.

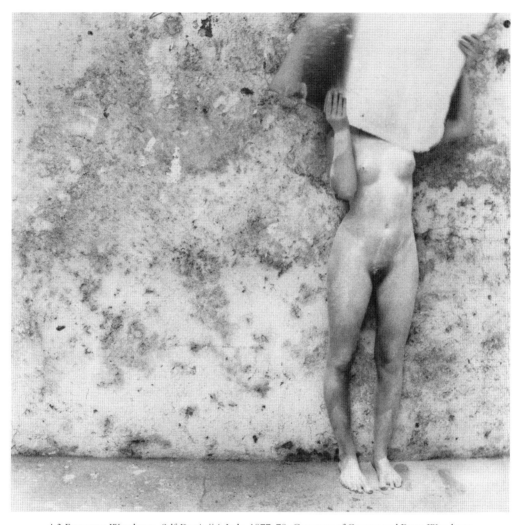

4.3 Francesca Woodman, *Self-Deceit #4,* Italy, 1977–78. Courtesy of George and Betty Woodman.

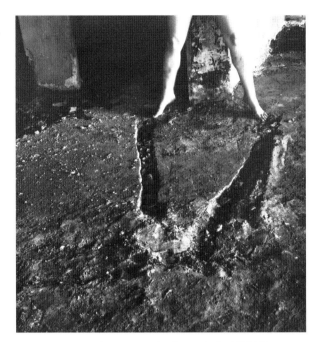

4.4 Francesca Woodman, *From Angel Series,* Italy, 1977–78.
Courtesy of George and Betty Woodman.

Woodman was by no means alone, either in her time-honored association of the female body with the mirror, or in her use of herself and her own body as photographic subject-matter. Indeed, she was very much of her generation, particularly on the latter count: one need think only of Cindy Sherman's *Untitled Film Stills,* carried out contemporaneously to Woodman's work in this vein.[16] And this brings me to another point about timing, which is the coincidence of Woodman's work with 1970s feminism, and in particular with the deconstructive trend in feminist thought, criticism, and art, of which Sherman's *Untitled Film Stills* may surely be taken as a prime example, both in the series' reference to the image of woman in film (a prime site of emerging feminist critique) and its antiessentialist demonstration that Woman is nowhere in Nature, that she is purely a matter of pose, costume, wig, and role, put on and taken off at will: that far from being biologically determined or an essential given, gender is an alterable cultural construct. But the difference between Woodman's play in this arena and Sherman's is also instructive: Woodman strips herself to her naked body and her "es-

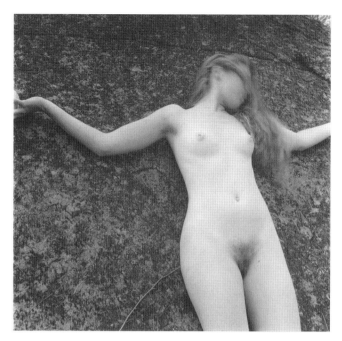

4.5 Francesca Woodman, MacDowell Colony, 1980. Courtesy of George and Betty Woodman.

sential" biological self (and when she wears clothes, as she often does, it is not to suggest different selves or different roles), so that the associations are not with film and its narrative performances but with the artist's studio and the muse of Nature and Art. She also shows herself either as a blank slate or in a regressive state, crawling on all fours like an infant or an animal, to investigate her likeness: to investigate, "mirror stage"-like, the ground of all identity and difference. This suggests a not-yet-gendered world—a world prior to the gender divide—of mirrored play and performance, but what interests me most about it is that it also offers a model of feminist investigation as regression, not masquerade.[17]

And there is other work by Woodman, using her body indoors and out, associating it with the materiality of walls and rocks, with surface, matter, and ground (and thus with other old myths of the feminine) that walks the line between constructionist and essentialist thought about femininity and the female sex (figures 4.4, 4.5). Not coincidentally, most of the good critical work on Woodman has concerned her indoor work—I wonder if that is because the outdoor photographs call

357

up naturist—that is to say, essentialist—notions of woman, of femaleness, too in-sistently for deconstructionist comfort? I myself was inclined to write off that worry by saying that Woodman *performs* such naturist myths of Woman, that she *performs* essence, in other words—and therefore deconstructs and critiques it. But now I wonder if it wouldn't be better to say "investigates" rather than "critiques"—which is somewhat more open-ended and experimental in its attitude to sex and gender, and which includes in its investigation the very dividing line *between* Na-ture and Culture, essentialism and constructionism. Perhaps the best way to think about Woodman's exercises in eccentric photography and off-center femininity both inside and outside is that they represent none of the expected stances of fem-inism exactly, but a possible feminist position nevertheless: not an identifiable fem-inist politics but feminist play, in the interstices of (at least two) feminism(s).

Of Metaphors, Essentialist and/or Otherwise

As much as Woodman's photographs coincide with work like Sherman's *Untitled Film Stills,* so they share space and time with work like Ana Mendieta's *Silueta* series, which in its evanescent earthworks way also resonates with Great Goddess ideas, and also inhabits the borderland between essentialist and (de)construc-tionist feminist thought. In this regard, it is important to note that many photo-graphs by Woodman collapse the difference between inside and outside, floor and ground, the materialities of Nature and Culture, not to mention presence and absence, corporeal volume and cavity, the concept of "lack" and that of the twofold or double form, as attributes of female bodiliness and spatiality and the psychic structure of femininity. They do so in much the same way that Luce Iri-garay, the French feminist psychoanalyst, did at approximately the same time: like Woodman, Irigaray straddled the line between essentialist and constructionist feminisms; like Woodman, she used essentialist ideas about the female body and female form in a metaphoric way to arrive at a kind of counteressentialism that was deconstructive in the work that it sought to do on patriarchal structures of thought and subjectivity, metaphysics and aesthetics.[18] Indeed, there are many ways in which Woodman's small, square, peculiar photographs can stand as ten-

tative visualizations of Irigarayan metaphorics: not because she meant them to, but because of the enfolded spaces to which her explorations in metaphor led her.

Woodman's photography, in fact, mobilizes a whole set of familiar metaphors and ideas about femininity: woman as house, house as female body, but also woman as (reversible) surface, woman as supplement and decor, the female sex as an opening or a tear, and the shell—a creatural house that is also a biological extension of the body of the animal that it houses—as like the female body, like the vulva (which is not seen) (figure 4.6). Or like a lily, a flower (figure 4.7): to quote Simone de Beauvoir's cataloguing of metaphors once more, she is "Venus newly risen from the wave," "the whole fauna, the whole flora of the earth; gazelle and doe, lilies and roses, downy peach, perfumed berry . . . precious stones, nacre, agate, pearl, silk, the blue of the sky, the cool water of the springs, air, flame, land and sea. . . . Woman becomes plant, panther, diamond, mother-of-pearl, by blending flower, furs, jewels, shells, feathers with her body; she perfumes herself to spread an aroma of the lily and the rose. But feathers, silk, pearls, and perfumes serve also to hide the animal crudity of her flesh, her odor. She paints her mouth and her cheeks to give them the solid fixity of the mask; her glance she imprisons deep in kohl and mascara . . . the iridescent ornament of her eyes; her hair . . . its disquieting plant-like mystery."[19]

If there is excess in de Beauvoir's catalogue of metaphors, so there is metaphorical excess in Woodman's work, which across its span addresses most of these myths of the feminine. And there is the same flipping between essences and supplements, nature and culture, and in some instances, a laying side by side and enfolding of one metaphor in the other, a placing next to each other in metonymical contiguity the metaphor and the body for which it stands: as in figure 4.7, where the phallic/vulval lily sits within an interior space, next to Woodman's body, next to a crumpled dress with an inside-out, vulval sleeve. Thus the female body and its multiple metaphors inhabit the same physical space, thereby both physicalizing the metaphor and multiplying (and destabilizing) its metaphoricity.[20]

It would, I think, be a miscasting of work like this, of its combined seriousness and playfulness, its lyricism, and certainly its open-endedness, to see it as either a critique or a flat-out deconstruction. Rather, it seems to have been a

4.6 Francesca Woodman, Providence, Rhode Island, 1975–78. Courtesy of George and Betty Woodman.

4.7 Francesca Woodman, Italy, 1977–78. Princeton University Art Museum. Courtesy of George and Betty Woodman.

photographic testing of some of the many things that have been said about Woman across a long tradition, a probing of how what the sages have said about woman— that she is like a lily or a shell, that she is all surface, supplement, and interior space—would look in a photograph. And the spatiality of Woodman's photographs, in which her female body is so often posed and into which it disappears, lines up too consistently with the "essentialist" side of feminist thought about "feminine" form—as twofold rather than "phallomorphic"—to allow us to place Woodman's work securely on the deconstructionist side of the debate.[21] Yet in its mercurial performativity and its multiplied metaphoricity, it is, much like Irigaray's "sex which is not one," no easy essentialism either; no final conclusions are drawn.

The house, the shell, the ornament, the lily: as de Beauvoir suggests, these are all very old metaphors. Some of them, like the lily, are also ones with a specific photographic and art historical past, looking back to earlier work—by women: to Imogen Cunningham, within photography, to Georgia O'Keeffe, within painting, and perhaps, again within photography, to Tina Modotti too, the model and mistress of Edward Weston. Woodman, that is to say, seems to tap into a matrilineage, a female line of descent.[22] Except it is too broken a lineage to suggest a connected line, and thus, I think, proposes a different model altogether from that of the lineage, something more like a space in which references to a past, or to several pasts, circulate, outside of any linear order. Indeed, Woodman's house of metaphors resonates most, for me, with the most marginal and therefore least likely of the three ghosts from the past that I have just cited: Tina Modotti, the decaying flesh of her lilies set flush against similarly eroded, imperfect, haptically fractured walls, her exploration of interior spaces similarly at once heavily material and subject to the evanescence of time. I have argued elsewhere for an Irigarayan reading of Modotti's work, a work undertaken decades before the onset of contemporary feminism in the United States, France, Great Britain, and elsewhere, and thus without any possible intention of a parallel feminist project, and without foretelling it in any teleological way. Similarly, while Woodman's photographic exercises come well after Modotti's and thus could have had recourse to them, Modotti's lack of an established place in the photographic canon makes her photographs much less probable as immediate sources for Woodman's pictorial ideas

than many others that one might think of.[23] But it is precisely that fact that recommends them to me, because what I am interested in here are echoes not sources, a haunting not a line of descent, eccentric coincidences not direct influences, a space of dim recollection and regression, not one of canonical progression.

POSTMORTEM

By way of an ending, I want to circle back to the beginning, to the related questions of photographic space, the "woman artist," and what sort of canon, if any, would fit a truncated and fragile figure like Francesca Woodman:

1. Space. Woodman marks almost all of her photographic spaces, whether inside or outside, inhabited by herself or other bodies or not (and they are often both at once), as "feminine": the windowed house, the dark cellar, the gash in the ground, the dryadic tree, often with attendant ghosts. But she begs the question of whether those spaces are essentially or discursively, naturally or culturally, corporeally or only metaphorically "feminine." And she does so by inhabiting and investigating the zone *between* those two ways of thinking about gender, by constituting herself within a series of fissured, enfolded spaces of fleeting appearance and disappearance, in which she models a series of metaphors.

2. The "woman artist." The answer to the question of whether an artist who happens to be a woman should be considered a "woman artist" or simply an artist varies according to the artist, her project, and what one wants to say about that project: there is and ought to be no one, fixed answer to the question. But Woodman belongs to a particular, liminal moment between then and now, when the "woman artist" was not simply a ghetto category on either side of the feminist divide—which is to say, either delimited by her sex, or pursuing a gendered agenda—and to a set of artists-who-happen-to-be-women who occupy a twofold position—which is to say, artist *and* woman-artist. Given that Woodman was so interested in modeling metaphors of femininity, it seems a mistake to discount the "woman" in the "woman artist" appellation. Yet at the same time there is no reason that that should negate or qualify the fact that Woodman was, or was

about to be, an artist: it is simply to suggest the kind of art that she was working toward. There is also no good reason that I can think of for her woman-artistry to be defined and denigrated by an equation with victimhood. And that despite her suicide, to return one last time to that vexed question: the suicide marks an abrupt and arbitrary ending; it does not describe an arc of development predetermined by Woodman's femininity or by any other condition whose symptoms we might take it upon ourselves to diagnose.

3. The canon. As to the question of a canon to which an artist such as Francesca Woodman might belong, I think the answer to that is that there is and ought to be none: no canon and no linear narrative to serve it, only an undercurrent, eddies and whirlpools and sidestreams to the mainstream, a voice from the unlocatable side. That is the difference of this kind of suicide story: while it ought not to be reduced to a symptom of an illness, at the same time it cannot and ought not to be assimilated to our master narratives of art either; rather, it should be left to break through them. The prematurely terminated beginner that Woodman was, with her disappearing act and the weirdly wraithlike "feminine" spaces that she explored for such a short time without a clear sense of what conclusion they might lead her to, suggest an allegory of one of the things a "woman artist" might be: a double figure, an inside-outsider, who uses her position as the Other to provide glimpses of an *other* space within the realm of art as it is usually constituted, something *else* between the lines of the reality that art more often constructs. They suggest an alternative to the three options of the "femmage"-style "woman artist," the feminist deconstructor, and the "great artist" with her fine and legitimate disregard for her gender: the artist who, neither criticizing nor inhabiting the canon easily nor making any claims to its importance, deploys her otherness within it both playfully and irruptively. An Emily Dickinson for photography, perhaps?

A certain mythology, if not a cult, has grown up around Woodman, though it is not the mythology or the cult of genius. It is, rather, the mythology of the Ophelia syndrome, which Woodman courted not only with her death but in her life and work. With that in mind, I close with a "late" photograph taken in New York (figure 4.8), in which the space of the house—the bathroom, in this case—

4.8 Francesca Woodman, New York, 1980. Courtesy of George and Betty Woodman.

is, as usual, marked by Woodman's body, or rather by the disappearance of her body from view, its invisibility—and by an enfolding of spaces, one inside the other: the unseen body inside the tub, the tub inside the cornered room, the room inside the containing box of the photograph—though in fact it does not quite contain its spatial contents, whose grid is skewed and catty-cornered to the photograph's plane and continues beyond its confining edges. It would not be my own immediate inclination to see it this way, but the bathtub in this photo-graph might be compared to a coffin, thus calling up another metaphor for the female sex, the echo of images and topics past concerning female madness and morbidity—it is here that a pre-Raphaelite Ophelia comes to mind—and of course, the suicide. I propose instead that Woodman's picture is better under-stood as picking up the dangling threads of a long tradition—exemplified in one of Bonnard's several paintings of his wife's body suspended in the bathtub, blended with the uterine space around her, making a decorative surface pattern, a particularly intimate variation on the topos of woman as artist's mistress and model—and torquing it to see what it would look like in a photograph, a *little* photograph, of and by herself.

NOTES

1. For the feminist view of Woodman's work, see Abigail Solomon-Godeau, "Just Like a Woman," in her *Photography at the Dock: Essays on Photographic History, Institutions, and Practices* (Minneapolis: University of Minnesota Press, 1991). For the counterfeminist view, see Ros-alind Krauss, "Francesca Woodman: Problem Sets," in her *Bachelors* (Cambridge: MIT Press, 1999), pp. 161–177. See also Margaret Sundell, "Vanishing Points: The Photography of Fran-cesca Woodman," in Catherine de Zegher, ed., *Inside the Visible: An Elliptical Traverse of 20th Century Art in, of, and from the Feminine* (Cambridge: MIT Press, 1995), pp. 435–439, and Kaira Marie Cabanas, "Francesca Woodman's Interruption," *Critical Matrix* 13, no. 1 (Fall 2002).

2. See Linda Nochlin's seminal "Why Have There Been No Great Women Artists?" in her *Women, Art and Power, and Other Essays* (New York: Harper and Row, 1988), pp. 145–178. Nochlin's essay in this volume revises that question to ask, with regard to the last thirty years, "Why have there been great women artists?"

3. On Judy Chicago, *Womanhouse,* and the *Dinner Party,* see Amelia Jones, *Sexual Politics: Judy Chicago's Dinner Party in Feminist Art History* (Los Angeles and Berkeley: Los Angeles County Museum of Art and University of California Press, 1996); and Lydia Yee, *Division of Labor: "Women's Work" in Contemporary Art* (Bronx: Bronx Museum of the Arts, 1995).

4. See Sandra M. Gilbert and Susan Gubar, *The Madwoman in the Attic: The Woman Writer and the Nineteenth-Century Literary Imagination* (New Haven: Yale University Press, 1979).

5. The "nightmare of femininity" formulation is Solomon-Godeau's in "Just Like a Woman." There are ways in which my reading brushes up against hers, but I wish to shift the focus away from a thematics of victimhood and desperation. In order to do so, it is true that I have been selective in my choice of photographs, and have stayed away from the most nightmare-evoking of them. My reading shares some features with Solomon-Godeau's essay in this volume, "Taunting and Haunting: Critical Tactics in a 'Minor' Mode," with its attention to the thematics of haunting in the work of Carrie Mae Weems and Tracey Moffatt.

6. Simone de Beauvoir, *The Second Sex,* trans. H. M. Parshley (New York: Vintage Books, 1989), p. 155. I use de Beauvoir's founding treatise here not as a theoretical point of departure but for its historical status, its richness as a text, and even its ambivalence as a feminist tract.

7. See Griselda Pollock, "Artists, Mythologies and Media: Genius, Madness and Art History," *Screen* 21, no. 3 (1980), pp. 57–96.

8. There are many examples of truncated careers in photography, or of photography being merely one of several successive vocations, particularly in the early history of the medium, when it was often taken up and put down as one of a series of short-lived, low-level entrepreneurial pursuits, rather than following the linear institutional path of the art career. See Rosalind Krauss, "Photography's Discursive Spaces," in *The Originality of the Avant-Garde and Other Modernist Myths* (Cambridge: MIT Press, 1985), pp. 131–150. In the twentieth century, photographic careers have increasingly been specialized and stabilized, but it is still remarkable that photography's practitioners often enter it as amateurs or entrepreneurs who begin by pursuing it in a secondary way, and that it has been particularly accessible to women artists working in the home and meeting the multiple demands of domestic and family life. The canon of photography by women is rife from beginning to end with cases of short careers and/or careers begun midlife, running all the way from Julia Margaret Cameron to Diane Arbus and beyond.

9. This exhibition ran from October to January at the Princeton University Art Museum and then traveled to Vassar College, where it was augmented with photographs from the collection of the Frances Lehman Loeb Art Center. See my *Camera Women* (Princeton: Princeton University Art Museum, 2001).

10. See Patricia Bosworth, *Diane Arbus, a Biography* (New York: Avon Books, 1984). For a critique of this lurid tale, unauthorized, much embroidered, and not so well substantiated, see Catherine Lord, "The Short, Sad Career of Diane Arbus," in Richard Bolton, ed., *The Contest of Meaning: Critical Histories of Photography* (Cambridge: MIT Press, 1989), pp. 111–123.

11. For this alternative view of photography, see Roland Barthes, *La chambre claire: Note sur la photographie* (Paris: Gallimard, Le Seuil, 1980). I have argued elsewhere for its application to the photographies of Julia Margaret Cameron, Lady Clementina Hawarden, Gertrude Käsebier, and Diane Arbus: see my "Cupid's Pencil of Light: Julia Margaret Cameron and the Maternalization of Photography," *October* 76 (Spring 1996); reprinted in *October: The Second Decade, 1986–1996;* "From Clementina to Käsebier: The Photographic Attainment of the 'Lady Amateur,'" *October* 91 (Winter 2000); and "Biology, Destiny, Photography: Difference According to Diane Arbus," *October* 66 (Fall 1993).

12. Woodman's work complicates and calls into question the division and sequencing of "modernist" and "postmodernist" art and photography, for it has elements of both and belongs securely to neither, while mining in a fairly erratic way several histories of photography.

13. See Rozsika Parker and Griselda Pollock, *Old Mistresses: Women, Art and Ideology* (London: Pandora, 1981).

14. If one looks through the history of picture-making by women, in painting as well as photography, one will find a remarkable amount of self-representations in which the represented self is split between its subject and object positions, and rather little of the same phenomenon in the history of self-portrayals by men, even in photography. See, for example, Ann Sutherland Harris and Linda Nochlin, *Women Artists 1550–1950* (Los Angeles and New York: Los Angeles County Museum of Art and Alfred A. Knopf, 1977).

15. See Fondation Cartier pour l'art contemporain, *Francesca Woodman* (Zurich, Berlin, and New York: Scalo, 1998), p. 17.

16. For key feminist readings of Cindy Sherman's work, see Laura Mulvey, "A Phantasmagoria of the Female Body: The Work of Cindy Sherman," *New Left Review* 188 (July/August 1991),

pp. 137–150; Judith Williamson, "Images of 'Woman,'" *Screen* 24, no. 6 (November 1983), pp. 102–106; and Abigail Solomon-Godeau, "Suitable for Framing: The Critical Recasting of Cindy Sherman," *Parkett* 29 (1991), pp. 112–115. For a counterargument, see Rosalind Krauss, "Cindy Sherman: Untitled," in her *Bachelors,* pp. 101–159.

17. See Jacques Lacan, "The Mirror Stage as Formative of the Function of I as Revealed in Psychoanalytic Experience," in his *Écrits: A Selection,* trans. Alan Sheridan (New York: Norton, 1977), pp. 1–8. Lacan's understanding of the infantile "mirror stage" bypasses gender; Woodman's variation on the theme, regressive though it may be, does not.

18. See Luce Irigaray, *This Sex Which Is Not One,* trans. Catherine Porter (Ithaca: Cornell University Press, 1977). This would also be my argument about Irigaray—not that she is an out-and-out essentialist, but that she uses essentialist ideas in an exploratory if not deconstructionist way.

19. Beauvoir, *The Second Sex,* pp. 151, 155, 158–159. The emphasis on artifice in this passage is pure Baudelaire, for whom woman's nature resides in her artifice, her essence in her lack of essence.

20. See my "This Photography Which Is Not One: In the Gray Zone with Tina Modotti," *October* 101 (Summer 2002), pp. 19–52.

21. These, again, are Luce Irigaray's terms.

22. I wish to honor Lisa Tickner's beautiful "Mediating Generation: The Mother-Daughter Plot" here, given as a paper at the conference Women Artists at the Millennium, and recently published in *Art History,* which she has kindly agreed to reprint in this volume. Crucial to the conference and this volume, it is admirable—and useable—for the intelligence and subtlety of its rethinking and regendering of the canon and its patrilineage in such a way as to allow a place for the "woman artist."

23. More than the figures I cite, Woodman's direct field of reference would have included the contemporary work of Emmet Gowin and the historical work of the surrealists.

Taunting and Haunting: Critical Tactics in a "Minor" Mode

Abigail Solomon-Godeau

> The space of the tactic is the space of the other.
>
> —*Michel de Certeau*, The Practice of Everyday Life

In their now-classic essay, "What Is a Minor Literature?" Gilles Deleuze and Félix Guattari posed the question of whether the cultural production of outsiders could be characterized by features that marked it as categorically distinct from the culture of the dominant.[1] Answering in the affirmative, they identified three elements: "The three characteristics of minor literature are the deterritorialization of language, the connection of the individual to a political immediacy, and the collective assemblage of enunciation."[2] Accordingly, the minority or outsider producer, as a consequence of her historical legacy and her relationship to the culture of the dominant, is thought to produce work that manifests this history, and thus this difference. And although Deleuze and Guattari's example of the "minor" or "minoritarian" artist is Franz Kafka, a Prague Jew writing in German, and therefore a specifically literary instance, logically there seems no reason not to expand their model to the visual arts, especially in that they specify that minor art "allows the writer all the more the possibility to express another possible community and to forge the means for another consciousness and sensibility."[3]

Putting aside for the moment their conclusions, questions about the speci-
ficity of "outsider" production have been posed before, nowhere more insistently
than in feminist theory, where the issue of difference—sexual or feminine—has
been a central concern. For those affirming the existence of a collective and iden-
tifiable difference in women's cultural production, it has been located, variously,
in such concepts as *écriture feminine,* forms of affiliation, linguistic specificity, and
somewhat more sociologically in the notion of "muted" or subaltern groups. To
an increasing degree, however, the notion of femininity as such, or even women
as such, has been rendered problematic, when not mooted altogether by the
recognition of differences within the category "women," as feminists have ac-
knowledged that class, race, age, ethnicity, nation all operate to render any such
universalizing collectivity suspect. "Femininity" too seems increasingly unstable
a concept, challenged on one hand by a rejection of gender binaries and prolif-
erating categories of sexual identity, challenged on the other for its hopelessly rel-
ative and culturalist definitions.

Yet to the degree that it remains the case that marked terms—woman artist,
black woman artist—as opposed to unmarked ones—artist *tout court*—are by no
means neutral, and to the degree that neither women artists nor artists of color can
be said to have achieved parity (however that is measured), we can hardly dispense
with a consideration of the possibilities and/or limitations that attach to those
artists perceived or positioned as different from their unmarked peers. Whether
this is a difference ascribed or imposed, a difference culturally and historically
produced, or a difference affirmed by the subject herself, difference remains a
problematic that requires address, especially by feminist scholars. Indeed, the con-
ference that occasioned this essay, Women Artists at the Millennium, with its
conspicuous dearth of women of color, suggests that notwithstanding the success
and prominence of perhaps a dozen artists of color, women of color who are also
artists remain a marginal group within a larger marginal group.

With respect therefore to the art of contemporary women of color, be it
literary or visual, Deleuze and Guattari's notion of a collective enunciation has a
certain resonance and critical applicability. In the context of the artists whose
work I will be considering here—all but one of whom are women of color—the

historical consciousness that underpins their art suggests new and significant articulations of the political in art, articulations that are both heuristic and affective. The works addressed can be seen to operate through the use of two different tactics of enunciation, one mode that works as a form of "taunt" addressed to the male and/or white spectator, and the other as a form of "haunting," the conjuring of historical absences and silences.[4] These artists—Tracey Moffatt, an Australian of partly Aboriginal ancestry; Carrie Mae Weems, an African American; and Zoe Leonard, a white lesbian artist whose *Fae Richards Archive,* discussed in this essay, was produced in collaboration with Cheryl Dunye, an African American filmmaker—were artistically formed in the 1970s and 1980s. Hence, their work can be situated within the compass of postmodernism, one aspect of which is evidenced in the range and variety of their artistic forms and hybrid media. But equally, these artists need also be situated within "second wave" feminism—that is to say, a pluralized feminism that rejects any simple affirmation of congruity between the sex of the artist and the nature, content, or form of her work. That said, the particular works considered here were chosen on the basis of their respective deployment of the tactics I've referred to as taunting or haunting. While in no way suggesting that the racial or ethnic identity of these artists *engenders* these tactics—quite the contrary—I do want to suggest that they answer to and foster the artistic expression of historical and political realities in ways that operate both critically and affectively. In this respect, Deleuze and Guattari's formulation of the "deterritorializing," "collective," and "political" elements informing minoritarian cultural production seems especially relevant to their work. This is because notwithstanding the elements of autobiography that feature in certain of the works of Weems and Moffatt, much of these artists' work is preoccupied by collective histories, histories, moreover, that are in large part largely unwritten, if not actually invisible. Thus, the tactical deployment of haunting might be said to turn on the mechanisms of historical and cultural *repression,* whereas that of taunting is a response to particular and public forms of social and cultural *expression.* The characterization of these two strategic modes in artistic practice corresponds to the two aspects of collective history that constitute the material with which these artists work. Taunting operates on the register of what everybody knows, the

totally available and altogether familiar manifestations of sexism, racism, domination, and aggression. Its mode is aggressive, confrontational: hence the rationale and utility of deploying the stereotype, which is the congealed *imago* of a collective fantasy. Such a strategy can be observed, for example, in Robert Colescott's delirious reiterations of racist stereotypes addressed to the presumed white spectator, serving up, as it were, the crudest of racial stereotypes in their most banal and kitsch incarnations. Similarly, Bettye Saar's *The Revenge of Aunt Jemima,* Adrian Piper's *Mythic Being* performances, and work produced by a younger generation of African American artists such as Renee Cox, Renee Green, Glen Ligon, Lyle Ashton Harris, Danny Tisdale, Kara Walker, Ellen Gallagher, and Fred Wilson have all utilized the stereotype as the actual "material" of their work. Such uses of the stereotype have long been identified with avant-garde and later with postmodernist practices.

If one deployment of the taunt turns on the use of the stereotype, another is characterized by the use of what the situationists called *détournement,* or reversal.[5] In Tracey Moffatt's 1987 film *Heaven,* it is the reversal of the voyeuristic gaze that structures the work, a venerable tactic within feminist cultural practice. In *Heaven,* the movie camera surveys the male surfers of Sydney's Bondi Beach as they clamber in and out of their wetsuits. The film has no verbal soundtrack, only ambient or supplementary sounds: the waves breaking, Aboriginal chanting, and Himalayan drumming. These serve to signal another aspect of the film, namely its parodic relation to traditional ethnographic films and their production of the "primitive." As Moffatt's camera stealthily moves closer and closer to the young men, filmically ogling their splendid bodies, they become aware of her invasive camera, by which point Moffatt is virtually "in their face."

The experience of watching *Heaven* is somewhat ambiguous. Funny it certainly is, especially for women viewers, but it is also uncomfortable to watch and experience, insofar as the viewer is herself positioned as the voyeur. Obviously concerned with the processes of objectification that operate within the "normative" terms of a heterosexual visual regime, Moffat gives women viewers the privilege of occupying the typically masculine position of leering voyeur, which only emphasizes the political limitations of reversal. Still, in reversing the con-

ventional order of the gaze, the woman with a camera becomes the active, viewing, and indeed, aggressive subject, and such a repositioning heightens awareness of the actual consequences of this predatory model of looking. In this instance, the men who struggle to hide from the camera, to cover themselves, become "feminized"; the invasive camera subverts the phallicism associated with such hard, muscular bodies and the surfers' athletic mastery. The taunting to which Moffatt herself is subjected by some of the surfers is in fact trumped by *Heaven*'s taunting of them, explicit in the structure of the film itself.

Ain't Jokin', which employs the taunt in somewhat different ways, was produced by Carrie Mae Weems an ocean and a continent away, in 1987–88—the same year that *Heaven* was made. It consists of a number of photo/text works, and involves its own forms of reversal (figure 4.9). The photographs are in black and white—the medium of photography most identified with photojournalism or documentary, that is to say, the photographic genre popularly supposed to represent the "truth" of its subject. Appended to the bottom of certain of the photographs are a series of racist jokes or riddles, the answers to which are supplied when one slides open the bottom part of the slot:

> Question: What's black on the inside, yellow on the outside and looks funny going over a cliff?
> Answer: A bus full of niggers.
> Question: What are three things you can't give a black person?
> Answer: A black eye, a fat lip, and a job!

In *Ain't Jokin',* the racist joke, itself a form of taunting, is generated by the (black) artist; hence the reversal: it is she who is the source of the utterance, and the joke's address is to the presumed white spectator.

We may assume that racist jokes such as these are rarely—at least nowadays—recounted by the kinds of educated liberal spectators likely to go to a Carrie Mae Weems exhibition in the first place; and thus to the extent that such a spectator might find them secretly funny, or alternatively, vulgar and offensive, the response itself might be marked by discomfort, guilt, embarrassment. More-

WHAT ARE THE THREE THINGS YOU CAN'T GIVE A BLACK PERSON?

Answer: A Black Eye, a Fat Lip and a Job!

4.9 Carrie Mae Weems, *What Are the Three Things You Can't Give a Black Person?*, from *Ain't Jokin'*, 1987–88. Silver print, 20 × 16 in. Courtesy of the artist and Pilkington Olsoff Fine Arts, New York.

over, the physical act of moving the slot to see the answer implicates the viewer in the joke in an active form. For the white spectator, then, the work is equipped with a kind of psychological fishhook by which she is metaphorically captured by her own collusion in the racism and the stereotyping informing the joke itself. The act of recognition is here prompted by the revelation of the viewers' complicity with these meanings. Few white spectators, and I do not exempt myself, are so untouched by racism as to find such jokes meaningless or incomprehensible; insofar as one "recognizes" the joke, one is effectively implicated in its system.[6] Indeed, as Freud pointed out, that is one element of the joke's modus operandi. Moreover, the contrast between the sobriety of the photographic image, especially when it has the dignity of a portrait, or in other cases, presents the viewer with a documentary photograph of the historical reality of racism, promotes what Weems has described as "another kind of information." In several of the works in the series, the stereotype is visually contradicted by the gravitas of the image. As Weems has remarked about her tactics, "I'm interested in . . . forging another kind of information that opens up another kind of space to think about what might be offered to you. And at times, what's going on in the text contradicts what's going on in the photograph, forcing you to look at the photograph to go to the text, and then somehow to go back to the photograph so that there's this double meaning going on."[7]

The taunting qualities that characterize both *Heaven* and *Ain't Jokin'* do not by any means produce the same effect. *Heaven* addresses women spectators, and even as it questions the political utility of reversal, it produces that carnivalesque effect associated with "the world upside down," an instance of what Joanna Isaak, in her 1986 exhibition of the same name, celebrated as "The Revolutionary Power of Women's Laughter." *Ain't Jokin'*, however, is certainly not funny and is extremely uncomfortable to view—and that is clearly the measure of its intention and effect. All of which is to say that *as* an artistic strategy, taunting is flexible; it can do different kinds of critical work. The aggression and fear that underpins the visual, textual, or verbal stereotype is in these instances itself "deterritorialized."

If taunting operates on the level of public discourse, the already-known, the more elusive concept of haunting turns on what is hidden, unsaid; it involves the presence in the present of the unredeemed past, a past that refuses to be done with, shriven, surmounted. Psychically related to Freud's concept of the uncanny and the return of the repressed, haunting in the sense I use it here has less to do with individual subjectivity and the vicissitudes of the individual unconscious than with the collective unconscious and its historical determinations. "Haunt-ing," as Avery Gordon writes in her extraordinary study *Ghostly Matters,* "is a constituent element of modern social life. It is neither pre-modern superstition nor individual psychosis; it is a general social phenomenon of great import."[8] In fact, the notion of haunting is one that has an interesting legacy in modern the-ory and philosophy, from Adorno and Horkheimer's "On the Theory of Ghosts" to Nicolas Abraham and Maria Torok's discussion of the phantom, to Derrida's *Specters of Marx* and numerous other texts.[9] Although such philosophical or psy-chological considerations of ghosts and haunting hardly constitute a unified field, and are theorized very differently, what is significant here is that the interest in spectrality appears to have a new urgency in contemporary thought. This is not motivated so much by an interest in the occult as such as is it by a concern with the modalities of historical memory and historical trauma as political agents in the present. As Warren Montage poses the question, "What exists between pres-ence and absence that prevents the non-present from simply disappearing?"[10] In Toni Morrison's novel *Beloved,* a central text in Gordon's argument, the epony-mous ghost who haunts the household is herself haunted. While on one narra-tive level Beloved is the ghost of the baby slain by her mother to save her from slavery, the ghost is also haunted by the history of the Middle Passage, a history anterior to her own. But with specific respect to the artists under discussion, it is also germane to note, as Gordon does, that "whatever can be said definitively about the long and varied traditions of African-American thought, writing, and radicalism, the social reality of haunting and the presence of ghosts are promi-nent features."[11] It is therefore not at all surprising that references to haunting occur regularly in the work of Moffatt and Weems as well as in the critical com-mentary about them.[12]

Weems's work has changed substantially over the past fifteen years, even if her "subject" in the broadest sense (African American life and culture traversed, as it were, by the various modalities of racism and its intersections with class) has remained consistent. Projects such as the *Family Stories* of 1978–84, or her well-known *Table Top* series of 1990, were stagings of contemporary African American life, in which she herself embodied a contemporary woman navigating the demands and conflicts of family life, relationships, love, sex, friendship, and so forth. But with her first work using historical imagery, the photographs exhibited at the Getty Museum with the title *Hidden Witness: African Americans in Early Photography* (1995), the tenor of the work shifted. Viewed retrospectively, it would seem that the haunting and haunted aspects of her art emerged when she moved to historical subjects, to themes and motifs concerned with slavery and its aftermath. Distance and absence, temporal and spatial, seem to have suggested this mode of appropriation, and if the historic "documents" she employed are themselves linked to the development of stereotypes (e.g., "mammies" or bare-breasted African women), they have been reworked to render them ghostly. Invited by the Getty to design an installation referring to the photographs on display in *Hidden Witness,* Weems duplicated and enlarged approximately thirty-two photographs of black subjects from the mid-nineteenth through the twentieth centuries, tinted them red, and mounted them in circular mounts. Texts composed by Weems, almost all in the second person, were etched onto the glass covering the pictures. Superimposed over a photograph of an elderly woman slave is "You became a scientific profile" (figure 4.10); over a cabaret entertainer, "You became an accomplice"; over a family portrait of a father with two children and a mammy, "Your resistance was found in the food you placed on the master's table—Ha" (figure 4.11). The exhibition was bracketed by two identical blue-tinted photographs of an African woman, the first facing toward the exhibition reading, "From here I saw what happened," and its double, facing toward the end of the exhibition, inscribed, "And I cried."

Weems's act of reframing and her emotionally powerful texts together operate to activate the haunting, to summon the phantoms that would otherwise be frozen, inert and inactivated, within the (original) photographs. Which is to

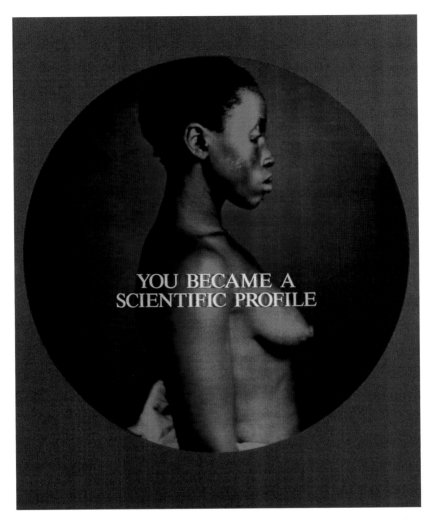

4.10 Carrie Mae Weems, *You Became a Scientific Profile,* 1995–96, from *From Here I Saw What Happened and I Cried.* C-print with sandblasted text on glass, 26¾ × 22¾ in. The Museum of Modern Art, New York. Gift on behalf of The Friends of Education of The Museum of Modern Art. Reproduced courtesy of the artist and Pilkington Olsoff Fine Arts, New York. (From an original daguerreotype taken by J. T. Zealy, 1850. Peabody Museum, Harvard University. © 1977 President and Fellows of Harvard College. All rights reserved.)

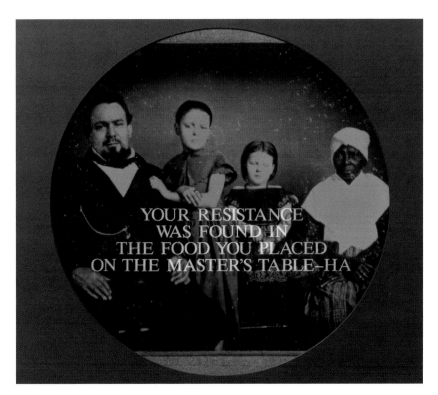

4.11 Carrie Mae Weems, *Your Resistance Was Found in the Food You Placed on the Master's Table—Ha*, 1995–96, from *From Here I Saw What Happened and I Cried*. C-print with sandblasted text on glass, 22¾ × 26¾ in. The Museum of Modern Art, New York. Gift on behalf of The Friends of Education of The Museum of Modern Art. Reproduced courtesy of the artist and Pilkington Olsoff Fine Arts, New York.

say that in her textual act of addressing these effigies, she summons them, quickens them to do their work as ghosts. The very language of haunting refers to what comes back again; the revenant is she who returns. "The ghost," writes Gordon, "is a crucible for political mediation and historical memory; the ghost story has no other choice than to refuse the logic of the unreconstructed spectacle."[13] In the original Getty installation, the exhibited photographs are nothing *other* than spectacle; trivialized as aesthetic objects, grotesquely euphemized in the wall labels with terms such as "Madonna" (substituted for the term "mammy"). Converting the space of spectacle to the space of haunting, Weems, as Andrea Liss observes, "disrupts the serene surface of portraiture in order to reveal the multiple paradoxes between the seen and the obscene. As with her methodology in general, she confronts stereotypes without dehumanizing the people pictured."[14] What is considered to be "obscene," in its etymological sense of being off-scene, unseen, leads ineluctably to the problem of representability itself. Thus, to the degree that it is the work of the minority producer to invent representational forms for what is otherwise unrepresented, occluded, or falsified, we may consider such work to be engaged in producing, as Weems says, "new information," or as Gordon argues, "new knowledges." For these new knowledges to become politically animated, they need to become affective as well as heuristic, empathetic rather than purely objective. The invisibility of the violence of slavery, scarcely even glimpsed in most of the exhibited daguerreotypes, ambrotypes, and collodion prints of the antebellum period, can only be countered by making us see their subjects as phantoms, as apparitions, making claims on us now, inhabiting the present as much as the past.

"The collective assemblage of enunciation" that Deleuze and Guattari identify as one of the characteristics of minor literature seems especially applicable to Weems's work overall. This is not merely because of her concern with oral culture, so apparent in her photo/text work, where the cadences and expressions of black American speech are attentively registered, but equally because of her engagement with diasporic formations within African American culture as they continue to inform individual subjectivity.[15] In projects such as Weems's *Sea Islands* series of 1991–92 (figures 4.12 and 4.13), her search for extant "Africanisms"

**THE
HOUSE**

When you move into
a new house, remove old
spirits by washing around the win-
dows and doors with vinegar water. But,
prevent spirits from crossing the doorstep by
putting salt and pepper along the door and window sills.

Trimming the windows in blue will ward off hags,
witches and other evil spirits.

Wall paper your home with newspaper. Before a hag can bother
you, it must read every word. And if it can't read, then there you go.
But newspaper strung between an antenna will do the job too.

Place rice in the four corners of your home for good luck and
put a glass of water in a corner to absorb evil spirits.

A kitchen knife stuck into the wood over the door will keep
witches out of the house when the family is away.

If you swept dust out of the house at sunset you just might sweep away
the spirit of a family member.

Never build an addition to your house. A home can never be extended.

4.12 Carrie Mae Weems, *Untitled (The House)*, 1991–92, from the *Sea Islands* series. 3 silver prints, 1 text panel, 20 × 20 in. each. Detail. Courtesy of the artist and Pilkington Olsoff Fine Arts, New York.

BONEYARD

alarm clocks wake the dead on judgment day

kerosene lamps light the path to glory

the last cup, plate and spoon used by the departed
should be placed on the grave

keep a child safe from a dead person's spirit
by passing the child over the dead person's
body or coffin

If you suspect that a person has been killed by hoodoo, put a cassava stick in the hand and he will punish the murderer. If he was killed by violence, put the stick in one hand and a knife and fork in the other. The spirit of the murdered one will first drive the slayer insane, and then kill him with great violence.

If people die wishing to see someone, they will stay limp and warm for days. They are still waiting.

If a person dies who has not had his fling in this world, he will turn on his face in his grave.

I got a black cat bone
I got a mojo tooth
I got John the Conqueroo
I'm gonna mess with you

4.13 Carrie Mae Weems, *Untitled (Boneyard)*, 1991–92, from the *Sea Islands* series. 3 silver prints, 1 text panel, 20 × 20 in. each. Detail. Courtesy of the artist and Pilkington Olsoff Fine Arts, New York.

in contemporary Gullah culture attempts to locate and commemorate the survival of a minor and marginal culture, a syncretic one forged from West African roots in the crucible of slavery. "Deterritorialization" is here quite literal, insofar as Gullah language and culture was salvaged and re-formed in the Sea Islands by ex-slaves from the ruins of their own.[16] Haunting has here an ethnological reality manifested in Weems's recording of the survival of magical processes, spirit rituals, and other traces of occult beliefs found in the graveyards and abandoned houses, and within the unruly landscape itself. Weems's perception of the Sea Islands (in which she herself appears) is presented as integrally shaped by its ghostly past.

Where Weems's work in the *Went Looking for Africa* series is based on the photographic record and employs so-called "straight" photographs, Tracey Moffatt's work is staged: scripted, acted, and studio-based. In her *Laudanum* project of 1998, she orchestrates a drama—more precisely, a melodrama—that is entirely set up and artfully constructed (figure 4.14). Laudanum, the opiate derivative widely used in the nineteenth century for its analgesic, narcotic, and sedative effects, was massively prescribed for bourgeois women for psychological as well as physical problems; many of its users became addicted, and at certain doses it could produce hallucinations. Moffatt's sequence of nineteen pictures, with neither captions nor text, presents an elusive and enigmatic narrative, enacted between two women, one the mistress, the other the maid. Formally, the individual photographs have been variously manipulated so as to resemble—but not entirely duplicate—the look of Victorian photographs, alluding in certain instances to nineteenth-century technologies such as stereopticon imagery, and in others to Victorian "art" photographs made by combination printing, such as those made by Oscar Reijlander. On the other hand, the nineteen photographs in the series are as evocative of cinema as they are of nineteenth-century photography, not simply because of their narrative quality, but because of their allusion to various cinema conventions, genres, and even specific films. Certain of them recall Murnau's *Nosferatu* or Dreyer's *Vampyr;* another evokes the *Bride of Frankenstein;* yet another recalls Bergman—and other references could likely be identified. To the extent that the pictures resemble old photographs technologically and materially, and because the two women are clothed in Victorian clothing or underwear, we

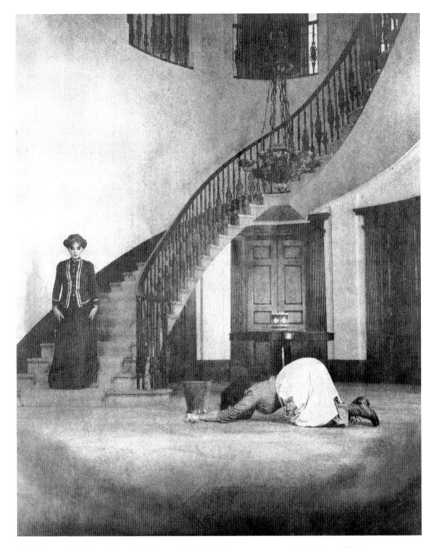

4.14 Tracey Moffatt, from *Laudanum*, 1998. 19 photogravures, 57 × 76 cm. © Tracey Moffatt. Courtesy of L.A. Galerie Lothar Albrecht, Frankfurt.

are prompted to read the series "historically," as though they were actual histor-ical artifacts. But to the extent that they equally read as cinema—and thus as a simulation of the historical past—they must be perceived as modern and not his-torical at all. In addition to this double and mutually exclusive appearance, there exists a third level of reference, and that is to various literary sources. And while Moffatt has herself made reference to Lorca's *House of Bernardo Alba* as one of the inspirations for this series, one might also see in *Laudanum* a reference to Char-lotte Brontë's *Jane Eyre,* or even more suggestively to Jean Rhys's rewriting of *Jane Eyre* in *The Wide Sargasso Sea,* in which Rochester's mad Creole wife, Bertha Mason, is the protagonist. As the racialized figure who is the locus of both "ex-cessive" sexuality and the symbol of the expropriated wealth produced by the plantation system, Bertha is a ghostly ancestor of Moffatt's wild-haired woman surrounded by flames. Such a dense orchestration of reference and allusion oper-ates to suggest that what is at stake is both a reconstruction of something past and at the same time something also present, for clearly this is not a series that oper-ates on the register of nostalgia or period pastiche. In this respect, we might iden-tify the "pastness" of its reference as alluding to the relations between bourgeois white mistresses and subaltern, colonial servants; to the imprisonment of femi-ninity within the claustral spaces of house and household; to the social and cul-tural hystericization of femininity, a hystericization abetted and managed with the aid of laudanum. But there is operative too within the series a distinct ele-ment of eroticism, of sadomasochism, or a violence that is psychosexual as much as it is socially or economically inscribed in the hierarchical relation of mistress and maid. Thus, the implied savagery of the cutting of the maid's hair, the erotic presentation of the maid's body, the mistress weeping over the supine maid, the two women's dishabille, the rage of the maid wielding the scissors, the rage of the mistress—all mobilize the sexual subtext underpinning hierarchical relations be-tween women who are nonetheless locked into some kind of forced intimacy. Hegelian master/slave relations revised by Freud and recast for women; in short, a melodrama. In this respect, Moffatt reminds us of the complexity of relations between women in colonial contexts where the colonizing white woman, sub-ordinate to the white man, is dominant in relation to both the native woman and

the native man. In *Laudanum,* the element of haunting that is denoted in the very look of the pictures, in their oneiric and surreal qualities, pivots on the dialectics of visibility/invisibility, itself the register of the apparitional. Where the conventional spectacle of femininity is easily (re)figured, made visible, as in the picture of the mistress framed by the keyhole, or in the supine figure of the Asian maid, it is the invisible Australian colonial history that has coupled white mistress and Asian maid in the haunted house of domination and servitude.

In previous work by Moffatt, such as the film *Night Cries: A Rural Tragedy* (1989), the political and the collective are also present, but, as it were, in the interstices. In this extraordinarily dense seventeen-minute film, the story appears to be that of a middle-aged woman compelled to take care of her aged mother—an intimate relationship, similar to that between *Laudanum*'s mistress and maid, alternately tender and fraught with anger and implied violence. As Ewa Lajer-Burcharth has described it, "The visual poetics of artifice and disassociation conveys the psychic reality of the mother/daughter relation as always underwritten by alienation from within, a haunting by a kind of loss that cannot be articulated but always makes itself felt."[17] In Lajer-Burcharth's reading, the element of haunting is considered in terms of Nicolas Abraham and Maria Torok's psychoanalytic concept of the phantom, which she describes as "account[ing] for the gaps in the psyche that are due not to the subject's own psychic history, but to the history of others in the subject's family. Phantom is an unconscious formation produced by the unspeakable secrets the subject inherits, usually from the parents."[18] But the haunting element is also fully historical as well, for the daughter in *Night Cries* is Aboriginal and, like Moffatt herself, was adopted by white parents. Central to the film is the fact that, until as late as the 1970s, it was official Australian policy to take, often to kidnap, Aboriginal children from their birth parents and foster them out to white families to promote racial assimilation. Hence, the maternal bond (and bondage) is shadowed by the political history of enforced adoption and, by extension, the larger background of Australian racial policies. Moreover, the repeatedly intercut appearance of an Aboriginal pop singer, Johnny Little, the first "cross-over" entertainer in Australia, refers to the contradictions and aporias of assimilation, as does the lip-synching that features in one shot.

In other of Moffatt's works, such as the still photo series *Up in the Sky* of 1997 (figure 4.15), shot on location in the outback, the various personae—white woman with black baby, menacing nuns, fighting men, the Australian equivalent of "trailer trash," the muscular women laborers, and an emaciated elderly man— all evoke stills from an unknown but familiar film by, say, Pasolini, or early Visconti, but somehow made retro, postmodern. Other than two photographs depicting a fight, or one in which the old man crawls across the road, none of the images is especially violent or shocking, but the aura of brutality, poverty, and

4.15 Tracey Moffatt, from *Up in the Sky*, 1997. 25 offset prints, 71.5 × 101 cm. © Tracey Moffatt. Courtesy of L.A. Galerie Lothar Albrecht, Frankfurt.

danger is all the more potent. Here too, viewers have been struck by the photographs' aura of haunting: "The effect . . . is of a haunting, an incomprehensible small-town ritual, as glimpsed perhaps from a passing car: a view of the world so impoverished and debauched that one maintains one distance, never achieving a sense of . . . understanding."[19] In fact, it is the classical documentary photo series, or photo essay, that purports to produce "understanding," an understanding that, as many critics have demonstrated, is both specious and objectifying.[20] Moreover, the kinds of down-at-the heel, working class, or other marginal types pictured in the series have long provided the subjects of such photography. Moffatt's fractured and enigmatic narrative, and the very obliqueness of its reference, however, is obviously not intended to foster understanding, neither of the culture of the outback nor the lives of its inhabitants. Instead, it does another kind

of work, implying histories, both individual and collective that, like real histories, do not add up to a knowable, integrated, and certainly not visibly comprehensible entity. Here, it is documentary as a genre that is "deterritorialized," removed from a discursive space that purports to present the reality of "other" lives, to one that implicitly refuses the notion of a direct, objective—i.e., photographic—knowledge of outsider or marginal communities.

With Zoe Leonard's *The Fae Richards Photo Archive,* the last of my examples of tactical haunting, we are presented with a fictive biography, a simulation of the life of an invented black lesbian actress, an "archive" seemingly put together by an anonymous fan (figures 4.16 and 4.17). Like Moffatt's photo works, this is an

4.16 Zoe Leonard, *Martha and Fae at home. (mid-1930's),* 4 × 6 in., from *The Fae Richards Photo Archive,* 1993–96, created for Cheryl Dunye's film *The Watermelon Woman* (1996). 78 black and white photographs, 4 color photographs, and notebook of 6 pages of typed text on onion skin paper, edition of 3. © Zoe Leonard.

4.17 Zoe Leonard, *Fae Richards, circa 1940. Photographs are unsigned, but are attributed to Kenny Long,* 8 × 10 in., from *The Fae Richards Photo Archive.*

entirely fabricated story. Enacted by a cast of ten, the *Archive* is made to resemble the look of a fan's homemade scrapbook, mimicking period snapshots, movie stills, glamour and publicity pictures, and ending with an imperfectly typed list of accompanying captions. *The Fae Richards Photo Archive* is a work of fragments about a fragmented life, an "individual" life which, in keeping with Deleuze and Guattari's formulations, is intended as a collective representation of little-known or entirely undocumented histories. The "archive," however, was made for and is the companion piece to the film *The Watermelon Woman* made by Cheryl Dunye, which recounts the "discovery" of Fae Richards and the formation of the archive by a woman filmmaker who has become, in effect, "haunted" by her.[21] *En abyme* in the film, the *Archive* project (which has been presented in exhibition format, but also exists as an artists' book) documents a life that the reader/viewer, like the protagonist in the film, must constitute between the lines. "Between the lines" is in fact an apt description of the work, for the lines that are evoked are color lines, class lines, and sexual lines. From the pictorial shards and textual fragments, we are presented with the individual "Fae Richards" who, among other things, emblematizes the legions of young black women who entered the film industry from the 1930s on, condemned to the role of maid, of "watermelon woman," or Josephine Baker-type entertainer, clad only in a skirt of bananas— such is the last film that Richards makes in Hollywood after failing to be cast in nonracial, that is to say, nonracist roles. Her lover during her movie years, a white lesbian director, is by virtue of her race, class, and education, the cultural producer; Fae, on the other hand, after the economic failure of the black film studio where she was featured in what were called "race" movies (i.e., movies for black audiences), has no such option. Between the lines, however, are other little-known and untold histories: of interracial gay communities, of passing women, of independent black movie companies of the 1940s producing "race" movies. We glimpse Fae after she has left the film industry, as cabaret singer, as active in the NAACP, in gatherings with friends, and in her final relationship with a passing woman. It is not, or so it seems, a tragic life, and yet the haunting, haunted aspect surrounds the archive, the individual pictures, the figure of Fae herself. What constitutes this haunting?

As with *Laudanum,* we know that the pictures are not "real," and that the people in them are actors. Even the melancholy "pastness" evoked by clothing and type of photograph is a virtuoso simulation, a work of art, artifice, and dark-room wizardry. But because of its wealth of real historical allusion—to the history of actual black women in the movies, the waste of their talents, the role of cinema itself in producing and disseminating racial stereotypes, the double op-pression and marginalization of black women who were also gay—the *Archive* operates as though it were an authentic historical document. This is especially the case with respect to the *Archive*'s lacunae—the missing names and unidenti-fied figures, the unaccounted-for periods in Fae Richards' life. Arguably, it is the absences, above all, that mobilize the haunting, just as the unknown aspect of Richards' life and career prompts the haunting of the film's protagonist. Fae Richards is thus a kind ghost figure. As Gordon remarks, "The ghost is not simply a dead or missing person, but a social figure, and investigating it can lead to that dense site where history and subjectivity make social life. The ghost or appari-tion is one form by which something lost, or barely visible, or seemingly not there to our well-trained eyes makes itself known or apparent to us."[22] Insofar as "real" history has its own lacunae, and until quite recently was rarely history from below, the production of stories by minority or outsider producers offers differ-ent kinds of knowledge. Writing on the subject of "History as Gesture," Lynn Hunt has observed that "History is better defined as an ongoing tension between stories that have been told and stories that might be told."[23] Hence, the stories told by Weems, by Moffatt, and by Leonard and Dunye, stories that might be characterized as ghostly stories, if not ghost stories, give us, if we responsive to them, a mode for empathetic access via aesthetic languages to forms of knowl-edge that our postmodern spectacular culture occludes. The political import of this "minor" production is difficult to gauge, but how is one to gauge such things in any case?

In selecting these artists for the occasion of Women Artists at the Millen-nium, it was important to me that the artists I would discuss should not only be women, but artists doubly marked by reason of race or ethnicity. Assuming in advance that such artists would be underrepresented if represented at all in an ac-

ademic conference, I thought a decision of this type seemed a necessary inter-vention.[24] And taking these differences as a point of departure, I believed it was equally apposite to revisit Deleuze and Guattari's conception of the minor in re-lation to Michel de Certeau's notion of tactical intervention. While it might ini-tially appear that the effectiveness of the tactical *as such* is better traced in specifically activist practices such as those exemplified in the work of the Guerilla Girls, Gran Fury, Act-Up, Group Material, and so forth, I believe that art pro-duced by an individual, rather than a collective, or art that does not necessarily announce itself as "political" in the vernacular sense, is able to do comparable work: thus my continued commitment to art production defined *as a critical practice*. In this regard, it seems to me that the emergence of numbers of signifi-cant artists in the past twenty years under the crude designation "multicultural-ism" has altered the artistic terrain as decisively as has feminism, notwithstanding the current disavowal of the latter.[25] Although these artists are frequently, and of-ten negatively, associated with "identity politics"—another bad object in the contemporary artistic lexicon—this description is by no means universally accu-rate. As Coco Fusco has observed,

> Although some might cling to the idea that all artists are bound to a specific group-oriented mandate, or a fixed notion of community, the most intriguing work takes those very assumptions apart and presents new possibilities for old terms. . . . It appears that we have worked away from the once widely held belief that artists of color must all be engaged in what Stuart Hall has called the act of imagi-native recovery of a single, unifying past in order for their work to be valid. No longer bound to a sense of having to restrict one's fo-cus, materials, or genre, many contemporary artists of color move back and forth between past and present, between history and fic-tion, between art and ritual, between high art and popular culture, and between Western and non-Western influence.[26]

Most of the elements Fusco lists are evident in the work of Moffatt, Dunye, Leonard, and Weems. Moreover, the specific tactics of taunting and haunting that I have identified in certain of their works fit readily enough into Fusco's general account. But where the tactical taunt is equally found in agitprop and activist production, the more elusive and allusive conjuration of the ghostly past of historical violence (experienced both collectively and individually) has now, perhaps, a particular power and a particular effectivity. For in keeping with Gordon's brief for this modality of address and reception: "Being haunted draws us affectively, sometimes against our will, and always a bit magically, into the structure of feeling of a reality we come to experience, not as cold knowledge, but as a transformative recognition."[27] At this historical moment in which we have begun to reckon with the ghosts, a transformative recognition may lay the groundwork for a transformative politics.

<div align="center">Notes</div>

1. Gilles Deleuze and Félix Guattari, "What Is a Minor Literature?," in Russell Ferguson, Martha Gever, Trin T. Minh-ha, and Cornel West, eds., *Out There: Marginalization and Contemporary Culture* (Cambridge: MIT Press, 1990), pp. 59–70. As the context makes clear, their use of the word "minor" has nothing to do with artistic quality.

2. Ibid., p. 60

3. Ibid., p. 61

4. With respect to the forms of art making that can be designated as critical practice and in keeping with an important distinction formulated by Michel de Certeau, there is a difference between the notion of "strategy" and the notion of "tactic." Strategies, associated with apparatuses of power, operate to colonize, appropriate, master. ("A Cartesian attitude, if you wish: it is an effort to delimit one's own place in a world bewitched by the invisible powers of the Other. It is also the typical attitude of modern science, politics, and military strategy." Michel de Certeau, *The Practice of Everyday Life,* trans. Steven Rendell [Berkeley: University of California Press, 1984], p. 36.) Tactics, however, are defined as the techniques of the other—an art of the weak—and they take place in enemy territory: "The space of the tactic is the space of the other. Thus it must play on and with a terrain imposed on it and organized by the law of a foreign

power. It does not have the means *to keep to itself,* at a distance, in a position of withdrawal, foresight, and self-collection: it is a manoeuvre within the enemy's field of vision as von Bülow put it. . . . It must vigilantly make use of the cracks that particular conjunctions open in the surveillance of the proprietary powers. It poaches on them" (de Certeau, *Practice of Everyday Life,* p. 37).

5. The practices of *détournement* were developed by Guy Debord and the Situationist International as a subversive tactic against what Debord famously defined as the society of the spectacle. Using the material of the spectacle itself—e.g., advertising, comic books, press, film, etc.—these were variously "turned around," or subverted by altering their texts and contexts, recollaging or reconfiguring the object, annotating, and so forth.

6. How black spectators respond is, of course another story. Bridger R. Cooks reported, "When her series was shown at a gallery in the Rhode Island School of Design (RISD), the first group of Black Americans that saw the show were the custodians who clean the gallery. This group went on strike immediately after seeing the series. After the group was told that the artist was a Black woman, one custodian quit and the others went back to work." Bridget R. Cooks, "See Me Now," *Camera Obscura,* no. 36 (September 1995), p. 73.

7. Cited in Ibid.

8. Avery Gordon, *Ghostly Matters: Haunting and the Sociological Imagination* (Minneapolis: University of Minnesota Press, 1997), p. 7.

9. "On the Theory of Ghosts" is a two-page note in Max Horkheimer and Theodor W. Adorno, *The Dialectic of Enlightenment,* trans. John Cumming (New York: Herder & Herder, 1972); Jacques Derrida, *Specters of Marx: The State of the Debt, the Work of Mourning, and the New International,* trans. Peggy Kamuf (New York: Routledge, 1994); the discussion of the phantom is in Nicolas Abraham and Maria Torok's *The Shell and the Kernel: Renewals of Psychoanalysis,* trans. Nicholas Rand (Chicago: University of Chicago Press, 1994).

10. Warren Montag, "Spirits Armed and Unarmed: Derrida's *Specters of Marx,*" in Michael Sprinkler, ed., *Ghostly Demarcations: A Symposium on Jacques Derrida's Specters of Marx* (London: Verso, 1999), p. 71.

11. Gordon, *Ghostly Matters,* p. 152.

12. For example, Patricia Mellencamp, "Haunted History: Tracey Moffatt and Julie Dash," *Discourse* 16, no. 2 (Winter 1993–94). Also, Mark Nash, "Only Angels Have Wings," in *Tracey Moffatt: Free Falling* (New York: Dia Center for the Arts, 1998), p. 45: "Opening the grave, freeing the ghosts whose presence haunts the living, is not only essential to understanding, it is also an essential part of her art."

13. Gordon, *Ghostly Matters,* p. 18.

14. Andrea Liss, "Facing History," *Afterimage* 23, no. 2 (September/October 1995), pp. 21–22.

15. It should be mentioned, however, that this concept of "collective enunciation" as a privileged mode in African American art and culture is not without criticism. Hortense J. Spillers, for one, has argued powerfully that this collective consciousness may be experienced by African Americans as an almost coercive demand, one that effectively represses the claims of individual subjectivity:

> It is widely believed that black people cannot afford to be individualistic. I must admit that most of the black people I know who think this are intellectuals, who in practice, not only insist on their own particularity but in some cases even posit uniqueness. But if we can, we must maintain a distinction between the "one" and the "individual," even though the positions overlap. The individual of black culture exists strictly by virtue of the "masses," which is the only image of social formation that traditional analysis recognizes. Practically speaking, the masses were all there were against the great totalizing narratives—"white" and "Indian"—in the historical period stretching from colonization to nationhood. The individual of the life-world does not stand in opposition to the mass, but at any given moment along the continuum might be taken as the supreme instance of its synecdochic representation. In other words, Every Black Man or Woman *is* the "race"—as the logic of slave narratives amply demonstrates—and the elements of the formula are reversible and commensurate.

Hortense J. Spillers, "All the Things You Could Be by Now, if Sigmund Freud's Wife Was Your Mother: Psychoanalysis and Race," in Elizabeth Abel, Barbara Christian, Helene Moglen, eds., *Female Subjects in Black and White: Race, Psychoanalysis, Feminism* (Berkeley: University of California Press, 1997), p. 141.

16. This is as well the subject of an important film by Julie Dash, *Daughters of the Dust*. See Mellencamp, "Haunted History," which discusses it in relation to Tracey Moffatt's *Night Cries: A Rural Tragedy.*

17. Ewa Lajer-Burcharth, "A Stranger Within," *Parkett,* no. 53 (1998), p. 45.

18. Ibid.

19. Justin Spring, "Hunters and Collectors," *Art Text,* no. 60 (February/April 1998), pp. 60–66, 61.

20. See for example, Martha Rosler, "In, Around, and Afterthoughts (On Documentary Photography)," in Rosler, *Three Works* (Halifax: Press of the Nova Scotia College of Art and Design, 1981).

21. Since I wrote this essay, two essays related to this project have appeared: Laura L. Sullivan's excellent study "Chasing Fae: The Watermelon Woman and Black Lesbian Possibility," in Jacqueline Bobo, Cynthia Hudley, and Claudine Michel, eds., *The Black Studies Reader* (New York: Routledge, 2004); and Ann Cvetkovich, "In the Archives of Lesbian Feelings: Documentary and Popular Culture," *Camera Obscura,* no. 49 (2002), pp. 106–145.

22. Gordon, *Ghostly Matters,* p. 8.

23. Lynn Hunt, "History as Gesture," in Jonathan Arac and Barbara Johnson, eds., *Consequences of Theory: Selected Papers from the English Institute* (Baltimore: Johns Hopkins University Press, 1987), p. 103.

24. I hasten to say that this dearth should not necessarily be laid entirely at the feet of the conference organizers. These absences and underrepresentations, especially in academia, are, to put it mildly, overdetermined.

25. For an especially egregious example, see for example the two "anniversary" issues of *Artforum* (March and April 2003) which, while purporting to reexamine the art of the 1980s, have made feminist artists and feminist theory invisible. Likewise the two previous Documentas, 10 and 11, while proclaiming their political commitment, similarly managed to repress all consideration of the political implications of feminism and women's emancipatory movements.

26. Coco Fusco, "Passionate Irreverence; The Cultural Politics of Identity," in Brian Wallis, Marianne Weems, and Philip Yenawine, eds., *Art Matters: How the Culture Wars Changed America* (New York: New York University Press, 1999), p. 71.

27. Gordon, "Ghostly Matters," p. 8.

Sally Mann has achieved a success that transcends gender. In the summer of 2001, for example, *Time* magazine named Mann "America's Best Photographer."[1] Her work is so well known that it also transcends medium, though she is identified, and identifies herself, as a photographer. Yet Mann has paid a price for her success that is distinctly gendered. Along the way, Mann's work has challenged the histories of artistic, commercial, and amateur photography, as well as the reality effect that impinges on all three of those histories. The reception of those challenges has also been bound up with gender issues. From about the mid 1980s onward, Mann has been accused of building her reputation on the exploitation of her children. Mann's reputation continues to dwell on the photographs she made of her three children between about 1984 and the mid 1990s, many of them published in a book titled *Immediate Family*.[2]

Despite the overwhelming role those photographs of children have played in creating Mann's reputation, I would like go into my subject with the observation that Mann's work on childhood belongs within a long, productive, and inventive career. Mann, who was born in 1951, began exhibiting her work prominently in 1977, at the Corcoran Gallery of Art. The first photographs she included in her 1994 retrospective book *Still Time* date from 1971. Mann has worked cyclically on several quite different subjects: young women, landscape,

young women again, still lives, the cusp between child and adult in the *At Twelve* series, childhood in the series called *Immediate Family,* more on childhood, two series of landscape images, a series about marriage, and most recently a series about decay and death, *What Remains.*[3] She has worked on scales ranging from the intimate to the wall-size, and with many photographic techniques, both color and black-and-white, including cibachrome, Polaroid, archaic-toned gelatin silver prints made with nineteenth-century cameras, and ambrotypes.

Mann's work has been qualitatively cumulative. Not only have first rounds of work on a subject provided a conceptual basis for more mature and complex later work on the same subject, but as Mann works through subject cycles, her different subjects have also become increasingly connected. Compare, for example, her 1987 *The Ditch* (figure 4.18), an *Immediate Family* photograph, with a 1998 untitled photograph from *Deep South: Landscapes of Mississippi and Louisiana* (figure 4.19). It is perhaps to be expected that a series of images about childhood would include an archetypal birth image. In *The Ditch* the child's body, her son's body, pushes headfirst through a watery organic channel, limbs folded, out through the narrow passage toward open space. Mann focuses in every way on the space along which the child moves out from her, away from the indistinct blur which is her space, past the anonymously looming witnesses on either side, leaving darkness and uncertainty aside. The same use of a central channel in sharp focus, flanked by indistinct form and darkness, approached across a soft-focus foreground point of view, reappears in the image of a landscape made eleven years later. Formal structure adds an archetypal resonance to Mann's meditations on the image of the Deep South, where she was born and raised and where she still lives, close to the land, on a farm. It expresses in purely formal terms the idea Mann explores of the Deep South as a "Mother Land" (the title of her 1997 Edwynn Houk Gallery show). She has thus repeated an idea, but also expanded it, conceptually and literally. By 1998, Mann's scale had grown to the proportions of a mural, and her imagery therefore shifted from the intimacy of the ordinary occasion to the monumentally imposing quality of a public event. In addition, by 1998, Mann's technique invokes time past, and therefore the distance between the past and the present, in contrast with the comparatively transparent technique of *Immediate*

4.18 Sally Mann, *The Ditch,* 1987. © Sally Mann. Courtesy of Edwynn Houk Gallery.

Family that could appear to isolate a fleeting moment. In the *Deep South* series, Mann's black edges, as if curtains of darkness drawn back from her images, function both as formal elements of her composition and as the content of her subject matter, but they are also the technical effects of a nineteenth-century camera lens. Mann knows that we know what photographs looked like when the Old Deep South was new. She taps into our nostalgia by replicating the technical signs of age, only to strip sentimentality of its reassuring anecdotes, magnifying the bare land and the ruins of the Deep South into haunted dreams.

4.19 Sally Mann, *Untitled,* 1988, from the series *Deep South: Landscapes of Mississippi and Louisiana.*
© Sally Mann. Courtesy of Edwynn Houk Gallery.

Mann's most recent work, *What Remains,* brings together images of her children and of landscape into one installation, and one book. Images of matter's disintegration are carried by the decomposing techniques of ancient photographic equipment: peeling, scratched, blistered, torn, mottled, light-blasted vestiges of realism past. What remains of the bodies so vividly present in Mann's earlier photographs of her children are ambrotypes of faces at once looming and vanishing, exceeding the limits of the image and falling into darkness, the signs of young flesh and living eyes barely discernible, as if a memory straining against oblivion (figure 4.20). Contrary to many predictions, Mann did not cling to the subjects, the style, or the issues that first launched her reputation. While it is fair to say that no other of Mann's works has become as famous as *Immediate Family,* Mann has proved herself to be an artist whose work is not limited to what made her notorious, even within the subject of childhood.

4.20 Sally Mann, *Emmett,* 2001. Ambrotype, 8 × 10 in. © Sally Mann. Courtesy of Edwynn Houk Gallery, New York.

But back to the reasons Mann first became famous. Her photographs got a lot of publicity, most glaringly by being the cover story of a *New York Times Magazine* in 1992, which fueled more publicity. Rumors circulated that Mann was making inordinate sums of money on sold-out shows. It is true that Mann's gallery, Edwynn Houk, has had waiting lists of buyers for her *Immediate Family* prints, limited to editions of twenty-five (many of them sold out) and priced according to size, starting at $1,500 for the smallest eight-by-ten-inch prints, every single one of them printed by Mann herself. Mann's prints have a craft dimension to them which may be unfashionable, but which many photography collectors appreciate. After the initial gallery market comes the open resale market, driven by the great art auction houses. Of course Mann makes money only indirectly from this second market, inasmuch as it raises or lowers the gallery sales from which she can profit directly. A quick glance at prices reached by Mann in comparison with others at Christie's and Sotheby's contemporary art auctions in May 2000 does put Mann in a high-price league, but not in any startlingly exceptional way.[4] Another significant source of Mann's income is curiously related to her artistic reputation. It comes from—of all unlikely phenomena—the blockbuster movie *Titanic.* As the would-be artist hero Leonardo DiCaprio flips through his sketchbook, what should appear but an image clearly taken from *Immediate Family.* Apart from being a flagrant violation of the laws of chronology, this was also a copyright problem. Of course, the makers of *Titanic* could, hypothetically, have used any image, but the fame of Mann's images was, arguably, the reason it was her image and not another that was used.

It turns out, however, that Mann's single greatest financial success has been the sales of her landscape photographs.[5] This discrepancy between fact and the assumptions of both academics and a general public extends to the durability of Mann's market. While Mann's notoriety has all too often been dismissed as an ephemeral phenomenon, the market for her work remains exceptionally reliable. According to Sotheby's contemporary photography expert Denise Bethel, Mann's work is among the safer investments she can recommend.

Mann's fame is of the sort that inevitably summons the words "notorious," "disturbing," and "troubling" (as in the *New York Times Magazine* cover story title:

"The Disturbing Photography of Sally Mann"). As a long 1999 *Vogue* magazine article headlined: "Her startlingly intimate photographs of her own children—direct, untamed, and often nude—made Sally Mann one of the most acclaimed and reviled photographers of the decade."[6] Mann's fame has been based on scandal. While she has always had her admirers, the scope and the intensity of Mann's reputation comes from the negative reactions her work has elicited. The scandal is ostensibly the scandal of child abuse. Because they are both sexual and violent in content, the claim goes, Mann's photographs abuse their subjects. Worse, they incite further abuse of other children by fostering a climate that tolerates or even urges child abuse. Even worse, Mann turns out to be the mother of the three children she photographs, so her photographs are accused of originating in a mother's ruthless sacrifice of her children.[7] This interpretation is expressed in what are basically three tones, which I list in order of increasing ferocity. (Mad) Mann herself did not originally intend the abusive qualities of her work, but she irresponsibly kept producing it once she knew how the work was being understood in public. (Madder) Mann craved fame no matter what the means, so she cynically courted outrage. (Maddest) Mann is a child abuser.

Yet no one proposes that Mann's photographs are not beautiful. On the contrary, much of the outrage Mann elicits revolves around her aestheticization of child abuse. The photographs are perceived to be all the more insidious because they are so ravishingly composed, lit, and printed. In a twist on the usual scandalized resistance to something controversial being called art, Mann's work is decried because content seduces through form.

Since Mann's intentions seem to be at issue, I'll go all the way back to the first *Immediate Family* picture. *Damaged Child,* dated 1984 (figure 4.21), opens the *Immediate Family* book, on a page facing a page laid out with family snapshots of Mann's parents and her father's genital found-object sculpture, images that stand for the origins of Mann's medium, self, and force. Like all original images, *Damaged Child* is mythically first, and therefore all the more significant. What matters is not whether it actually was or wasn't the first photograph taken, but why this photograph is designated as first.

4.21 Sally Mann, *Damaged Child,* 1984. © Sally Mann. Courtesy of Edwynn Houk Gallery.

The title of the photograph makes sure we notice the child is damaged. We see with our eyes that this isn't just any damage, but damage to an eye. The origins picture signals that the whole series is going to be hard on the eye. It announces that the series it initiates will deform and damage our vision of its subject, the subject of childhood. Moreover, the damage to one eye only heightens by contrast the alert perfection of the other eye. Mann isn't going to let us retreat into safe pity, but is going to make us confront the coexistence of damage and beauty in our own surroundings and among our own relations, in our own "immediate family."

Other neat oppositions are also dismantled. Lest we dismiss *Damaged Child* as an amateur snapshot of a child by her mother, Mann invokes photography's aesthetic canon by reusing the title as well as the subject and frontality of Dorothea Lange's famous 1936 *Damaged Child* (figure 4.22). Lange's photograph, made un-

4.22 Dorothea Lange, *Damaged Child*, 1936. Library of Congress.

der the auspices of a government welfare program, pictured the suffering of a child in order to indict it, and furthermore to protest against the human consequences of the economic Depression. The progressive political purpose, as well as the aesthetic prestige, of the image Mann chooses to echo complicates any impulse to see nothing in her *Damaged Child* but child abuse.

It would be easy to say that *Immediate Family* simply merges beauty, suffering, and sex. Many photographs do hint at, or at least refer obliquely to, violence and wounds, with legs covered in "flour paste" that look like burn damage, fleshy flowers called "night-blooming cereus" hanging over the two sides of a child's chest, or dark liquid "popsicle drips" smeared over a torso. Often the hint seems to be made explicit by titles, titles like *Hot Dog, Dirty Jessie,* or *Last Light.*

I prefer to move beyond that simple description, to accept beauty, sexuality, and suffering among the conditions of intense physical presence—or, more precisely, the photographic fiction of physical presence. Mann's subjects are among the most vivid children in the history of art. Mann allows us to see an innocence treasured by desire, a joy in life stalked by death, to understand the beauty of youth as a recognition of its fragility or its devastation by time, to embrace the accidents of ecstasy and the exultations of the ordinary. What other people see in Mann's work as pedophile sexuality, I see as the experience of maternity unleashing the representation of a primal life force that unites eros and thanatos, desire and death.

I've written an entire book on how this version of childhood painfully contradicts two centuries of assumptions, visual and otherwise, about childhood, and I don't want to repeat myself.[8] What I would like to add now is that Mann's work has proved to have a profound influence on the representation of childhood, a rather major subject. Perhaps Mann's photography is only the most striking, and among the first, work to express a change in concepts of childhood much broader than any individual's work could ever be. To anticipate and express a cultural shift of this order of magnitude, however, is itself no small feat.

Mann's work, or perhaps the spirit of Mann's work, has imprinted itself on the work of artists after her who represent children. The power of her imagery can be gauged by the fact that her influence has made itself felt not in a narrowly

sexual way, but more fundamentally. It is since Mann that we have seen a critical number of images that represent the child's body as a body—a body that, being alive, appeals and feels and wants, that can be disguised, distorted, damaged, or even volatilized in the cross-cultural exchange of artificially generated electronic images. Suddenly the child became a reputable artistic subject (even for male artists), susceptible to a wide range of interpretations. Many established names in photography—such as Andres Serrano in the art domain or Herb Ritts in the commercial domain—began in the 1990s to include images of children influenced by Mann in their wide repertoires. More recently, and in a more conceptual mode, Pierre Huyghe, winner of the 2002 Hugo Boss prize and awarded a major exhibition at the Whitney Museum, devoted himself to a collective project entirely based on a Japanese anime girl character called Annlee, culminating in 2002 in a show titled *No Ghost in the Shell* (a reference to the already-classic 1995 anime film *Ghost in the Shell*), and celebrated on the cover of the January 2003 issue of *Artforum*.

In the immediate wake of Mann's *Immediate Family* notoriety, several women photographers began to build strong reputations in the art world based on work devoted almost exclusively to children, or to the adolescent transition between childhood and adulthood; these photographers include Inez van Lamswerde, Corinne Noordenbos, and Hellen van Meene. The number of such dedicated careers has accelerated with startling rapidity. One of Mann's own assistants, Anna Gaskell, quickly rose to art star status with her 1996 *Wonder Series,* loosely based on the stories of Lewis Carroll's *Alice's Adventures in Wonderland* and *Through the Looking-Glass,* as well as on the photographs of girls for which Carroll is now infamous. Gaskell had been the student of Gregory Crewdson in the Yale photography MFA program. In 1999, Crewdson organized a New York gallery exhibition called *Another Girl, Another Planet,* including several more of his students. The show instantly endowed its thirteen artists with celebrity. Julie Becker, Gabriel Brandt, Sarah Dobai, Jenny Gage, Katy Grannan, Jitka Hanzlová, Dana Hoey, Sarah Jones, Justine Kurland, Malerie Marder, Liza May Post, Dayanita Singh, and Vibeke Tandberg not only were "girls" themselves, but, more to the point, their work was about the experience of childhood adolescence

and young womanhood as they both imagined it and had lived it. Their work on the subject of childhood (broadly defined) joins a considerable body of work on the same subject by a flock of very young artists who are not all necessarily photographers, but who also have been receiving unusual critical attention and prominent exhibitions, including Amy Cutler, Rineke Dijkstra, Kim Dingle, Marcel Dzama, Nicky Hoberman, Anthony Goicolea, Marlene McCarty, Deborah Mesa-Pelly, Simen Johan, Alessandra Sanguinetti, and Loretta Lux.

Mann's work has influenced our vision of the photographic past as well as its present. Many nineteenth-century photographs of children look different when seen through Mann's work (witness Anna Gaskell's neo-Carroll series), so much so that Mann can be said to have retroactively brought an entire nineteenth-century subject into the history of art, and with it, not incidentally, several women artists. Since *Immediate Family* there has been a burst of scholarly work on nineteenth-century women photographers, especially those who represent children, such as Gertrude Käsebier and, above all, Julia Margaret Cameron. Mann herself cites Cameron, notably in her 1988 *Kiss Goodnight* (figure 4.23) that intensifies, even as it further blurs, Cameron's 1864 *The Double Star* (figure 4.24). This scholarship looks at the past through Mann, not only concentrating on what she and earlier photographers have in common, but actually making explicit comparisons between nineteenth-century photographs and Mann's.[9] Exactly those aspects of Victorian women's photography that made it seem trivial to their contemporaries—its concentration on children, on the maternal, on haptic presence, on intimacy—now seem radical.

Whether or not all these effects of Mann's work are positive, they are at least powerful—and so powerful as to be virtually unprecedented for the work of a woman artist. I am not saying that there are no other women artists prior to Mann whose work has not been equally historically significant, understood retroactively. Nor am I making any claims about work by women younger than Mann. What I am suggesting is this: few women artists before Mann had had such an immediate impact on public discourse. From the point of view of the history of women artists, such importance is a positive effect in and of itself. That Mann's

4.23 Sally Mann, *Kiss Goodnight*, 1988. © Sally Mann. Courtesy of Edwynn Houk Gallery.

4.24 Julia Margaret Cameron, *The Double Star,* 1864. Albumen print, 25.4 × 20 cm. The J. Paul Getty Museum, Los Angeles.

impact had its source in scandal is therefore all the more curious. How are we to understand negative scandal as the cause of a woman artist's power?

The issue of whether scandal is the condition of fame in today's art world is too vexed and tendentious to go over now as a general proposition. What matters here is that the particular scandal of Mann's work depended on a perceived opposition between artistic freedom and gender. The scandal of Mann's work puts the ambition to be a great artist in conflict with the duties of maternity, a biologically female function still so densely accreted with social expectations that in effect it is a feminine role rather than a biologically female function. According to this opposition, Mann expressed herself artistically at the expense of the children whose safety it was her maternal duty to protect. At its most extreme, Mann's scandal takes the following form: Mann's photographs were an unnatural betrayal of maternity by art.

Mann's case teaches us that, as recently as the mid 1990s, only the violation of a gender role could produce the degree of scandal requisite to a certain kind of success when the artist happened to be a woman. Which is to say that we are still capable of making gender, however negatively, the condition of a woman's artistic success. What bothers me the most about that condition is how it rests on a persistent assumption that in the case of women artists it is valid to interpret their work through their personal lives. Here a comparison between Sally Mann and Kara Walker, whose success has also been accused of being caused by scandal, seems useful to me. Both scandals accuse the artist of having betrayed her personal self—maternal in Mann's case, racial in Walker's case. In both cases, the artist is assumed to have created emotional excess out of biography. In both cases, a cause and effect relationship has been posited between the reality of a person's biographical circumstances and the representations of her art. In its most subtle form, this personal-cause/representational-effect relationship is presented as the danger of the effect of the work in its ambient cultural climate. But at its heart the argument is always predicated on a belief that art is about a personal reality.

Walker's scandal has elicited quite a few illuminatingly intelligent retorts. As those responses point out, Walker's use of a medium that is very clearly a medium—wall-scale silhouettes—helps keep in mind the representational quality

of her enterprise. Walker, completely self-consciously, works in and through fictions.[10] In comparison, Mann's criticism suffers from photography's reality effect. Photography has consistently offered women more professional artistic opportunities than any other medium precisely because it was more institutionally and psychologically accessible to women than any other even marginally fine-art medium. But to the extent that photography continues to be considered documentary, it therefore overburdens women with photography's tenacious reality problem.[11]

Yet Mann's work is rife with signs of meanings much larger than her own personal life. There is, to start with, what Emily Apter has called Mann's propensity to make marks.[12] Playing against her mechanical photographic medium, Mann repeatedly represents the organic marking of living surfaces, for instance in *Last Light* (1990), *Popsicle Drips* (1985), *Fallen Child* (1989), *Emmett's Bloody Nose* (1985), *Emmett and the White Boy* (1990), among others, and perhaps most keenly in *The Terrible Picture* (1989) (figure 4.25), with its crusted thighs, blackened eye sockets, and filigree noose. Besides acting as the signs of being created signs, these marks demand careful looking. The fears they trigger of damage pull the viewer into a close examination of the image, whereupon the marks turn out to be only that: marks. The crust is just sand, the eyes are merely in shadow, the noose is nothing but a toy tattoo utterly unlike, and therefore unconnected to, the strip that appears, but only appears, so tautly straight above the child's head. We have been pulled into the kind of mark deciphering, the connoisseurship, that characterizes looking at traditionally handmade unique media, paradoxically achieved through provisional reliance on photography's documentary truth-value. Darkness in Mann's work acts similarly, forcing us to look for light in the darkness, forcing us to see in the dark. Mann's photographs raise issues that are troubling, and they take some trouble to see.

Then there is Mann's habit of citing liberally from the history of photography. Her crucial citations of Lange and of Cameron have already been shown. (Note that both those models are women photographers.) There are countless other citations throughout Mann's career,[13] which are not at all limited to the history of fine art photography. The fine art references are available to a crucially powerful segment of Mann's audience, the part that buys and exhibits and gives

4.25 Sally Mann, *The Terrible Picture,* 1989. © Sally Mann. Courtesy of Edwynn Houk Gallery.

talks. The references, however, that make her photographs publicly difficult (not just academically different) are the ones that deal with popular and commercial clichés of childhood. Here the linguistic meeting at the word "cliché" of the photograph and of the stereotype is entirely appropriate.

And here, at the cliché, I have to make one last comparison between Walker and Mann, or rather between what critics have recognized in Walker's work that should be recognized in Mann's. Walker displays racial stereotypes that our culture has declared offensive, stupid, and brutal, however humorous and erotic Walker makes us fear we continue to find their offensive stupid brutality. Most important, Walker reveals how powerfully those clichés are what still convey the meanings of race and race history in the United States of America.

Mann does the same thing, but with clichés that our culture still idealizes and sanctifies in the realm of the cute. They are the images that we would like to assume are truthful and timeless, often by pretending they are imagined from a child's point of view. Typically, in a 2002 *New York Times Magazine,* a children's fashion editorial reproduced a whole batch of such images, under the title "Kids Love . . . A reminder of their enduring passions."[14] Mann reveals how innocent surfaces cover complicated and contradictory impulses. She shows us how we have fabricated an image of childhood with cute masks that hide something not at all cute. We would like to think that our passions and our clichés belong apart, but Walker and Mann suggest they are always yoked. Mann's imagery is not about her personal life; it is the imagery of an entire culture, and the way our culture imagines itself through a past much longer than Mann's lifetime. Mann's work visualizes myth, our myth of childhood, the myth of the innocent Other to our adult self.

Clichés are part of the myth: the easiest part. A cliché admits nothing; a myth uses fictions to mask and also to reveal itself, or rather to confess that the mask is a condition of what it conceals. Mann grapples with each and every visual cliché of childhood, as if systematically searching and seizing. As they appear in Mann's images, the clichés creep and twist, growing to mythic proportions. The cliché's inanimate surfaces become something all too alive for comfort, something with roots where we didn't want to look. Take just one instance, the cliché of the child embracing a pet animal (figures 4.26). Candy brightness has turned into the lurk-

4.26 Sally Mann, *Holding the Weasel*, 1989. © Sally Mann. Courtesy of Edwynn Houk Gallery.

ing ambiguities of shadow; evenly crisp focus into sudden passages of indecipherable form; frontal symmetries push akimbo; form escapes neat boundaries into clutter, tendrils, seeping stains, and brittle wisps; the gentle hug tightens into a deadly grip; the cheerfully compliant pose swings into a defiant stance; and last but not at all least, the child-surrogate animal that was once a fluffy groomed accessory has turned into a nasty pest. And in the midst of this carnal confusion, because of it, Mann's child is profoundly beautiful, perfect and pure.

Conservatives are not comfortable with pictures as big as myths being ascribed to children. Nor made by women. Especially not by mothers. But liberals are not so comfortable either. Wildly dark human impulses are not politically correct. Feminism, in particular, has been so busy denouncing the injustices of the art world and demanding cultural progress that it didn't predict that a woman artist might burst through the tidy hedges of liberal nicety. We wanted women artists to be able to rove freely through the human condition, but we forgot what that human condition would look like at its most extreme, and most enthralling.

Now a woman has helped us to remember. What is really important to feminism about Sally Mann is that her scandal puts her on a critical cusp. The allegations of Mann's scandal have mired her work in the past, but the magnitude of her scandal indicates the future. A feminist will be quick, I hope, to defend work like Mann's from interpretations based on gendered assumptions, because a feminist will know from past experience how insidious such interpretations can be. The worst of those assumptions, I would maintain, is the assumption that women because they are women make art about themselves, or about their personal femininity. Artists who happen to be women may not be reflecting their personal lives, even when their subject is ostensibly maternity or childhood.

Hypothetically, Mann's work needs no feminist defense because her work is not hampered by gender, because her work is not about any one person's life or circumstances. Historically, it has needed some defense from what it is not. Already Mann's work, in some ways and for some audiences, needs no defense. If scandal has been the price Mann paid for her success, she has proved to have plenty with which to pay. Feminism may be necessary to understand how Mann's work has fared so far, but feminism will not be necessary to understand where

her reputation goes from here. Feminism is still absolutely necessary for a clear understanding of the position of at least half the human race within the visual culture of the past—along with other perspectives, of course. Most people in the world have not been allowed to transcend their personal circumstances and have therefore not been able to make what we call great art (or any art, for that matter). Gender has been among the principal excuses for keeping the history of art one supremely privileged strand within the history of culture.

Yet enough has changed to be able to see Mann's position in perspective. The precipitous ascent to fame and fortune of the latest cohort of artists who represent childhood photographically shows us that we have really crossed Mann's cusp. These artists—most of whom are women—address exactly the same kinds of issues about childhood, clichés, and photography as Mann. They may be her legacy to the history of art, whether directly or indirectly. And their careers seem completely unencumbered by gender issues, despite their being styled as "girls." They spark no scandal, on the contrary. Although they are at the very beginnings of their professional careers—Crewdson's *Another Girl, Another Planet* students, for instance, had graduated from the Yale MFA program between 1996 and 1999—they have already been lionized by both the artistic and commercial image mainstreams. They have received commissions from such high-circulation magazines as the *New York Times Magazine, Vogue Hommes, Harper's Bazaar,* and *Details.* In galleries, color photographs by Mesa-Pelly were then selling for between $2,500 and $5,000, by Grannan for $3,000, by Marder between $3,000 and $5,000, by Hoey between $2,500 and $6,000, by Becker between $3,000 and $10,000. More recently, Simen Johan's photographs have sold for between $2,000 and $9,500, Loretta Lux's for between $4,500 and $28,000. In February 2000, *Harper's Bazaar* ran an article titled "Hot Shots," including a large and glamorous color photograph of six artists, five of whom had been in *Another Girl, Another Planet:* Jenny Gage, Katy Grannan, Dana Hoey, Justine Kurland, Nikki Lee, and Malerie Marder. *Harper's* announced: "Young, ambitious, and fiercely talented, they navigate the boycentric art world with the supreme confidence and savvy of superheroes."[15]

Nor were the girl and boy superheroes from another art-planet. They were not being hailed for their difference, but rather for the way in which they were transforming the conventions of art from within. With their impressively large formats, resolutely mechanical color-printing, and theatrically staged subjects, their images successfully staked a claim to matching and even exceeding other media's ability to express the contemporary scene, not despite being photographic, but because they were photographic. And in so doing, the young superheroes were achieving the dissolution of whatever boundary remained between artistic and commercial realms of photography. Cindy Sherman, Laurie Simmons, and Nan Goldin—among others—had already, a generation earlier, hoisted photography's artistic status higher than it had ever been able to reach before. Andreas Gursky—among others—had recently been credited with merging commercial and artistic conventions so thoroughly that neither had survived intact. What was new, and historically momentous, was the idea of a collective phenomenon, of a force that went beyond individual achievement to constitute a movement. (Whether or not all, or even most, of the individual reputations of the artists involved will stand the test of time therefore doesn't matter.) The very characteristics that had made Mann scandalous were suddenly conditions of importance. Younger photographers were being hailed because they dealt with the fundamental problems of representation and realism, all hinged around a transformation in the perception of photography, pithily summed up in the *Harper's Bazaar* "Hot Shots" article: "It doesn't have to be real to be true." When they visualized a truth whose authenticity was not empirical or documentary, but rather a truth of fantasy, fable, and myth, all guaranteed by childhood, they, unlike Mann, became "superheroes."

Feminism is of no use to this new generation. One of them, Justine Kurland, has said: "I don't mind being called a 'girl photographer.' It's a subversive term that depoliticizes the whole feminist issue—besides, the terms 'men' and 'women' are kind of icky, don't you think?"[16] Someone has to stay behind to guard the past with a feminist perspective, if only because feminist advances can be turned backward all too easily. Barring such a catastrophe, feminism now finds itself on a historical cusp. A different set of criteria will have to evaluate each side

of a divide. But if feminism has to think about the past in a radically different way than it thinks about the present and the future, it will be a trivial price to pay for its success.

NOTES

1. *Time,* 9 July 2001.

2. Sally Mann, *Immediate Family* (New York: Aperture, 1992).

3. Sally Mann, *What Remains* (Boston: Bullfinch, 2003).

4. Comparisons between prices are difficult to make, because so many factors are involved: medium, size of edition, size of a print, etc. A few figures may help to give a sense of the spring 2000 auction market. For a 1992 Mann gelatin silver print, 18¾ × 22¾ in., one of twenty-five: $30,550. For a 1991 Andres Serrano cibachrome triptych, 16 × 12 in.: $12,000. For a 1995 Kara Walker cut paper, 120.7 × 106.7 cm: $20,300. For a unique 1994 Rachel Whiteread drawing: $70,500. For a 1998 Andres Gursky C print, 67 × 188 in.: $181,750. Mann, Serrano, Walker, and Whiteread seem to be in roughly the same price league, and Gursky way out ahead. Auction catalogue, Artfact Professional <www.artfact.com>, Spring 2000.

5. E-mail from Sally Mann to Anne Higonnet, 13 April 2002.

6. "Nature of Mann," *Vogue,* September 1999, pp. 608–615.

7. To give just one example: "It is hard to believe a mother will knowingly propel her children into this spotlight of adult lasciviousness. I found the image deeply offensive." Christina Cunningham, "Making a Spectacle of Oneself," *Make: The Magazine of Women's Art,* no. 83 (March/May 1999).

8. Anne Higonnet, *Pictures of Innocence: The History and Crisis of Ideal Childhood* (London: Thames & Hudson, 1998).

9. Carol Armstrong, "Cupid's Pencil of Light: Julia Margaret Cameron and the Maternalization of Light," *October* 76 (Spring 1996), pp. 114–141; Carol Mavor, *Pleasures Taken: Performances of Sexuality and Loss in Victorian Photographs* (Durham: Duke University Press, 1995). For a popular, mass-media variant, see, for example, Sara Sklaroff, "The Timeless Moment," *U.S. News and World Report,* 9–16 July 2001, pp. 24–25.

10. See, for example, David Frankel, "Kara Walker," *Artforum,* April 1999, pp. 122–123; Scott Rothkopf, "Walker Show Subverts Racial Stereotypes," *Harvard Crimson,* 19 March 1998, p. 1; Jerry Saltz, "Making the Cut," *Village Voice,* 24 November 1998. And to quote one more, Miles Unger, "Contested Histories," *Art New England,* June/July 1998, p. 29: "One of the virtues of her work is to demonstrate the extent to which the very concept of race is a powerful fiction based on the construction of a mythical Other upon whom we project our irrational fears and compulsive desires. Stereotypes carried to such an extreme reveal their origin in the obsessions of the one who does the stereotyping, but Walker's work also addresses how such caricatures are internalized to form the basis of a charged narrative of self. Her archetypal characters, who lust after and maim each other with gleeful abandon, live at the intersection of history and the individual psyche where fear and desire are generated."

11. The strongest recent example is Jonathan Weinberg's 2001 essay on Mann, which looks through her photographs to diagnose her family's psychology, concluding that Mann's work is driven by her personal ambition. Jonathan Weinberg, "Staged Artist: Sally Mann's *Immediate Family,*" in his *Ambition and Love in Modern American Art* (New Haven: Yale University Press, 2001).

12. Emily Apter, unpublished talk delivered at symposium Imagined Children, Desired Images, Wellesley College, April 1995.

13. See Shanna Ehrhart, "Sally Mann's Looking Glass War," in *Tracing Cultures: Art History, Criticism, Critical Fiction* (New York: Whitney Museum of American Art, 1994), pp. 52–56.

14. "Kids Love . . . ," photographs by Robert Trachtenberg, styled by Elizabeth Stewart, *New York Times Magazine,* 3 February 2002, pp. 52–57.

15. "Hot Shots," *Harper's Bazaar,* February 2000.

16. Quoted in Steve Vincent, "Alice in Levittown," *Art & Auction* 23, no. 2 (2001).

Responding:

Responding:
Scandalous Matter: Women Artists and the Crisis of Embodiment

———

Maria DiBattista

At the outset of the essay that inspired the critical terms of this conference, Linda Nochlin enjoined her readers not to dally over the labor of chipping away at "the top tenth of an iceberg of misinterpretation and misconception" that kept us defensively explaining why there are no great women artists. Rather, she exhorted us to delve into the "vast dark bulk of shaky *idées reçues* about the nature of art and its situational concomitants, about the nature of human abilities in general and of human excellence in particular, and the role the social order plays in all this."[1] Thirty years later we are still struggling to do so, but it is obvious from the presentations, commentaries, and audience responses of this two-day conference that our excavations proceed with no clear consensus about the nature of human abilities in general or of artistic excellence in particular.

How salutary this array of varied, often divided opinions is remains to be seen, but what remains to be seen is always an enticement to those enamored of the visual arts in all their forms. What does appear undeniable at the shadowed dawn of the new millennium is that the relation between the official and unofficial establishments that train, exhibit, and promote individual artists—be they great or relatively minor—is a relation amazingly, to some alarmingly, to others reassuringly, marked by scandal. We have heard throughout this conference about the various ways scandal announces and propagates itself: in the obscene perfor-

mances of Carolee Schneemann, in which, drawing a scroll from her vagina, she seems to give birth to herself, or at least to an inner imago gestating within her; in Judy Chicago's lithophotograph *Red Flag,* a banner of femaleness flaunted in defiance of atavistic menstrual taboos that still exert a great inhibitory force; in the lamentable brevity of Francesca Woodman's career, a career and life cut short by her own hand, suggesting that her death might have been the last, desperate work of that tormented creature—the madwoman-artist; in Sally Mann's notorious photographs of her children, but also in the allegedly exorbitant prices said to be paid for her prints, and in that curious *succès de scandale,* her suit against the producers of *Titanic,* who appropriated her work without permission. Abigail Solomon-Godeau in her turn called attention to the continuing, undiminished notoriety of women artists who aggressively champion the rights and realities of minority culture, the culture of outsiders and interlopers, like Tracey Moffatt, an Australian of Aboriginal ancestry, or African-American artists like Carrie Mae Weems or filmmaker Cheryl Dunye. Citing that roster of names, Solomon-Godeau sensibly reminded us, too, that the scandal of minority culture often entails isolating femininity or some other "essence" of womanhood as self-sufficient and all-determining, thereby excluding equally compelling realities of class, race, ethnicity, nationality.

I repeatedly characterize these examples as scandalous, not to insist on their nature as potent eruptions of dissident vision, social protest, or ideological controversy, since this meaning of "scandal" seems to me easily available and, indeed, incontrovertible. I want to pause, rather, before the Latinate root of "scandal," *scandalum,* meaning cause of offence or (moral) stumbling, itself derived from the verb *scandere,* to climb. Scandal, this etymology instructs us, comprehends at its origin the notion of blocked ascent, surely a fitting, properly monitory image to accompany our reflections on why so few women artists have scaled that summit known as artistic greatness. Scandal warns us to take heed of those stumbling blocks that impede our progress in understanding and assessing the work of art offered to our contemplation.

The richly detailed account of the disturbing, fearless work of scandal-prone women artists that Carol Armstrong, Solomon-Godeau, and Anne

Higonnet have presented suggests, however, that scandal is the most sensational-ist, but by no means the most significant aspect of a crisis in the visual arts, at least in the visual arts practiced and produced by contemporary women artists whose work has been displayed and analyzed in these proceedings. Let us call this crisis the crisis of embodiment. We have heard this crisis described from widely diver-gent perspectives that nevertheless all converge on the body as the material lo-cus, the vital and sentient center that, except for the artist's labor of registration, might fade, historically evanesce, and disappear from view.

This indeed is the forlorn prospect that motivates, indeed haunts, Francesca Woodman, whose work, brief as it was, momentously captured the fragility of the female body and the metaphors it carries and enfolds within it-self. Armstrong is well aware that, given Woodman's suicide, it is tempting to re-gard this fragility psychologically, as an unmitigated pathos. She prefers to suspend that possible, if to her inadequate, somewhat myopic interpretation of Woodman's work in order to develop what she calls a "mythological" reading of Woodman's unique evocation of the crisis of embodiment. The myth of the body that Woodman confronts in her photographs is the myth of sexual difference, a confrontation made more intimate and, arguably, more dangerous by Woodman's posing her own body before the inquisitive, transfiguring lens of her camera. This confrontation with sexual identity, in which Woodman acts both as muse and artist, experimental subject and photographic researcher, is thus directly, un-avoidably, a mode of self-confrontation.

Such doubling of artistic identity gives Woodman great freedom to exper-iment with, question, and recast traditional figures and conventional tropes for the female body, but, as Armstrong observes, it also suspends her in an indeter-minate space not quite public and yet never fully private. Armstrong character-izes this space as haunted, a chilling image that emotionally heightens her more sober observation that Woodman's photographs depict (not just record) a liminal state between visibility and nonvisibility in which the outlines, boundaries, even surfaces of a female body (Woodman's own) tremble on the verge of dissolution. Sexual difference, the "nightmare of femininity," the disordered interiors of fe-male social and psychic space—these are the existential themes of Woodman's

work, but Armstrong's more intriguing claim is that for Woodman sexual differ-
ence and the enigma of female identity are inalienably connected to the formal
"difference" that distinguishes photography from painting and from a rival visual
technology, cinema. Photography, like painting, may freeze an image in time, but
for Woodman the "lived" photographed instant is the instant of momentarily ar-
rested metamorphosis, the uncanny instant when the body hovers between visi-
bility and invisibility, being and nonbeing. Her artistic life might have been brief,
but the questions she put to it were unsettling enough to outlive her, mainly be-
cause she never had the chance or perhaps felt the desire to answer them defini-
tively. They are the questions of the young artist first encountering the crisis of
embodiment and unsure whether that crisis can be, indeed ought to be, resolved.

Thus Armstrong alerts us to the way Woodman's youth and the exercise
quality of many of her photographs are reflected in her artistic persona—the
artist as beginner. She is, more singularly, a beginner too absorbed in exploring
the nature of the threshold she occupies to move on, break new ground, found
new visual regimes, or enlist in any particular feminist brigade intent on revolu-
tionizing dominant ideas about what woman is and can do. It is this repeatedly
indulged desire to linger in haunted, liminal spaces that paradoxically makes
Woodman's work admirably open-ended, but undeniably regressive.

It is a paradox that Armstrong herself explores with great subtlety and with
some risk, aware as she is that Woodman's work—devoted to experiment and
play over dogma and commitment, "minor" exercise over monumental state-
ment—might appear as an aberrant, ultimately futile attempt to regress to a time,
presexual and preconceptual, when the female body had yet to acquire cultural
as well as physical definition. To her credit, Armstrong does not try to minimize
this risk, insisting, for example, that we not regard Woodman's inquiring play as
a form of masquerade, a model of play and self-invention much favored by cer-
tain feminist and gender theorists. Woodman's disinterest in masquerade and im-
personation seems to me the least youthful thing about her, and I can't help
wondering how different her career might have been had Woodman experi-
enced—or imagined—a genuinely childish delight in self-projection. But if she
lacks a childish fancy for masquerade, she retains the child's awe of magic, which

manifests itself in her apparent indifference to photography as a technology. Woodman's appreciation of the camera as an instrument that can make things appear or disappear seems archaic, even prehistorical, as befits an artist fascinated by, and herself apparently arrested in, the state of things-about-to-be.

What gives this regressive aesthetics its startling precocity and urgency is the historical depth into which Woodman's photographs plunge us, conjuring as they do the metaphorical and rhetorical bodies that traditionally have materialized woman's cultural and historical being. The disordered and haunted interiors she photographs become the scenes where Woodman can explore this mythological heritage in hopes of recovering an inspiriting, sustaining matrilineage, what we might call a woman's usable past. That the past be made visible, that it become usable, is the first task that awaits beginners, that is imposed upon daughters. What complicates Woodman's personal effort is her scandalous, consciously stumbling attempt to rematerialize the spirit of her artistic mothers through the mediating figure of her own fragile body.

Woodman might thus be invoked as one of the ghosts whose testamentary power Solomon-Godeau wants to impress upon us. Drawing on the work of Avery Gordon, Solomon-Godeau, however, considers the ghost less as a material absence clamoring for visibility than a social figure through whose mediatory presence we might gain access to the past. This resurrected past would comprehend not only the untold stories of unique individuals, but more impressively, a collective history still in need of articulate expression and eloquent image, that is, a past that has yet to be embodied. For Solomon-Godeau this crisis of collective embodiment is related to the woman artist's unsettled, vexed relation to majority culture. She thus approaches the question of why there have been so few great women artists as a question about "minor" and "minority" art (not cognates, of course). Moreover, she directs her inquiry in the very terms Nochlin proposed—by asking us to set aside any preconceptions we might still entertain about what art is and how it is produced.

Solomon-Godeau identifies two strategies adopted by those whose art never detaches itself from its origins in the minority culture and collective experience from which it emerged. Taunting is one such strategy. It is a tactic de-

ployed in Tracey Moffatt's breezy voyeuristic comedy *Heaven,* in which the camera, at the service of female visual pleasure, brazenly fixes its eye on a series of male bodies, or Carrie Mae Weems's equally impudent but more agitated work, *Ain't Jokin'*. *Ain't Jokin',* a photo/text in which Weems captions selected photographs with blatantly racist jokes or riddles, prompts me to wonder whether taunting, however polemically exhilarating, may be rhetorically ineffective in producing the response it desires. *Ain't Jokin'* set out to caricature bigotry, but also to capture the spectator in a moment of unavoidable complicity. Solomon-Godeau relates, however, that when the work was shown at the Rhode Island School of Design, the first African Americans to see the show were the custodians who cleaned the gallery. They decided to strike in protest. When informed that the artist was a black woman, one of the custodians quit and the others returned to work. Should we take their unanimous, although admittedly first response as an object lesson in the sociology of art, one that might clarify the extent to which class complicates racial feeling, not to mention gender differences, in the art as taunt? Taunting in this instance proved a strategy that outraged, but also misunderstood, its audience.

Whatever the polemical piquancy of taunting as counterresponse, I can't help wondering whether the taunt too quickly collapses the space between curiosity and collusion, thus severely restricting the range of spectator response. Weems's desire to set text and image in dialogue may ultimately be frustrated by the univocal texts she inscribes. Weems isn't kidding when she says she *Ain't Jokin'*. *Ain't Jokin'* is serious about banishing ambiguity, indeed ambivalence from its rhetorical exchanges. This seems to me an unfortunate restriction, since it precludes the spectator, not to mention the artist, from encountering a whole posse of meanings roaming between the stated and the implied, the said and unsaid. Sometimes what remains unsaid or is left unstated can be as eloquent as any blatant indictment. Moreover, the implied is more likely to insinuate itself more deeply into the spectator's consciousness, penetrating those more protected regions of the mind where feelings are formed and perceptions take shape.

Haunting seems a less direct strategy for penetrating consciousness, but it may prove more effective in overwhelming the viewer with the transparent, but

dense life of felt presences. The observing eye or mind that is the object of the artistic taunt can rebuff it as an irritant or, alternately, accept its censure for the sheer masochistic pleasure of self-accusation. The apparitional aesthetic of works like Moffatt's *Laudanum* acts differently on the mind. Such haunted and haunting work renders the barrier between fictive and real, visible and invisible a more permeable membrane. The problem of embodiment in these works is not presented to the spectator as a problem awaiting an immediate and visceral reaction—the response the visual taunt hopes to provoke. Haunting makes the viewer aware of a continuing but neglected obligation. Its ghostly images and disembodied specters impress upon the embodied spectator that art entails the ongoing labor of reembodiment.

A pun, of course, awaits its turn here, eager to make the connection between the mother's labor and the artist's strenuous work of embodiment. The pun ought to be indulged, I would plead, since it articulates a knowledge of the body that mothers and artists share, the elementary but often forgotten knowledge that the body grows, mutates, endures damage, recuperates, ages, dies. But if the body dies, it need not disappear as long as it is perpetuated in other bodies or its existence memorialized in works of art. Thus the work of embodiment comes to define an artist's relation not only to her own art, but to the tradition that precedes her, to art that is, or is about to become, a cultural institution.

As Anne Higonnet demonstrates, Sally Mann's work is exemplary in undertaking the labor of artistic embodiment patiently and, as we know, fearlessly, without censoring what she sees, no matter how untraditional or unwanted what she sees might appear to less instructed and more timid eyes. Her scandalous series of family photographs and her latest work, *What Remains,* have in fact offended those who charge her not only with the particular outrage of sexualizing her children, but of the general offense of objectifying them. Mann seems to acknowledge these ethical perils in what Higonnet calls her "mythic origins picture"—*Damaged Child* of 1984—which candidly offers us the picture of the cherished, vibrant, but clearly damaged body of her own child.

Yet I am less interested in the possible psychological injury Mann might have inflicted on her children by making them the subject of her photographic

art, especially since most parents understand the poignancy of photographing the child who each day recedes a little more out of range from one's observant, custodial, enamored eye. Rather I am intrigued by the ethical conundrum that seems to lurk as a hidden but increasingly audible meaning in a section of *What Remains* called "Matter Lent." The title, taken from Bossuet's *Sermons on Death,* signals Mann's own transformative vision, the vision of a mother-artist whose subject is the sexual vibrancy of the body, the child's eros, but also the pathos of its helpless subjection to thanatos. This is the complex story of human sentience that Mann's scandalous photographs tell over and over again. In telling that story, Mann quotes and observes Bossuet's admonition in all its serene wisdom:

> All things summon us to death;
> Nature, almost envious of the good she has given us,
> Tells us often and gives us notice that she cannot
> For long allow us that scrap of matter she has lent . . .
> She has need of it for other forms,
> She claims it back for other words.[2]

Mann has made timely, ravishing use of the matter lent her. Before relinquishing or ceding back the matter lent to her, she has transformed it, made it her own, inscribed on it a signature of her identity.

Because of Higonnet's paper, I now see how art may be conceived and interpreted in its aspect as matter borrowed, but also irreversibly transformed before it is returned to be lent out so that others may do their work, generate new forms in the hard, but creative labor of embodiment. Mann's photographs, like Francesca Woodman's, are highly literate evocations of the history of photography, but it is a history told from the perspective of the mother rather than the daughter, of an artist confident of her medium and secure in her materials, even if those materials are as tender as Woodman's diaphanous figures—the bodies of her own children. The shots of Mann's children captured in the throes and accidents of becoming thus seem to be elaborating an allegory about the relation of a woman to her artistic as well as biological progeny. I believe it is worth re-

marking how the crisis of embodiment inspires both Mann and Woodman to re-cover for themselves an artistic matrilineage. If Woodman, as Armstrong sees her, is a daughter arrested on a threshold between the haunted past and a lost future, Mann is the mother who regards the life that issues from her with all the cool authority and discipline of the sage who abides by nature's law that all human matter accorded us is only matter lent. But rather than being a cause for despair, this law appears to her as the rule of continuity and connection that regulates and preserves tradition.

One final remark and request for those concerned with exploring and perhaps improving the fate of women artists. Nochlin concludes her essay by urging us to face up to the reality of history. "Disadvantage," she counsels us, "may indeed be an excuse; it is not, however, an intellectual position."[3] Nochlin then proceeds to exhort women artists and critics to use our position as "underdogs in the realm of grandeur"[4] to ensure that greatness becomes a possibility within the reach of anyone tempted to achieve it. In taking up the challenge, I would in turn urge that more thought be given to women's relation to artistic greatness, more specifically women's relation to grandeur. I would like to know more about the great ambitions and grand designs that motivate contemporary artists and the place of grandeur in contemporary art history. Again, an etymology may help me convey the urgency, at least to my mind, of addressing such questions and responding to the challenge Nochlin issued more than twenty years ago. "Grandeur" derives from the Latin for "full grown," so that etymologically the challenge represented by artistic grandeur is for women to come into their rightful artistic estate. Grandeur need not reside in the historical sweep or the magnitude of the image, but might repose, as all grand things tend to repose, in a secure angle of vision, in the confident disposing of the matter lent. Grandeur is the supreme achievement of the artist's work, the labor of dignifying, clarifying, transforming all that otherwise might elude our reach, our sight, our comprehension. This may be the final scandal or stumbling block for women artists to surmount—to aspire to grandeur, to transfigure the matter lent us, the social times into which we are born, the personal time allotted us.

Notes

1. Linda Nochlin, "Why Have There Been No Great Women Artists?," in her *Women, Art, and Power and Other Essays* (New York: Harper and Row, 1988), p. 152.

2. Sally Mann, *What Remains* (Boston: Bulfinch, 2003), p. 11.

3. Nochlin, "Why Have Their Been No Great Women Artists?," p. 176.

4. Ibid.

ELLEN GALLAGHER

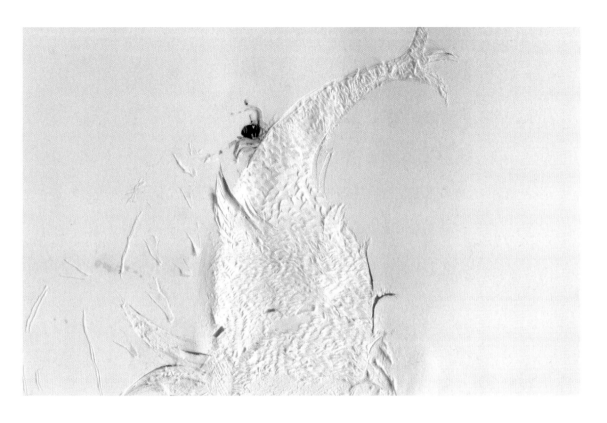

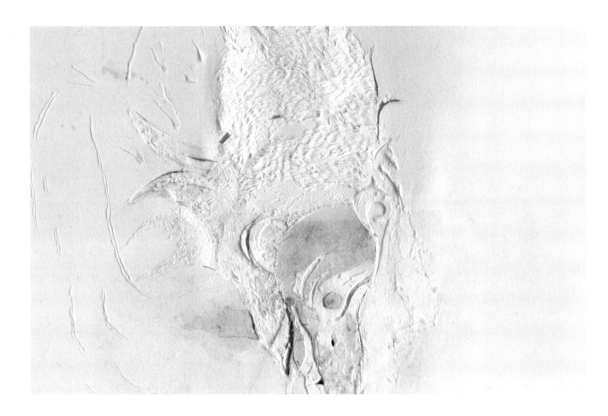

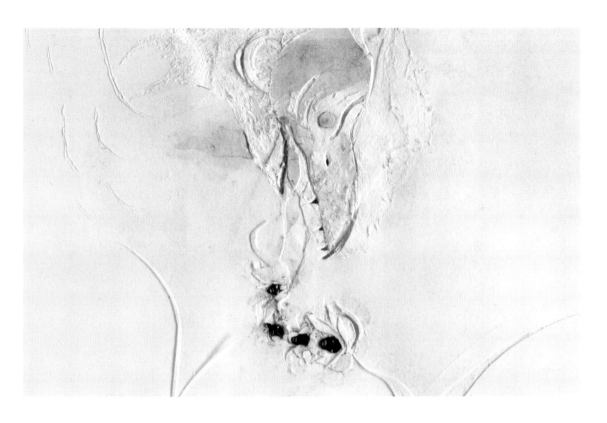

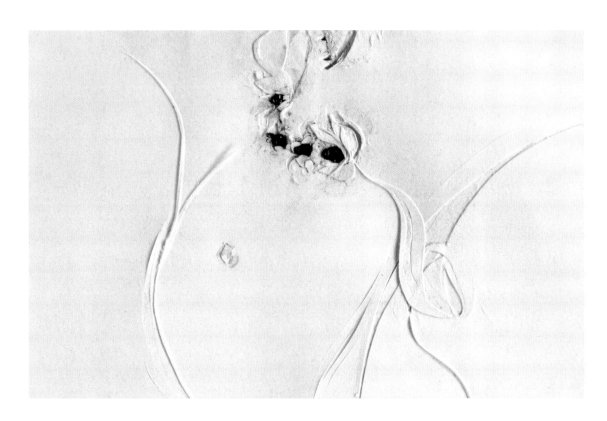

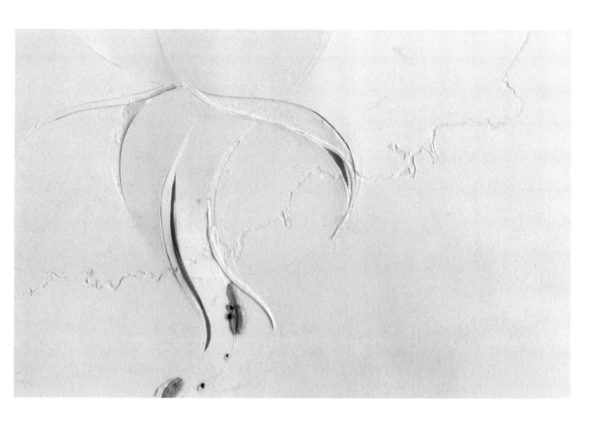

Index